THE
EXCEPTIONAL
WOMAN

THE EXCEPTIONAL WOMAN

Elisabeth Vigée-Lebrun and
the Cultural Politics of Art

MARY D. SHERIFF

THE UNIVERSITY OF CHICAGO PRESS ❖ CHICAGO AND LONDON

Mary D. Sheriff is professor of art at the University of
North Carolina at Chapel Hill.

The University of Chicago Press, Chicago 60637
The University of Chicago Press, Ltd., London
© 1996 by The University of Chicago
All rights reserved. Published 1996
Printed in the United States of America
05 04 03 02 01 00 99 98 97 96 5 4 3 2 1

ISBN (cloth): 0-226-75275-5

This book has been supported by a grant from the National
Endowment for the Humanities, an independent federal
agency.

Library of Congress Cataloging-in-Publication Data
Sheriff, Mary D.
 The exceptional woman : Elisabeth Vigée-Lebrun and
the cultural politics of art / Mary D. Sheriff.
 p. cm.
 Includes bibliographical references and index.
 ISBN 0-226-75275-5
 1. Vigée-Lebrun, Louise-Elisabeth, 1755–1842—
Criticism and interpretation. 2. Women painters—
France—Psychology. 3. Artists and patrons--France—
History—18th century. I. Title.
 ND1329.V53S54 1996
 759.4—dc20 95-16654
 CIP

For Keith Luria: An exceptional man

Contents

List of Illustrations

Acknowledgments

The National Endowment for the Humanities, the American Council of Learned Societies, and the University of North Carolina Faculty Research Council generously funded the research for this book, and the UNC Art Department provided me with excellent research assistants. My sincere thanks to those assistants, without whom this work really would not have been possible: Carolyn Allmendinger, Louly Konz, Helen Langa, Fiona Ragheb, Ann Ruckdeschel, and Michael Yonan. I am also grateful to the Hohenberg Chair of Excellence fund at The University of Memphis for providing research support during my visit there, and I thank Hollye Maxwell for her help in checking references and ordering photographs. Critical to the production of this book was the excellent photography of Patti McCrae and Jerry Blow, and I also thank Maya Hoptman, Anne Samuel, and Alden Sinicrope for their help in securing illustrations. My sincerest appreciation I extend to all those who helped me gain access to research materials both at home and abroad, and I am especially indebted to Jennie Buzas, Kathy and Raymond Everlet, Signora Guisti, François Louis, Harriet McNamee, and Régis Michel. I am grateful to the Baron Edmund de Rothschild and to the Comte d'Haussonville for making materials from their collections available to me.

My participation in the "Consumption and Culture" series organized by Ann Bermingham at the Clark Library greatly aided the development of this study. I am grateful to Ann Bermingham for her astute reading of my work and ongoing intellectual exchange. I profited equally from presenting my work at an early stage to Lynn Hunt's seminar at the Folger Library, and thank the members of that seminar for their helpful comments and questions. I am especially indebted to Lynn Hunt for her support of my scholarship and for the inspiration her example provides. Closer to home, my thinking about feminist issues and theories has been constantly enriched by my conversations with Jane Burns, to whom I am grateful for many years of friendship and in-

tellectual exchange, as well as for reading parts of this manuscript. I am also indebted to Alice Kuzniar and Alicia Rivero-Potter, who together with me and Jane Burns formed a reading group that was fundamental for my engagement with feminist theory. Other colleagues contributed to this study by reading and commenting on parts of the manuscript, and for this important and generous service I thank Whitney Davis, Gary Kates, Sarah Maza, Felicity Nussbaum, and Erica Rand. I am particularly indebted to three colleagues: Keith Luria, Nicholas Mirzoeff, and Janie Vanpée, who read the entire manuscript and whose comments on content, writing, and organization proved invaluable. For hours of reading proof, for help at all stages of the project, for enduring my fixations and frustrations, and for making me go back to France, I owe Keith Luria more than I can repay.

Over the years that I have been working on this project, many other friends and colleagues contributed to its completion. My interpretations of specific works of art, as well as my thinking about the representation of women, has been honed in conversations with Vivian Cameron, Madelyn Gutwirth, Suzanne Pucci, Erica Rand, Julie Plax, and Wendy Roworth, and I am especially grateful to these colleagues for sharing with me their knowledge and insights. Paula Radisich and I have shared intellectual interests and a close engagement with the visual image for many years, and our long association has enlivened and improved my work. I am indebted for general and specific ideas to discussions with Candace Clements, Patricia Crown, Dena Goodman, Christopher Johns, Dorothy Johnson, Andrew McClellan, Jeffrey Merrick, Jerrine Mitchell, William Ray, and Susan Taylor-Leduc. I very much appreciate Richard Shiff's continued support of my work. Kathleen Nicholson, with whom I have spent many productive hours in French art collections and libraries, I thank for sharing her sensitive interpretations of visual images and wide knowledge of eighteenth-century art. I am also grateful to Kathleen Nicholson and Suzanne Pucci for their conversation and companionship while I was working on this project in France. For single-handedly running the journal when I was away from Chapel Hill, and especially for much moral support and intellectual discussion, I thank James Thompson, my co-editor of *Eighteenth-Century Studies*. Last, but certainly not least, special thanks go to my past and present dissertation students, whose enthusiasm and confidence have been a constant source of encouragement for my work: Elizabeth Buck, Margaret Farr, Christine Huber, Candace Kern, Louly Konz, Jean Morris, Katherine Nordenholz, Kristen Ringelberg, Anne Schroder, and Alden Sinicrope.

One final note: Unless otherwise indicated, all translations are my own.

Introduction

The Exceptional Woman

Proverbial wisdom has it that the exception proves the rule, a familiar adage guaranteed to drive a logician to despair. Most apt to elicit this wisdom is an annoying counterexample or challenge to a favorite generalization. In that case, however, the response suggests not that the exception proves the rule, but that it does not *dis*prove it. Using this reasoning of the doubly negative in Book 5 of *Emile*, Rousseau preempts those who might support women's claim to equality by citing exceptions to the rule that maternity is a woman's *état* or occupation: "To assert vaguely that the two sexes are equal and their duties the same, is to lose oneself in useless phrases. This is not a response to what I have said. It is not a solid way of reasoning to give exceptions in response to laws so firmly established. Women, you say, are not always bearing children. No, they are not; yet that is their proper business."[1]

Rousseau plays on the point that a generalization can hold true logically despite isolated exceptions (what we commonly mean when we say the exception proves the rule), but at the same time, the exception is conceptualized as a transgression against a firmly established natural law. A challenge to (his) reasoning thus becomes a breach of, rather than an exception to, the rules. Rousseau's handling of the exception points to the law—that arena in which "the exception proves the rule" had a force or truth expressed in the Latin phrase *exceptio firmat regulam*.

When it pertains to logical reasoning about fact, "firmare" can mean "to prove," "to confirm," or "to assert"; but its first meaning is to strengthen, support, or fortify. *Exceptio firmat regulam*—the exception strengthens the rule—was a maxim of law for the Romans, and as such was restated in eighteenth-century France. I first encountered it in the *Encyclopédie* under the entry for *Exception, Jurisprudence*:

[handwritten marginal note: def of exception]

Exception is also sometimes a dispensation from the rule in favor of some persons in certain cases: one commonly says that there is no rule without *exception* because there is no rule, however narrow it be, from which someone cannot be exempted in those particular circumstances; it is also a maxim in Law that *exceptio firmat regulam*, which is to say that exempting from the rule someone who is in the category of the exception, is tacitly to prescribe the observation of the rule for those who are not in a similar category.[2]

The entry affirms that the exception confirms or strengthens the rule for those who are not excepted. Thus an exception cannot become the ground on which the rule is changed or challenged, nor can it be a model for the majority who live under the rule.

In this context the term, "exceptional woman," has a specific meaning and refers to the woman who, owing to some particular circumstance (talent, money, family ties, beauty, luck, political clout), has been exempted from rules or laws (be they perceived as natural, social, or statutory) prescribing the behavior of the female sex. In her recent book, *La Raison des femmes*, Genviève Fraisse has suggested how the play of the exception and the rule related to women in *ancien-régime* France.[3] Fraisse argues that the exceptional woman is a traditional figure of masculinist discourse, tolerated, even admired in her originality. Although it remains unacknowledged in Fraisse's text, the concept of the exception and the rule articulated in the *Encyclopédie* underpins her argument that exceptional women trouble the public order only to reinforce its rules. Thus defined, the exceptional woman can only be a problematic role model, for aspiring to her position implies collusion with the general subjugation of women. Separation from other women is the price a woman pays for her exceptionalness, and she pays it doubly, since the exceptional woman was easily construed as the unnatural or unruleable (unruly) woman by men and women alike.

In titling this book *The Exceptional Woman*, I intended that the term would point in at least two directions. First, toward the exceptional person—that individual who achieved something considered out of the ordinary, an individual whose success historians or contemporaries valorized. And second, toward the exceptional woman—that woman whose achievement required a dispensation from and strengthening of the laws that regulated other women.

This book focuses on one exceptional woman, the painter Elisabeth Vigée-Lebrun, but it is equally concerned with the debates over the "woman question" as those debates related to women artists in the late eighteenth and

early nineteenth centuries. I am interested in how the exceptional woman
was managed, contained, and controlled; and I investigate the mechanisms
through which she was prevented from becoming a rule. For Vigée-Lebrun,
these processes are especially clear in the wrangling over her acceptance to the
Royal Academy of Painting and Sculpture in 1783, which I investigate in
Chapters 3 and 4. The texts generated in this case allow us to read quite clearly
the play of the rule and the exception. On the other hand, throughout my
analysis of Vigée-Lebrun's images, I examine how the exceptional woman
could, especially through her self-representations and representations of other
exceptional women, both support and subvert the notion of "exceptional-
ness." Chapters 6 and 7 address this issue expressly.

Fraisse argues that the exceptional woman's difference from other women,
and the transgressions it allowed, made her a fascinating figure for men.[4] The
other side of fascination, however, is fear—here the particular fear that too
many exceptional women would make them (the) rule. Far from being differ-
ent from other women, the exceptional woman would make women more like
men, and vice versa. Although Fraisse did not link fascination and fear explic-
itly, she spelled out the particular worries articulated by masculinist writers in
the eighteenth century. They were specifically troubled by the thought that
equality would produce competition between the sexes and a loss of sexual
differentiation and attraction. Such fears were deeply rooted in the fantasized
loss of male (sexual) identity. Those who were most anxious insisted that there
be *no* exceptions, and condemned any woman who did not observe the rules
of her sex. At the other extreme stood those exceptional men whom we might
call feminists, those who accepted that every woman had the rights accorded
only to the exceptional ones. In the middle, no doubt, stood the majority,
suspicious that the proliferation of exceptions would challenge masculine
identity and control over the female sex.

Susan Faludi has argued that a backlash falls on women when a few visible
examples are given their freedom. Strengthening the rule is for Faludi a pre-
emptive strike: "The antifeminist backlash has been set off not by women's
achievement of full equality but by the increased possibility that they might
win it."[5] Although Faludi is here addressing her remarks to the backlash
prompted by our modern women's movements, the eighteenth century had a
most effective preemptive striker in Jean-Jacques Rousseau, whose concep-
tions of woman's place in society I explore especially in Chapter 4. Rousseau's
influence before, during, and after the Revolution can hardly be overesti-
mated, and there was scarcely a medical tract, advice manual, or treatise on
the nature of woman published between 1770 and 1810 that did not cite his

authority. Rousseau's arguments for secluding women in the domestic sphere were especially timely, given that other social and political pressures were working to distinguish public and private spaces more rigidly.

Elisabeth Vigée-Lebrun presents a particularly interesting example of the exceptional woman because her life and work is more or less split in two by that great cultural and political divide known as the French Revolution. She was an exceptional woman, a visible presence in artistic circles, before she emigrated in 1789, during her years of exile, and after she returned to France in 1801. During the *ancien régime*, Vigée-Lebrun, along with several other women, was admitted into the Royal Academy—the official art institution—as an exception. Her position as an artist, however, changed with the reorganization of institutions that followed the First Republic's fall. After the Revolution, women could no longer be admitted to the Academy, even as exceptions. They were thus totally excluded from the privileges and prestige of this honorific body. As an artist outside the Academy, Vigée-Lebrun no longer held the official public position that the institution guaranteed.

Many scholars have recently located the French Revolution as a rupture in history and a rupture in the history of women precisely connected to the question of women's (political) rights. Fraisse argues that the exclusion of women from rights and privileges accorded to the exceptional woman was not problematic in the *ancien régime*, because the notion of the exception was coextensive with the whole of society. In other words, in an absolutist, or what she calls a feudal, regime there is already a hierarchy at work that ensures different rights and different privileges for different persons.[6] The play of exception and rule becomes more problematic, she argues, in revolutionary France, which operates on (what Fraisse calls) a principle of democracy wherein all individuals potentially have the same rights: "The exception, recognized as such, was appropriate to political regimes that were strongly hierarchical; it is without theoretical justification in a regime that supposed equality."[7] Thus, in a democratic system the exception becomes, rather than proves, the rule. In a similar vein, Lynn Hunt concludes that the liberal politics (she prefers this term to Fraisse's "democracy") of post-Revolutionary France problematized the exclusion of women in a way not possible under the *ancien régime:* "Misogyny has been a nearly continuous feature of social life throughout western history, but it does have a history; that is, it has not remained the same over time. The exclusion of women was not theoretically necessary in liberal politics; because of its notions of the autonomous individual, liberal political theory actually made the exclusion of women much more problematic."[8]

Although the exclusion of women from citizenship and civil rights became theoretically problematic within an ideology of equality, many attitudes toward woman's nature and her place in society persisted before and after the Revolution, as did the presence of exceptional women in those societies. Fears about the proliferation of exceptional women haunted the old regime just as fears about demands for equality disturbed the new one. Yet the debate took a different turn once an ideology of equality was in place. The issue would no longer be one of the rule and the exception, but one of equality and difference.

Along with the historian Thomas Laqueur, Hunt and Fraisse have stressed that the medical literature (or what Fraisse calls the medico-philosophic literature) around 1800 was particularly obsessed with demonstrating that women were in essence different from men.[9] If the concept of equality proposed that all persons had the same rights and opportunities, nature showed (at least it showed to certain men) that all persons were not the same and hence were not destined for similar social and cultural functions. As is well known, differences could be used to justify exclusion (or to turn exclusion into equality via the notion of separate but equal), and differences were found between men and women, blacks and whites, Europeans and "Orientals." Theories of woman's difference had been articulated since antiquity, but in the period between 1770 and 1830 woman's difference was posited anew in various discourses including the physiological, moral, and philosophical. Part 1 of this book, "The Anatomy Lessons of Elisabeth Vigée-Lebrun," takes up the question of the woman artist in relation to ideas about women's bodies and minds, and considers both eighteenth-century thinking and its heritage in psychoanalysis. As Michèle Le Doeuff has argued, the eighteenth-century medical-philosophical construction of woman still seems pertinent today because so many of its beliefs have been reconstituted in psychoanalytic theory.[10]

In regard to this reconstitution, recall that in his essay on femininity Freud invoked the rule of the exception to explain the intellectual woman and to discredit "the ladies," that is, women analysts, who objected to a privileging of the masculine (the phallic) in psychoanalysis:

The ladies, whenever some comparison seemed to turn out unfavorable to their sex, were able to utter a suspicion that we, the male analysts, had been unable to overcome certain deeply rooted prejudices against what was feminine, and that this was being paid for in the partiality of our research. We, on the other hand, standing on the ground of bisexuality, had no difficulty in avoiding impoliteness. We

had only to say: "This doesn't apply to *you*. You're the exception; on this point you're more masculine than feminine."[11]

Just as the exceptional woman theoretically ensured the efficacy of the rule, the masculine, or phallic, woman upheld the "rule" of psychoanalysis. In *The Enigma of Woman*, Sarah Kofman pointed out that the phallic woman "proved *from a different direction* [Freud's] valorization of the penis, in her alleged fantasmatic belief that she possesses or will one day possess it."[12] In the last four chapters, I address the "phallic women" that the Revolutionary period represented as hermaphrodites, tribades, and femmes-hommes. Reading the painted image in conjunction with Judith Butler's theories of citation and performance, I explore in Chapter 6 how Vigée-Lebrun's self-presentations disrupt the logic that structures conceptions of the man-woman.[13]

As an exceptional woman during the *ancien régime*, Vigée-Lebrun had a particular position as a favorite painter and protégée of Marie-Antoinette. I take up the relation between artist and queen throughout this book, and in Chapter 5 focus on how portraying the queen of France emerged as a charged issue in certain portraits of Marie-Antoinette, and especially in the so-called portrait *en chemise* shown at the Salon of 1783. Elisabeth Vigée-Lebrun was the first and only woman artist to occupy such a significant and visible position vis-à-vis the monarchy, and it seems more than a trick of fate that a woman should have been accorded a singular royal honor just when that honor was about to become a mark of disgrace in Republican France. Is it any surprise that the artist continued to revere Marie-Antoinette, or that she clung to her royalist sympathies all her life? To do otherwise would have been to sully what I imagine she considered a great achievement—especially for a woman. One cannot deny those aspects of Vigée-Lebrun's life that a feminist might want to forget: her unabashed royalism, her aristocratic friends and patrons, her retrograde politics, her posturing as a beautiful society woman.

Nevertheless, it is time to question and interpret all the stories told and images built in her *Souvenirs* and elsewhere. It is naive to believe that writers and artists mixed with the court and the aristocracy on an equal social footing, and unfair to think her more a society lady than a working artist. Recent interrogations of sexual politics and gender construction as related to political institutions and visible women, both real and represented, in the Revolutionary period have opened the way for an analysis of cultural politics and the woman artist. In addition, feminist theory has suggested various strategies for conceptualizing woman's often contradictory place in the sociopolitical order and for explicating historically how women have coped with their subjugation within a particular patriarchal situation. Throughout history each woman has

had to cobble together for herself what it means to be classed as "woman." Moreover, as Le Doeuff has suggested, "that a woman is oppressed on the one hand, and on the other has a chance, her chance, explains the hesitant or split character we find in many women."[14]

In 1985, Toril Moi opened her *Sexual/Textual Politics* with the challenge of rescuing Virginia Woolf, whose work feminist critics had received negatively, for feminist politics. Moi posited there: "It is surely arguable that if feminist critics cannot produce a positive political and literary assessment of Woolf's writing, then the fault may lie with their own critical and theoretical perspectives rather than with Woolf's texts."[15] I do not claim Vigée-Lebrun was a feminist, but throughout my writing I have tried to view her work from a critical and theoretical perspective that will reclaim it for feminism. That perspective values the multiple shifting and fictive identities assumed by the artist in representing herself and other women, as well as her continual questioning of the divide between woman and artist, between "natural" (re)production and cultural production. These undercut any attempt to view her art as essentializing gender, sex, or desire, or to see it as constructing women as Woman, the eternal feminine.

On Reading Vigée-Lebrun's Souvenirs

I write about a woman apprehensive of what would be written about her, a woman who tells us she was finally convinced to write her memoirs by a friend's admonition: "Very well Madame, if you do not do it yourself, it will be done for you, and God knows what will be written."[16] The friend preys on the woman's history; God knows what will be written, but Elisabeth Vigée-Lebrun imagines what might be, for she had often been a target of malicious quills and tongues. Throughout her memoirs we find references not only to pamphlets and texts, but also to the "bruit," to the rumors or literally, the "noise" that surrounded her. But in the *Souvenirs*, "bruit" has a variety of forms: there is good noise and bad noise, malicious rumor and the clamor of praise, noise that keeps her awake at night and noise that lulls her to sleep. She becomes an expert on noises, supposes she can write a treatise about them in which she synaesthetically sees them as shapes; there are soft round noises and sharp pointed ones. I wonder how she would figure the noise that this book makes?

One might suppose from her apprehensions that Vigée-Lebrun did not want to be represented at all—at least not by someone other than herself. But this surely is not the case. Her souvenirs are filled with what others said about her—soft round noises, the kind that would induce sweet dreams. There are

flattering poems and letters, and when transcribed word for word into her memoirs, they make a scrapbook of representations—a collection of fragments selected and remembered. Vigée-Lebrun claims these representations, just as she claims the standard tropes of biography and the myths of the painter's imaginary.[17] She inserts into these representations the events— remembered, fantasized, or constructed—of her own life. There are nearly as many anecdotes in the *Souvenirs* constituted from someone else's life as there are incidents that can be verified as part of her own. She stakes her claim by publishing these representations and self-representations as the text of her life, her biography in an approved version. Whether or not this life genuinely belonged to her, whether or not she actually lived or wrote it, matters little here. This was the life she appropriated for herself; or she found in this written life the text of her experience. The artist even appropriates someone else's words to proclaim her sincerity: "In writing my souvenirs, I will recall the times past, which will double, so to speak, my existence."[18] That the text puts itself under the sign of *l'ami* Jean-Jacques by quoting from Rousseau's *Confessions* on the frontispiece only now seems ironic. The *Souvenirs* present Vigée-Lebrun as precisely the sort of woman Rousseau censored, but it is not clear that she would have recognized—as did her English contemporary Mary Wollstonecraft—the deeply mysogynist streak in Rousseau's thinking.

Reading the *Souvenirs* in the way I have suggested obviates certain questions that other art historians and biographers might choose to ask: Did she actually author them? Are they true? How much have they been edited? For my purposes it is enough that she acknowledges this text as the representation of her life both explicitly in the body of the work and implicitly by publishing it under her name during her lifetime.[19] The *Souvenirs* represent what she imagined she was, perhaps even what she desired to have been in 1835 when they went to press. Even if parts of the text were shown to have been written by someone else—say her niece or her editor—from notes based on conversations; even if the *Souvenirs* were revealed as an "as told to" book, they would still remain the authorized version of her life, the one she chose and recognized. As to the "truth" of her life—well, God only knows.

Even as we try to tell the truth, we cover our subjects with our own stories and write not our detachment but our projection. I write for Vigée-Lebrun the life I imagine she lived and imagine for her works a meaning I construct. Inevitably the subject's life and work are represented according to the interpreter's desire, which some modes of scholarship proscribe in favor of an imagined objectivity and which others represent as the interpreter's self-consciousness or "position." Whether repressed through proscription or representation, desire returns in our choice of subjects, questions, and meth-

ods. It is through our desires that the subject long dead regains the power to fascinate. Our desire for a subject inevitably attracts someone else to that subject. If my text encourages others to go and read hers, to go and see her paintings, to consider the issues she faced, to rewrite my account, to contest my readings—then, if I am speaking in her place, she is seducing others from mine. Like all artists, Vigée-Lebrun needs readers, viewers, commentators, critics. Why else is it that David is a canonized master?

This writing through and with, this inhabiting of another's text, seems quite appropriate to the task at hand. In 1995 it is commonplace to say that we construct ourselves through the discourse and image of others and that it is language that writes us and not we who write language. Vigée-Lebrun in her writing and painting continually identifies with the constructions of others. She casts her life and self-portraits in pre-established conventions and as the images of another because she never learned to do otherwise. In 1770 one became someone by becoming someone else—Apelles, Rosalba, Raphael, Rubens, Yolande de Polignac, Dibutadis. One became original by imitating. As I discuss at length in Chapter 6, imitation and identification occasion the sort of criss-crossing movement across the sexual divide that produces a complex, layered, and (apparently) contradictory subject.[20] More importantly, although citing or adhering to the norms that legislate sexual identity is culturally mandated, citation is inevitably interpretation, and as such it opens gaps between the cultural text and the individual's mimicry of it.[21] In those gaps lie possibilities, no matter how momentary, for subverting and questioning the very norms and laws cited. I tease out the subversive possibilities of Vigée-Lebrun's citations and self-representations, but I also show how the artist's interpretation of the cultural text was shaped—but not entirely determined—by the particulars of her historical moment, individual experience, and socioeconomic status. My study, then, is a local one; but it also (re)constructs the broader cultural and social conditions that circumscribed the choices made by one exceptional woman.

Forming the Exceptional Woman

In *The Exceptional Woman*, I have tried to mimic the plurality of citations and performances inscribed in Vigée-Lebrun's images by writing in a variety of discourses and rhetorics. I frame feminist theories and cultural histories with readings of texts and images indebted to both traditional techniques and more recent interpretive strategies. In arranging the chapters, I visualized the book as a triptych. Chapters 3, 4, 5, and 6, together called "Elisabeth Vigée-Lebrun in 1783," form the central panel. At the core of the book, then, is the year

Vigée-Lebrun entered the Academy and first showed at the Salon. My readings of the academic documents and Salon criticism along with her Salon entries, explore how women artists, and French women in general, were positioned in overlapping discourses, including the academic, legal, and moral, as well as that of labor. This central part is flanked and framed by two side panels, both of which highlight stories written and paintings painted after 1783. Grouped together as "The Anatomy Lessons of Elisabeth Vigée-Lebrun," Chapters 1 and 2 constitute my triptych's left wing; Chapters 7 and 8, entitled: "Staging Allegory," form its right.

Although the images and anecdotes of Vigée-Lebrun recounted in Chapters 1 and 2 postdate those presented in the central panel, my exploration of the issues raised by those later self-representations is critical to understanding the interpretive strategies and particular feminist thinking engaged in subsequent chapters. I have omitted the position paper or theoretical statement that could have opened this book. I have tried, instead, to explicate theory as I am demonstrating its practice, and rather than front-end-load the text, I have attempted to integrate my theoretical speculations into the appropriate chapters.

The other wing displays incidents and works associated with two later periods of Vigée-Lebrun's career: her years of exile and the time after her return to France. I particularly draw attention to her experiences in Italy and her later identification with another well-known exile, Germaine de Staël. As a whole, this part considers how issues of identity that particularly concerned the artist in 1783 were represented after 1790, and especially after 1800, in the post-Revolutionary years when Romanticism was gaining force. In taking up the question of allegory, one of my major concerns is to explore in the changed artistic climate depictions of the woman genius. My central character, then, is presented in a different costume in each of the three connected panels. For her anatomy lessons, Vigée-Lebrun disguises herself as "Woman," but only to teach her viewers and readers that she is an artist. In the center section, she is posed as the exceptional woman, although some will take her for a hermaphrodite. On the right, she postures more boldly, attempting to identify herself with the exceptional exceptional woman—the woman genius.

Like a painting executed as a triptych, *The Exceptional Woman* inflects, expands, and reiterates the ideas and events depicted in the central panel by framing them conceptually with related scenes, left and right. Whenever possible, I have tried to make relationships evident to those who open my triptych, and I expect that readers will see both intended and unintended associations in the pictures I am about to set before them.

PART ONE

The Anatomy Lessons of Elisabeth Vigée-Lebrun

ONE

The Sense and Sex Organs

Of Body Parts and Masterpieces

In the Summer of 1792, Elisabeth Vigée-Lebrun visited the cabinet of Felice Fontana, the celebrated Florentine anatomist and maker of wax anatomical models.[1] The memory of what she saw there followed her, pursued her, haunted her for a long time, or so she writes in her *Souvenirs*.[2] Within the travelogue of Vigée-Lebrun's Italian voyage, Fontana's cabinet assumes an unexpected importance, unexpected because she opens her recollections of this second trip to Florence by leading readers to anticipate another destination: the art exhibition. "It was for me a great joy, as soon as I found myself in this city, to go to see again so many of the masterpieces to which I had been able to give only a quick glance in passing [through Florence] on my way to Rome."[3] But beyond mentioning that she copied Raphael's self-portrait, she offers not a glimpse of Renaissance art, not a single insight gleaned from her study of it. What substitutes for these masterpieces are Fontana's body parts, and instead of the gallery she takes us to the anatomist's cabinet, the site of haunting memories.

Although Vigée-Lebrun has changed the destination, art is very much on her mind as she initially presents Fontana as artist and scientist. Among the objects in his cabinet, she remembers particularly a model showing the attachment of the eye to the body: "He took me to see his cabinet, which was filled with pieces of anatomy made in wax the color of flesh. That which I first observed with admiration was all the nearly imperceptible ligaments that surround our eye and a host of other details particularly useful to our well being or to our intelligence."[4] To many contemporary readers of the *Souvenirs*, a wax model of the eye, seen in an anatomist's studio, might suggest the observing and intrusive medical gaze that guided the modeler's art. Vigée-Lebrun also sees a medical gaze, although at this point she does not find it intrusive,

but sensitive and admirable. It allows the anatomist to see what is "nearly imperceptible," just as the modeler's skill permits those with equally sensitive eyes to see something like what the anatomist saw. It is for the viewer of the wax models that the ligaments must be "nearly imperceptible." The text suggests that the artist Vigée-Lebrun, like the anatomist Fontana, has a sensitive eye; she observes those nearly imperceptible details that (even in the model) others might not see.

But the painter does more than look at Fontana's models. She looks through them and sees the celestial craftsman: "It is quite impossible to consider the structure of the body of man without being persuaded of the existence of a divinity."[5] Here the ground has shifted. Although Fontana looked at the body with a medical gaze, Vigée-Lebrun sees his models with a religious one. Her look is organized by faith, by a structure of belief that hearkens to an earlier epistemic moment when the visible world mirrored the Creator and bore everywhere the signature of God. In Fontana's cabinet, to see (the body of) man is to see God, and to remember that God made man in His image. Nothing, by the way, is yet said about woman. The text enacts several returns and reversals as it pulls away from the Enlightenment rationalism that these wax models are often taken to represent. Sander Gilman has suggested that wax models made directly from cadavers duplicated the technique used to create realistic relics of saints and martyrs. Gilman sees both this shift from religious art to anatomical study, and the privileging of sight (the rational sense) as indicating a general secularization characteristic of the eighteenth century.[6] (But did not the tradition of reproducing relics *and* ex-votos continue uninterrupted side by side with that of anatomical illustration?) Although Fontana's model of the eye prompts Vigée-Lebrun's response, she directs her readers away from human reason and toward the all-seeing eye that is God. In returning these wax models to a religious realm, the text reminds us that they are not entirely free from their own past, from the (represented) body part as fetish object—as relic, as ex-voto, as substitute for or gift to the holy.[7]

Vigée-Lebrun's text, moreover, reverses the church's general resistance to anatomy, turning the anatomist's cabinet from a site of sacrilege into one of religious experience. Fontana's cabinet thus suggests those anatomical texts, such as Jean-Jacques Scheuchzer's *Physique sacrée* (1732–37), in which the human eye is pictured as the work of God and conduit to the divine.[8] The artist, moreover, sets Fontana's cabinet against the Enlightenment by refuting "what miserable philosophers have dared to say"—that God does not exist.[9] Vigée-Lebrun throughout the *Souvenirs* aligns herself with the religious—with church and monarchy—as a way of positioning herself against the Revolution, that other all-seeing eye.[10] Indeed, her *Souvenirs* record only one instance in

which the artist wishes herself blind, and that is when she imagines seeing the sites of events directed by that eye. She writes to her brother from Dresden in 1801, "In drawing near to France, the memory of the horrors that happened there came back to me so vividly that I feared to see again the places that witnessed these horrifying scenes. My imagination will bring it all back. I would like to be blind or to have drunk from the River of Forgetfulness to live on this blood soaked earth."[11]

In the cabinet of Fontana, the eye and the dismembered bodies—those in wax that the artist sees and those in flesh that she imagines as their models—implicitly oppose the sacrifice of headless corpses to the all-seeing Revolutionary eye. In the cabinet of Felice Fontana, the eye of God reigns supreme, and Vigée-Lebrun concludes that there, "one must believe and prostrate oneself." The phrase will prod the memory of those attentive readers who have come across it earlier in her *Souvenirs*. Recalling her first trip to Florence, Vigée-Lebrun noted, "It is in the church of Santa-Croce that the tomb of Michelangelo is located. There, one must prostrate oneself."[12] In the anatomist's cabinet she falls prostrate before God, in the house of God she falls prostrate before the godlike creative artist. We can now refine our concept of her gaze; it is more the gaze of the nineteenth-century Romantic reweaving together the religious and the aesthetic, seeing God in and as the individual artistic genius. In this particular text, the religious and the aesthetic are inseparable from the scientific represented by the anatomist's work.

Indeed, in Fontana's cabinet science points to the aesthetic as well as the religious. It is not simply that Fontana's technical procedures resemble those of wax sculpture, but that his works evoke specific art objects, and he consciously posed them to do so. One such model in the Museo Zoologico della Specola, Florence, recalls Adam from Michelangelo's God creating man on the Sistine Ceiling. Referring to the relation between creator and created, this precedent reconfirms the textual relation between Michelangelo and Fontana established in the *Souvenirs* and based on the parallel of anatomist and sculptor as artists and substitutes for God. Put in Vigée-Lebrun's terms, one can "see" the divine through and in their works.[13] Barbara Stafford has pointed out that the simile likening the excellent medical practitioner to the hand of God persisted into the eighteenth century, citing as one example the *ostensor-magus* of Jacques Gamelin's *Anatomy Theater* (1779; figure 1). Intended for use by both anatomists and artists, Gamelin's work demonstrates the mixing of art and science, and surely the Rembrantesque elements are strong in this image.[14] *The Anatomy Theater*, however, can also be read through Michelangelo's creation of Adam. What links these, is the gesture of the clothed, bearded magus who, like Michelangelo's God the Father, points vigorously toward a reclining

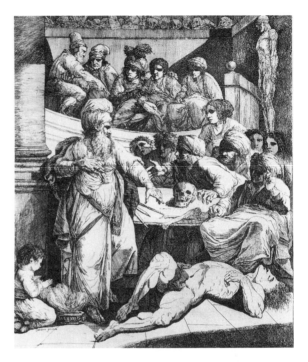

Figure 1

Jacques Gamelin, *Anatomy
Theater*, 1779. From *Nouveau
recueil d'ostéologie et de myologie*

male nude. Yet this father figure can only bring the corpse to life by encompassing it within the larger project of anatomy, taken as the (aesthetic) idealization of individual bodies to produce a generalized model. Also pertinent to the double function of anatomical engravings and models in the eighteenth century is that art students trained in the French Academy drew after wax models of body parts, just as they did after plaster casts of masterpieces.[15]

Venus Unveiled

Although Vigée-Lebrun at first seems indifferent to sexual difference in Fontana's cabinet, her story has a turning point marked by the words "before this I had seen nothing that caused me distress."[16] Some shock is coming, and it is occasioned not by contemplating the structure of man, but by viewing the body of woman. What unfolds from this point makes a different sense of the initial marveling and stakes for this woman a claim to artistic excellence. Among the wax models Vigée-Lebrun notices a reclining woman of natural size, which she finds truly illusionistic (figure 2). Indeed, such waxes were highly sensual and coded with conspicuously feminine features: long hair, smooth skin, passive pose, jewelry.[17] Fontana's relation to this woman trans-

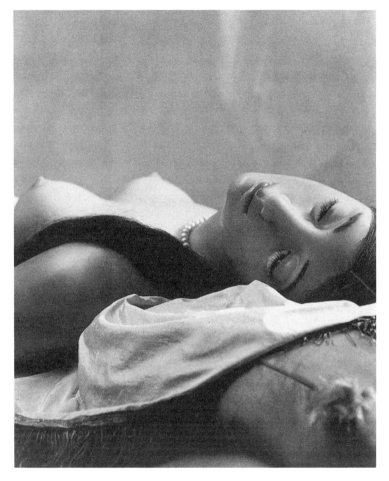

Figure 2 Wax Venus. Florence: Museo Zoologico della Specola

forms the celebrated anatomist from admirable god-like creator to purveyor
of voyeuristic thrills: "Fontana told me to approach this figure, then, raising a
kind of cover, he offered to my regard all the intestines, turned as in our bod-
ies. This sight made such an impression on me that I sensed myself near to
being sick."[18] Although the artist finds assurance in man's body, that of woman
(figure 3) sickens her. The wax figure is uncannily lifelike, and the artist's
physical identification with it turns her admiration to nausea.

We soon learn just how fully this sight impressed the artist; her nausea
turns to obsession, to a compulsion to repeat the scene outside the cabinet.
She tells us that on several outings "it was impossible to distract myself from

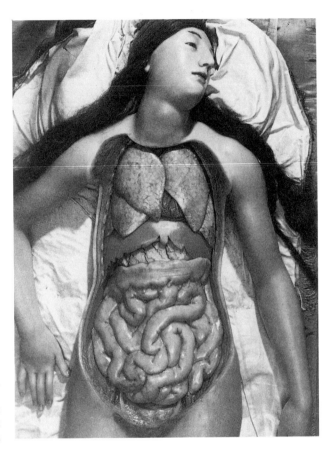

Figure 3

Wax Venus. Florence:
Museo Zoologico della
Specola

it, to the point that I could not see a [woman] without mentally stripping her of her clothing and of her skin, which put me into a deplorable nervous state."[19] The artist has moved from feeling sick to being sick; she is in a deplorable nervous state whose symptoms—headaches, sleeplessness, lethargy, convulsions, whatever they might have been—are left unstated. Readers are not asked to discern the causes from the symptoms, but to imagine, perhaps even experience, the symptoms from the cause. In short, readers must identify with Vigée-Lebrun in trying to assess the effects of the impression: the success of that effort depends on the strength of the reader's imagination.

To be cured of her deplorable nervous state, Vigée-Lebrun returns to Fontana's cabinet as a patient, a "fool" as she later calls herself: "When I revisited M. Fontana I asked him his advice to deliver me from the troublesome susceptibility of my organs. I hear everything, I told him, I see too much and

I sense all from a mile away." She has made the diagnosis—she suffers from the troublesome susceptibility of her organs—and she needs the cure. The anatomist answers, "What you consider as a weakness and as an evil . . . is your force and talent; however, if you want to diminish the inconveniences of that susceptibility, paint no more."[20] He delivers to Vigée-Lebrun a curative shock, an absurdity—he tells her not to paint. Similar treatments were the trade of therapists such as Dr. Pinel, the early psychiatrist who corrected an imagination gone awry by various shocks intended to dislodge some erroneous idea. Yet just what is Vigée-Lebrun's erroneous idea?

The artist identifies the error in a concluding segment in which she offers the reader a commentary on her memory: "You will easily believe that I was not tempted to follow his advice; to paint and to live have only ever been a single and identical word for me, and I have quite often rendered thanks to Providence for having given me this excellent sight, of which I had taken it into my head to complain like a fool to the celebrated anatomist."[21] The erroneous idea here is not connected to the impression that deranged her imagination but to her foolish doubting of her gift—her momentary blindness to the source of her force and talent, of which the obsessed imagination was also a symptom. The commentary returns us to the opening theme of the eye, in that it again focuses on sight. The excellent sight that has made her an artist is necessary not only for her intelligence, but also for her preservation: to paint and to live—for her they are the same thing. The point of the story is clear, it is an affirmation of Vigée-Lebrun's acute sensibilities and artistic talents.

The Inconvenient Susceptibility of Her Organs

At the center of the story lies, uncovered, the inconvenient susceptibility of her organs, cause of her deplorable nervous state and her artistic talent. But of what organs is the artist speaking? The immediate qualification indicates that it is her sensory organs: "I hear too much, I see too much, I sense all from a mile away." Yet what resounds through the passage is also the contemporaneous discourse on women's viscera, in general, and their sexual organs, in particular, for it was supposed that these organs held a privileged relation to their imaginative powers. A hypersensitive imagination, moreover, was common to three types—the insane, the artist, and the woman—all of which Vigée-Lebrun plays in this scenario. But things need to be sorted out and put in their places. Although set in Florence in 1792 (the year of her trip), the scene resonates with attitudes typical of French medicine and psychiatry in 1827, the year the *Souvenirs* were published. By then Condillac's sensationalist psychology had been made to tell scientific truth, in this case truth about woman.

What becomes of that truth, the turns it takes in one woman's story, is another matter entirely.

Inside all the visibles—the eye, the intestines, the organs—that appear in this text, there lurks the invisible power of imagination. Everywhere present and nowhere named, that power is even activated by the text as Vigée-Lebrun asks her readers to imagine imagination in an extreme state, imagination obsessively fixed on one object. Her story focuses attention on what sensationalist psychology considered a primitive sort of imagination closely tied to perception, or the power of recognizing that an impression had been received from the sense organs. Because directly connected to sensation, perception stood on the threshold between the material body and mental powers it developed.[22] Primitive imagination preserved perception and was commonly likened to a mirror, since it spontaneously recalled a perception (or its stored reflection) in the presence of some object closely associated with it.[23] This sort of imagination was not controlled by any other mental power, but triggered by an exterior object that by chance struck the senses. Condillac called primitive imagination instinct—a nonverbal mental operation shared by animals and human beings. We see an example of its working in the story told by Vigée-Lebrun. At the initial sight of the intestines, which leave a deep impression on her mind, she feels ill. Later, in the presence of an object (a real woman) similar to the one that occasioned the perception (a wax model) her imagination brings back the entire scene and the attendant feelings.

It is not surprising that the anatomist Fontana locates in the susceptibility of the organs, especially the sensory organs, an artist's force and talent. He takes his cue from colleagues like Pierre Fabre, professor at the Ecoles Royales de Chirurgie, who in 1781 argued that a man could never be a sublime poet or an orator, never a "Raphael or a Rubens" without extremely delicate organs of sensation. The imagination required of all great artists was rooted in these sensitive organs.[24] What is unexpected is that Fontana makes this claim not about a man, but about a woman, for the particular kind of sensitivity writers usually attributed to a woman's organs prevented her from artistic achievements and left her prey to mental instability.

The sensitivity of woman's sense organs was only a particular case of that which marked all her viscera and distanced her from the vigor and force of the male body governed by the solid and regulated movements of firm and dense muscles and organs. Physiologists showed the organ tissue of the female body to be more delicate, the muscle and nerve fibers less dense. Woman was thus susceptible to lively and rapid contractions of the muscles, nerves, and organs.[25] Pierre Roussel's influential treatise, *Système physique et morale de la femme*, first published in 1775, explicated how woman's active and sensitive

sense organs conditioned her imagination. They enabled her to outstrip the smartest man in rapidly seizing objects in their infinite detail, yet this sensitivity prevented woman from fixing her mind on one idea for any length of time. Because in woman the variety of sensations was much greater than their duration, she was constantly distracted and could not develop strong powers of reflection, which was the ability to control and direct attention. This control was so important that reason, or the ability to order ideas, depended on it. Indeed, reason was bound to reflection in a tight circle: the more the mind reflected, the greater the power of reason; increased powers of reason led to even greater powers of reflection.[26] Roussel concluded that woman's existence consisted more in sensations than in ideas, that the difficulty of sloughing off the tyranny of her sensations attached her only to immediate causes. What is at stake in Roussel's argument is the power of creativity—artistic creativity— which, although allied with imagination, must be put on the side of the masculine: "[woman's] imagination, more lively than constant, lends itself little to those true and picturesque expressions which are the sublime of the imitative arts. . . . More capable of sensing than of creating, she receives more easily in her mind the image of objects that she cannot reproduce."[27]

In finding woman more capable of "sensing than creating," Roussel invokes the distinction between an imagination that mirrors perception (imagination that is like instinct) and imagination that creates ideas. This first form of imagination Roussel genders as feminine, and leaves for men the more exalted processes. The gendering of imagination, however, was a more complicated business than this quotation from Roussel suggests, and that complexity is rooted in Condillac's formulations. Condillac's work is significant here not only because so much of later medicine and psychiatry—and especially that associated with the Idéologues—depended on his thinking, but also because, in providing a ground for associating imagination with sensibility, nature, and cultural production, Condillac helped make possible a new theory of creativity that exalted the imagination.[28] That theory, full blown, has been called Romanticism.

Recall that in tracing the "development" of imagination, Condillac charted a course leading first to a primitive or instinctual imagination whose operation was tied to the perception of some bodily sensation. A more developed power evolves from instinct, but this evolution is more an adding to than a transforming of. When memory is added to the arsenal of mental powers, the imagination can take on another function—that of operating apart from sensations or perceptions. Memory, Condillac defined as the process by which the mind both retained and retrieved the *signs* for perceptions, and it presumed society: "Since people can make up signs only through living in society,

it follows that as their minds begin to develop, the source of their ideas is in their mutual intercourse."[29] Henceforth this socialized imagination can conjure from signs stored in memory the perception or simple idea associated with those signs.

Once memory and imagination are working together, the stage is set for the most important of imagination's powers—that of combining simple ideas to form more complex ones.[30] In explaining how imagination can be a source of knowledge, Condillac writes: "Up to now I have taken the imagination to be merely the operation that revives perceptions in the absence of objects. But now that I am considering the effects of this operation, I see no reason not to conform to standard usage, and I am even obliged to do so. That is why in this chapter I take imagination to be an operation that, by reviving ideas, freely makes new combinations. So from here on, the word *imagination* will have two different meanings."[31] In actual practice, however, Condillac gives imagination more than two meanings, for combinatory imagination is the basis for forming complex ideas *and* the basis for artistic achievement.

Although artistic achievement was often denied women, as Roussel's remarks indicate, combinatory imagination itself was gendered as feminine. For Condillac, imagination is a flirtatious woman "whose only desire is to please." As woman, the imagination is *mobile*, unstable, ever-changing, moving from saucy to noble to amusing to impudent to sweet to languorous.[32] Thus imagination preserves the "feminine" characteristics of mobility and variety that deprived woman of the ability to reflect and create. This combinatory imagination is the only part of the mind that bears the mark of sex, and it seems that Condillac writes in tandem with older conceptions of imagination and rhetorical theory. Before Condillac, many writers held imagination in deep suspicion, opposed it to truth, and often constructed it—at least implicitly—as the feminine within man. Pascal, for example, thinks of imagination as the deceptive part in man, a mistress of error and falsity. With many other early-modern thinkers (for example, Montaigne), he views it in a framework of truth and error, wherein imagination cannot be separated from human nature after the fall, after the sin of Eve. Imagination, moreover, is related to the senses, to the body, and to illusion as false perception.[33] As in the rhetorical tradition, Condillac associates the ornamental with the feminine, and then goes on to tie them up with imagination: "imagination associates the truth with the ideas fittest for beautifying it, and this union forms a whole in which we find both solidity and pleasure. Imagination is to truth what jewelry is to a beautiful woman. It should lend every help to set her off to best advantage."[34] Thus truth and solidity—the masculine or unmarked qualities—are set

against imagination, beauty, pleasure, and ornament (jewelry), the marked, or feminine qualities.

If combinatory imagination is gendered as feminine in the chapter entitled "Where the Imagination Gets the Embellishments it Gives to Truth," it is because here Condillac maintains an older tradition. Indeed, this chapter seems a bit out of place in Condillac's text, and more than any other section it defines things figuratively, through simile or metaphor. Thus Condillac uses the rhetoric of imagination to define imagination. In the larger perspective of his analysis, a "feminine" combinative imagination looks a lot like imagination cross-dressed; like a man bedecked in woman's jewels and finery. Although combinatory imagination is in this one chapter designated as feminine, in the larger scheme of things the rather unwieldy concept of imagination is differently split into gendered components by the function of the sign. Combinative imagination is an aspect of higher imagination, for no ideas could be combined without memory. Because memory presupposed conventional or institutional signs, Condillac placed it on the side of language and society. Primitive imagination, on the other hand, he equated to instinct, and allied with the body and nature because tied to sensation. In this context we should also recall that in his *Discourse on the Origin of Inequality* (1754), Rousseau located the origin of language and the origin of society at the same moment.[35] That moment was defined by man and woman coming together as family, the social unit in which, as Carole Pateman has argued, a "sexual contract" authorized the subjugation of women.[36] Condillac conceives the sign's function as dividing a newly socialized imagination (now a power only of the mind) from sensory stimulation (or the body). Resulting from this division are differently gendered powers of imagination: a feminine one that remains dependent on the body and receives impressions easily and a masculine one (higher imagination) that lines up with the sign.[37] Closest to instinct, feminine imagination in and of itself can produce no new ideas; it can only reproduce sensations. Based on memory, combinatory imagination is the agent responsible for cultural production.

Woman could not be denied combinatory imagination altogether, for surely women could connect simple ideas to form more complex ones. However, in articulating the difference between a voluntary and involuntary connection of ideas, Condillac outlined the dangers of combinatory imagination, especially for women. It is not surprising that the difference between voluntary and involuntary connection coincided with that between memory and instinct. Voluntary connections came from the manipulation of signs, and for Condillac the clearest example of making voluntary connections was using

language. Involuntary connections, on the other hand, came from external impressions and fixed themselves without the subject's awareness.[38] Building from these ideas, medical practitioners commonly argued that the susceptibility of woman's organs (to impressions) and the rapidity of her sensations pushed her toward a disorderly, inappropriate, and often involuntary combination of ideas. Condillac's heir and critic, Pierre Cabanis, wrote in his 1805 work, *Rapports du physique et du moral de l'homme:*

> In general, erudite women know nothing well. They confuse and mingle all objects, all ideas. The moment their lively conception has seized certain parts they imagine that they understand everything. Difficulties rebuff them: their impatience overcomes them. Incapable of fixing their attention long enough on one thing, they cannot feel the lively and profound pleasures of a deep meditation. They are incapable even of this. They go rapidly from one subject to another and retain only partial, incomplete notions that almost always form the strangest combinations in their heads.[39]

In the standard account derived from sensationalist psychology, insanity was, in essence, an extremely sensitive imagination. Condillac first laid down the premise that "physically, imagination and insanity differ only in degree."[40] Moreover, Condillac claimed—and certainly was neither the first nor last to do so—that any activity exciting the imagination could be dangerous for women, whose brains were especially impressionable (soft).[41] The belief that insanity was defined by an uncontrolled imagination pushed the association between women and madness because woman, as we have seen, was believed to have weak powers of reflection and hence less control over her imagination. Of course, women's entire organic makeup exacerbated the problem. The Montpellier physician Pierre-Edme Chavot de Beauchene argued that by virtue of her sensitive internal organs and more rapid movements of nerve and muscle fibers, a woman's equilibrium was more easily upset, her functions more easily deranged. Thus she was susceptible to nervous diseases—the vapors, melancholia, migraine, and monomania, or obsessive fixation on a single object.[42] Later she would be called hysterical.

Among those things that upset women's systems were activities that unnecessarily stimulated and deranged the imagination. Condillac, Beauchene, and many before and after them, cited novel-reading as particularly dangerous. Women could so easily attach themselves to fictions that they could not long distinguish between reality and fantasy.[43] Woman, who on the one hand was infinitely variable and mobile, was on the other likely to fixate on some erroneous idea developed from imagining herself a fictional character. Indeed,

we see Vigée-Lebrun's imagination in somewhat of the same disorder when a representation so affects her that she cannot turn her mind from it. She confuses the illusionary wax woman and the real women she passes on the street. Moreover, in women the sensitivity of the organs and the activity of the imagination exacerbated one another in what was a (feminine) version of the relation between reflection and reason. The more sensitive the organs the more active the imagination, and the more active the imagination, the more the sensitivity of the organs was increased.

Within this context, Fontana is not uttering an absurdity calculated to shock Vigée-Lebrun back to her senses when he says, "if you wish to reduce the inconvenient susceptibility of your organs, paint no more." The logic of his advice is the logic of medical opinion, and his suggestion resonates with many of the "moral" cures of the eighteenth and nineteenth centuries. To save women from mental disease they had to be separated from all those things that dangerously excited the imagination—novels, spectacles, stimulants, mental labor, and painting.[44] What runs against the grain of medical opinion is that observation with which Fontana prefaces his advice: "what you call your unhappiness and weakness is actually your force and talent." The comment is particularly pointed because force was a masculine quality tied closely to the male body and mind, and because talent, especially in its higher forms, was reserved for men. And most importantly, it is pointed because Vigée-Lebrun's senses and imagination seem to be acting in so feminine a manner. The advice is particularly interesting in that this scenario was written in the 1820s, after French psychiatry had made its return to the womb.

Soft Body—Soft Brain

By 1825 the cause of madness had wandered from the sensory to the internal organs. Although associated with the Idéologues, the French physician Cabanis broke with Condillac in hypothesizing that ideas began not only in perceptions, of which one was totally conscious, but also in impressions originating within the organs and outside of conscious awareness.[45] Psychic disturbances could thus arise from an internal source, as much as from a disorderly connection of ideas derived from external objects. He believed that the procreative organs and those of the lower abdomen were the most likely seats of madness, and here he was inspired by a variety of earlier works tying active imagination to the onset of puberty in women.[46]

Not only were the reproductive organs a potential site of madness, they also caused the normal mental and organic weaknesses of women. In the fifth memoir of his *Rapport* entitled, "On the Influence of the Sexes on the Char-

reaffirms P's organs are weaker and more feeble

acter and the Ideas of the Moral Affections," Cabanis writes: "It is first of all certain that, regardless of the way this may come about, the fleshy fibers are weaker and the cellular tissue more abundant in women than in men. Second, it cannot be doubted that it is the presence and influence of the uterus and the ovaries that produce this difference."[47] As Geneviève Fraisse has argued, the uterus became not a site of difference, but a cause of difference.[48] From this "new" position, Cabanis arrives at an old conclusion: woman's brain was more impressionable, more sensitive than that of man: "In the woman, the cerebral matter shares the softness of the other parts." He continues, "Thus, whereas in the man the vigor of the nervous system and that of the muscular system increase through each another, the woman will be more sensitive and more mobile, because the texture of all her organs is softer and weaker and because these initial organic constitutions are at every instant reproduced by the way in which the sensibility is exercised in her."[49] Once again medical science proves, as Stephen Gould suggested long ago in *The Mismeasure of Man*, what the prevailing ideology has established. Thus it should not be surprising that Cabanis found women unfit for important cultural production. Describing the differences observed in the turn of man's and woman's ideas, Cabanis argues that these differences correspond to the constitutions of the two sexes. Of woman he writes: "She is rightly put off by those works of the mind that cannot be carried on without long and profound meditations. She chooses those that require more tact than knowledge, more vivacity of conception than force, more imagination than reasoning—those in which it is sufficient that a perceptive talent lightly raise, as it were, the surface of objects."[50] This light touching of surfaces and objects was obviously in distinction to the penetration and probing that defined man's cultural achievement, the kind that uncovered the anatomy of the woman's body. Woman was closed out (and opened up) because of the sensitivity of her sense- and sex organs.

My discussion has moved from surface to depth—from the sense organs to the viscera to the organs of procreation. Given that the organs of procreation were believed to have such an important effect on the constitution of woman, it seems that they, like imagination, are conspicuously absent in Vigée-Lebrun's text. How could she, in the 1820s, conceive a memory based on the susceptibility of women's organs and exclude discussion of that single defining one? Especially in the cabinet of an anatomist. Surrounded by wax models of the body. The question becomes especially pressing if we consider not so much what the artist says she saw, but what she could have seen, and repressed. Many of the wax women of the type she mentions had not one, but several layers that could be lifted to reveal what was underneath. The intestines usually nestled not just beneath the cover, but in the second layer, and

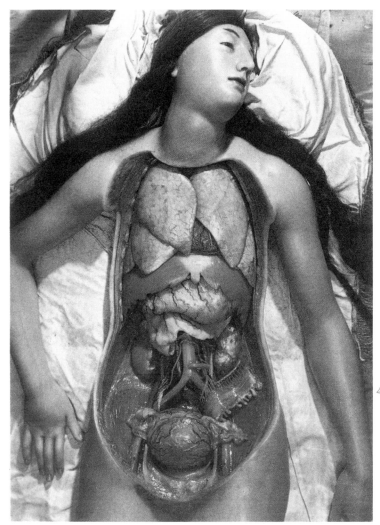

Figure 4 Wax Venus. Florence: Museo Zoologico della Specola

below them lay the procreative organs, often including the gravid uterus (figure 4). In the late eighteenth century, wax models had a special relation to women and were used to initiate them into the mysteries of reproduction.[51] Diderot's daughter, for example, learned the facts of life from the anatomist and wax model maker Mlle Biheron, and it was these lessons that prepared her for the marriage bed.[52]

Vigée-Lebrun's text represses the sight of the woman's reproductive or-

gans and substitutes the less charged "intestines." Nevertheless, like the un-
mentioned imagination, conceptions about the sexual organs are fundamental
to reading Vigée-Lebrun's text. I have already suggested that Fontana's cure—
give up painting—resembles the moral cures prescribed for women through-
out the late eighteenth and early nineteenth centuries. But the most common
cure, the cure for all that ailed her, was motherhood. Echoing Rousseau, doc-
tors advised women to return to the home, to nurse their children, and to be
good mothers. Beauchene, for example, advised distressed women to call
themselves back to the happy time when a mother gloried in her fecundity,
when one of the most inspiring spectacles was a large family that she made
virtuous.[53] And Bressy, a doctor at the university in Montpellier, exhorted
women to avoid the vapors by nourishing their children: "Recall the milk in
your breast and you will lack no happiness." Tender mothers were not only
healthy women, but also the symbol of perfection and model of contentment.[54]
Thus the uterus that made woman unfit for intellectual rigor and susceptible
to mental disease could also save her. Given these widespread cultural ideals,
it is not surprising that women were encouraged to view anatomical models as
preparation for their reproductive destiny, but barred from studying similar
models in the Academy's anatomy classes for history painters in training.[55]

The anatomist Fontana thus plays an interesting role as a character in
Vigée-Lebrun's text, for he is made to speak *some* truths of medical opinion:
that talent and force in an artist come from sensitive organs; that overactive
imagination can be the source of nervous distress; that to cure nervous distress
one must reduce the stimulation of the imagination. And he is made to speak
these truths at the site of his investigation of women's bodies, to a woman who
has been deranged by the simulacra of her organs. Yet what he does not say is
equally important. Nowhere do his words deny Vigée-Lebrun's talent, no-
where does he advise her to return to the home, and nowhere does he distin-
guish the sensitivity of the woman from that of the artist. Can it be that this
scenario is constructed so that, in the face of medical opinion common be-
tween 1792 and 1827, this particular anatomist uses his authority to suggest
that the mind has no sex? If this is the case, what opinions emerge as unrea-
sonable, even deranged?

In her memory of Florence, Vigée-Lebrun presents herself as both the
typical and the exceptional woman. Typical because she suffers/benefits from
all the susceptibility of a woman's organs; exceptional because she is a great
and dedicated artist. I have argued that in the scenario Vigée-Lebrun suffers
from a fixation caused by a bad idea, something she took into her head like a
fool—namely, that the susceptibility of her organs caused her unhappiness
and distress. And where did she get this idea? Perhaps, like a woman, she has

been too impressed by reading fictions, anatomical treatises that define and limit woman. Perhaps in her imagination she has too closely identified with the fictional character of "woman" that these authors have painted for her, a fictional character represented by the wax model in Fontana's cabinet. Is it the sight of woman's organs, or the opinions about them, that has upset the equilibrium of Elisabeth Vigée-Lebrun?

Throughout my reading of this text, I am taking Vigée-Lebrun's story as a subversive reworking of myths about the eternal feminine that took hold in French philosophy and medicine during the eighteenth century. Influential versions of this myth issued from Jean-Jacques Rousseau and Pierre Roussel, among others. Michèle Le Doeuff highlights the historical and structural relation between these two thinkers, showing how Roussel conferred the status of a physiological fact on what in Rousseau was merely an ideal. What is more important, she sees that Enlightenment anthropology and medical science (of which Rousseau and Roussel provide examples) collude in establishing an asymmetry between the sexes: a plurality of masculine temperaments versus a single feminine temperament governed, naturally, by the function of reproduction. Le Doeuff writes that in this structure "there is no self-identical substance of 'man,' because each man maintains an intense relation with his situation: man is a being 'in situation,' not an essence. On the contrary, there is a substantive, immanent essence of femininity."[56] It is this idea that Elisabeth Vigée-Lebrun disrupts in reflecting on her experience in Fontana's cabinet. She claims the right to reject male authority and to be assessed not as the eternal feminine, but within her particular situation as a practicing artist.

In her story the artist does not come to this position directly, and her strategy is a coy one that leads the reader on with reference to the inconvenient susceptibility of her organs. Although she qualifies these organs as the sense organs throughout, the collusion of anthropology and physiology (not to mention psychology) conditioned readers to make the connection between the sense and sex organs. The text leads readers to make this connection, only to show that they have jumped to conclusions. At the end of her story, the artist speaks directly to her readers, telling them that they will easily believe she was not tempted to follow Fontana's advice. At this point she speaks not as woman, but as artist. The purpose of her life is not to reproduce, but to paint: "to paint and to live have only ever been a single identical word for me." And the coy, almost coquettish figure of the "inconvenient susceptibility of her organs" gives way to a more direct name—"excellent sight." Moreover, at this point she speaks apart from the influence of the anatomy lesson, the lesson that not only offered the figure of the "pan-hysterized woman" (Le Doeuff's term for the suffusion of the female body and brain with femininity) but also

prepared women for the destiny anatomy dictated to them—reproduction. We should not forget the cultural practice of using anatomy lessons to prepare young girls for the marriage bed.

Despite the text's thwarting of the reader's expectations, however, it is still difficult to separate entirely the artist from the figure of woman. The text negotiates a new relation between these two terms rather than pose them as mutually exclusive categories. Indeed, the text calls into question the cultural gesture of "feminizing" the category of artist (through the notion of sensitivity) while at the same time excluding from that category persons defined by their particularly sensitive organs. Thus throughout the text Vigée-Lebrun plays various "feminine" parts ranging from admiring audience to deranged woman to damsel in distress. Such play also entices the reader to imagine that the effects described are produced by the sexual organs that modesty forbids her to cite directly. Indeed, one of the roles that propriety demands this artist assume is that of the modest woman, for the situation of a woman and man in an anatomy studio, looking at bodies, would, I imagine, have been perceived as erotically charged and hence morally precarious. Something like the woman artist in the atelier with the male teacher or in the studio with the male model. In Fontana's cabinet, however, there is not even a hint that the artist or anatomist could be excited by the tokens of sexuality displayed all around them.

Love and Death in the Anatomy Studio

In thinking the cultural meaning of the anatomical model, Ludmilla Jordanova has stressed the erotics of viewing the wax Venuses. For Jordanova these erotics are rooted in issues of control and power (à la Foucault) as well as in the sexual resonance suggested by the coupling of seeing and knowing (coming, of course, from Freud). The recumbent wax women, Jordanova points out, present themselves as objects rather than subjects, as in the throes of experience rather than as active agents, as both pregnant and erotic.[57] Excepting of course the point about pregnancy, much the same could be said for the recumbent wax men in the Florentine collection. Jordanova, however, quickly writes off the male figures and argues:

> We [?] have concluded that the viewer was intended to respond to the model as to a female body that delighted the sight and invited sexual thoughts. One form such thoughts might take is of mentally unclothing a woman. Of course, these models were already naked, but they gave an added, anatomical dimension to the erotic charge of unclothing by containing removable layers that permit ever deeper looking

sexualizing the wax Venus

into the chest and abdomen. It is certainly possible to speak of shared metaphors at work here, such as penetration and unveiling, which are equally apt in a sexual and in an intellectual context.[58]

This is a powerful argument, but, in focusing on the male gaze conflated with the scientific gaze, Jordanova glides into an analytic situation where she only considers men as they look at (idealizations of) women's bodies. By limiting herself to this possibility, Jordanova diminishes the complexity of the viewing situation. She does not consider men as they look at models of men's bodies (thereby foreclosing the homoerotic situation) nor does she entertain the possibility that men could identify in any way with the dissected wax women. She does not consider women looking at all. Thus, while asserting the right of women, of feminists, to interpret a historical situation, Jordanova unwittingly erases the female subject from the specific history she is interpreting. Women appear, at least in this section of her text, only insofar as they are objects for the male gaze. Jordanova leaves no room for women like Mlle Biheron to assume a medical gaze, nor for wily women like Elisabeth Vigée-Lebrun to turn the tables on the medical profession. Moreover, the text of Vigée-Lebrun's *Souvenirs* records a response to the scene in Fontana's cabinet that resembles Jordanova's hypothetical construction of male pleasure gained in looking at the wax Venuses. The artist records how the sight of the internal organs prompted her imaginative activity—mentally undressing and dissecting persons viewed on the street. Yet Jordanova's reading does not easily pose the question of what meaning this imaginative activity has for a female subject.

One can make a similar point about another line of interpretation that bears on the experience told in the *Souvenirs*. This line is broadly psychoanalytic and is represented here by Elisabeth Bronfen, who uses the wax Venuses to suggest the anxiety that looking at the female body produced in the male viewer, and the association in Western culture of death and female sexuality. She views these anxieties as more explained than constructed by psychoanalysis, and although Bronfen invokes the framework of deconstruction, her deeply informed readings of psychoanalytic texts do not disrupt their analytic structures or assumptions. For example, she writes, "The fascination engendered when the wax cast depicts a feminine body has to do with the fact that the two *enigmas* of western culture, death and female sexuality, are here 'contained' in a way that exposes these two conditions to a sustained and indefinite view, but does so in such a way that the real threat of both, their disruptive and indeterminate quality, has been *put under erasure*" (my emphasis).[59] Bronfen offers this analysis in her consideration of Richardson's *Clarissa*, as she interprets Lovelace's scheme to embalm and preserve Clarissa's corpse:

She is truly an object—she has no life she is only a body.

"As a corpse, the feminine beloved loses her quality of being Other (another sex), and becomes the site where the gazed-at-object and the object desired by the gazing subject merge perfectly into indistinction. . . . By turning the feminine body into a dead body, phallic idealisation places itself on a pedestal."[60] Bronfen moves effortlessly from this specific interpretation of Lovelace's motives in wanting to preserve the dead Clarissa, to a generalization about eighteenth- and nineteenth-century culture: "That Lovelace's fetishistic fantasy of embalming a dead body so as to counteract anxieties about decomposition of the corpse and feminine sexuality are but an extreme version of eighteenth- and nineteenth-century sentiment is suggested for example by the popularity of wax anatomical models, of which the collection in La Specola . . . set up between 1776 and 1780, was the largest."[61] Bronfen thus imagines a whole range of cultural production from a phallocentric viewpoint, which is not surprising given that Freud imagined the "enigma" of female sexuality from the standpoint of the little boy and the male analyst. When it comes to that enigma, much of psychoanalysis can be read, as Irigaray, Kofman, Le Doeuff, and others remind us, as the production of specific men projecting their anxieties and attempting to "pass off this discourse of desire and defense as a rational theoretical discourse."[62] In considering how a woman subject, Vigée-Lebrun, configured her experience with these wax models, I prefer to see her writing as closer to Irigaray's questioning of Freud's essay on femininity than to Lovelace's phallic desires projected onto the female body.

Although she expresses herself in a very different idiom, Vigée-Lebrun, like Irigaray, imagines that a woman can question the structures that work to objectivize her by imagining herself as a subject. She even approaches, albeit unwittingly, what Irigaray has termed a strategy of mimicry, a strategy in which women deliberately assume the feminine style assigned them by a dominant discourse to uncover the mechanisms of that discourse.[63] We see mimicry at work in Vigée-Lebrun's text as she plays the sensitive woman to Fontana's man of science only in the end to reveal herself as artist, and at the same time show him the fool for proposing that she give up painting. For Irigaray, mimicry is an interim strategy distinct from the masquerade expected of women by a phallocentric and phallocratic culture. This masquerade is an alienated form of femininity whereby a woman plays out her awareness of man's desire for her to be his other. In masquerading as man's other, a woman can experience desire only as the man's desire situates her.[64] There is surely a mixture of masquerade and mimicry throughout Vigée-Lebrun's written and painted self-representations. She does seem to take pleasure in being what man desires her to be—beautiful, sensitive, easily deranged—even as she dis-

rupts the discourses that force her to take those positions. In the end, however, it is difficult to judge the pleasure she takes, for she is acutely aware of what she must do to succeed socially, artistically, and financially. It is not difficult, however, to interpret the scene in Fontana's studio as questioning a part of the dominant discourse that excludes those with susceptible organs from the category of artist.

I have projected a relation between Vigée-Lebrun's unmasking of one discourse and contemporary feminist critiques of another. I want to pursue this line of reasoning a bit further. In working with this material, one particular problem seemed to call for a psychoanalytic approach—the problem of the intestines. I suggested earlier that Vigée-Lebrun's text leads us to believe that the less charged intestines substitute for the uterus. Aside from the real relation between these organs, in the imaginary geography of the female body prevailing in 1827, the intestines bore a metonymic relation to the internal organs of reproduction, since they together filled what was perceived as the site of mental disorders and desirous thoughts—the lower abdominal cavity. Moreover, in wax women, the intestines were situated and could be seen in the layer just above that in which the uterus was visible. At one point I refer to this substitution as a "repression" and at another I develop it as a "coy" or "modest" gesture. The first term suggested a psychoanalytic explanation, but the more seriously I considered one, the more prominently feminist writing about psychoanalysis figured in my imagination. Returning to these feminist challenges once again put me on the track of my own analysis, an analysis that proceeded not from repression as theorized by Freud, but from modesty as theorized by Michèle Le Doeuff.

Reading with Michèle Le Doeuff

In returning to Le Doeuff I noticed set up in her text a passage from Roussel's *Système*, which more than Vigée-Lebrun's story courts a psychoanalytic explanation. Le Doeuff, however, refuses to pursue this explanation. She refuses but does not dismiss psychoanalysis. Through her work, I was able to grapple with several related problems haunting my enterprise. The most important of these were: (1) the relation between psychoanalysis and a nexus of ideas about women developing in the late eighteenth century, and (2) the relation between theoretical and historicized modes of analysis.

Le Doeuff uses the figure of *chiasma* to describe the structural principal that governs Roussel's text, explaining it as "the denial of a quality 'X' to an object or place which common sense holds it actually to possess, with the com-

pensating attribution of that same quality to everything but that object or place."[65] In Roussel's case, he sees sexual difference everywhere in women's lives and bodies except in places where it should be located, like the pubis, the one bone he believes is identically formed in men and women. Chiasmatic reasoning thus comprises four terms, contingent on one another: two different qualities (x and not-x) and two distinct places (y, defined as the commonsense place belonging to x, and not-y, defined as any other possible place). In this scheme two terms (x and not-y) present the possibility for articulating a relation at infinitely many points. Thus the structure is one of denial and un-limited substitution. Later Le Doeuff suggests how a similar play on the spa-tialization of woman's body founds psychoanalysis, which combines silence about the thing itself (the woman's sex) with a hyperbolic proliferation of metaphors.[66]

Only after having established her analysis of chiasmatic logic does Le Doeuff introduce what for my purposes is a key strategy. She points out that whereas Roussel holds all of woman's social and natural condition attributable to her reproductive destiny, he "proves" that menstruation is entirely of cul-tural origin and related to the need to purge after overeating and drinking. Le Doeuff notes, "Six pages are devoted to denying the mark of sex in this 'great inconvenience' and assimilating it to nosebleeds, the masculine form assumed by this flow."[67] With this image of the male menstrual nosebleed Le Doeuff concludes the section entitled "The Female System," and the break that fol-lows gives the reader time to speculate. Le Doeuff wagers that for many this speculation will move toward psychobiographical concerns.

In opening the next section, "The Mirror of Modesty," Le Doeuff mod-estly refuses:

> The nature of the topic might certainly encourage one here to speak of repression, and a return of the repressed, marked by a displace-ment, and Roussel's biography indeed offers abundant justification for such a psychoanalytic interpretation. Freud, as reread by Lacan after a conversation with Jakobson? The *Système physique et moral de la femme* might well serve to illustrate the idea that human desire is constituted like a metonymy. But while such an approach to his text is certainly pertinent, it would be illegitimate to reduce the meaning of Roussel's work to this psychobiographical level. Does the entity called "desire" function according to the same mechanisms at every time and place? There is no doubt that a frustrated drive can find a form and a means of satisfaction in the chiasmic schema that struc-

tures the feminine image in Roussel, but this does not mean that all that is involved here is the resurgence of censored drives.[68]

In justifying her refusal of psychoanalysis, Le Doeuff suggests that only in a totalizing gesture of chiasmatic logic would one imagine either that psychoanalysis could provide the answer to every question or that one should ask only the sort of questions that psychoanalysis can answer. Earlier Le Doeuff had noted that chiasma figured Roussel's relation to his own discourse. In the course of his treatise he renders problematic his particular area of expertise, yet he holds forth dogmatically on every other aspect of woman. Here we have the more generalized figure of a system. Le Doeuff writes, "The theoretical position of *any* savant who purports to draw global consequences from his partial knowledge came to strike me as a paradoxical one which falls under the sign of the chiasma."[69] Those who believe in such totalizations mark themselves with the sign of the cross, which signals their allegiance to a system, a language, a master. Le Doeuff's refusal thus is part of a broader critique of all hegemonic discourses, and she identifies the structure of an ideological formation. Arguing for a notion of ideology that is historically based, a genealogy of ideology, she situates its beginnings at the end of the eighteenth century, when a group of savants possessing limited authority conferred by a localized competence expanded it into a right to pronounce on everything. These savants were the Idéologues, who claimed to provide a new first philosophy founded in observation and experience, but based on a cerebral physiology inherited from Condillac.[70] Ideology thus provided the grounding for a general theory of thought. Le Doeuff claims that "ideology" has long outlived Roussel, Cabanis, and the other Idéologues. With this claim, Le Doeuff answers the question posed at the beginning of her essay—why Roussel's text, despite a physiology outmoded for more than two hundred years, seems so pertinent today. It offers the model for an ideological system and creates the ground for that system in the figure of the pan-hysterized woman.

Le Doeuff reintroduces a conception of historicity, but it is a strange brew. On the one hand she is after "the history of mentalities," or claims to be, thus seeming to ally herself with a branch of more or less traditional historical inquiry. On the other, the mentality that she unearths is entirely contained within (learned) discourse, and related to the institutionalization of certain discourses and their power to establish repressive norms. All this connects her enterprise to Foucault's cultural genealogy and his theorizing of history. Most importantly, in reintroducing historical contingency Le Doeuff aligns herself with a feminist critique of Lacanian psychoanalysis that contests its

insistence on unchanging and inevitable structures, particularly the Law of the Father. Although feminist defenders of Lacan have argued that it is precisely the ignoring of social effects that Lacan addresses, his feminist critics contend that in the Lacanian account patriarchal dominance is displaced from biology to the equally unchangeable sociolinguistic Law of the Father. For these critics, Lacan's account could only be descriptively accurate if it analyzed the historical, changing nature of patriarchy. It is in recognizing and deconstructing historically specific forms that the Law of the Father loses its fixed character, and can be challenged.[71]

Modesty and Refusal, or, the Crux of the Matter

What is most significant for this study is that Le Doeuff addresses the specific relations between psychoanalytic structures and eighteenth-century notions, particularly the historical forms of desire. She posits a final chiasma in Roussel's text, which she calls *pudeur*, and takes as an implicit theory of Roussel's practice. Once again the object he figures is woman. Nature made woman, or so he argues, to attract man, and this principle of attraction bears the name of Beauty, defined as the "rapport" of forms to use. Because woman's use value is entirely contained in her reproductive function, all signs of her beauty— her freshness, round forms, good health—call to mind that function. As attraction, beauty is tied to the aims of the species and thus to reproduction and genital sexuality.[72] Beauty, however, has two moral qualities attached to it: coquetry and modesty. Roussel writes that "coquetry is another natural sentiment, but opposed to modesty. It is a vague desire to please and to capture the attention of all men without fixing on any one man."[73] Nothing can efface woman's natural coquetry, since it derives from the "caractère mobile," caused by her sensitive organs. Modesty, on the other hand, is a virtue that derives from timidity, itself linked to her "natural" weakness and the fear it occasions. Coquetry and modesty are two resources that act in a contrary sense; the former wants to produce the desires that the latter rebuffs. Modesty, then, is a contrary force, a negative-centered psychological disposition.[74] To understand modesty in this particular relation to coquetry is to pose a dialectical theory of eros based on attraction and denial.

Le Doeuff finds a similar structure underpinning Kant's philosophical enterprise, also developed in the late eighteenth century. In her introduction to *The Philosophical Imaginary*, Le Doeuff analyzed Kant's image of pure understanding as an island surrounded by a wide and stormy ocean, an island opposed to those of the South Seas, which promise a golden age of unalloyed enjoyment. She takes the island of pure understanding as an image of castra-

tion, and argues that, for Kant, accepting symbolic castration—separation from or renunciation of pleasure—offers the "iconoclastic gratification of detaching oneself from imaginary satisfactions (pleasing images and illusions) to espouse only a single image, that of a break marked as constitutive: a map of the land, a title of ownership, and the vague fantasy of bodily integrity, all so many threads binding together the project of constituting oneself as subject."[75] Chiasma is thus the story of the X-rated and the X of prohibition, the sign of the crossed-through subject.

Le Doeuff works to establish that the subjectivity founded on renunciation and articulated in Kant's *Critique of Pure Reason* is sociohistorically determinate, and that the island of castration dates from the eighteenth century. She concludes with a very useful concept of historicizing intertextuality, which allows her to consider that when Freudianism theorizes castration it "intuitively summarizes" Kant:

> In speaking of the crossed-through subject, the analysts are returning without necessarily knowing it, to a Kantian formulation. This does not mean that Kantian philosophy possesses some privilege of oversight over psychoanalytic theory. The two discourses have the same standing, as sciences constituted and transmitted by the school institution. Each confronts the same question: that of the subjective conditions for an abandonment of the right to dream.[76]

For Le Doeuff, both Kant and Freud pursue inquiries that are "those of an epoch, and of a social category."[77] If Freud can be understood to "intuitively summarize" Kant (or Roussel, or Rousseau) can a similar process of transmission be helpful in theorizing relations between women across history? Or, to pose the question broadly, are (some) feminists in the late twentieth century intuitively summarizing formulations of those women in the late eighteenth who talked back to the image of woman projected on them by men thinking the questions of an epoch, from their particular historical situation? Obviously I would like to entertain this possibility, first because resistance to a modern masculinist discourse was also initiated in the eighteenth century, for example, with Mary Wollstonecraft, who in 1792 talked back to Rousseau, or with Olympe de Gouges, who in 1791 answered the rights of man with those of woman.[78] Moreover, at least since the eighteenth century, ambitious and learned women have confronted a similar problem: how to rupture a discourse determined to configure them as lack, as impuissance, as object of desire. How to argue against a discourse that by excluding the possibility of woman's reason defends itself against any assault by a "real" woman.[79] But equally important to realize is that the institutionalization of feminism has

facilitated this "intuitive summary" by offering ways to imagine and transmit woman's resistance—and to write it as a history.[80]

In concluding this section, I want to return to issues I highlighted at its beginning: the relation between psychoanalysis and late eighteenth-century ideas about women, and the relation between theory and history. Even if Le Doeuff can be proven wrong in locating the beginning of a particular formulation of desire in the late eighteenth century (as opposed to earlier), her work reveals both a set of connections between that thinking and later psychoanalysis, as well as a way to theorize historicizing intertextuality in terms of institutionalized transmission. She also suggests why engaging the eighteenth-century discourse on women is pertinent today, thus answering for herself why we still feel compelled to refute Roussel, and, for me, why we should care about the struggles of Elisabeth Vigée-Lebrun. Le Doeuff, moreover, reminds us of the hegemonic tendencies in theoretical systems, and also that such systems are free of neither time nor desire. And in theorizing historical relations, Le Doeuff shows history itself as a system or structure subject to the very changes it claims to explain, as well as to the desires it sometimes denies. Thus, all theoretical systems are objects of investigation. Le Doeuff positions her work as, not a system, but a practice, although concepts like historicizing intertextuality emerge not merely as a description of practice, but also as a (retrospective) theory of it. Although Le Doeuff contests psychoanalysis as a master discourse about women, she never dismisses psychoanalysis as a practice, either as a practice of healing or a practice of reading. In fact, she herself is indebted to psychoanalysis, whose reading practices she uses in various essays. Thus psychoanalysis has a doubled status in her text: it is contested as a transhistorical theory explaining how an individual becomes a man or woman, but it is respected as a set of analytic techniques. In Le Doeuff's account, theory is not only returned to its temporal moment, or epoch, it is also demystified, and reconnected to practice. Once demystified, theory becomes contingent and partial, dislodged from its position as universal truth. The theoretical text—like any other ideological formation or cultural text—is permeable, and susceptible to both challenge and appropriation even as it proclaims itself closed and inevitable.

TWO

The Mother's Imagination
and the Fathers' Tradition

Portrait of the Artist as a Young Mother

In late eighteenth-century discourse on woman's mind and body, the uterus becomes that organ responsible for mental and organic weakness and motherhood the antidote for an excessively active imagination. In view of this prevailing attitude, it is significant that in Vigée-Lebrun's *Souvenirs* making babies is always inflected by making art. The most straightforward example of this mixing comes when she adapts for the expectant mother Roger de Piles's version of Charles V bending to pick up Titian's brushes.[1] The artist reports that she was far advanced in her pregnancy when one day she was suddenly taken ill and had to miss a sitting with the queen.[2] The next day she hurried to Versailles to make her excuses, and was met by Monsieur Campan, one of the queen's attendants, who reprimanded her in a censorious tone. At that moment the queen appeared on her way to an appointment. Vigée-Lebrun explains her absence, and the queen, not wishing the artist to have made the trip for naught, decides to sit for her right then and there. Eager to please her amiable patron, Vigée-Lebrun seizes her brushes and colors so forcefully that they fall to the ground. As she moves to pick them up, the queen commands: "Leave them, leave them . . . you are too advanced in your pregnancy to bend down." And before the artist could reply, Marie-Antoinette retrieved them all herself.[3] Like Titian before her, Vigée-Lebrun is honored by her royal patron, and the story interprets the queen's "natural" gesture of picking up the painter's tools metaphorically as bending before the artist's talent. Just as important in Vigée-Lebrun's version is that pregnancy allows for an understanding between two women, one of them a queen, the other a famous artist. Two exceptional women thus show themselves also not to be exceptional, sharing what was then considered the definitive female experience.

The imbrication of art and motherhood becomes more complex in the

account of her pregnancy and delivery, which Vigée-Lebrun includes in that part of her *Souvenirs* written as letters to the Princess Kourakin. The section juxtaposes a moment of recognition to the joys of motherhood, and the story opens at the Académie française, where La Harpe is reading a discourse on the talents of women:

> The author of *Warwick* [La Harpe] looked at me when he came to these verses in which the praise is strongly exaggerated, and I heard for the first time:
>
>> LeBrun, of beauty she is the painter and model,
>> Modern Rosalba, but more brilliant than she,
>> Joins the voice of Favart to the smile of Venus, etc.
>
> Soon the entire audience, including the Duchess of Chartres and the King of Sweden who attended the meeting, rose, and turned toward me applauding with such enthusiasm that I found myself nearly sick with embarrassment *(mal de confusion)*.
>
> These pleasures of pride, of which I have spoken to you dear friend because you demanded that I tell you all, are quite far from comparable to the pleasure I experienced when, at the end of two years of marriage, I became pregnant. But here you will see how much this extreme love for my art made me impervious to the little details of life, because, as happy as I felt at the idea of becoming a mother, the nine months of my pregnancy passed without my having thought in the least to prepare anything necessary for a delivery. The day of my daughter's birth I did not leave my studio, and I worked at my *Venus Tying Cupid's Wings* in the intervals between my contractions.[4]

The triumph that Vigée-Lebrun, with (false) modesty tells only because her interlocutor demands to hear all, the triumph that brings the entire Académie française—not excepting the Duchess of Chartres or the King of Sweden—to their feet, this triumph cannot compare with the joy of anticipated motherhood. It would not do for a woman to be too boastful even as she is telling of her glories.

The artist seems, at first, to know her priorities as a woman, and again she is playing the proper feminine role in extolling maternity. Yet in the next breath she overturns all the womanly fulfillment. The artist is so absorbed in her art, she loves it so ardently, that she hardly pays any attention to being pregnant. She forgets to plan for her delivery, and her preparation is characterized as among the "little details of life." What should be a woman's crown-

ing glory, what should occupy all her attention, she forgets in the satisfaction of making art. The contrived story of giving birth while painting in the studio is designed to fulfill several purposes. Clearly the account raises the general problem of cultural production and natural reproduction. Less clearly it has a specific "source," Voltaire's well-known story of Madame du Châtelet's giving birth, various versions of which he recounted in 1749. Here is what he wrote to Marguerite Jeanne Delaunay, baronne de Staal: "She was at her desk at two o'clock in the morning, according to her admirable custom. She said in scribbling from Newton: *'But I sense (feel) something!'* This something was a baby daughter who came into the world much more easily than a problem. She was received in a briefcase *(serviette)*; placed on a folio volume, and the mother put herself to bed out of respect for convention."[5]

If the *Souvenirs* take Voltaire's telling of an exceptional woman's story as a model, the two narratives differ in their comparisons of reproduction and intellectual achievement. In writing to the Comte d'Argental, for example, Voltaire used Madame du Châtelet's maternity as an introduction to his own creativity, concluding: "I will deliver my *Catelina* with much more difficulty."[6] To the Abbé de Voisenon he notes, "I give birth in eight days to *Catelina*," and then points out that although he does not know if Madame du Châtelet will be pregnant again, he is already carrying his *Electre*.[7] To the Marquis d'Argenson he embellishes a bit more. Whereas Madame du Châtelet has given birth to an infant who cannot speak, he has found it necessary to make his characters articulate their thoughts, and "it is more difficult to make those characters speak than to make babies."[8] Voltaire paid dearly for these witticisms at Madame du Châtelet's expense, for his friend died of complications several days later. Voltaire's next letters are remorseful; he never suspected the gravity of her condition. But had he not, in a sense, already killed off her creative and cultural production? Although he says the birth of her daughter was "easier" than her work, he goes on to proclaim his own creativity as superior to hers, implicitly posing reproduction as woman's creativity and writing as man's. In Vigée-Lebrun's account no male voice intervenes to tell his superior pregnancy, however, the artist stresses her ignorance of "feminine" knowledge even as she is fulfilling her womanly destiny. Reading on in her account we realize the artist must have missed Mlle Biheron's lessons:

> Madame de Verdun, my oldest friend, came to see me in the morning. She had a feeling that I would deliver during the day, and as she knew my distraction, she asked me if I had foreseen all that I would need. Astonished, I responded to her that I did not know what I needed, to which she responded, "there it is, you are a real boy. I warn you that

you will deliver this evening." No! No!, I said. I have a sitting tomorrow; I do not want to deliver today. Without responding to me, Madame de Verdun left me a moment to go find the midwife, who arrived soon. I sent her away, but she remained hidden in my house until the evening, and at ten o'clock my daughter came into the world.[9]

Again Vigée-Lebrun stresses her professional commitment—it is inconvenient to deliver because she has a commission to fulfill the next day. She also confesses her un-womanliness, her ignorance of female things, which Madame de Verdun brings to the fore in calling her a "real boy." Thus even as she performs the quintessential role of woman, the artist reminds her readers that she cannot be reduced to this role, of which she is "ignorant."

How does this paragraph accord with the statement that precedes it directly: "I had not left my studio and I worked at my *Venus Tying Cupid's Wings* in the intervals between my contractions"? The sentence that presents Vigée-Lebrun as Madame du Châtelet is obviously sutured into the text, and none too skillfully at that. If that line were omitted, the narrative would be continuous and coherent, moving from her lack of preparation for delivery ("the nine months of my pregnancy passed without my having thought in the least to prepare anything") to Madame Verdun's arrival the critical morning. Yet if the entire story is meant to stress Vigée-Lebrun's commitment to work, Madame du Châtelet becomes the model through which her experience, her story, is constructed. Moreover, as an intellectual woman concerned with precisely those areas for which women were thought to have no aptitude—e.g., the abstract sciences of mathematics, physics, and philosophy—Madame du Châtelet provides a precedent for Vigée-Lebrun's practice of that genre—history painting—supposedly most foreign to those who could be mothers. The particular painting Vigée-Lebrun claims to be making in the intervals between her contractions—*Venus Tying Cupid's Wings* (figure 5)—was among those shown at the Salon of 1783, in which she presented herself as a history painter. I will take up this issue of history painting in the following chapters. That she claims herself able to execute this most taxing of genres even during her labor stresses the ease with which she can produce history paintings—indeed she can give them birth at the same time that she is bearing her daughter. Moreover, this history painting itself represents a mother and child, for Cupid was imagined to be Venus's son. This relation doubles the reference to maternity posited in the *Souvenirs:* Elisabeth Vigée-Lebrun is making an image of a mother and child as she is giving birth. What prevents her art production from becoming a "natural" occurrence or a mirror image of her situation, is that

Figure 5

Elisabeth Vigée-Lebrun
(engraving after) *Venus
Tying Cupid's Wings*,
Salon of 1783. Paris:
Bibliothèque Nationale

she is making a history painting, which demands that she idealize the human form and imagine events she cannot see. The situation is parallel, yet the difference between "natural" childbirth and "ideal" image production is critical.

The Maternal Image

Simone de Beauvoir maligned Vigée-Lebrun when she wrote: "Madame Vigée-Lebrun never wearied of putting her smiling maternity on her canvases."[10] I'd wager that the only two self-portraits of the artist Beauvoir knew were those in the Louvre, one a remake of the other, which show the artist with her daughter (figures 6 and 7). These are not typical of Vigée-Lebrun's self-representations, and it is misleading to suggest that she tirelessly made such images. Even if Beauvoir is not referring only to self-portraits, images of mothers and children—of other women with their offspring—form only a small percentage of the artist's works. Many (but certainly not all) of these date from the years just before the French Revolution when images of moth-

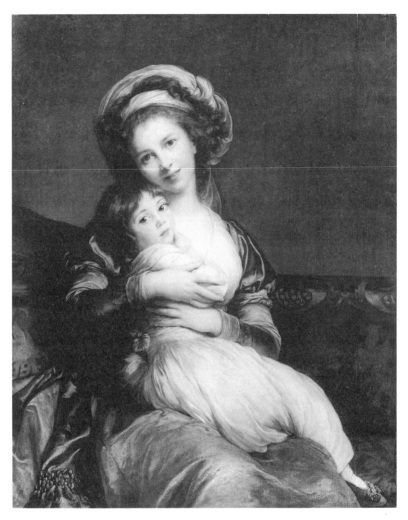

Figure 6 Elisabeth Vigée-Lebrun, *Self-Portrait with Julie* (called
 Maternal Tenderness), Salon of 1787. Paris: Musée du Louvre

erhood were fashionable among the upper-class ladies who were her clientele.
The "good mother" as idealized in Vigée-Lebrun's painted portraits was a
social category, and the good mother can be termed narcissistic insofar as
good mothering reflected her status and modishness. Although it is possible
to imagine that Vigée-Lebrun's images are merely complicitous with the pre-
vailing (and often Rousseauian) discourse on motherhood, another reading of

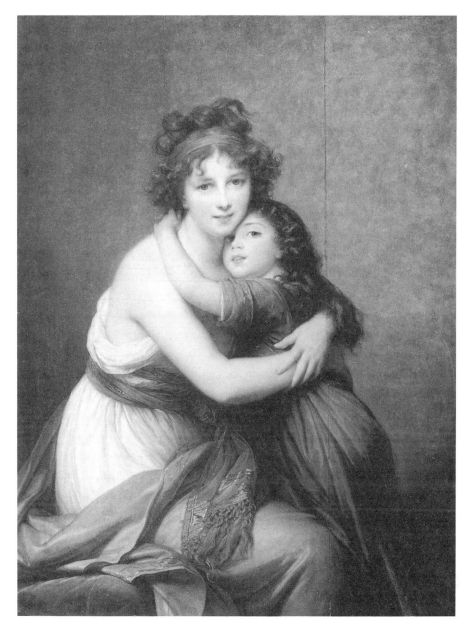

Figure 7 Elisabeth Vigée-Lebrun, *Self Portrait with Julie* (called *Self-Portrait à la Grecque*), 1789. Paris: Musée du Louvre

her self-portraits suggests that they self-consciously posed the problem of pro-
duction/reproduction broached in the *Souvenirs*.

In this light, consider Vigée-Lebrun's two portraits in which she shows
herself embracing her daughter Julie. Each undermines the ideal of good
mother not only by intertwining biological reproduction and cultural produc-
tion, but also by showing in their very making and exhibition that their author
was a working artist who could not have the leisure to devote herself entirely
to raising and educating—or even simply to bearing—her children. Since the
eighteenth century, spectators have found these images so pleasing and so
convincing that they have not generally troubled themselves with the contra-
dictions within them. The image called "Maternal Tenderness" (figure 6) was
surely Vigée-Lebrun's most popular painting at the Salon of 1787, where crit-
ics praised lavishly the sentiment it expressed, forgetting that such expression
was merely an effect of art wrought by the mother-artist. One critic used this
work to commend Vigée-Lebrun for finally giving up history painting.[11]
Clearly here is an image of a woman painter that even the most Rousseauian
critic could love, and among Vigée-Lebrun's motivations for making the im-
age we can count her desire to be fashionable, to show herself as upper class,
to demonstrate that she was both woman and artist. As Paula Radisich has
pointed out in her insightful analysis of this painting, the artist further under-
cut this image of herself as "mother" by making one year later a pendant for
the work—the portrait of her good friend the painter Hubert Robert (Salon
of 1789; figure 8).[12] The logic holding these works pendant is unorthodox and
unprecedented. A portrait of her husband would have been the appropriate
companion piece if she had wanted to anchor her image in the space of the
family. Vigée-Lebrun, however, avoided that space and pushed her contem-
poraries to conceptualize a connection between the paired sitters based on
their shared profession. Here are two artists: one of them also happens to be a
mother.

Although Vigée-Lebrun has represented herself in a traditional woman's
role, the pendant portraits taken together make the point that she could paint
in what was perceived as a masculine mode as well as in what was perceived as
a feminine one. Critics praised the Robert portrait for its force and vigor,
qualities associated in contemporaneous art criticism with man's work.[13] The
painting is therefore distinguished from other portraits by Vigée-Lebrun that
critics described as having a soft and feminine touch. (I discuss these critics at
length in chapter 6.) In these portraits, Vigée-Lebrun shows that in depicting
a woman she can touch the canvas like a woman, but also that if the situation
demands it, she can touch the canvas like a man. She ruptures any natural
connection between her sex and her touch.

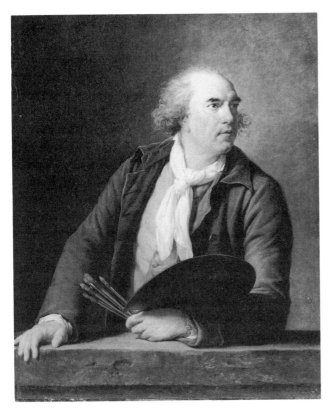

Figure 8

Elisabeth Vigée-Lebrun, *Portrait of Hubert Robert*, 1788. Paris: Musée du Louvre

In 1789, Vigée-Lebrun made a second version of *Maternal Tenderness*, one that was commissioned by the Director General of the Bâtiments, the Comte d'Angiviller (figure 7). The image, I believe, pleased the Comte's traditional attitudes as well as his Rousseauian thinking, which will figure prominently in the next two chapters. But the image again is fraught with contradictions. For example, consider the Greek dress she wears. D'Angiviller might have viewed the costume as evoking the simple dress of the ancients; indeed, Salon critics often compared the frivolous fashions worn by modern women to the modest tunics of their ancient foremothers.[14] These associations certainly can be read in the painter's costume, but the dress simultaneously recalls one of the most scandalous affairs of Vigée-Lebrun's career, the Greek dinner party of 1788 that rumor speculated cost an incredible sum of money.[15] Vigée-Lebrun refers to this self-portrait, and only this self-portrait, as *à la Grecque*.[16] In recalling the Greek supper, the costume could signify the scandal that the supper provoked, but it could just as easily represent the artist's appreciation of the clas-

sics that she claims in her *Souvenirs* inspired the festivities.[17] Like the image made pendant to Robert's portrait, this painting points beyond the good mother.

In relation to Vigée-Lebrun's two paintings, the viewer who willfully forgets he is looking at self-portraits refuses to see that the mother has given birth to both her child and her image. He also overlooks the mother's skill and her forceful imprinting of the image on the spectator's imagination. It is this imprinting that leads to another line of analysis. Marie-Hélène Huet has recently examined the relation between monstrous births and the mother's imagination in exploring a belief that persisted from the Renaissance through the Enlightenment: that some monsters were created by an "imprinting" of the fetus with the mother's wanton desires, fears, or fantasies.[18] Huet points out that from ancient times the concern with the mother's imagination was entangled with art and desire. Having no resemblance to their parents, monsters were begotten by a mother's passionate and desiring consideration of images. Even as late as 1788, writers referred to Empedocles's alleged formulation that "progeny can be modified by the statues and paintings that the mother gazes upon during her pregnancy."[19] Huet argues that monstrous births "erased paternity and proclaimed the dangerous power of the female imagination," and that the Romantics later refigured and regendered the theory: "By assigning to the artist as monstrous father the power once attributed to the mother to create singular progeny."[20]

If the Romantics "restaged" the ideology of misguided desires in one direction, Vigée-Lebrun's art reinvented it from another. Huet also points to a tradition that describes the mother as an artist. Paracelsus wrote, "By virtue of her imagination the woman is the artist and the child the canvas on which to raise the work."[21] The later writers that Huet considers, Colonna (*Les Principes de la nature*, 1731) and Dubuisson (*Tableau de l'amour conjugal*, 1812), transferred the artistry to its "proper" place: "The semen is to generation what the sculptor is to marble; the male semen is the sculptor who gives shape, the female liquor is the marble or matter, and the sculpture is the fetus or the product of generation."[22] In her self-portraits, Vigée-Lebrun reappropriated for the mother the role of proper creator, and far from producing monsters she makes beautiful and compelling works of art. This reading, moreover, joins up with the *Souvenirs*.

After expressing her joy at becoming a mother, and before continuing her anecdotes about society figures, Vigée-Lebrun comments: "During my pregnancy I had painted the Duchess de Mazarin, who was no longer young but who was still beautiful; my daughter has her eyes and resembles her prodigiously."[23] Here the *Souvenirs* evoke the tradition of the mother's imagination,

if only in terms of what Barbara Stafford has termed the lingering belief that the fetus could be imprinted with the image of *whatever* the pregnant woman saw.[24] On this point, moreover, I want to read the *Souvenirs* intertextually with Lessing's *Laocöon* (1766) where he writes:

> The plastic arts especially, besides the inevitable influence which they exercise on the character of a nation, have power to work one effect which demands the careful attention of the law. Beautiful statues fashioned from beautiful men reacted upon their creators, and the state was indebted for its beautiful men to beautiful statues. With us the susceptible imagination of the mother seems to express itself only in monsters.[25]

The text refers both to Empedocles's remark and to the theories of monstrous births, aligning the first with the ancients and the second with the moderns. If pregnant women were influenced by images in ancient times, they were influenced by beautiful images. By this logic, the modern mothers who give birth to monsters must see only monstrous art. Lessing's commentary, moreover, develops within a discussion of how the ancients legislated beauty by legislating portraiture. He refers to the law of the Thebans that commanded the artist to make his "copies" more beautiful than the originals, and to another law that allowed only three-time Olympic victors to be portrayed. Lessing sets this Greek legislation of beauty against modern practice: "Many a modern artist would say, 'No matter how misshapen you are, I will paint you. Though people may not like to look at you, they will be glad to look at my picture; not as a portrait of you, but as a proof of my skill in making so close a copy of such a monster.' "[26] The passage, moreover, contrasts the mimetic art of copying nature, found among the moderns (who make close copies of monsters) and in mothers (who reproduce the images they see), to the ideal art of the ancients legislated and produced by fathers, who ensured a control over the mother's imagination.

In her self-portraits with Julie, the mother-artist Vigée-Lebrun created neither a monster child nor monstrous art. The Duchess of Mazarin's beauty, it seems, inspired her art and her imagination, which imprinted that beauty on her daughter. Reading her comments again, however, one can take them as a more thorough undermining of Lessing. "During my pregnancy I painted the Duchess of Mazarin"—the emphasis here is not so much on her looking, which clearly she must have done, but on her painting a portrait. In making the portrait, the artist surely looked at her emerging image as much as she looked at the Duchess, probably more, since Vigée-Lebrun completed the work in the studio, away from the model. It was her painting of the Duchess

that she contemplated long and hard, and this portrait, moreover, represented the (mental) image fantasized by the mother-artist. On the basis of this reading, I would rewrite Lessing according to Vigée-Lebrun's portraits of herself with Julie: Beautiful portraits fashioned by the woman artist reacted upon their creator, and the state was indebted for its beautiful women (at least, Julie Lebrun) to these beautiful paintings. The father's paternity is doubly usurped, as the mother—both in her womb and in her work—creates her child, her daughter, her simulacra, through her imaginative power. The susceptibility of the mother's imagination, like the susceptibility of the woman's organs, thus subverts a prevailing notion about woman's relation to art. In contemplating her work, who but a fool would suppose that the imagination of this modern mother-artist expressed itself only in monsters?

If we return to the painting Vigée-Lebrun says she was making while giving birth, *Venus Tying the Wings of Cupid*, we can read it as further undermining Lessing's proposition. The image that seems to have imprinted itself most forcefully on this mother-artist's imagination, at least in terms of the painting born the same moments as her daughter, is Raphael's *Madonna della Sedia* (ca. 1514; figure 9). She has not, however, merely copied that work. Rather, she has adapted the pose of Mary embracing the infant Jesus to suit the gesture of Venus reaching around to bind Cupid's wings. This pose the artist further varied for her two self-portraits as a mother. The three images thus bespeak a process of conscious imitation rather than one of spontaneous copying. Moreover, the artist's skill at idealization is noted in her *Souvenirs* as she quotes La Harpe's poem: "LeBrun of beauty she is the painter and model, / Modern Rosalba but more brilliant than she." Not only is Vigée-Lebrun made possessor of Venus's charms, but she is both the painter of and the model for beauty, one who can idealize herself. That the poem reflects back on the *Venus Tying the Wings of Cupid* is an effect of the *Souvenirs*, which maneuvers the two into a mimetic relationship. However, in posing as both subject and object, in painting beauty by conceptualizing the beauty that is her own, Vigée-Lebrun is cast as a narcissistic subject.

In terms of both her art practice and self-portrayals, however, I read the artist as narcissistic, not in the negative way that Beauvoir defines it, but in Sarah Kofman's more positive mode derived from her re-reading of Freud's *On Narcissism*. For Kofman, the narcissistic woman is Freud's only example of the self-sufficient woman, the woman *not* dependent on male desire, since she desires and values herself. Kofman writes that, in *On Narcissism*, what makes woman enigmatic "is no longer some 'inborn deficiency,' some sort of lack, but on the contrary her narcissistic self-sufficiency and her indifference; it is no longer the woman who envies man his penis, it is he who envies her for her

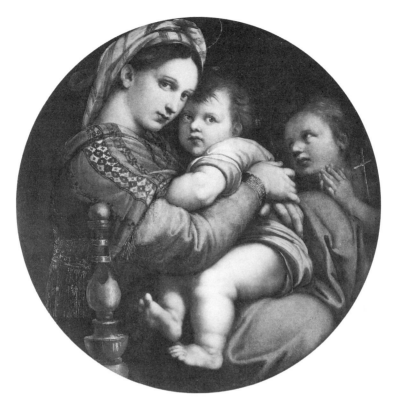

Figure 9 Raphael, *Madonna della Sedia*, ca. 1514. Florence: Pitti Palace

unassailable libidinal position."[27] In Kofman's formulation it is men who find a woman's self-sufficiency intolerable and imagine that her beauty is a supplementary adornment destined to deceive them. Hence men are apt to fantasize this woman as the "essence" of womanhood, as the eternal feminine, *despite* the incongruity of self-sufficiency.[28] In the self-portraits with her daughter, Vigée-Lebrun is this narcissistic woman insofar as she is self-sufficient, insofar as she takes herself as an object of desire, creating, idealizing, celebrating, and re-producing herself. And especially insofar as the "paternity" of her daughter is attributable to the mother's imagination. If men imagine Vigée-Lebrun's beauty (or her maternity) to be merely a supplement "for them," it is part of a defensive mechanism designed to cope with the intolerable thought of the self-sufficient, self-(re)producing, self-imaging woman.

Narcissism, moreover, has a particular historical and mythical relation to the self-portrait. Leon Battista Alberti attributed the origin of painting to

Narcissus, who dies because he cannot possess his own image; who dies, as
Jacqueline Lichtenstein puts it, "of a desire that painting alone can satisfy."[29]
What is the image Narcissus perceives in the mirror but a self-portrait, and
what better than the self-portrait implies the artist as he or she stands before
a reflecting surface? Yet there are other ways to view Vigée-Lebrun's work,
especially in its relation to Raphael and artistic tradition. In paying particular
attention to Raphael's *Madonna della Sedia*, Vigée-Lebrun figures herself as
heir to that master. She creates herself through appropriating his image and
identifying with his (presumed) power.

The Father's Lineage: Tradition and Desire

What does it mean for a woman artist, a mother, to figure herself as the heir
to Raphael? or, to put the question in more general terms, what is the relation
between the woman artist and tradition, given that woman was theoretically
(and women practically) excluded from the circuits of cultural production and
lineage? Is Vigée-Lebrun different from other heirs of Raphael, for example
Ingres, whose later appropriation of the *Madonna della Sedia* art historians
have accepted as *his* trademark?[30] I want to explore these questions through a
reading of Norman Bryson's *Tradition and Desire*, now nearly a decade old, but
still the most recent text to theorize the artist's relation to tradition in early
modern France.[31] I have selected this particular text, moreover, because in
reading it I can further establish my relation to certain psychoanalytic con-
cepts that have become prominent in the feminist debates I invoke here and
in later chapters. Because Bryson uses Lacanian theory to explicate art pro-
duced during the period under consideration in my text, *Tradition and Desire*
is especially pertinent as an object of analysis. In the end, I hope to suggest
another approach to theorizing the relation between an artist's desire and her
relation to tradition and to conceptualizing how an artist uses her "sources."

Bryson analyzed Ingres's relation to Raphael through a trope called
counter-presence that "enables the force of tradition to be defeated by ab-
sence, or desire."[32] Given the general psychoanalytic and often specifically
Lacanian ambiance within which Bryson writes, one might expect here a La-
canian definition of desire. Yet Bryson turns instead to Kojève, and by not
allowing Lacan to be an "origin," Bryson places him in a tradition—not un-
like what he claims Ingres did with Raphael. It is a clever move on Bryson's
part, and turning to Kojève[33] also leaves him free to suggest a relation (by
implication, by writing, by "tradition") to Lacan, without having to engage
the more problematic (at least from a feminist point of view) aspects of Lacan's
notion of desire. When Bryson "transposes" Kojève's notion to painting, the

result takes a decidedly Lacanian tone wherein counter-presence figures "desire that is infused into an image as the force that separates itself from a tradition into which, if no such principles had been installed, the image would otherwise merge and dissolve."[34] I interpret this statement in two ways. (1) Counter-presence, or desire, maintains a distinction between the image and "tradition." I assume that desire is "infused" into an image by the painter or image-maker, since Bryson poses this process as a "transposition" of Kojève, for whom desire resided in the subject (of course the viewer could also infuse desire into an image in reading it, but I'll let that point go for now), and (2) Desire is the differentiating principle within, but distinguishable from, tradition (a force that separates *itself* from a tradition). This second interpretation reads Bryson in relation to Lacan and suggests that tradition is like language, which operates on a principle of differentiation. No one need infuse desire into tradition/language because desire (as absence or lack) always already resides there.

Drawing on Lacanian accounts of the subject's relation to language, Bryson earlier figured tradition as a language in miming the artist's position: "I paint; but to communicate to my viewer what it is I see, I must paint in the visual language that is already spoken; I must find signs that pre-date my vision, signs into which my vision must be inserted."[35] As Bryson grafts Kojève's conceptualization of Desire onto his account of "counter-presence" in Ingres's work, he produces an analysis of the artist's relation to tradition remarkably resonant with a Lacanian account of the child's accession to the position of speaking subject:

> In terms of painting and its tradition, the artist possesses no identity unless he can achieve distance from the work of the past. Until such distance is reached he is absorbed by what he contemplates; tradition floods him and reveals only itself, not the subject that views. Separation from tradition occurs only when the painter is brought back to himself or revealed to himself by his desire, since the lack at work in desire draws a line around himself, while at the same time establishing tradition as the background against which his identity emerges.[36]

The resonance with Lacan is worth pursuing here, since it is precisely what Bryson makes of Lacan that renders a relation between desire and tradition problematic for the woman artist. Vigée-Lebrun could never occupy the relation to tradition that Bryson hypothesizes as motivating her male contemporaries Ingres and David.

Tradition occupies in Bryson's account the place of the mother [read, (m)Other], from whom the child has no distance in Lacan's theory of the

imaginary order. Although the child can distinguish between self and other, its identity remains indistinct because the child is caught up in its primary identifications with objects outside itself—in particular (the image of) the mother. The artist facing tradition is like Lacan's infant who relates to the mother's image as if it were his own, but ultimately realizes that it is not. The mirror stage marks the first division in the subject; it places the child in a two-person structure of imaginary identifications, alienating the subject from itself and forever orienting the ego in the direction of fantasy.[37] But just as the artist must be separated from tradition to achieve his identity as an artist, so the child must give up its imaginary identifications with the mother to achieve individuality. This separation is effected by a third term—the phallus, the symbolic agent through which the child figures desire as lack. In Bryson's account, separation is achieved through desire; what becomes occluded (veiled) in the derivation from Kojève, is the relation of desire to the phallus. This relation constructs gendered identity and determines if a person takes a position in society as a "man" or as a "woman." At the risk of explaining what is well known to some, let me briefly rehearse some aspects of Lacan's account significant to my reading of *Tradition and Desire*.

The child's conceptualization of the phallus develops in relation to the paternal function, the third term, which the child understands as an obstacle to total identification with the mother. Lacan insists that the paternal function be separated from the real father, with whom the child could be caught up in imaginary order relations. With the intrusion of the paternal function into the mother-child dyad, the child realizes that the mother's desire is not focused exclusively on itself, but what is more important, the child recognizes that because the mother desires some-thing she must be lacking. The child wants to be what the mother lacks/desires.[38] The child's desire is thus constituted intersubjectively, as the desire to be desired, as the desire to be the source of the mother's desire. It is the recognition of the mother's desire that initiates the Oedipal drama according to Lacan.

The child must accept the mother's lack of the phallus—her castration—as the price of entry into the symbolic order. According to Lacan:

> Clinical experience has shown us that this test of the desire of the Other is decisive not in the sense that the subject learns by it whether or not he has a real phallus, but in the sense that he learns that the mother does not have it. . . . Here is signed the conjunction of desire, in that the phallic signifier is its mark, with the threat or nostalgia of lacking it. Of course, its future depends on the law introduced by the father into this sequence.[39]

Lacan reinterprets the Freudian moment when the little boy peeks up his mother's skirt. The very meaning of the Oedipus complex, in Lacan's terms, is that it introduces the subject to the dimension of desire; the child must accept that Desire (to be what the mother desires) will never be satisfied. The Lacanian castration complex turns the subject away from the primary identification with/desire for the mother and toward a secondary identification with the father's law, which also represents an entry into language and culture.[40]

Like Freud's Oedipal moment, Lacan's is decisive in determining the relation between the sexes and the subject's apprehension of him or herself as sexed subject in a cultural order. Lacan explains:

> Let us say that these relations [between the sexes] will turn around a "to be" and a "to have," which, by referring to a signifier, the phallus, have the opposed effect, on the one hand, of giving reality to the subject in this signifier, and, on the other of derealizing the relations to be signified. This is brought about by the intervention of a "to seem" that replaces the "to have," in order to protect it on one side, and to mask its lack in the other.[41]

The phallus is misapprehended as the penis, and reduced to an instance of visible perception; it appears as that thing (the penis) the mother lacks—and the father has. Lacan insists, however, that castration anxiety involves a symbolic object and not a real or imaginary body part:

> In Freudian doctrine, the phallus is not a phantasy, if by that we mean an imaginary effect. Nor is it as such an object . . . in the sense that this term tends to accentuate the reality pertaining in a relation. It is even less the organ, penis or clitoris, that it symbolizes. And it is not without reason that Freud used the reference to the simulacrum that it represented for the Ancients. For the phallus is a signifier. . . . For it is the signifier intended to designate as a whole the effects of the signified.[42]

Anatomical difference thus comes to figure sexual difference, and all subjects must line up on the side of having or being (not having) the phallus. Yet the fantasy of *having* the phallus belongs only to the little boy, who identifies with the law that demands separation from the mother (i.e., with the Name of the Father) and with the paternal function (and its cultural privileges). Here we can see a later version of the "island of pure reason" in which the status of thinking subject (the subject of the symbolic) is achieved through the renunciation of pleasure.

The position of the little girl, on the other hand, is less clear. Feminist

commentator Elizabeth Grosz writes that, insofar as she speaks, the little girl, too, takes a place as a subject of the symbolic, yet insofar as "she is positioned as castrated, passive, an object of desire for men rather than a subject who desires, her position in the symbolic must be marginal or tenuous; when she speaks as an 'I' it is never clear that she speaks (of or as) herself. She speaks in a mode of masquerade, in imitation of the male, phallic subject."[43] Desire is thus alienated from the little girl and always mediated by the male. To take a position in the symbolic and sexual order, she must reject femininity. At the same time, she must take a cultural position that is the maternal function, and so identify with her mother. What woman lacks—what she envies—is the male's ability to signify lack and to experience desire. Thus in the conception of psychoanalyst Michèle Montrelay, woman suffers from the "lack of a lack," that is, from the lack of Desire.[44] For Lacan, the phallus defines each subject's access to the symbolic order. He can say that all subjects are "castrated," even those who imagine that they are not, because the fantasy of wholeness is just that, a fantasy. All subjects are castrated because they are spoken by the Other—by language and the unconscious. The phallus, moreover, establishes substitutive Desire as a permanent state, and regulates the subject's relation to language.[45]

The debates over how the phallus relates to the penis are by now well known to feminists interested in psychoanalytic inquiry. Lacan and his feminist supporters argue that the equation of the phallus with the penis is illusory; the penis is "misrecognized" as the phallus. On the other hand, many feminists have found the relation of the phallus to the penis highly problematic. Diana Fuss has summarized some of their arguments:

> To the extent that the phallus risks continually conjuring up images of the penis, that is, to the extent that the bar between these two terms cannot be rigidly sustained, Lacan is never far from the essentialism he so vigorously disclaims. It is true that the phallus is *not* the penis in any simple way. . . . The phallus is pre-eminently a metaphor but it is also metonymically close to the penis and derives much of its signifying importance from this by no means arbitrary relation. It is precisely because a woman does not have a penis that her relation to the phallus, the signifying order, the order of language and law, is so complicated and fraught with difficulties.[46]

The problem of "correctly" interpreting Lacan on this point is surely irresolvable, and both sides are "right" about the issue. (This is especially problematic since the fraudulence of the phallus develops strongly in Lacan's late works, such as in "God and the *Jouissance* of ~~The~~ Woman." Do we take the

late work as a "definitive" or "closing" statement because it comes last? Do we consider the general thrust of his theory over many years?) Assessing the cultural effects of the theory is another question. What matters in terms of Lacanian theory—at least at this point—is what others *do* with it, how they use it, rework it, treat it as a permeable text.[47] From this perspective, let's make our return to *Tradition and Desire*. I want to stress that this history has difficulty accounting for Elisabeth Vigée-Lebrun, or for any other woman artist, and that much of this difficulty is rooted in Bryson's implicit and explicit use of Lacan.

In *Tradition and Desire*, the problem of positioning subjects in relation to the phallus first surfaces prominently in Bryson's analysis of David's paintings. Although his argument works to foreclose any relation between the woman artist and tradition, Bryson projects the failure to represent women as participating in culture entirely onto David, casting it as David's insight into patriarchy. For example, in the *Oath of the Horatii* (1784; Paris: Musée du Louvre), Bryson sees that women "are placed *outside* the register of speech," they are "drained, exhausted, hardly capable of sustaining the weight of their own bodies" and "unable to mobilize any resource of language or image that might challenge the males."[48] This argument is preceded by the familiar line that *both* sexes are castrated (lacking): "The *Oath* is an exact image of visuality for the subject living under patriarchy. The females, denied political authority by the patriarchal mandate, are consigned to silence, to the interior, to reproduction; while simultaneously the males are inserted into the equally [?] destructive registers of language and of power convergent in the oath."[49] Power, it seems, has always been the white man's burden. As his argument unfolds, Bryson does not express directly the idea that men are also castrated, but figures their castration as blinding:

> For the males, visuality is dominated and blinded by signs: both as the signs of strength and virile possession they must project outwards, in constant strain towards the gaze of the adversary, the gaze of alterity; theirs is essentially a paranoid vision, if we take paranoia in its technical sense, as referring to a representational crisis in subjectivity; a crisis in which material life is invaded, devoured by signs, turned everywhere into the sign.[50]

And this confirms what Bryson has earlier argued: "For the men, signs have eaten vision away; they have blinded sight."[51]

From Bryson's argument one might conclude that it is actually disadvantageous to be a subject.[52] But this is not the case. Without the move into the symbolic, without the separation from the mother, the subject would be

caught up *entirely* in imaginary identifications—totally dependent on them. As Carolyn Dean has recently shown, subjects stuck in the imaginary order were, for Lacan, liable to psychic disturbance.[53] Taking a place in the symbolic order is not the tragedy Bryson makes it out to be; it is, in Lacan's theory, a necessary condition for the individual's and culture's psychic health.

Although both genders may be equal because living under "affliction," they are equally different, as Bryson's text acknowledges: "The women in the *Oath* do not speak, and they hardly see: their eyes are all but closed; they themselves are signs, units to be exchanged between the men in their inter-male alliances. Their degraded status, almost of commodity within a circuit of exchange, is made clear in the narrative."[54] Equal but different, afflicted and not equal. Men, one might say, are afflicted as active subjects; women as passive objects. Which position would you choose?

"Equal but different" has been a way to subjugate women (and minority groups) at least since Rousseau, and what I see in the *Oath* is women taking the position designated as feminine in theories of sexual difference ranging from Aristotle, to Rousseau, to Freud, and beyond. I think Bryson is entirely correct in arguing that "both David's painting and psychoanalysis are investigating the same area," but I am not convinced that area is the visuality of the subject.[55] What is of interest to me is how these works collaborate in a certain idea of "woman" and "father" deeply rooted in the imagination of the modern West. Carolyn Dean's recent work on French psychoanalysis after World War I has shown that Lacan, like his contemporaries, developed his theories in reference to certain crises in French culture, primary among them the "decline" of the traditional patriarchal family, a decline held responsible for the moral, political, and physical decline of France.[56] Dean explicates how Lacan's solution was to shore up the "paternal function," which Dean calls restoring the father's difference. A strong paternal function was necessary to ensure that the (male) subject passed successfully from the primary identifications of the imaginary into the secondary, "healthy" identifications of the symbolic. He must identify not with the real father but with the Name-of-the-Father, with the father's law.[57] We are not far from Rousseau's contention that it is in the interests of society that paternal authority be maintained.[58] Indeed, Lacan used the logic of "equal but different" to restructure a (perceived) collapse of gender boundaries through the idea of the paternal function. Dean concludes that Lacan, while rejecting the more traditional ways of shoring up patriarchy suggested by his contemporaries, ultimately could not imagine a world without some kind of father figure. And in 1784, neither could David.[59]

Lacan and David *are* responding to a similar problem—to the (perception

of a) decline in the family and a decline in paternal authority. To a crisis in male authority. Given the contemporary gender ideology within which David spoke, it seems likely that he embraced an *essentialized* difference between men and women, rather than a difference constituted through cultural imperatives.[60] I shall return to these eighteenth-century conceptions of patriarchy in assessing Vigée-Lebrun's relation to the "reform" of art fostered by the French Academy in the 1770s and 1780s.

Now Bryson's interpretation of David would not be problematic for (some) feminist readers, except that he exalts the male hero-genius-artist in a celebratory tone as grandiose as the one he derides in (what he calls) traditional art history. Here are some examples: "The *Oath* marks the end of that playfulness of the early David, for now he paints as no one before him has painted, and with a fury of commitment, in the style of Neo-Classicism" (80). "With David in the *Oath* the antique style is so purged, so stripped away, that when it arrives at the Salon it presents itself as an absolute break in the paradigm, as a trauma for French painting" (82). "It is a painting radically unlike those that surround it, at the Salon of 1785; its force is irruptive, invasive" (82). (What impact could Vigée-Lebrun's images hanging in the same Salon have in comparison to this!) "David is a deep painter," his work "leads him to insights which even I doubt that we possess an adequate language to describe" (83). This is heady stuff, and David—like Ingres and Delacroix after him— emerges a hero.

The traditional fathers of art's history are fully vindicated in this new history dependent on Lacanian ideas. But at least one of those fathers, David, is seen in a different light: "Strength . . . is to be found only in what David discovers in the *Oath* and again in *Socrates* and in *Brutus*: the *acceptance* of latecoming, of tradition and of tradition's gaze."[61] By accepting tradition's gaze, by accepting his castration, David finds his strength, and Bryson poses him as the avant-garde artist who "ruptures" tradition. The position itself is gendered as "feminine," which is problematic insofar as it is only occupied by men who risk their secure positions as subjects in the symbolic to become representatives of the feminine.[62] I am reminded here of Condillac's theory in which combinatory imagination is gendered feminine but assigned to men, and of Vigée-Lebrun's protest against the doubled gesture of feminizing the artist while refusing artistry to women. Instead of disrupting the traditional histories of male genius, Bryson's account, if only inadvertently, reinscribes them from another direction. Only male subjects, whether properly phallic or heroically feminized, fashion the world of art in *Tradition and Desire*. If the text takes an apparently "feminist" line in explicating the woman's position in

the symbolic order, intentionally or not, it works to allow women no escape from that position.[63] Judith Butler has argued that the phallus gains its privilege through the reiteration or citation of its position in the Lacanian symbolic.[64] In this light, *Tradition and Desire* helps ensure phallic efficacy even (or especially) as it veils the phallus.

A second trope through which Bryson represents Ingres's relation to tradition—that of displacement—"joins together the lack or absence in human sexuality (as Ingres conceives of it) [?], and the lack or absence with which Ingres carves out his images from tradition."[65] Bryson's analysis of displacement in Ingres's *Bather of Valpinçon* (Paris: Musée du Louvre) clarifies the proposition in terms of his relation to Raphael:

> The *Valpinçon baigneuse* is *La Fornarina*, but in another guise; she has been seized from Raphael, has been subjected to the strange and personal distortion Ingres characteristically inflicts on the object of his delight. . . . By linking the bather to two very different works of Raphael, given equal privilege, Ingres ensures that neither can stake a definitive claim: the quotations neutralize each other and instead open on to the spaces between them. The intervals between images-in-displacement, the gaps in the series that runs from *La Fornarina* to the *Madonna of the Chair* to the *Valpinçon baigneuse*, are modulated into the central absence that constitutes his own bodily desire, tradition and desire joining in a single term, the Muse. The Muse is technically female and in Ingres' work the juncture between tradition and bodily desire is almost always represented by a woman.[66]

In Bryson's theorizing of Ingres's practice, woman becomes the ground of the male artist's "modulation" of tradition, the figure of his desire, and the object on which he erects his subjectivity in relation to tradition. No male viewer, *in terms of this theory*, can identify with the bather of Valpinçon: male identity is dependent on a differentiation from and an interval between himself and "woman." The analysis recalls counter-presence, the trope by which the artist separates his identity from mother/tradition, but also reminds us that the phallus underwrites the processes of substitution upon which language and representation depend.

Bryson makes the female body a privileged object of representation, but for an academically trained artist (which Ingres was) the male body was the primary site of artistic transformation. In drawing the *académie* (at that time only male models were used for these exercises), the artist learned to negotiate the "gap" between nature and art, between tradition and individuality, be-

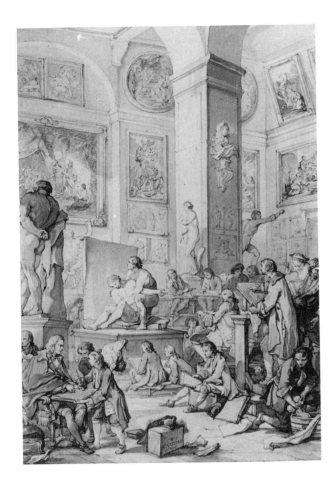

Figure 10

Charles Natoire, *Life Class at the Academy*, 1746. London: Courtauld Institute of Art

tween convention and personal style (figure 10). Different poses, moreover, charted the various traditions for representing the male body, since *académie* poses often were drawn from types seen in works of art. The male body, at least in the theory Bryson deploys, does not stand for these "real" gaps, but represents the imaginary completeness fantasized by subjects who misapprehend the penis as the phallus. Because women were prohibited from drawing after and idealizing the nude male body, this aspect of an artist's relation to tradition remained foreign to them. As I shall argue in Chapter 4, women could draw and idealize their own bodies, and so establish a relation to tradition parallel to that of the male artists. The pattern in which male artists take the male body, and female artists the female body, as a privileged model to negotiate the "gaps" inherent in art making, disrupts the circuits of hetero-

sexual desire that Bryson privileges in analyzing Ingres's *Bather of Valpinçon* and taking her as a paradigm for all Ingres's work.[67]

Looking at the problem from the historical perspective of art theory, Richard Shiff has pointed out that in academic thinking, such as that of Ingres's close associate Quatremère de Quincy, ideal art was a combination of a "general cultural ideal reflected through canonical artistic procedures," and "an ideal associated with the individual who had formed it, a personal ideal."[68] Making art, then, is a question of *both* adherence to and deviation from tradition, both identification and differentiation. This notion Shiff supports by quoting Ingres admonishing his students:

> I send you [to the Louvre] because you will learn from the ancient works to see nature, because they are themselves nature: you must live off them, consume them. . . . Do you think that in directing you to copy them, I would make you copyists? No, I want you to partake of the sap of the plant. Address yourselves then to the masters, speak with them; they will reply to you, because they are still living. It is they who will instruct you; I myself am only their assistant [*répétiteur*—the one who repeats the doctrine]. There is no misgiving in copying the ancients. . . . [Their works] become your own when you know how to use them: Raphael, in imitating endlessly, was always himself.[69]

Throughout his analysis, on the other hand, Bryson privileges separation and focuses on an artist's separation from and antagonistic relation to the past. Although I cannot here explore all the complexities of Ingres's relation to Raphael, I do suggest the obvious—that Ingres uses Raphael to reflect on himself as an artist. The repeated citing of Raphael's works, as Ingres adapts fragments of Raphael to his own use, suggests a relationship founded on processes of identification, themselves eroticized and composed of idealization, mimesis, narcissism, and aggression. If Oedipal identification is a *transcendence* of the aggressivity constitutive of primary subjective individuation, as Lacan argues in "Aggressivity in Psychoanalysis," then can we not locate antagonistic relations to tradition in a structure of pre-Oedipal or imaginary identifications rather than (or as much as) in the symbolic relations dependent on separation and desire as lack?[70]

Lacanian theory, moreover, presumes that adults are always caught up in the spatial lures of identification with their similars, which is a replay of primary identification with the mother. An ego or "moi" is elaborated throughout life by taking on different love objects that function as ego ideals. Identi-

ficatory processes are not limited to same-sex relations, although in other aspects of Lacan's theory there is clearly a push in this direction.[71] Moreover, the "moi" produced through unconscious identificatory processes has a structure analogous to that of art consciously made according to mimetic theory; the human ego as conceived by Lacan and a work of art as theorized in the French Academy are more or less constructed along the same lines. Both are built up of fragments (of other objects, artists, models, or works of art) that the subject imitates and combines into a new something that has an illusory wholeness. Because in art theory imitation can signify imitation of other artists, the relationship an academic artist forges with predecessors and contemporaries is one in which the artist fabricates an identity as an artist by taking on the images of another. The process of imitating acknowledged past masters, academic theory defined as both erotic and aggressive in a concept of emulation that made the other both ego-ideal and rival. Indeed, many self-portraits produced during the eighteenth and early nineteenth centuries can be considered (if one so desires to consider them) allegories of ego formation as theorized by Lacanian psychoanalysis.

Lacan, moreover, posits the possibility of a consciously fictive self projected by the human subject. For example, in his seminar now called "What Is a Picture?" Lacan defines mimicry as it operates in the animal world, especially in sexual union and deadly struggles when the "animal breaks up in an extraordinary way between its being and its semblance, between itself and that paper tiger it shows the other."[72] He differentiates this mimicry from that undertaken by human subjects: "The only subject—the human subject, the subject of the desire that is the essence of man is not, unlike the animal, entirely caught up in this imaginary capture."[73] The human subject can isolate and play with the function of the screen, as he projects a mask, double, or image. In mimicry, man presents to the gaze something that he is not, an image produced to have a particular effect in view of the gaze. On this concept Luce Irigaray bases her notion of mimicry wherein women flaunt the conventions of femininity that society demands of them, flaunt them in the face of the gaze, so as to subvert pretensions to a "natural" order.

The Painterly Imaginary

Vigée-Lebrun's relation to tradition in general, and to Raphael in particular, is based on imitation (mimicry). It is, however, also structured by an "imaginary" of art made up of the various (and often gendered) stories taken as points of identification for artists: Pygmalion and Galatea, Zeuxis choosing his models, Alexander ceding his mistress to Apelles, Saint Luke painting the

Virgin, Veronica and her veil, Dibutadis tracing her lover's profile, to name only a few. A particular artist's relation to an "imaginary" of painting is rooted in identificatory processes similar to those Lacan defined as imaginary stage relations. The painterly imaginary that I am proposing, however, is adapted from Michèle Le Doeuff's concept of the philosophical imaginary. This imaginary belongs to the discipline of philosophy, and it is properly philosophical, because it deals with problems posed by the theoretical enterprise itself. In Le Doeuff's analysis the definition of an "imaginary" remains quite fluid and evokes several discourses including the rhetorical (the imaginary as a collection of images or figured descriptions) and the psychoanalytic (the imaginary as a sort of textual unconscious and locus of psychic identifications with the discipline).[74] Moreover, Le Doeuff makes the imaginary both time-bound and sociological—it belongs to a specific profession and is transmitted through cultural institutions. Le Doeuff understands the imaginary as analogous to an institutionalization of subjectivity (a term Barthes applied to language), and views imaged texts as charged with "the affectivity of an educated subjectivity."[75] She explains the institutionalization by demonstrating that "for the apprentice philosopher there are classical images—images in which he or she learns philosophy, as one learns Latin in a Cicero constituted as a reference work, because desire structures itself into the desire to philosophize."[76] Thus for Le Doeuff, "Philosophical texts offer images through which subjectivity can be structured and given a marking which is that of the corporate body."[77] It follows from Le Doeuff's analysis that any institutionalized corporate body has an "imaginary" through which members mark themselves, and which, as a "learned mythology," serves the needs of self-justification.

One significant aspect of Le Doeuff's philosophical imaginary has a particular relation to the imaginary of painting. Le Doeuff contends that because "philosophic discourse inscribes and declares its status as philosophy through a break with . . . the domain of the image," philosophers view images as alien and extrinsic to their enterprise.[78] Throughout her readings of philosophical texts, Le Doeuff demonstrates that philosophy, even as it rejects images as outside its domain, relies on images to legitimate itself.[79] The image thus operates on a theoretical level and on a psychic level, and indicates places in the text where philosophical subjects inscribe themselves. Obviously the imaginary of an art form cannot depend in the same way on the distinction that philosophy makes between itself and the image. Yet there remains a deep connection between the philosophical and painterly imaginaries. Jacqueline Lichtenstein has argued that the antipathy for the image can be traced back to Plato's binding together of rhetoric (eloquence) and painting and associating

the two with sophistry. Their alliance, moreover, was sealed with a philosophically injurious double condemnation: not only are rhetoric and painting seductive and false, but they also have no aim other than pleasure.[80] Lichtenstein concludes that throughout their histories painting and rhetoric have attempted to respond to these accusations. Plato, in fact, forces them to self-justification, and Platonic texts on pictorial imitation treat painting as a "defendant charged with trying to achieve something that it never intended in order to reproach it in turn for failing to do so. In choosing for its questions criteria that painting never claims to use, philosophical discourse draws painting onto its own ground."[81] What painter ever claimed, Lichtenstein asks, to be making the real thing? What painter wants to deny the nature of his or her own work? Thus if Plato's distinction between philosophy and the image is central to the philosophical imaginary, it also shapes the imaginary of painting, since painting's need to justify itself is a response to Plato's division.

The stories that artists returned to again and again either directly or indirectly, intentionally or inadvertently, revolved around a few limited themes, the most important of which represented the artist's divinity—a relation to absolute creativity, an ability to confer immortality, and so forth. Lichtenstein has shown how even images of the relation between painting and Love fit this theme, as painting, through representation, compensates the desire of lovers for the absence of their beloved.[82] Through a reading of Félibien's "Songe de Philomathe," she concludes: "The language of love, Painting is the language of origins twice over. . . . The visual signs she uses belong to the language of creation. And the reality that painters imitate on their canvases is already a work of painting, of the original painting that gave form and color to the universe and transformed chaos into cosmos." Painters imagined painting as a "divine language," for "God first manifested himself to human beings by way of iconic and mimetic signs."[83] It is not, I believe, mere coincidence that Vigée-Lebrun's story in Fontana's cabinet emphasizes this mythical image so central to painting's imaginary. Recall how she figures Fontana and Michelangelo as godlike creators before whom we can only prostrate ourselves.

Such images on a theoretical level justified painting, and on an emotional level deflected the artists' sense of their femininized, (i.e., devalued) cultural status. This point is interesting in terms of Le Doeuff's suggestion that philosophy's separation of itself from the image was also a separation of the masculine (reason) from the feminine (imagination).[84] Le Doeuff deems this separation "imaginary" since philosophy depends on the images it, in theory, repudiates, and because no clear line can be drawn between what is knowledge and what is image. Moreover, self-justification, which is a major theme of both the history of philosophy and the history of art, cannot be other than an

imaginary construct, since, according to Le Doeuff, it is not possible for a discipline to validate its own "origins" or to explain its conditions of possibility without overstepping its range. Meaning contained in these sorts of images works both for and against the system that deploys them; an image both sustains something that the system cannot justify, but which is needed for its proper working, and unravels the system precisely because the image's meaning is not compatible with the system's possibilities.[85]

Despite the inequality between the sexes that has always existed in the academic disciplines (and especially in philosophy), Le Doeuff sees the learned imaginary as something that can be transmitted to or learned *by men or women* through texts, through educational institutions, through a guild or professional organization. Thus, although "the imaginary is as difficult to pass on as knowledge," an individual's relation to it is not collapsed into a relation to the phallus or to lack, even though gendered distinctions are obviously in play. Moreover, Le Doeuff insists that there is no closure of discourse, "discourse only ever being a compromise—or bricolage—between what it is legitimate to say, what one would like to contend or argue, and what one is forced to recognize."[86] If the imaginary of painting is filled with images gendered as masculine, and if the category of artist in theory, although not in practice, excluded women, then any self-justification made by a woman artist is likely a negotiation, a compromise, an opening of discourse.

Artists can engage subjects from the imaginary of painting in all genres. A still life in the manner of Jan van Huysum, now in the Rijksmuseum, evokes the contest between Zeuxis and Parrhasios in a *trompe l'œil* image that depicts a half-transparent sheet of paper lying atop a drawing of roses and forget-me-nots (figure 11).[87] Shadows are skillfully placed so the lower and left edges of the overlaid paper seem at points raised above the drawing's surface, and the lower right corner particularly invites the viewer to try, as Zeuxis did, to lift the veil. The still life appears to be what it is—a picture of flowers rendered on paper—and at the same time what it is not—veiled with a second, semi-transparent sheet. But the image does much more than simply deceive the eye with appearances; it also refers to a classic tale about the nature of painting, and transforms itself into the idea of painting, into a discourse on illusion. In its association with trickery or delusion, that discourse is underscored by the fake signature prominently displayed on the lower right border, a signature that for us announces the work's status as simulation/dissimulation. The still life becomes an idea, but only does so by presenting itself as an illusion, and by referring to a narrative that—at least for the eighteenth century—demonstrated that painting was not an idea, but a seductive and deceptive appearance.[88] In this case, the image refers to a story whose "message" was at odds

Figure 11

Dutch, *Drawing of Roses and Forget-me-Nots*, mid-eighteenth century. Amsterdam: Rijksmuseum

with the theory of painting broadcast and taught in art institutions throughout Europe. Indeed, particularly because this work casts still life, associated with the so-called lower genre, as an idea, it extends to all subjects the prominence theory sometimes accorded only to history painting. The relations between this *trompe l'œil* image and its textual referent are similar to those Le Doeuff finds between philosophical texts and the images they deploy: when brought into an eighteenth-century still life, a reference to Pliny's narrative works both for and against the system. The example demonstrates that although artists can directly represent in history painting the themes or stories that justify art making, the artistic imaginary also operates through isolating objects that are particularly charged with affectivity, having an association with the history of art's self-justification. Shadows, mirrors, reflecting pools, other works of art, curtains, veils, grapes—all these are charged elements when they appear in painting. The self-portrait has a particularly keen interaction with stories of self-justification.

Take for example Vigée-Lebrun's self-portrait with Julie, the one based on Raphael's *Madonna della Sedia* in which she is dressed *à la Grecque*. As the

"good mother" the artist is a secularized madonna, but one who nevertheless remains connected to the image we consider as her "source." That image, like all those of Mary and the Christ Child, has for its originary myth the story of Saint Luke painting the Virgin, one of the many evocations of the divinely inspired artist. As the patron of artists' guilds and academies throughout Europe over many centuries, Saint Luke had a special relation to painters, for whom he was both original model and protector. Each artist who represented the Virgin, in effect, cited Saint Luke's "vision." In situating its mythical origins in an internal vision divinely inspired, painting defined its task as that of merely copying the vision faithfully. Although painting could thus claim to be the true image of the divine (another Veronica's veil), it could never make good on that claim, because the divine image was already painting's own construction. Moreover, if Saint Luke's story posits a divine origin to painting by avowing the artist's dependence on God's inspiration, it does so only to dissimulate the painter's pride in usurping God's place by posing as an inventive creator and not a mere copyist. This was the role artists took for themselves and that art theory often gave them, at least since the Renaissance.

Vigée-Lebrun poses in her self-portrait not only as an inspired friend of God, but also as his Virgin mother, admittedly secularized. Huet has proposed that for the iconoclasts of the Reformation, images of the Virgin were especially dangerous in that they granted to Mary powers that by right belonged only to God. And she further suggests that any image of the Holy was thought "feminine," because its representation of the material body distracted from the immaterial, abstract, and "masculine" power of the Divine Word. The later Revolutionary cults, and especially that of the Supreme Being, eschewed picturing their abstract divinities, which Huet also reads as a turn away from the "feminine." She suggests that this later iconophobia parallels earlier disavowals of Mary's image.[89] In this logic, a woman artist substituting herself for the Virgin Mary in a self-portrait suggests a woman appropriating divine power in and through the sensuous and feminine visual image of God's mother.

If Raphael's Madonna mediated between Vigée-Lebrun's representation and Saint Luke's vision, it also mediated between Vigée-Lebrun and Raphael's model—the Fornarina, his mistress and mother of his child. In casting herself as Raphael's Virgin, Vigée-Lebrun simultaneously cast herself as his mistress, particularly since the story of Raphael's Fornarina was well known by the 1780s.[90] Vigée-Lebrun's self-portrait, however, transforms the model-muse (the Fornarina/Vigée-Lebrun) into the artist, and the mother-artist substitutes her girl children—the one she makes on the canvas and the one she made in her womb—for those of her divine predecessors.

Besides engaging the bank of stories comprised by the imaginary of paint-ing, the woman artist activated identificatory processes in mimicking those masters institutionalized as proper models. Vigée-Lebrun claims to imitate Raphael "con amore," which I take to mean that she, like Le Doeuff's philoso-phy student, chooses a relation based on the "settled loves" of the profession. In discussing Raphael's position in the French Academy's pantheon, Martin Rosenberg has pointed out that Raphael was consistently referred to as the "modern Apelles" and viewed as "both a model and surrogate for the lost paintings of antiquity."[91] Vigée-Lebrun's costume *à la Grecque,* combined with the references to Raphael, underwrites her claim to be not only a lover/ imitator of Raphael, but like him one in whom the classics are reborn. The image also suggests that Vigée-Lebrun is descended in a line that runs through Raphael back to the great Apelles. From this vantage point, the artist-mother has again insinuated herself into a line of fathers. Moreover, the established association of Raphael with "grace" could work to her benefit in undermining the gendered divisions of painting. In eighteenth-century France, Raphael was reputed to be the master of "grace," both in the way he painted and in the way he lived his life as a perfect courtier. At the same time that grace was associated with the most perfect of painters, it was also a quality women were believed naturally to possess. Women were naturally predisposed to paint graceful sub-jects with a graceful style.[92] By choosing as her model an artist perceived to be the epitome of grace, Vigée-Lebrun imitates a master who represented what she was thought—as a woman—to possess naturally. Her imitation of what was already "natural" to her (that is, being graceful) coupled with her imita-tion of what was not (being a great artist) is a kind of mimicry in that it can reveal the constructedness of such gendered modes.

As my reading of *Tradition and Desire* suggests, an orthodox psychoana-lytic account of the artist, even one drawn from Lacan, can illuminate male subjectivity, but it tells us little about the woman artist beyond posing her as a phallic woman. Because such psychoanalytic theory accounts only for phallic subjectivity, women have had simultaneously to perform and theorize their relation to (the history of) cultural production. Feminist writers are now grap-pling with imagining women, both historically and theoretically, in a post-modern age marked by powerful and compelling challenges to the humanist idea of a unified subject, as well as to the category "woman." Throughout this book I focus on the ways that Vigée-Lebrun and some of the women she rep-resented can be understood as disrupting the received truths about "woman" taught in anatomy lessons, be they physiological or psychoanalytic, even as they were caught up in the very structures and practices dictated by those truths. In resisting the cultural text that constrained and oppressed them as

"woman," these women never defeated the regulatory laws that confined the sex, and it is not ever clear that they actually intended to do so. At best they found a temporary escape through the laws' fissures and pores, and through the possibility for subversion opened by the pressure to iterate over and over again the same cultural texts. In those fissures, pores, and reiterations, these women, I imagine, imagined other possibilities for representing themselves, and in those same fissures, pores, and reiterations I imagine we can find other possibilities for understanding their representations.

PART TWO

Elisabeth Vigée-Lebrun in 1783

THREE

The Law, the Academy,
and the Exceptional Woman

Prelude: A Modern Dibutadis?

In 1783, a Greek maiden dead more than three thousand years appeared at the Salon in Paris. As you might imagine, she caused quite a stir. Not that Parisians were unaccustomed to singular persons visiting their Salon. After all, Momus the jester and the Greek painter Apelles were also there. But still, the young maiden was an exceptional presence, a "nymph" dead more than thirty centuries, who was as "fresh as a blooming rose."[1] Appearing first in the sculpture court, she was antique in form and costume and expressed a "virginal and primitive nature." Clearly she was from another time and place. A learned abbé said it must be Dibutadis who invented painting by tracing the head of her lover on a wall, and her comments on art confirmed his opinion.

It was indeed Dibutadis, and giving her due honor, the Salon visitors addressed her as the inventor (*inventrice*) of painting. Being an appropriately modest woman, however, she underplayed her achievement: "If I am an inventor then it is of the *silhouette portrait*, for I have just heard called by that name a *profile in black* made by tracing the shadow of a young person. It is exactly the same procedure that love inspired in me and for which you claim to admire me."[2]

The report of the Greek maiden's visit was published in a Salon pamphlet as a letter from one unnamed Monsieur to another, and although the encounter with Dibutadis is narrated in detail, the correspondent admits that she only materialized in an intoxicating dream inspired by art.[3] —But what made Dibutadis decide to appear, if only in a dream, in 1783? —But why suggest that she chose the timing, that the game was her own? Maybe some god, or better yet some Pygmalion, fashioned and animated her to voice his concerns about the Salon of 1783.[4]

Just about a century later a reader looking at the Academy's records no-
tices something that might suggest what Dibutadis—or her Pygmalion—was
up to. This reader, Anatole de Montaiglon, is perusing the manuscript regis-
ters of the proceedings of the Royal Academy of Painting and Sculpture,
which he will edit and publish in 1889. His eyes are fixed on the entry for
7 June 1783. He reads, "In opening the meeting Madame Lebrun, received as
Academician *(Académicienne)* at the last assembly, took her place in this capac-
ity."[5] But in the manuscript this statement is interrupted by an alteration in
the text, something has been crossed out, even "surchargée de ratures." The
erasure comes from the middle of the line quoted above; the record had once
stated "in opening the meeting Madame Lebrun, received as academician at
the last assembly *and who has brought her works with which the Company was
satisfied* took her place in this capacity."[6] Was some academic authority so dis-
tressed with those words, "and who has brought her works with which the
company was satisfied," that the phrase was "surchargée de ratures," and the
official history of the Academy changed? With what works did the ambitious
Madame Lebrun try to satisfy the assembled academicians?

The altered Academy record and Dibutadis's commentary on the Salon
of 1783 have, I believe, much to do with one another. The work that Vigée-
Lebrun brought to the Academy in June of 1783 substituted for the reception
piece that in ordinary circumstances both determined and represented an ar-
tist's position as an academician. A *morceau de réception* gained its authority to
signify the artist's acceptance by and position within the Academy from the
Academy itself. Not only did the choice to accept the *morceau de réception* lie
with the academicians, but often they had assigned the subject. On the basis
of this work they decided the category or rank of the painter.[7] Vigée-Lebrun,
however, brought to the Academy in May of 1783 a work that was not the
usual reception piece. It was a dangerous substitute for that sign of official
approval, dangerous because, like Vigée-Lebrun herself, it could not be rec-
ognized in the normal academic categories.

The status of Vigée-Lebrun's painting(s) was and is problematic precisely
because she did not enter the Academy in an ordinary way. On the day of her
reception, 31 May 1783, she was not elected by a voice vote of the assembled;
she presented no *morceau de réception*, and was not positioned in a genre or
rank. She was admitted, as the record shows, by order of the king. This order
both mandated her acceptance and exempted her from the Academy's statute
banning commerce, thus obviating the institution's claim that her marriage to
an art dealer precluded her admission.

If accepting Vigée-Lebrun by order rather than vote was extraordinary,
much more was unusual about 31 May 1783, at least as far as academic history

goes. On that day the Academy admitted not one, but two women painters. If this double admission linked them, it was perhaps to emphasize the distance between the two, for the academicians conducted and recorded the acceptance of Adelaïde Labille-Guiard according to ordinary practice. Or at least according to the practices established for accepting women. Like other candidates, Labille-Guiard was presented to the company by an established academician (in her case, the portraitist Roslin), and elected by the "customary" voice vote. She brought to the session paintings from which the academicians selected her reception pieces and ranked her as a portrait painter.[8] Unlike Vigée-Lebrun's works stricken from the record, these paintings were not dangerous substitutes for those most important of academic symbols. They were—if you will—the real thing.

Judging from the Academy's *Procès-verbaux*, the admission of Labille-Guiard seems to have followed directly the irregular proceedings that placed Vigée-Lebrun within that privileged body but left her without an officially sanctioned rank. The controversy surrounding Vigée-Lebrun's admission was apparently well publicized. In the *Correspondance littéraire* of 1783, Grimm reports how finally seeing her paintings at the Salon recalled all the bickering and all the petty persecutions directed against her.[9] Vigée-Lebrun refers to this squabbling in her account of the event included in her *Souvenirs*:

> Shortly after my return from Flanders in 1783 . . . several . . . of my works prompted Joseph Vernet to propose me as a member of the Royal Academy of Painting. M. Pierre, then first painter to the king, strongly opposed my admission, as he did not wish women to be received; yet Madame Vallayer-Coster, who painted flowers perfectly, had already been received, and I believe even Madame Vien was also an academician. Be that as it may, M. Pierre—a very mediocre painter who thought of painting only in terms of execution—was clever, and moreover he was rich, and had the means of ostentatiously receiving artists, who at that time were less well-to-do than they are today. His opposition would have proved fatal to me if at the time true amateurs had not been associated with the Academy of Painting. They formed in my favor a cabal against that of M. Pierre, and it was then that one of them wrote this couplet:
>
> > To Madame Lebrun—
> > At the Salon your triumphant art
> > Will put you in the limelight.
> > Lise, To keep from you this honor,
> > One must have a heart of stone [de pierre], of stone, of stone.

Finally I was received. M. Pierre then spread rumors that it was by an order of the Court that I was received. I think that the King and Queen had been good enough to want to see me enter the Academy, but that is all. I gave for my reception piece *Peace Bringing Back Abundance*. This painting is today in the Ministry of the Interior.[10]

There is a notable difference between this account and the official records of the Academy, which underline that the king's order secured her reception by including a copy of the document. In the artist's *Souvenirs*, however, the phrasing seems ambiguous. Does she imply that the royal couple's wish to see her enter the Academy remained at the level of a desire? Or would her readers have known that their desiring her admission was enough to secure it? Because this ambiguity contrasts sharply with the apparent certainty of the *Procès-verbaux*, some interpreters might wish to dismiss her entire account, including her claim that the dispute focused on the status of women. Yet, as we know, official documents hide as well as reveal, construct truth even as they claim to

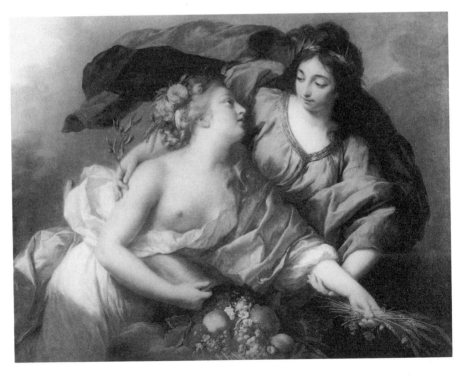

Figure 12 Elisabeth Vigée-Lebrun, *Peace Bringing Back Abundance*, 1780. Salon of 1783. Paris: Musée du Louvre

tell it. A set of documents overtly states only one story, one point of view among contesting ones. The king surely did give an order, but was the order necessary, really? Was it a façade for an entire conglomerate of (hidden) interests? Of what worth are the words of an elderly woman, a society portraitist, against the official records of the Academy?

Vigée-Lebrun makes a second significant point about her admission near the end of her account: "I gave as my reception piece *Peace Bringing Back Abundance*" (1780; figure 12). Recall that the Academy's proceedings record no reception piece, no rank. Yet this painting was, in fact, widely known as her *morceau de réception*. It is listed in the Salon livret and discussed throughout the Salon literature as such. Was this work the dangerous substitute, the proffering and approval of which some academic official erased? Is this the painting that is covered over, *surchargée de ratures*? And if it is, what larger story does the effacing conceal? Here is what I imagine it to be.

Elisabeth Vigée-Lebrun is both gifted and ambitious. The daughter of a guild painter and a hairdresser, she has become not only the court artist to Marie-Antoinette, but an intimate of the noble and the accomplished. Through talent, publicity, hard work, and personal assets (beauty, grace, a lively mind) she has enjoyed considerable social mobility and has developed great self-confidence. Anticipating that the Academy doors will be opened to her, she sets out to demonstrate that she is not a mere portraitist. She plans to enter herself as a history painter, as an artist of the highest rank, the rank closed to women. (And perhaps she also plots a little revenge on her detractors.) On May 31 she sits through the Academy meeting where an entire scenario has been staged. She notices—perhaps with satisfaction, perhaps with rancor—that her enemy Pierre has chosen to absent himself from the proceedings.[11] The corporate body accepts her by order, and in pointed contrast elects Labille-Guiard and chooses her reception piece(s) from among the portraits she has brought. They ask Vigée-Lebrun to bring her work to the next meeting. She has expected the request, and on June 3 she presents to the academicians the allegory, Peace Bringing Back Abundance. *Allegory, she knows, falls into the category of history painting. Seeing the work, some faces set into stony grimaces. Given the protection of the queen and the order of the king, and given that they have already admitted the painter, the academicians are in no position to refuse her work. The beautiful Madame Lebrun is laughing.*

Now this, of course, may not be the way things happened. No matter. One can paint other stories and imagine other motives, but my point remains: the academic officials would not have ratified her history paintings, and they would not have chosen her *Peace Bringing Back Abundance* as a reception piece. In selecting this work Vigée-Lebrun appropriated two kinds of symbol-making power: the power of the Academy to name the *morceau de réception* and the power of the male artist to dominate that genre devoted to texts of moral, historical, or intellectual significance.

Ruling the Exceptional Women

In reporting her struggles for admission into the Academy, Vigée-Lebrun stresses that the first painter, Pierre, wanted to exclude women. On the face of it, this claim seems suspect because other women were already members and because Pierre seems to have strongly backed Adelaïde Labille-Guiard. Yet a look at the Academy records suggests that it was never eager to admit women and always did so as "exceptions." Indeed, in addition to the order admitting Vigée-Lebrun, the Academy's director, d'Angiviller, persuaded the king to give a second order. The first ensured the acceptance of one woman, the second ensured the exclusion of many, and these were linked in d'Angiviller's *Mémoire* to the king concerning Vigée-Lebrun's admission. After asking the king to order Vigée-Lebrun's exception, he also asked for a law "limiting to four the number of women who can, in the future, be admitted into the Academy."[12] Here is the Academy's recorded response to d'Angiviller's maneuver: "The Academy has, moreover, decided that it will send a letter of thanks to M. d'Angiviller for having preserved the rights of the Academy and the force of its statutes, and for having fixed the number of women academicians at four."[13]

This victory for the rights of men was something to be thankful for, because the Academy had long wanted to limit the number of women within its ranks and on other occasions had taken steps to do so. On 25 September 1706, the *Procès-verbaux* record only one item of business at the regular meeting: *Règlement général que l'on ne recevra aucune Damoiselle en qualité d'Académicienne.* The rule was prompted when the Academy learned that "several ladies who have applied themselves to painting have planned to present themselves to be received as académiciennes."[14] After "une sérieuse réflexion" the company decided to forestall the presentations of these women by resolving that henceforth they would receive no woman as academician and that this resolution would serve as the "règlement général." The rule, however, was enacted without the king's consent, and so did not have the force of law. For the

next half-century the Academy admitted women sporadically, and during Pierre's reign as first painter proposed another *Règlement pour l'admission des femmes à l'Académie* on 28 September 1770:

> Although [the Academy] is pleased to encourage talent in women by admitting some into our body, nevertheless, these admissions, *foreign in some fashion to its constitution*, [my emphasis] must not be repeated too often. [The Academy] has agreed that it will receive no more than four women. It will, however, receive women only in cases in which their extraordinarily distinguished talents lead the Academy to wish, with a unanimous voice, to crown them with particular distinction. The Academy does not pretend to oblige itself always to fill the number of four, reserving for itself the right to choose only those whose talents are truly distinguished.[15]

Thus the Academy finds women foreign to its body, alien in some fashion to the constitution (the physical makeup?) of the Academy. The academicians never specified how or why the admission of women was alien, but given the general cultural construction of woman as outside the political body, it is not surprising they found it problematic to incorporate women into the academic one.

Fears over admitting women, and thus making the Academy a heterogeneous, mixed body, surfaced not just in the official resolutions, but in every acceptance of a woman. This was the case even though women were admitted infrequently and comprised a very small proportion of the membership.[16] Indeed, during its history the Academy admitted more than 450 artists, and of that number no more than 15—one-third of one percent—were women. The collective anxiety about these women is encoded in certain phrases that appear repeatedly in the *Procès-verbaux*, specifically, those indicating that the acceptance of a particular woman was not meant to set a precedent. For example, in 1680, twenty-six years before the first attempt to legislate the number of women, Dorothée Massé is accepted "in the position of Academician, without allowing her to be a precedent for the future."[17] In 1682, the admission of Catherine Perrot is qualified with the phrase, "ce sans tirer à consequence," which appeared again in recording the 1720 election of Rosalba Carriera, the woman for whom the academicians broke their edict of 1706.[18] In 1722, the same phrase marks the record of admitting a second foreign woman, Margueritte Haverman.[19] Although it was another thirty-two years before the next woman was admitted, the Academy still felt compelled to point out that the admission of Madame Vien, on 30 July 1754, was not to set a precedent.[20]

At this point one might well wonder why the Royal Academy of Painting

and Sculpture admitted women at all, given that the other academies did not.[21] The rationale for accepting the first woman in 1663 during Colbert's direc- torship, rests on interpreting the king's intention in founding the Academy. On April 14, the case for accepting Mlle Girardon was made as follows:

> Today the Academy is assembled extraordinarily because of what has been represented as the duty and honor of the Academy in following the King's intention to extend his grace to all those who excel in the arts of painting and sculpture and to those judged worthy, regardless of their sex. After Monsieur Le Brun presented a painting of flowers made by Mademoiselle Girardon, all the Company, touched by es- teem for this work and recognizing the merit of this young woman, resolved to give her the position of Académicienne, for which she will be sent the letter at the first opportunity.[22]

The first acceptance of a woman, like the acceptance of all academicians, is based on the king's grace, which makes clear why the king could order Vigée-Lebrun's admission. The Academy's willingness to accept a woman artist in 1663 might in part be explained by Colbert's desire to increase membership in the royal institution by recruiting artists who had never been associated with the guild.[23] For the history of women in the Academy, however, it is as significant that Girardon is related to the king's sculptor, François Girardon, and that many of the women subsequently admitted were the daughters or wives of academicians.

At that "extraordinary" meeting when the Academy admitted its first woman, it also received fourteen male artists, and in the records we find a significant difference between their acceptance and that of Girardon. Instead of being sent "la Lestre" all the male painters were ordered to take the oath in which they swore to uphold "religiously" the rules and statutes of the Academy.[24] Oath taking in *ancien-régime* France formalized and added force to commitments, but women were banned from swearing them, except, of course, the oath of marriage.[25] Beyond taking the oath, admission procedures were neither regularized nor admissions systematically recorded in the sev- enteenth century. Later, however, the differences between men's and women's admissions became more evident. Male painters usually went through the Aca- demy's training program, they presented a *morceau d'agréement* for their pro- visional acceptance and were assigned a topic for a *morceau de réception*, which they subsequently submitted for evaluation. Women were never received in this way, and the Academy usually made them *agréé* and *académicienne* on the same day. Most, although not all, brought to the session several paintings from

which the academicians could "find" appropriate reception pieces. Women continued to receive letters of acceptance instead of swearing the oath.[26]

Although the Academy could not exclude women entirely, it could maintain them in an equivocal position—as foreign elements—since they were not allowed to swear allegience to the institution and its rules. That the oath functioned in this way becomes clear from later Academy records; in 1790 the officers banned women from discussions about reorganizing the Academy because they had not taken the oath. That this ban followed Labille-Guiard's attempts to gain for women an unlimited number of seats in the Academy is significant. It demonstrates again that when under threat from women—as it had been already in 1706 and 1783—the Academy would act to limit their role, even though the records and reports suggest that the academicians were by no means unanimous in their resolve to keep women out. Moreover, the timing of this ban also supports historian Genviève Fraisse's argument that the ideology of liberty and equality fostered by the Revolution raised in a glaring way the problem of women's rights.[27] Indeed, an appeal to the new principles fueled Labille-Guiard's attempts to gain equality for women.

Little about these attempts is recorded in the Academy's *Procès-verbaux*, but more is suggested in the memoirs of the engraver, Jean-Georges Wille. His entry for 23 September 1790 begins, "Madame Guiard, seated next to me, made a very well justified speech on the admission of women artists to the Academy and proved that accepting an unlimited number must be the only admissible rule."[28] Wille also described a second motion made by Labille-Guiard and supported by the painter, François-André Vincent (who would later become her husband) that would allow some women to be distinguished with particular honors. Labille-Guiard justified the request by arguing that because women could neither participate in the governance of the Academy nor be professors in its schools, they had no way to elevate themselves within the existing hierarchy. Equality and liberty, it seems, are not incompatible with ranks and honors! Commenting on the fate of the proposal, Wille wrote, "This article, despite the opposition of M. LeBarbier, was approved and passed the vote, as did the first."[29]

Although the minutes in the *Procès-verbaux* do not record the meeting that Wille cites, the record does include a letter from the officers to the academicians, dated 23 September 1790, which refers to the meeting. The officers (and chief among them Vien) seem to have separated themselves from the academicians for the purpose of enacting new statutes. To justify the move, they argued that it was impossible to continue work with the entire Assembly because, among other things, "several members of your assembly supported

their opinions with a 'chaleur immodérée'" [I wonder which ones?], and "be-
cause we do not find it appropriate that women mix themselves in a work that
is foreign to them, it being only a question of redrafting the Statues, which do
not concern them at all since they have not submitted to them, never having
taken the oath to obey them."[30] How convenient that women are foreign to
the Academy because they have not taken the oath! Oath taking, it seems, both
in the old regime and during the Revolution, was a male enterprise. After all
the revolutionary dust settled and the Academy was reorganized, there were
no more exceptional women in that corporate body, for the Academy had
closed its doors to the sex. The play of the rule and the exception had come to
an end.

The Rule of the Exception

The play of the rule and the exception is nowhere more obvious, nor as subtle
and complex, as it is in the documents surrounding the admission of Elisabeth
Vigée-Lebrun to the French Academy. Having briefly sketched in the cir-
cumstances of Vigée-Lebrun's admission and the history of women in the
Academy, I now turn to a close reading of three documents: a *Mémoire* of
14 May 1783 presented to the king by d'Angiviller and transformed into law
by the king's order; a letter from d'Angiviller to Pierre dated 30 May 1783,
and the *Procès-verbaux* entry for 31 May, which interprets the Director's letter
and *Mémoire*. The documents appeal to four interacting species of law: aca-
demic law, national law, natural law, and the law of genre; and frame the dis-
cussion of women and the law within the broad question of national interest.
My reading focuses on the play of the rule and the exception within these
documents, and examines how they position women against, outside of, and
in reference to the law. I read these not just as a story about Vigée-Lebrun's
acceptance into the Academy, but as part of an ongoing struggle to define the
political, social, and professional status of women.

 The basic storyline of the controversy surrounding Vigée-Lebrun's ad-
mission is simple, and I have suggested some of it already. Because she is
married to an art dealer, the Academy, represented by its director, d'Angi-
viller, holds her in violation of the statute forbidding artists from mixing in
commerce. They refuse to admit her. At the request (insistence?) of the queen,
Marie-Antoinette, the king orders an exception to the rule, which opens the
way for the artist to be accepted as *académicienne*. Here is how d'Angiviller
summarized the situation for the king:

> Her Majesty [Marie-Antoinette] has done me the honor of asking me
> if there is not the means, without destroying the law, to admit Ma-

dame *Le Brun* into this Company, which is interested in supporting in all their rigor the Statutes, particularly since Your Majesty has given the Arts their freedom. I have had the honor of responding to her that the protection with which she honors the lady *Le Brun (La Dame Le Brun)* falls on a subject distinguished enough that an exception in her favor would become more a confirmation than an infraction of the law if it was motivated by this worthy patronage and if Your Majesty wished to authorize it by formal order.[31]

The text demonstrates clearly how the rule of the exception operated in an absolutist regime. D'Angiviller may flatter the power and rank of the queen, but the law responds only to the will of the monarch—the lawmaker. Aside from the Director's rhetorical bows, most evident in the passage is d'Angiviller's insistence that the rule be preserved in all its rigor. Approaching the matter from a different perspective in writing to Pierre, d'Angiviller described how the king considered "that the situation in which Madame Le Brun finds herself is of the sort that will not recur."[32] He also repeats in this letter that an exception for Vigée-Lebrun "founded on as powerful a reason as that of the protection of the queen, would be more a confirmation than an infraction of the law."[33] Thus d'Angiviller has found a way, at least in his own mind, to bring this exception under the law's control. Moreover, he asks the academicians to find in the exception (which he presents to them as a mark of the king's goodness toward the Academy) a new motive for "guarding more attentively than ever that none of its members ever stray from a law as honorable for the Arts as for those who cultivate them."[34] *Exceptio firmat regulam*. In being founded on royal favor, the exception confirms the law in a second and perhaps more important way. D'Angiviller points out earlier in the *Mémoire*, that the law was instituted to insure the nobility and liberty of the arts and their freedom from the taint of commerce. Vigée-Lebrun is worthy of the exception not simply because she is an excellent artist, but because royal patronage confers a nobility that counteracts the effects of (her husband's) *dérogeant* activities.

Regulating Commerce

What becomes clear in reading all the documents concerned with Vigée-Lebrun's admission is the insistence on the rule against commerce. In fact, the *Mémoire* opens by impressing on the reader the law's power and pedigree: "In the Statutes given by Louis XIV to the Academy of Painting, it is forbidden to any artist to engage in the commerce in paintings, be it directly, be it indirectly. This rule has been confirmed by Your Majesty in a most authentic

way."[35] The law rides the continuity of the monarchy itself. Dating from the Academy's first statutes, it was established by the ancestor/father/king, Louis XIV, and was reaffirmed by his great-great-grandson in a manner most "authentique." The qualifier "authentique" confirms the originary status of the statutes, and carries two other connotations: that of incontestability and (in law), that of making something legal and binding. The "règlement," then, has been confirmed in a manner most authentic, incontestable, and binding. Discussion of this statute forbidding commerce appears in 22 of the 36 lines in d'Angiviller's *Mémoire*, some of which have already been quoted above. Moreover, the law is invoked directly several times in all three of the documents published in the *Procès-verbaux*. Given that the exception confirms the rule, this seems rather an excessive attention.[36]

What are we to make of this obsessive citing of the law? Just what is at stake here, and why, beyond the stated reason of her husband's business, was it so zealously pressed in the case of Elisabeth Vigée-Lebrun? I approach these questions through two comments made in the *Mémoire*—the mention of the king having accorded "la liberté aux Arts," and a reference to the declaration of September 1776, which ensured this liberty. These connect the case of Vigée-Lebrun to the disbanding (and subsequent reorganization) of the *Maîtrise* (i.e., the Académie de Saint-Luc, or the artist's guild), and to the reaffirmation of painting and sculpture as liberal arts. Indeed, in an earlier letter to Pierre, dated 19 September 1771, d'Angiviller stated as his first priority "to procure for painting and sculpture the liberty that they have always enjoyed as holding one of the principal ranks among the liberal arts."[37] In analyzing the texts generated by the admission of Vigée-Lebrun, I want to examine how this particular artist, equally as a woman and as an art dealer's wife, threatened the liberty and liberality of the arts.

Under d'Angiviller, the Royal Academy zealously attempted to suppress the Académie de Saint-Luc, in which portraitists, still-life painters, even history painters, were mixed not only with art dealers but also with craftspersons. This mixing implied that no distinct boundary separated the liberal art of painting from the crafts, or mechanical arts. Nor was the noble practice of the arts distinguished from the degrading engagement in commercial enterprise. Historians have often viewed d'Angiviller's attempt to close down the Académie de Saint-Luc within an ideology of competition, citing the Director's desire to ensure a monopoly for his own institution.[38] Without forgetting that d'Angiviller's hostility to the Académie de Saint-Luc was part of a century-old feud between the two institutions, I suggest that the Director's desire to secure a monopoly was matched by his determination to establish an inviolable divide between, on the one side, painting and sculpture, and on the other, crafts and

commerce. Writing to the king in 1775, d'Angiviller vigorously protests an unnatural mixing: "the noble arts of painting and sculpture are confused in the common order with those of applying a layer of color on a revetment or on a wall and that, without a special act of royal authority, the Zeuxises and the Phidiases, the Raphaels and the Michaelangelos, if they were among us, would be reduced to inscribing themselves on the public register in a community mainly composed of copyists, sellers of curiosities, and art dealers."[39] Because a guild for artists existed in eighteenth-century France, academicians were still fighting the battle begun in the Renaissance to establish painting and sculpture as liberal arts. D'Angiviller's invocation of Michelangelo and Raphael reminds us of this battle's history.[40]

The academicians, however, were not successful in closing the Académie de Saint-Luc by stressing the "nobility" of painting. Rather, their fight was won by an influential government minister, Turgot, who wielded an ideology distinct from that of his friend d'Angiviller. Turgot persuaded the king to ban *all* trade guilds (of which the Académie de Saint-Luc was one) because the *Maîtrise* hindered free trade and denied citizens their natural right to work. Turgot detailed ways he believed the trade corporations denied this liberty: by limiting the practice of a trade to those who had obtained masterships; by limiting masterships by long apprenticeships, masterpieces, and high entrance fees; by preferential treatment for the sons of masters; and by excluding women.[41] Moreover, the historian William Sewell has associated Turgot with an Enlightenment view of the mechanical arts. He reads Turgot's attack on corporations as part of an attempt to elevate the mechanical arts and all productive labor from the disdain of opinion and to reconceptualize them as useful, essential to happiness, and complex productions of the human mind.[42] This "reconceptualization," however, never changed deep-seated attitudes. Jacques Rancière has argued that although representations created the nineteenth-century myth of the noble worker, the intelligensia could not abide a laborer (a practitioner of the mechanical arts) becoming an artist (a practitioner of the liberal arts) and fulfilling the "dream of moving to the other side of the canvas."[43] In other words, when the elite idealizes the worker, it does so qua worker; like a woman, the worker is not the subject, but the natural object of representation. In 1783, however, d'Angiviller still adhered to an "unenlightened" view of the arts, a formulation that policed the divide Rancière calls the "unjustifiable and inescapable frontier separating those whom the deity destines for thinking from those whom he destines for shoemaking."[44] For d'Angiviller, that divide still distinguished the noble from the not-noble, and although he does not seem to have shared Turgot's "enlightened" sentiments, he was quick to take advantage of the minister's success.

Turgot's decree made no mention of honorific associations like acade-
mies. Reading his edict and Parlement's response to it, however, suggests that
although the Academy of Painting differed from the *Maîtrise* in some funda-
mental ways, it actually held much in common with that mixed body. What
generally distinguished the two was that the Royal Academy did not demand
large fees for admission, and it did not deny painters or artists outside the
Academy the right to work. Hence it could claim to uphold the freedom to
practice the arts. At the same time, however, the Academy promoted a de facto
limitation of the right to practice by instituting a hierarchy among artists that
gave academicians a great advantage in receiving public and royal commissions
and attracting private patrons. The Academy, moreover, tried to ensure that
only academicians had the right to exhibit their work publicly. It was this latter
right, along with the right to pose the model, that they jealously guarded.
Drawing after the nude was essential to the successful practice of history
painting, and the right to pose the model was one of the most contested issues
between the two organizations. If the Royal Academy could secure the sole
right to this privilege, it would secure a privilege over history painting and the
prestige that accompanied the practice of the genre. Yet the very contesting
of privileges is redolent of territorial disputes between guilds. Never inter-
ested in free trade, the Academy, like the guilds, offered certain protections to
its members.

On several other counts the Academy functioned in a way similar to the
Maîtrise. It encouraged a long apprenticeship from students who learned their
trade in the studio of an established master and at the Academy schools. (Be-
fore its closing, the Académie de Saint-Luc also had a school for its students
as well as a gallery.) Like the *Maîtrise*, the Académie Royale asked for a mas-
terpiece, which it called a *morceau de réception*. Both institutions, like all other
guilds, gave preference to the sons of its members, and some consideration to
their daughters and widows. Although the Academy did not contain the vile
art dealers, as did the *Maîtrise*, it did admit the patrons of the arts, the major
buyers and collectors, as *amateurs honoraires* and *associés libres*. It was, of course,
convenient that the Academy declared the sale of one's own work not to be
commercial enterprise. Thus the Académie Royale was both fish and fowl—
partly honorific and partly commercial. Although this may have been, at least
to some extent, the nature of all honorific academies, d'Angiviller promoted
the myth of the Academy as a pure product mixed with neither craft nor
commerce.

The Academy functioned most like a guild in relation to national com-
mercial enterprise, and especially in terms of its position in the royal economy.
This position was an important issue in Parlement's opposition to Turgot's

disbanding of trade guilds. The "annoyances, fetters, and prohibitions" denounced by Turgot were, the parlementaires argued, responsible for the glory of French commerce:

> Why is France today commercially properous if this is not so? Why are foreign nations jealous of her? . . . Our merchandise is sought for its taste, its beauty, its finesse, its solidity; for the correctness of its design, the perfection of its execution, the quality of its raw materials. . . . Is it not more sensible to say that the guilds have aided commerce?[45]

In 1783, the year of Vigée-Lebrun's admission to the Academy, d'Angiviller's view of how the fine arts related to the monarchy's goals resonated with the parlementaires' 1776 response to Turgot. In his *Mémoire* on the admission of Vigée-Lebrun, d'Angiviller justified the statutes prohibiting commerce with this logic: "it is of the greatest importance to maintain a law that contributes to the glory of the arts, and it is of even greater importance to support them in a country where they are so useful and necessary for foreign commerce."[46] The irony, of course, is that artists must be free of the taint of commerce so that art can help the nation in its commercial competition with foreign powers. In this logic, the Academy substitutes for the guild as the regulator of the fine arts.

One final structural similarity is particularly interesting for my purposes. The acceptance of women moved the Académie Royale closer to the *Maîtrise* than to the other honorary academies (Académie française and Académie royale des sciences), which did not admit women. The admission of women bespoke a lowered status. In conjunction with this observation, consider that Mme de Coicy, in her 1785 *Les Femmes comme il convient de les voir*, anticipated what women know today: the higher the status of the occupation or institution, the more women are excluded. Her text surveys all the various professions of French society, showing how women were excluded from all but the lowest ones. She concluded that in agriculture, fabrication, and the trades women are equal in their functions to men, and although these ranks are considered the lowest, they are for women the most noble. Her argument plays on the meaning of "noble," especially in the changing ideology of labor. On the one hand, she defines noble according to an older paradigm in which those professions that require the least physical labor are the most "noble." On the other, she avails herself of a newer meaning, considering as noble what is most useful. Thus she can say that women in the "non-noble" ranks are the most "noble" (useful and productive), and conversely, that women are the least noble precisely when they do not work.[47] This nobility of the lower ranks, how-

ever, was just as imaginary as Rousseau's notion of woman's power. Mme de Coicy plays on the concept of nobility and idealizes work to dramatize the plight of the more well-to-do woman who would never change places with her sister in the leather apron.

It is clear that the fine arts, unlike letters, held an equivocal relation to the trades, commerce, and national commercial success. It is precisely because the Royal Academy shared so many characteristics with the *Maîtrise*, even filling the function of a guild in the royal economy, that academicians were so adamant about the difference between the two. Moreover, the presence of the *Maîtrise* further complicated social relations because there a mere craftsperson, a sign painter, for example, could conceivably acquire the skills that might allow him/her to claim the name of artist. Rancière has shown for the nineteenth century that the painter's guild was considered morally precarious precisely because it turned a worker's occupation into the means to flee the ig/noble condition of the laborer.[48]

A collective repression of the Academy's relationship to commerce and to guild practice accounts for the obsessive attention to the rule prohibiting commerce. Although the Academy found itself relieved of a problematic sister when the guilds were disbanded, by the summer of 1776 Turgot was dismissed and his reforms repealed in favor of a reorganized guild structure. Despite the reinstitution of the guilds, d'Angiviller's desire to see the emphatic separation of painting and sculpture from the crafts and commerce was satisfied. The Académie de Saint-Luc was reestablished, but its authority was limited. At the same time (1776), new statutes given to the Academy acknowledged that painting and sculpture were liberal arts on a par with letters and sciences, and would be free from the *Maîtrise* everywhere in the kingdom when "exercés d'une manière entièrement libérale." It is this granting of freedom that d'Angiviller points to in the *Mémoire* concerning Vigée-Lebrun and that he had inscribed on the seal of the academy: *Libertas artitas restituta.*[49]

Before continuing with my discussion, I would like to stress three points. First, the argument against the admission of Vigée-Lebrun, which in the official documents reads as an open-and-shut case, seems not to have been so. If we can accept the testimony of contemporary observers, there was contention within the ranks of the Academy over her suitability for admission, and her exclusion was not as self-evident as d'Angiviller made it appear. Grimm writes of the wrangling over her admission in reviewing the Salon of 1783:

> It is difficult to cast one's eyes over so many charming works by Madame Lebrun without recalling with irony all the torments, all the petty persecutions, which for a long time closed the door of the

Academy to her and which finally gave way only to the power of authority. The cause for so unfair an exclusion had no other explanation than the profession of her husband, one of our most famous painting dealers. The Academy found the interests of its body so essentially compromised by this circumstance that, in order to preserve itself from so dangerous an influence, it decided no longer to admit any woman, no matter how distinguished her talent and her works.[50]

Grimm's commentary suggests not only that Vigée-Lebrun's admission had for some time been a contentious issue, but also that the justifications given by an Academy reacting to an imagined threat, were neither fair nor reasonable. His conclusion implies that the "real" issue is the admission of women.

[handwritten margin note: ✳ threat of ♀ artists]

Second, this discussion focuses on d'Angiviller, who signed the documents and who was the most important shaper of the Academy in the late eighteenth century. In constructing his story, I stress his class biases, his deeply held commitment to raising the status of the fine arts, and, most importantly, the assumptions that he shared with his culture and class (and perhaps also the anxieties he privately experienced) about woman's nature. There is little evidence on his part of personal animosity directed toward Elisabeth Vigée-Lebrun—although he did not particularly trust her husband in his business dealings.[51] In her *Souvenirs*, Vigée-Lebrun writes sympathetically about the Director, who in 1789 purchased for his own collection one of her self-portraits, a work that at least superficially panders to the image of the happy mother.[52] On the other hand, there is not enough evidence to argue either for or against personal animosity. In dealing with other women artists, most notably Vallayer-Coster who conducted herself in a most modest and self effacing way, d'Angiviller was much more accommodating.[53] I am suggesting that Vigée-Lebrun particularly aroused his anxieties about women and his social elitism.

Finally, although d'Angiviller may not have held this particular woman in contempt, others in the Academy were likely to have been jealous and fearful of her. I cannot overemphasize the point that a woman holding the (official or unofficial) position as chief image-maker for the queen of France was unusual, if not unprecedented. Her special relation with the queen and the Court, her rapid ascendancy from more or less humble origins (daughter of a hairdresser and "second-rate" guild painter), her reputed beauty and social success, surely made Vigée-Lebrun a target. The Academy's first painter, Pierre, who, by all contemporary accounts had an enormous influence on the Director, may have been her particular enemy. In her *Souvenirs*, Vigée-Lebrun specifically says it was Pierre who did not want to admit women, and she holds him responsible

for barring her admission. She indicts his snobbism as she points out that he had the money to buy his way into certain circles, even though he was a mediocre artist. It would be an understatement to say that Pierre, from a rich family and himself ennobled by Louis XV, was always watchful of social position, and he may have been particularly annoyed to see a hairdresser's daughter presume to be the queen's painter. Writing to d'Angiviller to ask for changes in the regulation of the Ecole royale des élèves protégés, Pierre sets as a goal "to proscribe the vile masses who inundate the schools." The first two conditions of admission to the special school would be "to not be the son of a lackey and to have no sort of physical deformity."[54]

A Question of Etat

Keeping in mind, then, the play of the rule and the exception as well as the play of personal motivations, let us turn briefly to the Academy statutes of 1776. Although the new statutes are evoked again and again in the case of Vigée-Lebrun where they are claimed to be "most precise," there is actually nothing in them that directly pertains to her case. It is suggestive that specific terms and passages from the statutes make their way into the documents concerning the admission of Vigée-Lebrun, implying an easy passage from general rule to particular circumstance. In some instances, however, these echoes actually undermine the case for her exclusion and necessitate the addition of supplementary terms. Those terms, as I will argue, have strong connotative value and bring into the document an entire set of assumptions about women and their relation to the nobility of painting as a liberal art. More than the status of an art dealer's wife, what is at stake in these documents is the status of women as artists and the masculinity of the Academy. I will pursue these claims in different ways throughout the rest of this chapter.

Article 1 of the statutes claimed freedom for all those who practiced painting and sculpture in a liberal manner. Article 2 makes precise that a liberal manner (*libéralement*) means working in a genre that demands a knowledge of drawing and a study of nature. These genres were defined very broadly as historical subjects, portraits, landscapes, flower paintings, miniature paintings, and any that demands a talent meriting admission to the Royal Academy.[55] In short, the Academy determines which genres are or are not susceptible to liberal practice. The article added the very important stipulation that these genres must be practiced without any mix of commerce *(sans aucun mélange de commerce)*. The stipulation resonates with d'Angiviller's *Mémoire* in which the Director notes, in reference to Vigée-Lebrun, "It is said, and I believe it, that she does not mix in commerce."[56] I imagine from the wording of the comment

that someone or ones had pointed out to d'Angiviller that Vigée-Lebrun did not engage in commercial activities. Moreover, she pursued the art of portrait painting, which clearly fits the criterion of practicing her art "liberally."

The article that comes perhaps closest to disqualifying Vigée-Lebrun is number 34 of the statutes: "Any artist, member of the Academy, who does business selling paintings, drawings, materials and furnishings appropriate to the making of the arts, or puts himself in business with the sellers of second-hand goods, will be excluded from the Academy."[57] From this statute one can ask, did Vigée-Lebrun put herself in business with her husband when she married him? Is a spouse always a business partner? According to d'Angiviller's statement, she would have been a strange business partner, indeed, for he admits that she does not mix in commerce.[58] Rather than resolve the issue, this article—like Article 2—raises the Director's problem of reconciling her exclusion with the fact that she does not mix in commerce. Here is how d'Angiviller makes the case:

> The Lady *Le Brun (La Dame Le Brun)*, wife of an art dealer, is very talented and would have long ago been elected to the Academy were it not for the commerce of her husband. It is said, and I believe it, that she does not mix in commerce, but in France a wife has no other *état* than that of her husband.[59]

In France a wife has no other *état* than that of her husband. The comment is definite, presented as something that everybody knows. Certainly the Director cites no law here, which is in contradistinction to his insistent preoccupation with the laws forbidding commerce. Is the *état* of a wife, as this *Mémoire* states, always and only that of her husband? The issue is worth examining to explore the assumptions and attitudes that allowed it to be an argument at all. I have already suggested that certain terms used in d'Angiviller's *Mémoire* expose deeply held and unacknowledged attitudes toward women and their relation to the status of painting. *Etat* is perhaps the most loaded of these terms.

Etat is a slippery and multivalent term with several overlapping meanings. If we consider apart from its context d'Angiviller's statement that in France a wife has no *état* other than that of her husband, the statement is accurate only as far as *état* generally indicated social position, or the rank a family shares.[60] Rank was determined by the husband's position, so much so that a woman from a noble family lost her rank if she married a man without status, whereas a woman without status gained social rank if she married a nobleman. However, it is not that her husband has a specific social standing that disqualifies Vigée-Lebrun from the Academy (if he were a wine merchant, for example,

she would not be disqualified) but only that he has a specific occupation, that of art dealer. Thus, where it would make sense to say that in France a wife shared the social status of her husband, this meaning of *état* does not provide a reason for keeping Vigée-Lebrun out of the Academy.

In the context of d'Angiviller's *Mémoire*, *état* might be better translated as "occupation." Indeed, this was a common, everyday use of the term. In separating the definition of *état* in "langue usuelle" from that of "langue juridique," Marcel Planiol explained in his *Traité élémentaire de droit civil* that only in the first case did *état* refer to the different professions and functions, such as that of magistrate, merchant, or worker.[61] This meaning of *état* is among those that Marceline plays on in the *Marriage of Figaro*. She begins her ruminations on woman's fate by revealing how she had "fallen" (been seduced) and speculates on the lot of young women like herself. Lacking any honest means of subsistence, women are left with only one *état* or profession, that of prostitute:

> You ungrateful men, who stigmatize with your scorn the playthings of your passions—your victims! It's you who should be punished for the errors of our youth—you and your magistrates so proud of their right to judge us, who by their criminal carelessness snatch from us all honest means of subsistence. Is there only one profession (*état*) for unhappy girls?[62]

The speech resonates with Turgot's justifications for opening the guilds to women; women banned from guilds, from honest professions, were doomed to gain their living by immoral means, by "choosing" the profession of prostitute. That woman's sexuality and its disruptive potential were also considerations in Vigée-Lebrun's case is a point I reserve for the next chapter.[63]

D'Angiviller must have had a very precise use of *état* in mind, for what disqualifies Vigée-Lebrun is not that her husband is a merchant, but that the commodity he sells is painting. Moreover, d'Angiviller tries very hard in his *Mémoire* to establish rhetorically the identity between the specific professions of husband and wife. In that document he refers to Vigée-Lebrun as "La Dame Le Brun, femme d'un Marchand de tableaux," and calls her La Dame Le Brun, or Madame Le Brun throughout. This is, however, in pointed contrast to the Academy minutes that record the acceptance of Elisabeth Vigée-Lebrun. There the professions of husband and wife remain rhetorically separated. She is referred to as "la Demoiselle Louise Elisabeth Vigée, de Paris, Peintre, femme de Sieur Le Brun, Marchand de tableaux."[64]

Indeed, I would argue that the Academy's version, which assigns to the husband and wife two different *états*, is the more accurate. In France, a hus-

band and wife could theoretically have different professions. For example, in his *Traité de la puissance du mari sur la personne et les biens de la femme* (1770), Joseph Pothier discusses, the "femme, marchande publique." This name designates a wife who has a business other than and entirely separated from that of her husband. She can act in her business without his permission and is more independent than the wife of a merchant who, although she mixes in her husband's commerce, cannot act without his authorization.[65] Moreover, in 1783 it was possible for a wife to belong to a different guild than that of her husband, since the reorganization of trade guilds in September of 1776 extended the rights of entry to women.[66] Even before this reorganization, certain companies were given over to women, for example, the flowermakers, linen makers, seamstresses, and merchants of fashionable clothing. The research of historians Daryl Hafter and Michael Sonenscher has shown that in Paris and Rouen women were indeed guild members, and often enjoyed the same rights and privileges as their male counterparts.[67] Given his class biases, the Comte d'Angiviller may not have even considered women of this social category when he made his pronouncement. As we know from Mme de Coicy's text, it makes sense to say that a woman has no *état* (profession) except that of her husband in referring to households of the affluent and professional classes where women did not ordinarily work.

D'Angiviller's statement is particularly interesting because it only makes sense outside the specific context in which he is using it. Taking advantage of the slippage between the meanings of *état* as social status and *état* as profession, the Director works something of a substitution. In the case of Vigée-Lebrun entering the Academy, it hardly matters that a woman has no other social standing than that of her husband, because it is her profession, not her social standing, that is at issue here. Academy statutes forbade artists from engaging in commerce; they did not specify from what *état* artists were to come.

The term, however, carries other associations that open onto d'Angiviller's attitudes and anxieties about the nobility of painting. In *ancien-régime* France, *état* signified *estate* and referred to the traditional division of society into three orders, or estates, one of which labored (the third estate) and two of which did not (the clergy and the nobility). For the purposes of this division commerce was considered as labor, and it was *dérogeant* for nobles to engage in commercial enterprise. The proscription against commerce/labor encodes some of the deepest-held assumptions about women and the feminine as related to work, status, and the law. The entry of any woman, I would suggest, was problematic for preserving the liberal or noble status of the arts. But especially problematic was the entry of Elisabeth Vigée-Lebrun, a painter who

was the wife of an art dealer, the daughter of a guild painter, a former member of the guild, a maker of portraits, and a woman.

The notion of liberal or noble art is obviously related to *état* in its meaning of estate. The liberal arts, like the noble estates, were those most distanced from labor, whose productions pertained more to the mind than to the hand (or body).[68] There was no dignity to labor in the *ancien régime*. Sewell claims that in the nineteenth century the word *travail* (labor) connoted productivity and even creativity, but that earlier it carried the Christian associations of pain, burden, and penitence.[69] These are the same ideas that Christianity associated with the expulsion from Eden, which doomed man to work and woman to bear the pain of labor, of childbirth. Sewell writes:

> It was the curse of Adam to labor in the sweat of his brow for his daily bread and of Eve to bear children in labor. Adam's fate was thus precisely parallel to Eve's: to sustain the human species through painful, exhausting and unreflective effort of the body, through pure animal exertion. In the Christian scheme of things labor was a badge of vileness, the proof of and the punishment for man's original sin. It was not an ennobling activity but a mark of man's fallen nature, of his abject humility before God.[70]

At some level, commerce (as labor) was the mark of Eve, the woman who first broke the law of the Father. These attitudes, rooted as they were in religious belief and in a desire to maintain the traditional *état*, were very much those of d'Angiviller, who defended religion against the atheist philosophes, believed that art should glorify and serve the interests of the monarchy, and insisted that the noble liberal arts had to be distinctly separated from tainted commerce and labor.

The question of labor and childbirth raises the point that in the "new" social ideology formulated in the second half of the eighteenth century, the *état* proper to woman was motherhood. Rousseau writes in *Emile* that "to assert vaguely that the two sexes are equal and their duties the same, is to lose oneself in useless phrases. This is not a solid way of reasoning to give exceptions in response to laws so firmly established. Women, you say, are not always bearing children. No they are not; yet that is their proper business."[71] Continuing his logic of arguing the general law against the exception, Rousseau admits that there are places that women have few children, but asks the rhetorical question: "Is it any the less a woman's business *(état)* to be a mother?"[72] In practicing as a painter, Vigée-Lebrun abandoned her natural *état*. This notion of a woman's *état* would argue that the *état* of any woman was different from that of her husband, and invalidate d'Angiviller's ostensible argument

D

while supporting his less obvious one. Despite Rousseau's valorizing (could one say ennobling?) of motherhood, the idea that bearing children (being in labor) was woman's business emphasizes the connection between woman and degrading labor derived from Christian theology and implicit in d'Angiviller's text.

In this context it is important to note that where *état* could mean social standing or profession in common usage, in juridical use *état* signified a person's particular position in a network of familial and legal relationships, with each *état* having specific rights, duties, powers, and obligations under the law. Littré defines *état* as a term of jurisprudence:

> State of persons, the totality of the legal conditions of a person, of his rights and obligations. Characteristic by reason of which a person exercises a right or fulfills an obligation. State (*état*) of minority, of married woman. Civil Status (*Etat civil*), condition of a person deriving from the acts that constitute the associations of descendence, marriage and other facts of civil life.[73]

In this sense, to say that a woman has no *état* except that of her husband is meaningless, since the *état* of a wife and the *état* of a husband were two very different situations, as the entry in the *Encyclopédie* demonstrates. There the "état d'une femme" is defined as "the situation of a woman under the power of her husband."[74] It is this concept of *état*, of the status of being a wife/woman, that Mme du Châtelet evokes in her *Réflexions sur le Bonheur* (1761), in which she argues that because of their legal position in society, men have an infinite number of resources that women lack. In particular, they have many ways to arrive at *"gloire,"* for example, as soldiers or rulers or officials. "But women/wives," she continues, "are excluded by their station (*état*) from all kinds of glory. If it happens by chance that a woman is born with a keen wit (*esprit*), there is only study (*l'étude*) to console her for all the exclusions and all the dependencies to which she finds herself condemned by virtue of her station."[75] The study and writing allowed (privileged) women, however, are not of the same order as the profession sought by Vigée-Lebrun. Study and writing could be done in the privacy of the home. Vigée-Lebrun sought her *gloire* in a way not appropriate to her *état*, by trying to be a great artist and competing in public arenas, in particular, the Salon and Academy.

The juridical notion of a wife's *état*, however, has everything to do with the issue(s) the Director raises in conjunction with Vigée-Lebrun. The state of a wife was the state of being not free, of being subjected. The marriage contract placed a woman's person and assets under the legal and absolute control of her husband.[76] Pothier's 1770 treatise on the privileges of married men

summarizes the longstanding principle succinctly: the husband has "by natural law the inalienable right to demand from [his wife] all the duties of an inferior to a superior."[77] Those who believed in the natural inequality of the sexes on which the juridical notion of a wife's *état* was based, also found a persuasive spokesman in the master rhetorician Jean-Jacques Rousseau, who argued that civil order and moral good depended on the rights of husbands over wives. To summarize Rousseau's position broadly: A perpetual source of disorder, women must be subjected either to a man or to the judgments of men.[78]

Although there is no "real" connection between practicing an art "liberalement" and being "libre," women carried not only the stigma of labor, but also the stigma of being subjugated, of being not-free individuals. It is this aspect of woman's *état* that Irigaray has highlighted in *The Speculum of the Other Woman,* in which she follows Engels in arguing that a woman was possessed by the family head as an instrument of production.[79] Drawn up between father and husband, a marriage contract was implicitly a work contract, as well as a purchase agreement for the wife's body and sex. Carole Pateman's compelling analysis of contract theory, moreover, shows how the political rights claimed by men rested on a prior, but hidden, conjugal right over women.[80] A woman is thus herself an instrument of production, a laboring thing, and a commodity exchanged in a contract drawn up between father and husband. How could such a subjected being produce a noble art? Of course it was, in practice, possible, but it is not at this practical level that I am speaking. Theoretically a woman was foreign to the academic body because her *état* made her a lesser being subjugated and infantilized by the laws of France. She had no social status of her own, but assumed that of her father or husband. The general discomfort with allowing women into the Academy plays into the documents concerning the specific case of Elisabeth Vigée-Lebrun, and that discomfort can be read in d'Angiviller's appeals to a woman's *état*.

It is important to note, however, that ideas about the natural foundation for the legal (or contractual) subjugation of women did not go uncontested in eighteenth-century France. Challenges to the idea that natural law ensured and justified women's subjugation appeared on many fronts and proceeded from several rationales. The most subversive of these, as David Williams has pointed out, questioned the authority and interpretation of natural law and brought into focus the more "dazzling corollary: the ephemeral nature of social structures *per se*."[81] In this view, the subjugation of women was not a necessary fact of natural law, but the product of social convention. Those who held this view also maintained that if the subjugation of women had any basis in nature, that basis was in men's abuse of their superior physical strength. Indeed, for many the fundamental natural law was the equality of all persons,

and men violated this law by inventing social systems that enslaved women. D'Holbach's 1773 essay, "Des Femmes," for example, establishes a parallel between the open (physical) subjugation of women practised in so-called un-civilized societies and the equally uncompromising, but more hidden tyranny established in western Europe. In the latter case, the legal system supported the abuse.[82]

In regard to their own statutes and practices, the Academy was in a murky area in opposing the admission of Elisabeth Vigée-Lebrun. When d'Angiviller (or his advisors) decided to invoke the *état* of the husband to keep Vigée-Lebrun out of the Academy, it was a judgment call, as there was no obvious rule that forbade her entry. There is no citing of a specific statute in the case of Vigée-Lebrun, which suggests concerns beyond the mere enforcing of the rules. This point is clarified by turning to another alleged violation of the statute concerning commerce. The *Procès-verbaux* entry for 4 November 1780 records the reading of a letter from d'Angiviller to Pierre concerning the rumor that one M. Martin, *agréé*, was a dealer in paintings. An entry dated 25 November 1780 is notable for its specificity, as it refers to "M. Martin, History Painter, *agréé*, suspected of engaging in the commerce of paintings prohibited by Article 34 of the statutes of 1777." Despite d'Angiviller's fears, the academicians found no basis for the allegations and took no action against Martin.[83]

In its discussion of women (which includes more than the declaration of Vigée-Lebrun's legal status) the Academy record is not neutral. The acade-micians do not simply state the way things are; they choose to invoke a set of legal principles (which may or may not apply) and thereby take a position in an ongoing debate. To preserve the Academy from the taint of labor, the law against commerce had to be upheld in all its "force," as the documents con-cerning the admission of Vigée-Lebrun remind us. Force is an interesting term because it was taken as a masculine quality; God, after all, gave men (and not women) both physical force and the force of reason. In this context, pre-serving the statutes in all their force can be read as preserving the statutes in all their masculinity. No exception could be made, at least in d'Angiviller's mind, to the rule of a wife's *état*. No woman could be excepted from these strictures, since, at least for those who accepted them, they were based in natu-ral law. To allow Vigée-Lebrun's admission to the Academy, an "exception" was made to the law governing commerce among artists. Considering the enormous investment d'Angiviller had in keeping *this* rule, the decision to break it is most suggestive.

In the case of Vigée-Lebrun, there was something more than her associa-tion with an art dealer that disqualified her for membership in the Academy,

and that was her *état* as a *femme* (wife and woman), as a creature already marked as the body, as labor, as subjugated to another. The case of the academician Ménageot, whose father was an art dealer, highlights Vigée-Lebrun's position. At least until 1776, Ménageot lived with his father on the rue Saint-Thomas-du-Louvre.[84] There was in the 1770s a basis for arguing that the *état* of a son (especially an unmarried son in his minority) was that of his father. Yet, there was no problem with accepting Ménageot as an Academy student, or with awarding him the Rome Prize in 1766. His father's profession did not prevent the academicians from making him one of their protected students at the Ecole royale. In 1769, Louis Michel Van Loo showed at the Salon a portrait noted in contemporary journals as: "Ménageau, grand marchand de tableaux, dont le fils est actuellement à l'Ecole des Elévès Protégés."[85] From the painting's description, it is not clear if it is an honor to be the father of an Academy student or to be the son of a great art dealer. Not only was there no problem with Ménageot's admission as *agréé* in 1777, and as academician in 1780, but he was later favored by d'Angiviller, who gave him an atelier in the Louvre and made him director of the French Academy at Rome. Ménageot, however, was not a portrait painter, but a history painter, and so he practiced the "noble" genre.

To return one final time to the intersection of the documents surrounding Vigée-Lebrun's admission and the Academy rules, consider Article 3, which defined those excluded for not practicing the arts freely as those who "wish to hold an open shop; to make a business selling paintings, drawings, sculptures that are not their own work; to sell the paints, gilt, and other accessories of the arts of painting and sculpture; or, finally, who meddle, *be it directly or indirectly* in the business of painting or sculpture for buildings, or other works of this type, capable of being valued and paid for by the yard."[86] Now here is an interesting displacement. In the case of Vigée-Lebrun, the phrase *soit directement, soit indirectement* appears in both the *Mémoire* to the king and the letter to Pierre, where it is used to suggest that artists may not directly or indirectly participate in the (re)sale of paintings.[87] Although taken alone this wording might imply that the marital relationship constitutes an indirect participation in commerce for Vigée-Lebrun, in the statutes the phrase appears in relation to those who mix in making painting or sculpture "capable of being valued and paid for by the yard." In other words, those who practice art as a trade rather than as a free and noble profession. This sort of mixing is redolent of d'Angiviller's earlier disdain for mixing mere craftspersons with Michelangelo and Zeuxis. The displacement perhaps betrays a belief that the works Vigée-Lebrun made were more articles of commerce than of the noble and liberal art of painting. The Academy wanted all genres of painting and sculp-

ture to come under the heading of liberal arts, and hence within its purview. Yet, we know that society portraits in particular came under fire from reform-minded critics and academicians at mid-century, and their makers were chastised because the art form assured commercial success.[88] If d'Angiviller's project outside the Academy was to set up all painting as a liberal art, inside the Academy it was to reform and promote history painting. Betrayed by the displacement of a phrase, this second goal motivated d'Angiviller as strongly as his desire to save the fine arts from the stain of commerce.

A Modern Colbert?

1783 was an important year in d'Angiviller's scheme to revitalize history painting and reburnish the *gloire* of the French school. For several years he had planned to establish a museum in which there would be a place to display the *patrimoine*. This museum, as Andrew McClellan has written, was at the heart of the Director's plans both to return French art to the grand tradition and to demonstrate the superiority of the French school.[89] His scheme to transform the Louvre into the world's most imposing museum seems oddly prescient of the 1990s when the Louvre, already far surpassing d'Angiviller's wildest imaginings, saw its exhibition space increase dramatically. Especially favored in this expansion were paintings from the French school. Like France's more recent cultural ministers, d'Angiviller had an aggressive personal identification with the museum project, which would, not incidentally, afford him a modicum of *gloire*.

The financial outlays for the War of American Independence forced d'Angiviller to curb his ambitions, and all acquisitions of painting were suspended between 1778 and 1782.[90] Eventually peace brought abundance back to the arts, and in 1783 the king promised the Bâtiments an impressive 13 million livres spread out over six years. At the Salon of 1783, d'Angiviller's ambitions were touted by Lagrenée le jeune in his *Immortality Receiving a Portrait of the Director General from Painting, Justice and Charity;* several sculptors exhibited works from the series of the "grands hommes" commissioned by d'Angiviller; and history painters responded to his calls for reform. Salon criticism that year took note of the modern Colbert's ambitions. The anonymous author of *Observations générales sur le Sallon de 1783 et sur l'état des arts en France,* for example, was particularly sympathetic to d'Angiviller's cultural politics, and perceived that the French School was in a most happy "revolution" led by young painters returning to the "style of the great masters, the prudence of their compositions, the tone of their colors." All this, he argued, promised France artists truly worthy of her.[91] For this author, as for d'Angi-

viller, revolution is both a return to the masters and a turning away from the "little genres" that precipitated the decline. This decline the critic explains through logic particularly fraught with implications in the year the Academy accepted an art dealer's wife whose paintings reminded many of the Flemish school:

> Led astray by the charlatanism of the art dealers and the depraved taste of the amateurs, we disdained the great history paintings . . . we scarcely glanced at the most beautiful compositions of Poussin, of Le Sueur, and did not blush to waste, at the same time, our admiration on a cabaret scene and a Flemish *bambochade*. [92]

Although the machinations of unscrupulous dealer-charlatans and the depraved taste of false amateurs led to a disdain for history painting, the Bâtiments du Roi, the critic assures us, will correct these errors and make art speak the national interest and glory: "The history paintings commissioned for the King for several years now have returned us to the taste for the beautiful and have established it among us. Such has always been the effects of great encouragements. It is by them that the arts are reborn and elevate themselves to the degree that they can represent a Nation." [93]

This critic, moreover, also takes aim at d'Angiviller's favorite target, the painter's guild. He writes that, despite the example of Italy, despite the honors that French kings accorded Leonardo and Primaticcio, "The glaziers and painters formed a single corporation in France. The art of the one we scarcely distinguished from the craft of the other." [94] Yet, amid this sort of barbarism and prejudice, Louis XIV crowned the arts in the splendor of his reign. This argument gives on to the parallel that drives the discussion: the Comte d'Angiviller has also imagined all the best ways to encourage the arts and his is the only ministry "until the present that one can cite with that of Colbert." [95]

Other critics expressed similar sentiments on the revival of history painting, and one who called himself "Coup de Patte" will be increasingly important in my story. In his pamphlet of 1783, entitled *The Triumvirate of the Arts*, he argues that the "public" has become tired of the simpering *(read, rococo)* genres and now applauds instead the efforts of Ménageot, Vincent, David, and Renaud, who attempt to restore the antique: "Here are the men who, embellishing each Salon with their works, have made it a gallery worthy of attracting the crowd." [96] He goes on to say that the Academy previously demanded servile imitation, but now *(read, under d'Angiviller)* genius is recognized and the arts flourish. What is particularly interesting about Coup de Patte is that his reformist thinking about the arts is joined with an admiration for Rousseau. The beautiful, Coup de Patte argues, cannot be learned in the ateliers, nor is it

transmitted in painters' conversation. The beautiful pertains only to a *knowledge of the human heart*, and it is found in the writings of the "moralistes sincères": Montaigne and Fénelon in the past, and in the present Jean-Jacques Rousseau.[97] This dovetailing of Rousseauism with reformist zeal expressed as a desire to elevate history painting is also found in the writings of d'Angiviller, who in his memoirs noted that Rousseau painted virtue "with fiery features and with the most profound, the most communicative, and the most engaging sensibility."[98] About *La Nouvelle Heloïse*, the Director wrote: "Do you not sense in reading this work a certain sweet and heady scent of virtue?"[99] And addressing his comments to the writer Marmontel, d'Angiviller claims with true Rousseauian fervor: "Posterity will read your works, those of Diderot, and those of this unfortunate one [Rousseau]. And it will judge you not on your passions of a day, not on your social interests, not on the prejudices of your century, but according to the eternal truth. . . . The sentiment of the true breathes in [Rousseau's] writings and makes itself felt there with such liveliness and animation that it takes possession of you, seizes you, and transports you so that it is impossible for you to escape its dominion."[100] The Director reserves his strongest applause, however, for Rousseau's view of morality, and sees that "the contemplation of patriarchal and rustic morals, of these robust virtues marching with a firm and straight step in the path of nature, has given his eyes a brilliance more pure than the discursive and reasoned virtues that waste themselves in words and are not translated into actions."[101] Rousseau based his notion of patriarchal morals on Roman models of the father's power, which he claimed contained the truth of nature.

I want to emphasize here a familiar complex of ideas that emerges in 1783 not only in the case of Elisabeth Vigée-Lebrun's admission to the Academy, but also in the Salon commentaries of that year, and especially in those that herald d'Angiviller as the new Colbert.[102] A glorification of the *patrimoine*; an embracing of Rousseauian ideals of morality, gender, and paternal authority; a reassertion of art's nobility; and a rejection of the feminine (symbolized by the rococo style, the "little genres," and commodified art)—these are basic to the reform of painting and return to antiquity pushed by d'Angiviller and like-minded critics. This reform went hand in hand with attempts in the broader culture to shore up the paternal position and to ensure respect for the father's law (which demanded woman's return to maternal concerns). These point to coping with a cultural crisis in male authority, a crisis which, although largely imagined, was partly provoked by women like Elisabeth Vigée-Lebrun and Marie-Antoinette.[103]

I suspect that in 1783 d'Angiviller's attachment to the patriarchal values of traditional France was quite obvious. That much one can speculate from

the rhetorical strategy used by Labille-Guiard in rallying the Director's support for suppressing libelous pamphlets aimed against her.[104] What she chooses to stress is the effect of the calumny on her eighty-one-year-old father, who would die of sorrow if he knew her morals were impugned. (Usually, as we shall see, it is the daughter who dies of the father's sorrow!) For herself, she would not be sensitive to this scandal, but:

> I am in despair when I think about my father, about the effect that this will produce on him. One must expect to be torn apart for one's talents; the savants, the authors are exposed to the same sorts of satires. It is the fate of those who open themselves to public judgment. Yet their works, their paintings are there to justify them. If they are good, they will plead the cause. Who can plead that of women's morals?[105]

Labille-Guiard's invoking of the father's shame at the daughter's disgrace interacts with commentaries on the father-daughter themes represented at the Salon of 1783.

Consider, for example, Coup de Patte's review of Brenet's *Virginius Stabbing His Daughter* (1783; Nantes, Musée des Beaux-Arts), a painting commissioned by the Bâtiments du Roi. The subject is drawn from Roman history and represents the moment when Virginius, seeing his daughter about to become the concubine of the unscrupulous magistrate Appius, seizes a knife and cries out: "Here is the only way to save your honor and freedom!" Coup de Patte panned Brenet's picture only to reimagine the scene from the father's position:

> I see the unfortunate father give the mortal blow to his daughter as he says, "Die, Virginia, free and pure." Or even raising against Appius his bloody sword and crying out, "It is by this blood that I condemn your head to the infernal gods! A terrible exorcism after which the people dare charge themselves to the vengeance of the gods."[106]

Coup de Patte criticizes Brenet for not bringing out the specificity of the father's emotional conflict, but he does not give a thought to what the daughter might be feeling, and finds only that Brenet has not made her seem desirable enough to be the object of Appius's erotic schemes. The psychic drama is entirely within and between men.

Another critic travesties the painting in a particularly revealing way. In the pamphlet *Momus at the Salon*, a painter and a "marquise en chemise" stand before Brenet's image. The marquise finds the subject "frightening" and sings:

> My little heart at each instant sighs:
> What a Father! O Gods! is he a ferocious monster,
> Who stabs his daughter with his own hand?
> This action is barbarous, atrocious.
> Was there ever a more inhuman father? [107]

The painter answers,

> Madame, alas! restrain yourself please.
> He must do it to save her honor.
> Ah, look at how he grimaces!
> That tells you he shivers with horror.[108]

With the motive explained, the marquise concludes, not without irony: "The reason seems very good to me. / He is a little naughty, but we will excuse him."[109] She goes on to contrast the father forgiven for killing his daughter (he is only a little naughty), to the painter whose crime is much worse—abandoning his project to make her portrait, a project that emerges as an excuse for seduction. The "marquise en chemise," obeys modern morality; she obviously has no virtue to lose. But the commentary cuts both ways, for the justification of the daughter's murder, the sympathy for the father's plight, and any approval of his actions are made to seem ridiculous. Nevertheless, the painter in *Momus* speaks quite directly the moral message that viewers were "supposed" to receive from the image. The marquise, on the other hand, is incapable of identifying with the father's position and hence incapable either of contemplating those "patriarchal and rustic morals" or "marching with a firm and straight step in the path of nature." Indeed from her point of view the father is unnatural, a monster—but then what does she know of honor?

In the Salon writing we find tied together the reestablishing of a viable patriarchy and the return to the grand tradition. *Gloire* must be given back to the father/king through the strengthening of history painting. Despite d'Angiviller's plans and critics' attitudes, at the Salon of 1783 a woman stole the show, as was suggested in the *Mémoires secrets*, a journal hostile to Elisabeth Vigée-Lebrun throughout the 1780s. The review notes that despite the abundance of history painting, despite the numerous masters vying in the "grand genre," who would believe that a woman carries the palm? Implicitly referring to works by Vigée-Lebrun such as *Peace Bringing Back Abundance* (figure 16), the writer assures his readers that there is not more genius in a painting of two or three figures than in a vast composition of six or twelve persons of natural size. Nor is there more thought in a painting based on a simple idea than in one whose complexity makes it equal to an entire poem. Rather, he says, he

means only that the work of the Modern Minerva attracts the spectators' attention, calls them back unceasingly, and elicits from them the exclamations of pleasure and admiration that artists ardently desire. The writer goes on to say that the paintings he describes are the most highly praised; they are spoken of at Court, at suppers in town, in "les cercles," even in the ateliers. Arriving at the Salon everyone asks: Have you seen Madame Lebrun? What do you think of Madame Lebrun? "And at the same time the response is implied: Is she not an astonishing woman this Madame Lebrun? Such is the name, Messieurs, of the woman that I have seen become so famous in so short a time."[110] That astonishing woman posed much more than an imagined threat to the purity of the male academic body. She posed the real threat of usurping its *gloire*, its position, its commissions. It is this real threat that the *Mémoires secrets* maliciously record in immodestly exhibiting the triumph of one exceptional woman.

FOUR

The Im/modesty of Their Sex:
The Woman's Gaze and the
Female History Painter

Fallen to the Distaff Side

Whatever else might be said about the Salon of 1783, there is no doubt that the women who exhibited paintings there garnered a good deal of attention in the press and pamphlet literature. Some of that attention was positive, some negative, and some downright libelous. No journal, however, made the Salon's ironies more obvious than the *Mémoires secrets*, which showed that in the face of d'Angiviller's support for history painting, "the scepter of Apollo had fallen to the distaff side and a woman had carried the palm" (24:3). I noted at the end of the last chapter that the reviewer strays into pointed overstatement in touting Vigée-Lebrun's triumph. Although on the one hand public recognition enhanced a woman's career, on the other, too much notoriety made her a target for gossips and slanderers. Only a thoroughly immodest woman would be pleased to have her name on every tongue. Especially after Rousseau had reminded her that the ancients had a great respect for women but showed it by not exposing them to public judgment: "They had as their maxim that the country where morals were purest was the one where one spoke the least about women, and that the most honorable woman was the one about whom the least was said."[1] What would the ancients have made of the incessant talk about Vigée-Lebrun highlighted in the *Mémoires secrets*?

The gaze of the ancients by no means dissuaded this modern woman, who attempted to prove that she could be "useful to the progress of the arts." The last phrase is d'Angiviller's, and it comes, not surprisingly, from his *Mémoire* concerning Vigée-Lebrun's admission. I have extracted the phrase from the Director's justification for limiting the number of women to four, and the irony captured in the *Mémoires secrets* is best appreciated in light of that justification: "this number is sufficient to honor their talent; women cannot be useful to the progress of the arts because the modesty of their sex forbids them

from being able to study after nature and in the public school established and founded by your Majesty."[2] What d'Angiviller means by the progress of the arts is, of course, the progress of history painting. By presenting herself at Academy and Salon as a history painter, Elisabeth Vigée-Lebrun, intentionally or not, challenged the Director's logic.

It has been more than two decades since Linda Nochlin argued in her groundbreaking work that women were excluded from the highest achievements in painting because they could not receive the necessary training.[3] Not only does her point seem fully justified by d'Angiviller's statement, but her argument recapitulates an eighteenth-century feminist position: lack of education, not lack of natural faculties, explained why women had contributed little to cultural development.[4] In the visual arts, women were excluded from two learning situations—drawing after nature and attending the Academy school. Modesty dictated that women not look at the nude male body, which is what study after nature means in this context. Posing the male model was the only life drawing sanctioned in the Academy, and the practice was basic to d'Angiviller's conception of history paintings as subjects depicting the male body in heroic action. Because women could not paint these sorts of elevating subjects, the sorts d'Angiviller believed would revitalize the highest genre, they could not be "useful to the progress of the arts."

Modesty kept women from other aspects of artistic education, as well. They could not attend schools like the Ecole Royale des Elèves Protégés, where aspiring artists not only learned the finer points of practice, but also acquired intellectual knowledge in subjects thought essential to history painting: geography, history, literature, anatomy, and perspective. This exclusion exemplifies the general situation in France where young men and women were educated separately and learned different kinds of subjects and skills thought "convenable" to their sex. Woman's modesty prohibited women from occupying the same learning space as men, and it also forbade them from learning the same subjects. As we saw in the first chapter, intellectual work was deemed dangerous for women, because it could damage their health and, most frightening of all, impair their reproductive capacities.

Modesty and the Rites of Refusal

In his *Mémoire*, d'Angiviller limits a woman's cultural role by invoking the modesty of her *sexe*, a term referring both to the category of woman and to the vagina. The Director's assumptions about woman's modesty are unsurprising given his particular sympathy for family values and the widespread embracing of a Rousseauian discourse on women in the latter part of the eigh-

teenth century.[5] In that discourse, modesty functioned within what Sarah Kofman has analyzed as the grasp of respect, a grasp that held women in a tight and restricted circle. Part of modesty's particular hold was its perceived "naturalness," which allowed it to function as an effective regulator of the social relations between men and women.[6]

In his *Lettre à Mr. D'Alembert sur les spectacles* (1758), Rousseau "proves" modesty's naturalness by relating it to the economy of the sex act and invoking the most conventional philosophical notions of sexual difference. Because man is strong and active, and woman weak and passive, he sees that the union of the sexes depends on attack and defense.[7] What would become of the human race, Rousseau asks, if the positions were reversed, if women were on top? Such a reversal would be disastrous because the success of the sex act depends on male arousal. If women were the attackers they might choose times when victory would be impossible, or leave the assailed in peace when he "needs" to be vanquished, or pursue him when he is "too weak to succumb."[8] If women were the attackers (that is, those on whose *will* sex depended), the will and the power to have sex would be disjoint, which assumes that power is located in male sexuality, in the power of having an erection. One can gauge the staying power of Rousseau's argument by turning to the fifth memoir of Cabanis's 1805 treatise *Rapports du physique et du moral de l'homme* (On the Relations between the Physical and Moral Aspects of Man). There the physiologist singles out this passage from Rousseau, explaining how Rousseau has very well shown that to ensure the perpetuation of the species, "the man must attack and the woman must defend herself. The man must choose the moments at which the need for attack makes itself felt, at which this very need ensures success."[9] Rousseau, moreover, proves what Cabanis calls the law of nature: that the man must be strong, the woman weak. The physiologist concludes, "From this first difference relative to the particular aim of each of the two sexes, which is directly determined by the constitution, derives the difference between their inclinations and their habits."[10]

Central to woman's inclinations was modesty. For Rousseau, modesty compensated woman for her physical and moral weakness, and he cast modesty as what nature gave women because they lacked the penis, guarantor of power in the sex act. Modesty is woman's willpower and armament in the war between the sexes: true modesty ensures she can withhold when she must, and feigned modesty—and here Rousseau finds a moral use for the artifice of women, which he ordinarily condemns—enflames male desire, or more appropriately, the husband's desire.[11] Modesty, moreover, is both natural and artificial. In *Emile*, Rousseau posits that women in society have unlimited passions but no instinctual curb. So God, he supposes, gives them modesty.[12]

Modesty supplements nature and takes the place of the natural restraint be-
longing to female animals and women in the state of nature.[13] But Rousseau
also insists it is natural, God-given, and where women are given modesty, men
receive a far more useful, powerful, and effective curb—reason:

> The Supreme Being has deigned to do honor to the human race; in
> giving man boundless passions, he has given them at the same time a
> law to rule them, so that man can be free and self-controlled; in free-
> ing man to these immoderate passions he also endowed him with rea-
> son to control them. Woman is also given to boundless desires; God
> has joined modesty to these desires to restrain them.[14]

As a control for their passions, men receive the gift necessary for cultural pro-
duction; women, on the other hand, are endowed with the restraint that will
effectively bar them from it. Having a penis, having power, and having reason
go hand in hand in this logic of sexual difference.

Here again we can see that eighteenth-century natural philosophy and
twentieth-century psychoanalytic theory are covering the same ground. In his
essay on femininity, Freud also theorized modesty, or shame, as both conven-
tional and natural: "shame, which is considered to be a feminine characteristic
par excellence but is far more a matter of convention than might be supposed,
has as its purpose, . . . concealment of genital deficiency."[15] In Freud's psycho-
analytic narrative, however, modesty is all tied up with the castration complex,
out of which men develop a superego that controls behavior *and* directs cul-
tural production. In Lacan's rereading of Freud, he gives a similar function to
the little boy's internalization of and identification with the No/Name of the
Father. Having no explicit theory through which to explain man's acquisition
of reason, Rousseau simply hypothesizes man has it because God gave it to
him (but not to woman). God's divine wisdom thus justified man's monopoliz-
ing of intellectual life, public service, and cultural production.

Separate but Equal?

For Rousseau, two related premises followed from a woman's modesty: the
restriction of women to the home and the segregation of the sexes.[16] In his
Lettre à Mr. D'Alembert, Rousseau warns against the social corruption that
follows from immodest women finding their pleasures outside the home, in
society. He likens these women to actresses who choose "an occupation whose
only goal is to show themselves off in public, and what's worse, to show them-
selves for money."[17] Pressing the implicit comparison of actress and prosti-

tute, Rousseau asks: "Does one even need to discuss the different morals of the sexes to sense how unlikely it is that the one who puts herself for sale in performance would not soon put herself for sale in person and never let herself be tempted to satisfy desires that she takes so much effort to excite?"[18] As the paradigmatic immodest woman, the actress not only disgraces herself, she corrupts men—the men who watch her and the men who work with her as actors.[19] In conceptualizing the actor, Rousseau also describes him in terms applicable to the prostitute: he counterfeits himself, he performs for money, he engages in a servile and base traffic in himself. His profession emasculates him, for the actor is fit for all roles except the most noble one, that of man.[20] Yet the actor, despite his ignoble profession, is not fully corrupted, and Rousseau insists that his downfall is precipitated by the immorality of his female counterpart: "After what I have just said, I need not, I believe, explain further how the unruliness of actresses leads to that of actors; especially in a profession which forces them to live in the greatest familiarity with one another."[21]

Rousseau likens to the immodest actress women who attend the theater to enjoy the decadent pleasures of self-display. The society that encourages such public display encourages the vices of the *toilette*, of artifice, of makeup, and worse. A woman who shows herself off in public disgraces herself, and she is corrupted by seeking men's looks. For the married woman especially, public display suggests sexual immorality; for why, Rousseau asks, would she desire the admiration of men other than her husband? The decent woman seeks only one man's gaze. Rousseau elides the difference between being looked at and being possessed sexually. It is not just that one leads to the other; they are nearly the same thing. The indecent woman goes to the theater to see and be seen, and in the public context both looking and being looked at are transgressions of modesty.[22] Rousseau concludes that,

> there are no good morals for women outside of a withdrawn and domestic life; . . . that the peaceful care of the family and the home are their lot, that the dignity of their sex is in its modesty, that shame and chastity are inseparable from decency for them, that to seek after men's looks is already to allow themselves to be corrupted by them, and that every woman who shows herself off disgraces herself.[23]

In addition to closeting women within domestic spaces, Rousseau's writings also advocated the strict separation of men and women that followed from this logic. Sarah Kofman sees this separation idealized in *La Nouvelle Heloïse*, at Clarens, where occupations, duties, even amusements are distributed according to the inclinations proper to the sexes.[24] Kofman argues that

Rousseau avoids all suggestion of resemblance between men and women, and she writes with some irony: "If a man comes to like dairy products and sugar, a woman to lose her taste for them and prefer that of wine, it's a catastrophe."[25] When the diverse tastes come to confound one another, for Rousseau it is a nearly infallible mark of the "disorderly mixing of the sexes."[26]

In *La Nouvelle Heloïse*, this unnatural mélange especially characterizes Paris where, as Saint Preux observes to Julie: "women like only to live with men, they are at their ease only with them. In each society the mistress of the house is nearly always alone in the middle of a circle of men."[27] In Paris, moreover, men (usually bachelors) pass their lives running from house to house, and Kofman observes that they seem like so many coins, so much money in circulation. She reasons that money is the sign of general equivalence, and this masculine circulation signifies a loss of individual identity, and hence of the specificity "natural" to the male sex. In circulating through salons, men achieve the interchangeabilty reserved for the female sex.[28] Saint-Preux's observations resound in Rousseau's condemnation of salon culture as dominated by a woman who hosts a salon and gathers in her apartment "a harem of men more womanish than she."[29] It is in these mixed circles that the sexes learn to imitate one other. Women scorn "that charming modesty which distinguishes, honors, and ornaments" their sex, and learn to think, talk, and act like men.[30] Indeed, for Rousseau, "Everywhere women are esteemed in proportion to their modesty; everywhere, there is the conviction that in neglecting the ways of their sex they neglect its duties; everywhere, it is seen that when they turn the manly and steadfast assurance of the man into effrontery, they debase themselves by this odious imitation and dishonor their sex and ours at the same time."[31]

The metamorphosis of women into men is particularly grave because in effacing the difference between the sexes it puts into question the virility of men. The solution Rousseau embraces in his *Lettre à Mr. D'Alembert* is that of the ancient Romans—sexual segregation. It is only through segregation that boys can be boys:

> Let us follow the indications of Nature, let us consult the good of Society; we shall find that the two sexes should come together sometimes, and live apart ordinarily. I said it before concerning women, I say it now concerning men. Men are affected as much as, and more than, women by a commerce that is too intimate; women lose only their morals, but we lose our morals and our constitution at the same time; for this weaker sex, not in the position of assuming our way of

life, which is too hard for it, forces us to take on their way, which is
too soft for us. Wishing to tolerate separation no longer and unable
to make themselves into men, the women make us into women.[32]

The director of the French Academy, the Comte d'Angiviller, articulated
a similar critique of Parisian society in his memoirs, which are in large mea-
sure a response to those of the writer Marmontel, with whom d'Angiviller was
friendly. In those memoirs, Marmontel revealed details of d'Angiviller's rela-
tion with Elisabeth-Josèphe de Laborde, who was married to the Baron de
Marchais, and with whom d'Angiviller had had a long affair. In fact, he even-
tually married Madame de Marchais (as much, he tells us, out of duty as out
of love) after the death of her husband.[33] Although praising much of Marmon-
tel's character, d'Angiviller disapproves of his desire for social success and
compares the writer's loss of "delicatesse" or discretion, to a woman's loss of
modesty. Both are effaced when one abandons oneself to society in the hope
of being noticed, in the hope of pleasing. Virtue, in each case, has been eroded
by the desire to please, a desire conceived as fundamentally "feminine," be-
cause a characteristic of woman derived from her weakness. Not able to im-
pose her will by force, a woman could exert power only through pleasing men.
Similarly, d'Angiviller characterized Marmontel as having a "timide foi-
blesse," which degraded him and destroyed his talent: "This same character
of weakness and subordination can be seen in his relations with philosophes
and men of letters, and in the judgments he made on all those who were su-
perior to him."[34] Clearly it is Marmontel's virility, his "force" that has been
lost; he has learned to act like a woman.

This fear of woman's emasculating effect is partly at the root of preventing
women—always foreign to the academic body—from entering the Académie
Royale in too great a number. Too many women would dilute the proportion
of history painters, which is one measure of the Academy's manliness. In com-
parison to the noble genre of history painting, the lesser genres were theo-
retically feminized, since their only function was to please. History paintings,
on the other hand, were made to teach, to lead, to instill virtue, and to capture
gloire. That d'Angiviller also feared the mixing of men and women on moral
grounds is suggested elsewhere.

In the same way that Rousseau believed actresses led to the dissoluteness
of actors, female painters, in d'Angiviller's eyes, could bring down their male
colleagues. That the mere presence of women could lead to immorality is sug-
gested in a letter d'Angiviller wrote to the king in November of 1785 concern-
ing Labille-Guiard's request for lodgings in the Louvre. There he points out

that because "La Dame Guiard has a school for young students of her sex," allowing her to bring her studio and students to the Louvre would present great dangers. He reminds the king that "all the artists have their lodgings in the Louvre, and as one only gets to all these lodgings through vast corridors that are often dark, this mixing of young artists of different sexes would be very inconvenient for morals and for the decency of Your Majesty's palace."[35] The point, of course, ignores the reality of artist's wives and daughters and other women relatives living at the Louvre. The Louvre already housed a mixed-sex community, but perhaps d'Angiviller could accept this mixing because the women residing there were located firmly under the roof of male authority (of a father or husband).

Even more pernicious than denying Labille-Guiard's request for lodgings was d'Angiviller's order prohibiting artists from teaching women students in the Louvre. D'Angiviller was so adamant about the issue that in 1785 he went so far as to get an official order from the king forbidding these classes.[36] It is important to bear in mind that it was in such private lessons that many young women artists, Elisabeth Vigée, for example, received their early education. Thus d'Angiviller closed an important avenue for the training of women artists who were not the wives or daughters of academicians. The Director's zeal in enforcing the ban is evident in letters exchanged in 1787 between d'Angiviller and the artists David and Suvée, who had taken on women students in their ateliers. D'Angiviller reminded both artists on 19 July 1787 that the Louvre was a "place where it is particularly necessary that decency should reign, so we cannot allow ourselves to close our eyes to this abuse."[37] Suvée protested the innocence of his women students; their care was confided to his wife, who regarded them as her own children and kept them "always under her watch."[38] Despite Suvée's protest, d'Angiviller insisted the women be sent away.

David had a similar experience when he took on temporarily three women students of Vigée-Lebrun, whose studio was under construction. David assured the Director that the women had absolutely no communication with his male students, that their morals were irreproachable, and their families honorable and of good reputation. Moreover, his letter supports the motive behind d'Angiviller's exclusion of women, while suggesting that an exception be made in this particular case based on the women's status and conduct:

If there were any abuse in the Louvre and if it were contrary to decency, one could only applaud your watchfulness and the respectable motives that direct it. But undoubtedly your wish is not that these young women well-born and very judicious should share a common

fate with those whose conduct has been presented to you as guilty. I have no interest in defending students who are at my studio only in passing, but I know how much honor is dear to a sex of which it is the principal ornament, and I take on myself an exacting duty to tell you the truth.[39]

Despite David's affirmation that his virtuous and well-born students were not unruly women, the Director persisted. The law had to be obeyed. Even when one of the girl's guardians wrote to d'Angiviller, he received a curt and officious reply. In no uncertain terms d'Angiviller told M. le Roux de la Ville that his daughter's exclusion was not motivated by a mistaken impression of her conduct, but by a general consideration of the trouble that could follow from holding a school for girls. D'Angiviller says quite bluntly that even if all precautions possible were taken to ensure decency, this would not justify a departure from the rule.[40] One suspects the rule was meant to ensure something other than decency.

The Frame of National Interest

How convenient that the modesty of woman's sex demanded that she not mingle with men; how convenient for insuring the morality and decency necessary to uphold the honor of the Académie Royale. Nature herself dictated that women could not be useful to the progress of the arts or, for that matter, to any aspect of culture. It was thus not in society's interests to promote them as members of institutions like the Académie Royale. The argument from utility brings me back to some of the issues discussed in the previous chapter. By invoking woman's utility (or lack thereof), d'Angiviller closes the frame of national interest opened in the first paragraph of his *Mémoire* to the king, a paragraph in which he articulated why the stricture against commerce was necessary to the arts. The national interest is jeopardized by those artists who degrade art by engaging in commerce and by those women who demand places in the Academy. Women in the Academy are excess, and the restriction to four places based on their uselessness suggests that the number of places for academic artists, like the number of chairs in the Académie française, was limited. Women would impede art's progress by taking academic positions that might otherwise be filled by (male) history painters, who *would* be useful to the progress of the arts. But this is a specious argument—there was no limit on the number of academicians, and so the number of women who entered the Academy actually mattered nothing to the "progress of the arts."

Clearly the argument proceeds only from prejudice, as Condorcet was to

write of all arguments based on similar concepts. In his "On the Admission of Women to Civil Rights," of 1790, Condorcet proposed that prejudice was reducible to one issue: the public interest. This "principle," he maintained, was used to justify not only the subjugation of women to men, but abuses like the enslavement of Africans and the torture of prisoners.[41] Womanly modesty was thus very useful, and any sacrifices it demanded of women were surely more than recompensed by the general good achieved in maintaining the social order.

It can hardly be surprising that nowhere was the social utility of woman's modesty more clearly articulated than in the writings of Rousseau. His treatment of this issue, however, progresses as a defense against some unnamed enemy who, in denying the naturalness of woman's modesty, adheres to Parisian philosophy, and wants "to smother the cry of nature and the unanimous voice of humanity."[42] Thus Rousseau acted to combat the argument that woman's chastity was merely "an invention of social laws to protect the rights of fathers and husbands and to maintain some order in families."[43] He has a ready answer for those who might ask why women (and not men) are given natural modesty to preserve their "virtue." All the "austere duties of the woman," he proclaims, are derived "from this alone, that a child ought to have a father. . . . So Nature wanted it, and it is a crime to stifle her voice."[44] Here the father's need to know that his children are his own is transformed into the child's need to know its father. Rousseau tells us nature wants it so, but as he demonstrated in his earlier *Discourse on Inequality* (1754), in the state of nature no child knows its father, for men and women part after coupling.[45] It must be that only in the state of culture does nature "want" children to know their fathers.

As Derrida's readings of Rousseau have shown, Rousseau in spite of himself confirms exactly the hypothesis he wishes to deny—that modesty is a contrivance of culture. But Rousseau remains undaunted. If the reader notices the slippage from nature to culture, nothing is lost, for Rousseau concludes that even if chastity were not natural, it would still be true that women ought to lead a domestic life. If timidity and chasteness are social inventions, he says it is in society's interest that women acquire them:

> Even if one could deny that a special sentiment of chasteness was natural to women, would it be any the less true that in society their lot should be a domestic and sheltered life? . . . If the timidity, chasteness, and modesty, which are proper to them, are social inventions, it is in the interest of society that women acquire these qualities; it is

in society's interest to cultivate these qualities in women, and any woman who scorns them offends good morals [manners].[46]

Rousseau articulates here the futility of arguing that the natural is merely social convention: the interests of society must dictate what the dictates of nature will be. And while this master rhetorician is unveiling one of his sleights of hand (the presentation of the cultural as the natural), he distracts us from another—the fabrication of some absolute and universal good called the interest of society. Once again the dictates of nature conveniently accord with social utility—in the interests of one sex.

The Woman's Gaze

"Women cannot be useful to the progress of the arts because the modesty of their sex forbids them from being able to study after nature and in the public school established and founded by Your Majesty." When d'Angiviller called on woman's modesty to explain why she was excluded from artistic training he was, consciously or not, repeating Rousseau's gesture of attributing to natural law what was entirely of social convention. He blamed the victim, so to speak, for her own exclusion. It is modesty that dictates women not be seen in public; that they neither look nor be looked at. So as not to "offend" a woman's modesty, men must keep women from compromising situations, especially in public arenas. But is this argument not flawed logically? If modesty is a restraint, if it is what allows women to refuse, should it not be precisely what would allow them to enter morally precarious situations and emerge unscathed? Do women armed with modesty need to be segregated? Could modesty not be construed as precisely that which licensed women to enter life drawing classes? to control themselves when seeing the male body? Perhaps. . . . but what if people talked? Rousseau, in fact, regulates women by public opinion, they are slaves to public opinion, and they must avoid at all costs even the appearance of impropriety.[47] The whole issue of prejudice, gossip, and moralizing in relation to women artists looking at the male nude came together in the 1760s over the work of Mme Terbouche, the Berlin painter who was elected as a foreign member of the French Academy in 1767.[48]

Here is how Diderot described this artist in his "Salon of 1767": "[She] has had the courage to summon nature and look at her. She said to herself, I want to paint, and she said it well. She grasped accurate ideas of modesty, she bravely put herself before the nude model; she has not believed that vice has the exclusive privilege of disrobing a man."[49] Diderot here stresses Terbouche's courage in defying convention to do what needed to be done as an artist.

Far from conceptualizing her study of the male nude as an affront to modesty, Diderot folds it into a new definition of true modesty that considers the intention with which one looks. This notion is repeated and clarified in a letter to the sculptor Falconet dated May, 1768:

> This woman has put herself above all prejudices. She has said to herself: I want to be a painter, I will do all that is necessary to be a painter, I will summon nature, without which one knows nothing. And she has courageously undressed the model. She has looked at a man nude. Do not imagine that the prudes of either sex have stifled themselves over this. She has let them talk and she has done the right thing.[50]

In addition to pointing out the gossip that works to keep women in their place, Diderot goes on to explicate society's duplicity in using modesty as a pretext to prevent women from improving themselves:

> The envious make phantoms [false assertions] for us only to keep us mired in mediocrity. If they would look at these phantoms closely, they would see that decency is only the pretext of their commentary. How many dishonorable actions do they not speak of because they dishonor [those who speak of them], how many indifferent ones do they call dishonorable because they lead those who raise themselves above prejudice to wealth and status. We allow vice to look at nature but forbid talent to do so. . . . A thousand lascivious women will take themselves in their carriages to the banks of the river to see nude men, and one woman of genius will not have the freedom to make a man undress for her instruction.[51]

In Diderot's account there are (at least) two kinds of looking potentially available to women. The first is that which seeks instruction, and it might be equivalent to a detached, scientific gaze. The woman of genius wishes to examine the nude male body to learn how to render "nature" and hence how to make herself a history painter. It is noteworthy that throughout Diderot's comments the male body stands for Nature, and Nature is conceptualized as Truth. Diderot separates this innocent gaze, which he presents as free of sexual desire, from the lascivious woman's gaze on the male body—a gaze for her pleasure and her arousal. Several issues emerge. Diderot's separation of these two gazes suggests a confidence in the "objectivity" of vision since at this point the scientific gaze and the erotic one do not intersect. Also significant is that Diderot refers at all to women who wield an erotic gaze and derive pleasure in looking. Although this gaze is not explored but presented as attached to a social practice (which may or may not have actually occured), Di-

derot's account affirms that women were prohibited from looking and desiring openly. They indulge in voyeuristic pleasure from the safety of a carriage and under the pretext of innocent travel. Beyond the transgressive nature of the women's looking, the extent to which their pleasure is, strictly speaking, voyeuristic remains unclear. Diderot does not tell us how the men behaved—if they were aware of and posing for the woman's gaze. The pretext of travel, however, he presents as an obviously transparent disguise for their lasciviousness—their desirous looking violates womanly modesty.

We can view these women as taking the "masculine" position insofar as social codes (including psychoanalytic theory) have made the gaze man's prerogative. But are these immodest women, as Diderot describes them, doing something other than usurping a male prerogative? If the gaze is attached exclusively to male sexuality and pleasure, as Irigaray has argued, what then can be said of Diderot's gazing women? Are they merely a projection of his desiring gaze? If what Diderot describes was indeed a social practice, are the women who participate in it suppressing a specific feminine eroticism in masquerading as men? In contrast to Irigaray, Joan DeJean has suggested that we consider the gaze foreign to female eroticism out of habit—"we are accustomed to deciphering only the male gaze." DeJean argues that even if we admit that the gaze has been forbidden to women, that does not mean they have not used it.[52] In her consideration of the erotic female gaze in literature, DeJean analyzes instances of female desirous looking in three authors: Racine, Sappho, and Lafayette; and articulates for women a triangulated structure of desirous gazing that she calls memorializing. The desire Diderot projects for his lascivious women, on the other hand, seems quite direct. He imagines they take pleasure in viewing nude men, even though—if this looking was indeed a social practice—the thrill of breaking the rules might have been equally exciting.

As enlightened as some of Diderot's comments may seem, his construction of the female gaze as lascivious and improper suggests that, although the philosophe will allow women a scientific gaze, he is less comfortable when their behavior contests man's erotic privilege. Mme Terbouche's story, moreover, makes a more general point about the plight of all those who flaunt prejudice to raise themselves above mediocrity. Here I imagine that in writing to his friend Falconet, Diderot, for at least a moment, identified his own struggles against authority and convention, his own experiences of the envious, with those of Mme Terbouche. The text of the "Salon of 1767," however, also plays on the negative consequences of the woman artist's look at the nude male model in a risqué tale told by Diderot seemingly at his own expense. Unlike the comments made in his letter to Falconet, this story conflates the

woman's scientific gaze with eroticism, and suggests what womanly modesty
actually protects. Diderot dramatized the situation of the male nude before
the female painter by describing his portrait sitting with Mme Terbouche:

> When the head was completed, it was a question of the neck, and the
> height of my garment hid it, which vexed the artist a little. To put an
> end to her vexation, I went behind a screen, I undressed myself, and
> I appeared before her as a model for an *académie* [i.e., entirely nude].
> I would not have dared to suggest it to you, she said to me, but you
> have done the right thing and I thank you for it. I was nude, entirely
> nude. She painted me and we conversed with a simplicity and inno-
> cence worthy of earliest times.[53]

This scene of innocent conversation, however, leads to an embarrassing
outcome:

> As since the sin of Adam one has not had control over every part of
> the body in the same way that one controls the arms, and as there are
> some parts that desire when the son of Adam does not desire, and
> which do not desire when the son of Adam desires, in the case of this
> accident I recalled the words of Diogenes to the young combatant:
> My son, fear nothing, I am not as naughty as that one there.[54]

So much for male control. The woman's scientific gaze produces the same
physical result as her lascivious one.

At the same time that Diderot praises Mme Terbouche's courage in draw-
ing after the nude, he uses it as the occasion to exemplify the risks of the
Medusoid female gaze, which turns at least one part of his body hard, like
stone. Diderot perhaps had a reason for stressing that sometimes the son of
Adam has an unwanted erection. Later in his discussion of the Berlin artist he
addresses the rumors about his affair with Mme Terbouche, who was not
beautiful. Diderot laments that his support for the artist doomed him to hav-
ing everyone believe he had slept with an ugly woman.[55] The story is self-
serving in that it is calculated to dispel the talk about his alleged affair, and
certainly from our standpoint denigrating to the woman in question. We can,
however, read the joke otherwise, in terms of the discourse on modesty. In his
account Diderot reveals that men cannot control the penis ("since the sin of
Adam . . ."); this lack of control, this sin of Adam, however, Rousseau and
others projected onto woman. Woman thus becomes that which must be con-
trolled through the contrivance of a legislating function—modesty—that so-
ciety directs her to internalize. The unruly woman replaces the unruly penis,

and man's erection becomes not a sign of his lack of control, but a sign of his natural power and rightful superiority.[56]

Diderot's story also reminds us that men could respond to the woman's gaze, to the excitement of being looked at. Given the discourse on modesty as double-edged, both a restraint and a spur, and given the effect that even a modest female gaze might have on the male body, can one imagine women drawing after the male nude, even in a class entirely populated by women? What if their gazes excited the model? or what if they didn't? Imagine his embarrassment. And could modesty really be relied on to harness women's unruly sexuality?

Morals, in fact, might be endangered in any instance where women artists looked at male models, whether clothed or unclothed. A woman portrait painter depicting a male sitter was often suspected of seducing or being seduced by him through the exchange of glances. Rumors about Vigée-Lebrun's affairs with clients—in particular, M. Calonne and the Comte de Vaudreuil—circulated widely. Perhaps these sorts of rumors provoked her to address the general issue of male sitters in her *Souvenirs*. She tells how when she was a young, unmarried painter several male admirers came to sit for portraits in the hopes of attracting her. As soon as she discovered they wanted to gaze on her with "les yeux tendres," she painted them with their eyes averted. "Then, at the least movement that cast their eyes in my direction, I said to them: 'I am just at the eyes'; which annoyed them a little, as you can suppose."[57]

As in Rousseau's discussion of the sex act, the issue at stake in Vigée-Lebrun's ploy is one of control. The incident is amusing because it reverses the expected roles. Rather than allow the male sitter to position her as an object of his gaze, Vigée-Lebrun controls the model by speaking from the position of painter, subject of the gaze. Moreover, the context of the comment is particularly illuminating as the section focuses on four issues: the young artist's attractiveness, her dedication to art, her impeccable morals, and the machinations of male admirers who pose as sitters. Seeing through their pose, the artist accepts them as art patrons, but rejects them as suitors. Vigée-Lebrun obviously enjoys the game of thwarting their amorous advances while satisfying her painterly ambitions, and she even shares her delight with another woman—her mother—who acts not only as chaperone to the sitting, but also as amused accomplice to her daughter's ploy.[58] Yet even as Vigée-Lebrun is savoring her powers of attraction, her accomplishment as an artist, and her clever manipulating of admirers, she is also reminding her readers that she preserved her virtue amid the dangers presented by the male model. In this context it does not seem accidental when she reports at the beginning of

her story that the first novel she ever read was Richardson's *Clarissa*. Unlike Clarissa, however, the artist escapes the schemes of her male pursuers.[59]

On Viewing Women

In none of her history paintings does Vigée-Lebrun represent male figures, thus avoiding the recriminations that appear to have surrounded Mme Terbouche's attempts to draw after nature.[60] Women, however, could include male figures in their history paintings because they *could* draw after some male bodies—by copying other works of art, especially antique sculpture. Angelica Kauffman's ceiling design for the central hall of the Royal Academy in London, 1778, and Hubert Robert's many paintings of women drawing either in the Louvre or outdoors amid ruins, make exactly this point. This practice, of course, left women open to the charge that they did not really draw after nature but only copied art. Copying another work of art literally represented a less advanced stage of artistic training, for all young artists drew after plaster casts before progressing to live models. Thus in making her history paintings—*Peace Bringing Back Abundance* (figure 12); *Venus Tying Cupid's Wings* (figure 5); *Juno Borrowing the Belt of Venus* (now lost); and even the earlier *Innocence Taking Refuge in the Arms of Justice* (1779; Musée d'Angers)—Vigée-Lebrun focused her attention on the female body.

Vigée-Lebrun, in fact, capitalized on the changes in history painting that marked the first half of the eighteenth century. At that time mythological subjects of the type popularized by Boucher featured the female body (as well as the child's body, which women of course could see). Candace Clements has shown that the classification of such subjects stems from Félibien, who included *la fable* in the genre of history painting.[61] Such subjects, it could not be denied, were history paintings—they were based on stories drawn from literature, mythology, the allegorical tradition, and so forth. They demanded that the painter visualize an event not seen, idealize the figures, imagine their passions, and choose the artistic language best able to express the story's meaning. It could be argued, and indeed was argued, that such unedifying subjects debased history painting, eschewing its moral, serious (masculine) side and cultivating its erotic, frivolous (feminine) side. Indeed, d'Angiviller designed his reform of history painting to rescue the highest genre from the depths into which it had fallen in the hands of rococo painters like Boucher.

Those history paintings that featured the female body, however, opened possibilities for women practitioners. Vigée-Lebrun clearly took advantage of these possibilities in two of her Salon entries, *Juno Borrowing the Belt of Venus*, cited in the livret as a subject from the *Iliad*, and *Venus Binding Cupid's Wings*.[62]

Salon critics mentioned that these paintings reminded them of the genre as practiced by Boucher. Other elements of history painting provided openings for women as well. Within the allegorical tradition the idealized female body was used to represent any number of abstract ideas, and often made to stand for virtues that in the "real world" were not ordinarily ascribed to women or gendered as feminine.[63] Allegorical painting, interestingly enough, was considered by some theorists to be the most erudite of all history painting because in making an allegory the artist became both author and illustrator.[64] Perhaps Vigée-Lebrun had this notion in mind when she chose *Peace Bringing Back Abundance* as her reception piece.

But was drawing the female nude without censorship for women? Drawing after the female nude in all cases was conducted outside officially sanctioned academic training. Artists who worked from nude female models did so in a private studio situation, thus there was ample opportunity to make the scene of drawing a female nude an erotic one, either in fantasy or actuality.[65] Images of male artists and female models were by far the most common, for example, Gabriel de Saint-Aubin's engraving of *The Private Academy* (Paris: Bibliothèque Nationale), in which the female model, naked, prone, and seductively posed on a sofa, is positioned amid objects that refer to the sexual act and organs.[66] The artist sits across the room sketching, and in some versions a voyeur looks in through a window.

It was also possible, however, to make erotic hay of the female painter drawing after the female nude, as in Hubert Robert's *La Salle des Saisons* (1802–3; figure 13), which shows a young draftswoman posed between the statues of *Vénus Génitrix*, which she copies, and *Diana the Huntress*, which stands behind her. The image plays on the doubled position of the woman artist as both object and subject of the gaze, as is suggested by positioning her between the types for the womanly woman (Venus) and the masculine one (Diana). This copyist, moreover, is associated visually with both these figures. Her dress, hair style, and profile rhyme with those of Diana behind her. On the other hand, she is even more closely likened to the crouching nude Venus, object of her gaze and subject of her drawing. Her pose is configured to resemble that of the sculpture, and perhaps more importantly, Robert has positioned the young woman so viewers see her from precisely the same angle that they imagine her viewing the *Vénus Génitrix*. From the viewer's perspective she is the statue's equivalent, and the comparison blurs the distinction between the dressed and the undressed, inviting the viewer to contemplate the one as if the other. The artist becomes object of the viewer's gaze and the viewer's model. The obvious erotic charge of the work reminds us that, for women, modeling was an immodest profession.

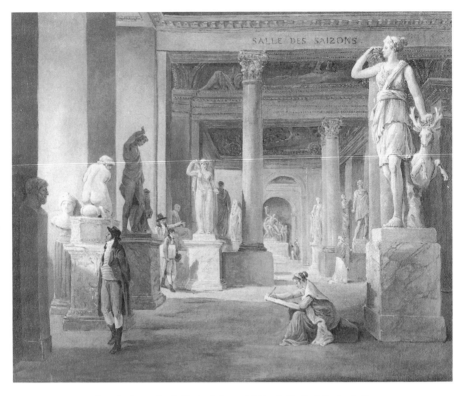

Figure 13 Hubert Robert, *La Salle des Saisons*, 1802–3. Paris: Musée du Louvre

Like the actress and the prostitute, the model was considered sexually accessible. As far as I know there is no evidence from the eighteenth century of women hiring other women to pose, but it is possible that women used their friends or servants as models. Comments about Mme Terbouche's nude women looking like *femmes de chambre* or *la servante de l'auberge* may hint at the latter practice, but comparing the look of figures to lower-class types was a conventional way of suggesting that the figures did not appear noble, or that the model (whom it was assumed was lower class) was not properly idealized. As likely—or perhaps more likely—is that women painters used themselves. This latter *possibility* is the most interesting here. Given the contemporary discourse on modesty, could the audience construe the woman painter playing the role of the nude model as anything but doubly immodest? The *possibility* that Vigée-Lebrun used her own body offered Salon critics the opportunity to titillate their readers.

Looking at her *Venus Binding the Wings of Cupid*, one writer criticized the proportions of Venus as not those of the goddess of beauty, but those of the Flemish school. He added the comment, "Surely in painting the nude woman the artist has not taken herself for a model, the contours would have been more delicate."[67] Although it might be construed as flattering, the comment actually asks the audience to imagine how Vigée-Lebrun's body looks, and thus uses her painting to make her an immodest woman. Here the suggested contrast between the nude model and the woman artist activates the viewer's fantasy in a strategy parallel to Robert's comparison between the crouching Venus and the woman copyist. Another critic sets up the conversation of a marquise, a chevalier, and an abbé as they stand before Vigée-Lebrun's *Peace and Abundance*. The marquise asks from where Madame Lebrun has taken her models. The abbé answers, "Has she not a mirror?" This exchange leads to a suggestive repartee in which the abbé contends that women should not paint other women, but leave that pleasure to men. If "the Graces have learned to paint themselves," he says, "farewell to our rights."[68] To paint women here is assumed as both male prerogative and male pleasure, which are jeopardized when women presume to paint and give pleasure to themselves, and one another. The comment implies, of course, that the woman painter also usurps the man's sexual rights, and thus it implicitly poses the woman history painter as a lover of women.

Peace Bringing Back Abundance

Looking at Vigée-Lebrun's *Peace and Abundance*, one can see why a critic might direct his insinuations to this particular work. Although the comment questions the relation between women painters and their models, *Peace Bringing Back Abundance* suggests an erotic encounter between women in showing two female figures in close physical contact exchanging intimate glances. Although physical contact between female figures was not uncommon in allegorical painting, such contact takes a different character in this work. In contrast to the abstracted and expressionless figures that usually frequent allegories, the figures of Peace and Abundance are rendered naturalistically. This is particularly striking if one compares, for example, Vigée-Lebrun's figures to the corresponding ones in Vouet's *Prudence Leading Peace and Abundance* (1630; figure 14). Vigée-Lebrun's two embracing women reconceive the relation of Vouet's Peace and Abundance as they approach the throne of Prudence. Vouet's figures, however, do not so easily sustain a reading that focuses on the erotic interplay between them: they are generalized and represented on a grand scale, but not sensuously painted. Despite the conventional contrast

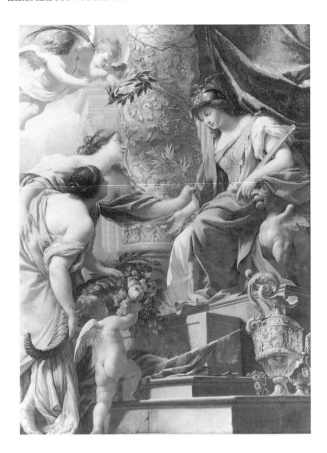

Figure 14

Simon Vouet, *Prudence
Leading Peace and
Abundance*, 1630. Paris:
Musée du Louvre

of brunette (Abundance) and blonde (Peace) often used to heighten difference for erotic effect, Vouet's women seem identical in their abstracted and almost antiphysical presentation. They seem disembodied signs for the qualities they represent. Both are rendered in a handling visibly different from that of the fleshy little putto who holds the fruit tumbling from Abundance's cornucopia. That figure has more naturally colored flesh tones when compared to the whiteness of the allegories; and where their bodies are smooth, unmodulated forms, Vouet has attentively painted the folds of flesh beneath the putto's up-raised arm and behind his supporting leg. Most conspicuously, the putto's rosy bottom turned toward the viewer suggests a sensuous appeal missing in the allegorical women.

It was the naturalism of Vigée-Lebrun's image (perhaps along with the desire to remove the work from the realm of history painting) that led later commentators, such as Charles Blanc, to suggest that the image is actually

a portrait made after the two daughters of the miniature-painter Pierre-Adolphe Hall.[69] Blanc's comments about the painting, however, are revealing: "But whatever be the art with which Madame Lebrun has applied herself to idealizing her models, one senses oneself in the presence of living individuals. The result is a strange embarrassment for the mind *(esprit)* of the spectator."[70] The strange embarrassment was perhaps less the effect of a conflict between an allegorical subject and individualized characters and more the result of eavesdropping on an erotic encounter between two women sensuously painted by a woman artist. If the viewer is cognizant of the artist who made the work, it is not so easy to see the interaction of Peace and Abundance as staged solely for the male gaze, since the artist's gaze cannot be unproblematically conflated with that of the male viewer. I am suggesting here that the work potentially has a different impact than a mythological painting showing two women in amorous embrace that the viewer knows was produced by a male artist. The painter's maleness allows his image of women together to be read as suggesting a prelude to heterosexual activity. Such a reading would be aligned with contemporaneous conceptions of sexual play between women as either a substitute for or preliminary to heterosexual lovemaking. Lucienne Frappier-Mazur has shown how in eighteenth-century male erotic writing "it is men who hide to observe lesbian couples, an occupation often leading to a threesome during which the male observer secures active control of the situation."[71] The voyeurism of the male character actualizes the reader's own position as voyeur.

It would, of course, be possible for any male viewer to imagine the women's embrace in Vigée-Lebrun's painting as for him, even though there is nothing in the painting to suggest that it is. However, recognizing that a woman made the image short-circuits the viewer's identification with a specifically male, heterosexual desire imagined as "expressed" through the painting. In its theoretical deceptiveness, painting implies a real model and the artist's presence before the model in a way that literature does not, and painting trades on myths that retell a story of male desire at work in transforming a real woman into a painted image. Of further interest in Frappier-Mazur's account of woman-authored erotica is her argument that as early as 1807, in fiction written by women, lesbianism signifies a refusal of male dominance. Erotica written by women, she argues, attaches greater value to female friendship than male-authored erotica, and makes little distinction between female bonding and erotic love. In this aspect, women's erotic novels actualize the unconscious or unavowed sexual component of romantic female friendships.[72]

Vigée-Lebrun's image suggests a physical and emotional engagement between the two women, as Abundance mimics the gaze that the weaker, "femi-

nine" lover casts on the stronger partner throughout rococo painting. The look thus signifies the differential power relations characteristic of both men's and women's erotica in the eighteenth century.[73] Indeed, although two women are represented, in terms of contemporaneous painting codes they are alternately gendered as "masculine" (Peace) and "feminine" (Abundance). This division is signaled by color tonality—the darker flesh tones and hair color traditionally used to indicate maleness, the pearly flesh and blonde hair to suggest femaleness—and by drapery—the fluttering cloak of Peace contrasts with the more restrained draping of Abundance. It is also indicated by ornament. Abundance is much more decked out in finery, although the finery is of a natural order, but Peace is presented as a sober, simple, and grand figure. These characteristics give onto locating the two figures in different traditions: Abundance in the more sensual colorist tradition and Peace in the more classical linear one. Peace even has a more simplified, Raphaelesque profile, and she is subjected to a greater idealization. Reading the gendered distinction as representing power and dependency, with Peace guiding and controlling the pliant, sensual, and dependent figure of Abundance, signals not only the painting's eroticism, but also the allegory's meaning. Abundance, here the abundance of the earth, is a symbolic woman who gives birth to the many fruits emerging from the open mouth of her cornucopia and whose bared breast associates her with fecund Nature. But what allows Abundance to flourish, what protects Abundance, is the accord between peoples indicated by the figure of Peace crowned with laurel and draped in purple. Indeed, we might draw up a whole list of gendered characteristics invested in the figures of Abundance and Peace: nature/culture, sensual/intellectual, color/design, control/dependency, and so forth.

The message of the allegory, which adheres to commonly held beliefs about masculine and feminine positions, is thus at odds with that of the painting, which represents an encounter between two women in a way unauthorized by the masculinist erotic discourse. The liveliness afforded to both figures disrupts any reading of them as mere allegories of the masculine and feminine, or of peace and abundance. If Vigée-Lebrun's handling of the figures disrupts the allegorical message, it disrupts one that was a traditional theme incorporated into both monarchical iconography and academic *morceaux de réception*.

Pierre de Sève in 1663 entered the Academy with his *Sur la Paix des Pyrénées traitée allégoriquement* in which "the arts of painting and sculpture, in the presence of Apollo, accompany Peace who gives hope to Abundance."[74] In 1702, François Marot presented for his reception piece *Les Fruits de la Paix de Riswyck sous l'Allégorie d'Apollon ramenant du ciel la Paix accompagnée de l'Abon-*

dance pour favoriser les sciences et les arts (Tours: Musée des Beaux-Arts). The work is a complicated baroque allegory, with Apollo standing at the center radiant and illuminated. Apollo, of course, was a figure for Louis XIV, and the Peace of Riswyck refers to Louis's victory, as did the Peace of the Pyrenees represented earlier by Sève. In Marot's work, Apollo-Louis grasps the arm of Peace, who in turn places her arm around the shoulders of Abundance. The *enchaînement* of the group, however, does not detract from the centrality of the central figure, Apollo, who within the larger composition holds the apex of its triangle. Allegorical figures representing the sciences and the arts, which flourish in times of peace, are located at the sides of the composition. To Apollo's right are the visual arts of painting, sculpture, and architecture; to his left, writing and history. All of these, as well as peace and abundance, are represented as generalized female figures, whose individuality is entirely subsumed in the abstract idea represented. The allegory works particularly well, since Apollo was also patron of the arts and often shown with the nine muses. In this context it is important to note that Abundance is represented traditionally as a woman holding a cornucopia filled with nature's bounty, even when she is meant to refer to the financial abundance that will accrue to the arts with renewed patronage after a period of military expenditures.

Although formally the image by Vigée-Lebrun is very unlike Marot's reception piece and contains considerably fewer figures, thematically there are obvious similarities. Made in 1780, Vigée-Lebrun's work perhaps anticipates the end of French expenditures for the American Revolution, which would bring back abundance to the arts, in the sense of providing money to continue d'Angiviller's projects. That it was and is possible to read Vigée-Lebrun's image in this way makes it doubly ironic that in the face of this *morceau de réception*, d'Angiviller argues that women could not be useful to the progress of the arts. But perhaps things were the other way around, perhaps his argument only strengthened Vigée-Lebrun's resolve to designate this particular work her reception piece.

In 1783, Vigée-Lebrun's contemporaries took her work as a comment on the reign of Louis XVI, for the treaty ending France's involvement in the American War for Independence was signed in that year. Indeed, they might have considered it in conjunction with a contemporaneous print celebrating the Treaty of Versailles in which Louis, seated in his regalia under a palm of victory, holds the olive branch to England, and to Abundance hands the caduceus of Mercury, a second symbol of peace. Thus the King is the distributor of peace and the restorer of abundance, as the allegorical figures of France, America, England, Spain, and Holland are assembled to witness the event.[75] In terms of Vigée-Lebrun's painting, it is particularly interesting that the con-

nection to recent events appeared in the *Mémoires secrets*, whose reviewer had this to say about the image:

> I do not know in which rank the Academy placed Madame Lebrun, whether it was history, or genre, or the portrait, but she is not unworthy of any, even the first. I consider her reception piece as very likely to allow her admission in the first rank. It is *Peace Bringing Back Abundance*, an allegory as natural as ingenious: one could not have chosen better for the situation. The first figure, noble, decent, modest as the peace that France has just concluded, is characterized by the branch from the olive, her favorite tree.[76]

Recall that earlier in the review the writer undercut Vigée-Lebrun's talent as a history painter and that throughout the 1780s the *Mémoires secrets* became increasingly hostile to the royal family (especially to Marie-Antoinette) and to Elisabeth Vigée-Lebrun. In this context, the comment on Vigée-Lebrun's painting as representing a noble, decent, and modest peace may indeed be ironic. It perhaps calls attention to the sad state of the French treasury in 1783, indebted by massive outlays of funds to finance French involvement in the American war. Given that the painting was made in 1780, nearly three years before either the peace was concluded or the artist elected to the Academy, I suggest that the work was conceived, at least in part, as a tribute to and "gift" for her patron Marie-Antoinette. Only later did it take on its more specific meaning in relation to contemporaneous political events. This interpretation accounts for one of the most striking features of Vigée-Lebrun's allegory when compared to those of her predecessors—the detachment of the allegorical figures from any direct reference or representation of the reigning monarch.

Vigée-Lebrun was first summoned to paint the queen at Versailles in 1779. There, the Salon de la Paix (Salon of Peace) was a central room in the queen's state apartments, functioning as a large drawing room. Decorating it were Charles Le Brun's *France Victorious Offering the Olive Branch to the Powers that had United against Her*, which commemorates the marriages tying France to Bavaria and Spain; and Lemoyne's *Louis XV Offering Peace to Europe* (1729). Executed in an oval format, Lemoyne's painting centralizes the regal figure of Louis XV, who supports, and even perhaps represents, Peace, as he holds out the olive branch to Europe. On the other side of the king is Fecundity, represented by a nursing mother suckling two infants. As there was no painting celebrating peace during the current reign, perhaps Vigée-Lebrun imagined she had the chance to extend these images already decorating the queen's chambers.

A location in the queen's chambers or even the desire to be associated with their iconography, would in part explain the style of the work, which recalls the Renaissance-Baroque grand manner then evident at Versailles rather than the new classicism fostered by the artists of Vien's circle.[77] Moreover, two significant allegories featuring figures of Peace and Abundance were associated with another Hapsburg queen, Anne of Austria, mother of Louis XIV and last of a line of women regents. One of these images, La Hyre's 1648 *Allegory of the Regency of Anne of Austria*, shows the figures of Peace, Abundance, and Fame. The second, Vouet's *Prudence, Peace, and Abundance*, may have provided a model for Vigée-Lebrun. It was owned by Philippe, Duc d'Orléans, in the eighteenth century, when it was assumed to be part of the decorative scheme commissioned by Anne of Austria in the 1640s.[78] If Vigée-Lebrun's *Peace Bringing Back Abundance* can be read as an allegory of Louis XVI's reign, it is one likely planned for Marie-Antoinette—his queen and the artist's friend and patron. It is in the context of the relationship between queen and painter that the image of one woman dependent on another begins to acquire greater resonance.

The Queen's Painter

In the 1770s and 1780s Vigée-Lebrun was busy identifying herself with Marie-Antoinette and the queen's intimate circle. The political climate of 1783 and subsequent events make it significant that the artist associates herself with Marie-Antoinette—rather than some other in/famous woman—and illuminates the multiple forces affecting Vigée-Lebrun's past and current reputation. Aligning herself with Marie-Antoinette's partisans at Court, the royalist artist would later find herself on the "wrong" side of the Revolution. How ironic that when a woman is considered painter to a royal sovereign she has the misfortune of associating herself with the most vilified of queens. That Vigée-Lebrun after the Revolution continued to consider herself honored by the patronage of Marie-Antoinette is evident from her *Souvenirs*, written many years later. There she plays up the mutual sympathy, respect, and friendship between herself and the ill-fated queen, often lapsing into the hagiography typical of Royalist writing about Marie. Although the honoring of artist by monarch was a common motif intended to demonstrate the artist's merit (the classical type was Pliny's description of Alexander and Apelles), it was a trope that shaped artist's lives. Living it could provide both financial and psychological benefits. Vigée-Lebrun never wavered in her attachment to Marie-Antoinette; yet for many that attachment is the dark side of the painter's career. Still, she can represent more than the frivolous extravagance that—often in a caricatured form—has become associated with the queen's circle.

Historians Sarah Maza and Lynn Hunt have recently reopened the case of Marie-Antoinette to show how we can read in her fate the gendering of political culture.[79] The case of Elisabeth Vigée-Lebrun similarly elucidates the gender politics of aesthetic culture in late eighteenth-century France. Hunt and Maza have shown that libels against Marie-Antoinette, which started as early as 1774, often focused on the queen's sexualized body. Exploiting the conventions of pamphlets denouncing women in the public sphere, particularly pamphlets that focused on the corruption of the king's mistresses, these libels suggested that unbridled female sexuality, once relegated to the margins of power (to the king's mistresses), had now moved to the center (through Marie-Antoinette).[80] Two influential pamphlets, the *Essais historiques sur la vie de Marie-Antoinette* (1781) and the *Portefeuille d'un talon rouge* (1783) were published in the early 1780s, and by 1782 the *Mémoires secrets* drew attention to the libels, by then fairly well known.[81] In these pamphlets, the queen's garden walks with friends were cast as occasions of unbridled licentiousness. One of the favorite charges called the queen a tribade, naming the Princesse de Lamballe and the Duchesse de Polignac her favorite lovers. I shall take up these issues in more detail in the next chapter. However, it is clear that by 1783 critics found Marie-Antoinette's female friendships suspicious. Beyond this, the queen was accused of obtaining recondite favors for her protégés, and it is in light of this accusation that the admission of Vigée-Lebrun into the Academy might have been cast. Maza argues that scandalous literature directed at powerful women characterized feminine nature as deceitful, seductive, and selfishly pursuing private interest. Thus the feminine became the antithesis of reason and law, the abstract principles held to govern the political sphere.[82] It is not difficult to read the academic record as telling this same story—the selfish pursuit of two women's private interests (that of the queen and that of Vigée-Lebrun) stands against both academic law and national interest. This is not the story I believe d'Angiviller intended to tell, but it is one that seeps into the very fabric of the academic documents, which situate the queen's "desire" for Vigée-Lebrun's acceptance against the academic statutes that allegedly barred her admission.

In analyzing the documents concerning Vigée-Lebrun's admission, I argued that the reasoning from *état* covered over the lack of precise grounds for excluding Elisabeth Vigée-Lebrun. In choosing to make that particular argument, the Director also chose to oppose the queen's desire and the law, and to articulate the problem as that of reconciling the queen's wishes and academic statutes. The three documents pose the dilemma differently, and the actions and motivations of the leading actors vary. In his *Mémoire*, d'Angiviller tact-

fully explains to the king that the queen has asked him to devise a way to admit Vigée-Lebrun without violating the law. The letter to Pierre differs from the *Mémoire* in that d'Angiviller is more explicit about his own role in the reconciliation process: he has instructed the queen on the necessity and utility of the academic statute. The Academy minutes open with a statement of the queen's interest in Vigée-Lebrun. Although her desire to honor Vigée-Lebrun is noted respectfully, but insistently, throughout the text, the queen's interest in upholding the law is nowhere in evidence. Rather, the Academy reads *d'Angiviller's actions* as calculated to "conform to the desires of the queen and to preserve at the same time the laws of the Academy in all their force."[83]

The New Apelles?

I read Vigée-Lebrun's suite of entries into the Salon of 1783 as chosen, among other things, to impress the public with her connection to the queen. Along with her self-portrait, she showed portraits of the royal children, a portrait of Marie-Antoinette (which is the focus of my next chapter), and an image of the queen's close friend, the Marquise de la Guiche, as a milkmaid. *Peace Bringing Back Abundance* could also have reinforced her association with the queen. Two of the artist's paintings the salon livret listed as belonging to members of the queen's circle, *Juno Borrowing the Belt of Venus* to the Comte d'Artois, the king's younger brother; and *Venus Binding Cupid's Wings* to the Comte de Vaudreuil, lover to the queen's favorite, Yolande de Polignac.[84] The connection between the artist and the queen was not lost on Salon-goers. A *Vers à Madame Le Brun*, signed by M. de Miramond and published as a Salon pamphlet in 1783, played up the association in a stanza on the queen's portrait (figure 18, p. 144),

> If the *embellished throne* offers you a worthy model,
> Whose enchanting features are soon recognized!
> The pride of Alexander called for an Apelles
> It is Le Brun whom Venus needs.[85]

The author presents the relation between Vigée-Lebrun and Marie-Antoinette as analogous to that between Apelles and Alexander, calling up one of the images sanctioned by the Academy through which painters identified themselves as painters and figured their imaginary relation to absolute power. Miramond, however, puts the relation in an appropriately "feminine" register by gallantly casting Marie-Antoinette as Venus, and comparing/contrasting Vigée-Lebrun's ability to represent the beauty appropriate to a queen with Apelles's skill at showing the male hero's pride. Yet we can read beyond the

contrast between masculine and feminine that both activates and contains Miramond's remarks. In each case the pairing between artist and ruler works an exchange: the ruler lends prestige to the artist who makes his/her portrait; the artist's skill gives the ruler immortality or fame. Félibien pointed out the reciprocity of the arrangement, since in exchange for the privilege of making the king's portrait, the artist makes the king available to his subjects and to posterity as king.[86] The representation, in fact, becomes an original to be copied endlessly by other, less favored, artists: "I know that it was permitted only to Lysippus and Apelles to work on Alexander's portrait. But it was not forbidden to all Greeks to admire the work of these two excellent men, to preserve their ideas and to make, of their originals, copies that were as so many glorious monuments dedicated to the memory of that great prince."[87] Moreover, by invoking the relation between Alexander and Apelles in the context of writing about Louis XIV as portrayed by Charles Le Brun, Félibien works a substitution, which Miramond later extends. The relation between Apelles and Alexander is first reconceptualized as that between Charles Le Brun and Louis XIV, and then as that between Elisabeth Vigée-Lebrun and Marie-Antoinette. The play between the names Le Brun and Lebrun could hardly have been lost on contemporaries. Indeed, I imagine this play of names helped activate the chain of substitutions leading from Apelles to Vigée-Lebrun and from Alexander to Marie-Antoinette.

Only in the case of Vigée-Lebrun and Marie-Antoinette is the exchange worked between two women, which radically changes the various meanings that devolve from the association. The substitutions particularly take on another connotation when we recall that the exchange between Alexander and Apelles, the exchange through which the ruler honored the artist, often involved a third term—the woman Campaspe. In figuring Marie-Antoinette as Venus, Miramond's poem slides into this story. It was Apelles's famous *Venus Anadyomene* that he eventually painted from Campaspe after Alexander brought her to his atelier. That work secured the artist's reputation as painter of beauty and grace. Indeed, Apelles's ability to paint beauty and his reputation as an artist endowed with graceful style were encoded in his Venus, and it is these aspects of Apelles's skill that Vigée-Lebrun appropriates in Miramond's poem.

Pliny recounted how Alexander brought his favorite mistress Campaspe to be painted by his court artist Apelles. In watching the portrait making, Alexander notices that the artist has fallen in love with his model, and out of a high regard for Apelles and satisfaction with his work, Alexander gives his concubine to the artist.[88] Pliny neglects to record what Campaspe thought of the bargain. By the eighteenth century, French painters considered the ex-

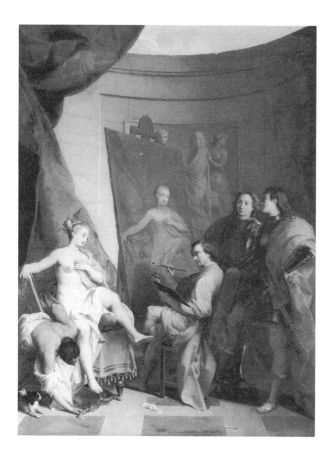

Figure 15

Nicholas Vleughels,
*Apelles Painting
Campaspe*, 1715. Paris:
Musée du Louvre

change of Campaspe between Alexander and Apelles symbolic of the high
consideration afforded artists, and the story eclipsed that of Saint Luke paint-
ing the Virgin as the primary symbol of painting.[89] A month before the death
of Louis XIV in 1715, the Academy commissioned Vleughels to paint as his
reception piece *Apelles Painting Campaspe* (figure 15), which the artist later
published as an engraving entitled *l'Amitié Généreuse*. In Vleughels's painting,
Campaspe is placed to one side holding a pose with the aid of a stick that
supports her right arm. A servant kneeling beside her tucks a cushion under-
neath her right foot. Campaspe is nude, except for a strategically placed cloth
draped over her left breast and between her parted legs, and she looks over at
Apelles. The men are gathered on the other side of the composition, and Apel-
les is seated at his easel with his left hand resting on his knee. He looks at
Campaspe and simultaneously touches the canvas with a chalk held in his right
hand. The touching and looking suggest his desire, and visible on the easel is

what love has prodded him to sketch, the figure of Campaspe as Venus. Behind Apelles's chair stand two figures, Alexander and a male companion. The latter is looking at Campaspe, perhaps catching something of the erotic charge that animates the scene. Alexander, on the other hand, is looking at the canvas, on which he reads the artist's desire. The story of Apelles and Campaspe encodes the erotics of looking and painting: the male artist's gaze on the female model enflames his desire, which then imprints itself on the image he makes. The story also naturalizes male image production and confirms myths about male sexuality and gaze. In Vleughels's visual narrative Alexander reads Apelles's picture as an image of male desire; to what extent do we as feminists validate this myth of male creativity when we see all representations of "woman" as little more than a similar projection?

In Pliny's story the relation between Apelles and Alexander is cemented by the exchange of a woman, Campaspe, whom the story makes as much the instrument for homosocial bonding as the heterosexual love interest. Diderot's reading of Falconet's relief sculpture of Alexander and Campaspe (figure 16) shown at the Salon of 1765 explicates this logic. In Falconet's representation, Campaspe does not even have the power to look back at Apelles or

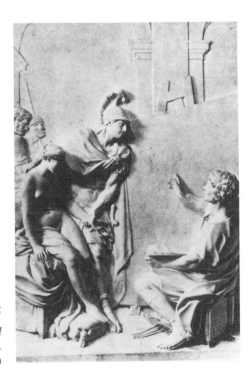

Figure 16

Etienne Falconet, *Apelles and Campaspe*, Salon of 1765. Private Collection

to express any emotion whatsoever. She must passively await the fate dictated to her, expressing no will or preference, since any expression on her part might interfere with the male exchange and the mutual recognition on which it is based. Diderot sees that Alexander must regret giving up Campaspe to make the gift a sacrifice and mark of honor; Apelles must not be humiliated by the gift that does not want to be given. Thus Falconet presents her with lowered eyes to blinker her expression, lowered eyes that in themselves represent subjugation and modesty. Here is how Diderot understands Falconet's piece: "It is an *homme d' esprit* who has rendered Campaspe with lowered eyes. Gay, she would have wounded the vanity of Alexander because she could leave him without being pained. Sad, she would have mortified the painter."[90] Even more interesting, however, is how Diderot can read the image as suggestive of another exchange: "But there is so much innocence and simplicity in the character of her head, that if you were to place a veil underneath her throat and have it fall to the tips of her feet, . . . you would take a concubine for a young daughter well brought up who does not even know what a man is, and who consigns herself to the will of her father, who gives her to the artist as if he were a husband."[91] Diderot goes on to say that the lowered head expresses too much modesty, that its character is false: "Falconet, my friend, you have forgotten the *état* of this woman, you have not considered that she slept with Alexander, and that she has known pleasure with him, and perhaps with others before him."[92] Diderot assumes that Campaspe is a whore, another object of exchange entirely different from the innocent girl handed from father to husband. Indeed, he makes Campaspe into an object of exchange par excellence; she is the currency that circulates among men, held first by who knows how many, then by Alexander, then by Apelles, and then? The image itself ensures not that she will be possessed only by one man (as a wife) but that she can be had by any and all takers, by viewers who can look at her body without even imagining that she will protest, that she will look back. Campaspe here is not merely an item of exchange, she is the very sign of exchange.

How different the situation becomes when the positions of Apelles and Alexander are given to two women. In this case the exchange is worked without a third term. Women are thus lifted from their place as goods in the circuit of exchange between kings and painters, husbands and fathers, pimps and johns. In the rewriting of this text, women, traditionally the objects of exchange, circulate among themselves. The goods, as Irigaray says, get together.[93] Replacing Alexander and Apelles with Marie-Antoinette and Elisabeth Vigée-Lebrun suggests not only a gynosocial, but also an erotic bond between the two women. The erotic bond is particularly implied if we imagine the women also appropriate the erotics of art making and friendship so central

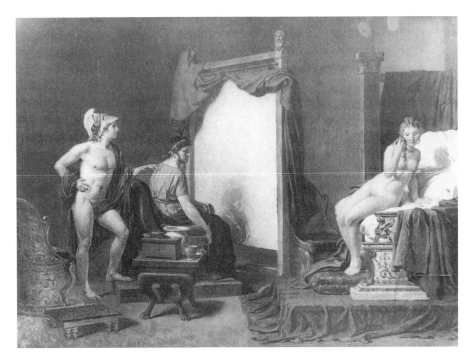

Figure 17 J. L. David, *Apelles Painting Campaspe*, 1813. Lille: Musée des Beaux-Arts

to the Apelles myth. In the case of Apelles and Alexander, the erotic desire is not represented when Apelles paints Alexander, but rather it is deflected into the story of Campaspe, where it is figured as the exchange of a woman. The image of Apelles painting Campaspe, however, does not usually suggest overtly the homoerotic desire between the painter and his patron also present at the sitting. A significant exception is the unfinished *Apelles Painting Campaspe* (figure 17) begun by David in 1813. There the nude Alexander, placed in close proximity to Apelles, seems much more like his lover than the shrinking Campaspe set at a far distance from the men. The canvas on which Apelles paints divides the scene and sets the woman's space apart from that occupied by artist and conqueror, who duplicate one another's profile view. With his foot resting on the painter's platform, Alexander points toward Campaspe, but his gesture is drawn so that his hand appears to touch the artist's back. The image uses some of the same devises as earlier works (*The Oath of the Horatii*, for example) to structure the canvas into masculine and feminine sides, but now the composition seems to suggest that desire—not heroism or duty—is what binds man to man.

When Miramond reached into art's imaginary to figure the relation be-
tween Marie-Antoinette and Elisabeth Vigée-Lebrun, he was searching most
likely for a paradigm that would flatter both queen and artist, and provide
the mythological references appropriate to the norms of panegyric poetry.
Whether or not Miramond intended to make the point, his poem reveals that
the actual patronage relation of queen to woman artist disrupted the imagi-
nary relations that bound artists to rulers and ensured the "nobility" of art.
Their disruptive potential is suggested by the implications that follow from
identifying two women with ego ideals imagined for male artists. Placing
Vigée-Lebrun and Marie-Antoinette in those paradigms uncovered not only
their deeply gendered nature, but also—and this would have been the signifi-
cant point—the instability of identity.

When masculinity is secured through its distinction from the woman-
commodity (just as art's nobility is secured through its distinction from com-
merce), what happens if that founding distinction is erased? if woman ceases
to play the object of exchange and initiates her own exchanges with other
women? if she refuses to be the ground of man's identity and instead imagines
her own? What happens when there is no Campaspe to mask the homoerotic
desire in men's relations with one another? In thinking about these questions,
however, one must bear in mind that the subversiveness of retelling the story
of Alexander and Apelles through Marie-Antoinette and Vigée-Lebrun only
emerges in reading Miramond's poem *beyond itself.* His text tries to capture
the queen in an acceptable female paradigm (i.e., she is an enchanting Venus)
but has only a limited success, first because Campaspe keeps intruding into
the image and second because he introduces at this point no feminine model
to counteract the characterization of Vigée-Lebrun as Apelles. Moreover,
whereas Miramond weaves Vigée-Lebrun's mythological paintings into a
story about artifice and love, the portrait of the queen is not absorbed into the
larger narrative that links most of the other images. It just wouldn't do to
appropriate the queen's simulacrum for the story of a male viewer's erotic
fantasies.

Although its structuring of the images into a narrative poem is unusual,
Miramond's pamphlet nevertheless represents a type of Salon criticism in
which praise and denigration of the woman artist are no more than a hair's
breadth apart. One of its laudatory aspects is no doubt its emphasis on the
artist's relation to the queen. Consider, for example, how Miramond both
connects one of Vigée-Lebrun's history paintings, *Juno Borrowing the Belt of
Venus,* to the queen, and uses it to reabsorb the women into the "normal"
femininity they are constantly threatening to escape—not only in his poem,
but also in Vigée-Lebrun's paintings as well as in her actual role as the queen's

painter. Since the image is not a portrait of Marie-Antoinette, Miramond is free to suggest in passing a reference to the queen—one that also refers back to his praise of her portrait by Vigée-Lebrun—and at the same time to use the painting as a prop for his narrative.

The image of *Juno Borrowing the Belt of Venus* is lost, but as the Salon livret indicated, its subject was drawn from Homer's *Iliad*, in which the queenly and august Juno, wanting to seduce Jupiter, borrowed the magic belt of Venus. Miramond forces the association between Vigée-Lebrun and Marie-Antoinette that might already have been implied in the subject matter chosen by the artist, and through her image Miramond draws the conclusion that if Venus's belt can render a woman irresistible, the brushes of Vigée-Lebrun are a surer way to enhance a queen's—Juno's or Marie-Antoinette's—charms:

> To seduce Love changes her features with brushes.
> Juno borrows the belt from Venus.
> Lebrun (I have for proof your divine masterpiece)
> She is more certain of charming
> In receiving [the belt] from your hand.[94]

Miramond's connecting of queen and artist in this image may not have been as idiosyncratic as it may at first seem, for the pamphleteer was hardly original in writing Marie-Antoinette into the story of the magic belt. For example, the connection could be read in *Le Bijou de la reine*, a pocket datebook *(agenda de poche)* for 1780, which included verses and images of the royal family. That by M. de la Coutunelle, entitled *Quatrin à la Reine*, is of interest here:

> You renounce, Charming Sovereign,
> The most beautiful of your revenues.
> But what need would you have of the *ceinture de reine*
> When you have that of Venus.[95]

A note attached to the poem explains that Marie-Antoinette renounced the right called the *Ceinture de la Reine*, which was a particular tax levied on all wine coming into Paris and destined for the queen's household.[96] Thus the play on the belt of Venus and the belt of the queen here works in Marie-Antoinette's favor and announces her goodness in relinquishing a right of taxation. The scandalous *Portefeuille d'un talon rouge*, on the other hand, also cast the queen as a wearer of the magic belt. Its author repeated what young men allegedly reported of Marie-Antoinette's behavior at balls: when she was Dauphine, "it was Venus always decorated with her belt, and today it is only Juno always ready to torment and humiliate those who approach her."[97] The

important point for my purposes is that the story of the belt could seem an appropriate point of reference for the queen in two very different contexts.

If *Le Bijou* evoked the belt in praise of the queen's generosity, and the *Portefeuille* in condemnation of her pride, how did Miramond figure it? Recall that in the opening stanza of the poem it is Marie-Antoinette who is compared to Venus, but here the comparison is drawn with Vigée-Lebrun. As goddess of beauty, as purveyor of a magic belt that is artifice, as the quintessential "woman," the figure of Venus becomes Miramond's standard for measuring an equivalence between the two women. Each woman is valued less for her intrinsic properties than for her relation to a sign of womanliness. In the end, Miramond's poem projects the queen and her artist back onto a sexual economy that the images made by Vigée-Lebrun, at least in part, challenge.

The poem was conceived as a tribute to Vigée-Lebrun, and we can only assume that it flattered and pleased her. However, the story is that of male desire told by a narrator whose erotic fantasies about the paintings are recorded in the poem. From his point of view, Venus, Juno, artist, queen, and art object are all conceptualized as "woman," as a beautiful coquette who hides her true nature in seducing men. Miramond's work is partly based on the aesthetics of Roger de Piles in which the art object is bound to deceive, seduce, and please the viewer. Yet, in Miramond's poem, Piles's sensualist and colorist aesthetics are given a Platonic bite as the feminine art object is a false object of deception, dangerous to those it attracts.

Miramond's poem offers us a reading of Vigée-Lebrun's *Juno Borrowing the Belt of Venus* in the context of another history painting, *Peace Bringing Back Abundance,* and in conjunction with the latter image the narrator cites its "skilled artifice of colors," in what at first seems innocent praise:

> How the skilled artifice of your colors
> Revives the charms
> Of the propitious Divinity
> Who chases the demon of battles far from us.
> No more blood, tears, nor alarms,
> At her feet we place our arms
> One is only happy under her rule.
> But I see Abundance with all her charms.
> God! I am far from calm![98]

This section immediately locates *Peace and Abundance* in an economy of heterosexual desire and tames its more subversive potential. The narrator briefly describes the more masculine Peace, "who chases the demon of battles," but,

as his gaze moves to the figure of Abundance, he inscribes himself in another struggle, an emotional turmoil in which he is "far from calm." What follows is by far the longest section of the poem in which the narrator tries to seduce Abundance and praises her beauty by fragmenting her into various body parts: the dear labyrinth of her ear, her divine mouth, her sensitive eyes, her golden hair, her breasts that Venus would envy.[99] But Abundance turns out to be a coquette, desirable and sensuously dressed, but ultimately unattainable; when he tries to grab her there is nothing there. In the end, skilled artifice turns to "lying features," and "vain image."[100]

The next part of the poem goes to the heart of the matter as the magic belt figures the deceitfulness of painting and woman. "Vain images" and "lying features" are now "false objects" and "dangerous impostures":

> But the august Juno will deck herself *du Ceste:*
> Juno can prevail over Venus this day.
> Too happy Master of the thunder!
> If I could . . . dare we declare war on him . . .
> Madman! Flee rather from false objects
> Of an imitative art, dangerous imposture![101]

The section concludes with his comparison (cited above) of the belt's power to produce illusion with Vigée-Lebrun's ability to make beautiful semblances. In this first reference to Juno's borrowing of the belt, however, Miramond refers to the goddess decked *du ceste*, a term that points to the belt Greek daughters wore to designate their *état* as unmarried women. For the ancients this belt called *ceste*, was the symbol of modesty and chastity, and the Amazons adopted it for their own. From this belt, however, came the fables of the "ceste fameux de Junon et sur celui de Venus" to which poets attached the power of inducing love.[102] Modesty, coquetry, artifice, and female authority are suggested in decking oneself *du ceste*. The belt's fundamental meaning, however, is that of chaste modesty.

Modesty, as we have seen, has long been considered a primary feminine characteristic, one formative of the eighteenth-century dialectic of desire, and central to more recent psychoanalytic thinking about woman's nature (which the earlier theory intuitively summarized, to use Le Doeuff's term). Artifice and deception have long traveled with modesty; for Rousseau, true modesty had its complement in "false modesty," which was nothing more than sanctioned coquetry—woman's artifice put to the service of male desire. Freud associated modesty with artifice in a more literal way. Since modesty had for its purpose "concealment of genital deficiency," woman's artifice—or rather her artfulness—was entirely related to this property. The only cultural inven-

tion Freud allowed woman was that of weaving, which he claimed was nothing more than her imitation of nature's model for hiding her lack—i.e., her pubic hair.[103] In this system, woman's artifice is deceptive; it fools men into thinking that there is something to see, something behind the veil behind which there is no-thing. Yet that deception is again necessary to women in their desire to be the phallus—to be the object of man's desire. In gauging the effect of modesty foisted upon women for so many centuries, Irigaray concludes that if woman must weave to sustain the disavowal of her sex, this weaving represents all the artifice, all the veiling, all the wrapping, all the ornament, and all the deception that women must use to make themselves desirable to men.[104] With all women so wrapped, they become interchangeable, so many fetish objects, so many belted Venuses.

Coquetry has been painted as dangerous artifice because woman's sexuality has been deemed dangerous. In veiling that danger, the coquette tempts in the same way that Parrhasios tempted Zeuxis, since she knows that there is nothing behind the veil, nothing to see. At the beginning of the eighteenth century, Roger de Piles turned the deception—the coquetry—for which art had been condemned into its greatest strength and celebrated the effect of art's seduction as an analog of physical desire. Miramond's poem suggests, however, that moral censure could not be kept from Pilesian aesthetics, not in 1783—and especially not when there was a woman in the picture.

Miramond's poem forestalls the subversive potential of the woman in the picture by putting Vigée-Lebrun and her work into the recognizable (if also dangerous) feminine figure of the coquette. In an odd way, the coquette-artist can allay male fears of her *professional* achievement by folding it into (what was considered) her natural "feminine" behavior. But her feminine *masquerade*, to invoke Rivière's term, is here not part of the woman artist's performance, but an interpretation, an emblem of her performance devised by the male poet.[105] Yet alongside that poet's coquette was Apelles, who as painter to her Alexander exceeded the role Miramond gave her. As Apelles, Vigée-Lebrun slips through the cracks in Miramond's text (the same cracks through which Campaspe entered), and escaping from his poem goes beyond her appointed role and unexpectedly shakes—if only momentarily—the foundation of sexual identity.

Vigée-Lebrun's images, on the other hand, can be more consistently read outside the masculinist discourse represented by Miramond's poem. Recall, for example, how in her *Souvenirs* the contextualization of *Venus Tying the Wings of Cupid* within a larger dismantling of the boundaries between male cultural production and natural female reproduction undercut contemporary ideas about woman's lack of cultural achievement, or how *Peace and Abundance* could challenge the male painter's presumed authority in depicting the female

body, how it suggested to some Salon critics that the Graces had learned to paint themselves. In the next two chapters I aim to demonstrate how three other images shown at the Salon of 1783, her *Self-Portrait*, *Portrait of Marie-Antoinette*, and *Portrait of the Marquise de la Guiche as a Milkmaid* can be understood as disrupting the widespread conceptions of woman represented in Miramond's poem. If the magic belt of Venus lent to Juno could be construed as the brushes of Vigée-Lebrun on loan to Marie-Antoinette, nowhere did that borrowing become more problematic or subversive, depending on your point of view, than in Vigée-Lebrun's portrait of Marie-Antoinette *en chemise*, the most immodest entry in the Salon of 1783.

FIVE

The Portrait of the Queen

The Queen's New Clothes

Imagine yourself a visitor to the Salon of 1783 gazing on the portrait of Marie-Antoinette painted by Elisabeth Vigée-Lebrun (figure 18). You see the queen sporting a straw hat and dressed fashionably in a simple gown of white muslin tied with a sash at the waist. How are you responding to the image? What narrative are you generating from the portrait? Ah, but you cannot have a response, you cannot generate a narrative until I tell you just what sort of visitor, even which particular visitor, you are; until you can measure your distance from (or proximity to) the viewer generated by the portrait itself. Marie-Antoinette appears at the Salon, but for whom, and as whom, is she appearing?

Vigée-Lebrun's portrait particularly raises these questions because the public decried it, even forced Vigée-Lebrun to remove it from the Salon. Why did this portrait disturb? What of queenship was or was not represented there? The immediate answer isolates the unsuitability of the costume *en lévite* or *en chemise* for public appearance. Imported from England in the 1780s and adapted by the famous dressmaker, Rose Bertin, the *robe en chemise* was made from sheer white muslin (called mousseline), fastened down the back, and caught at the waist with a sash. The underskirt and corset, which ordinarily showed through the transparent muslin, were often of blue or pink silk. A soft fichu, usually of linen gauze, and a straw hat completed the ensemble. The style was immensely popular in England, where it made a fashion statement for the "natural woman," suggesting simplicity and honest sentiment. In France, however, the formalities of the court made these simple styles less acceptable; for public appearances the *robe en chemise* was considered immodest, even though it revealed far less of the body than traditional court dresses with deeply scooped necklines. On the other hand, the *robe en chemise* was included in the *Cabinet des Modes* of 1786 under informal wear. When worn

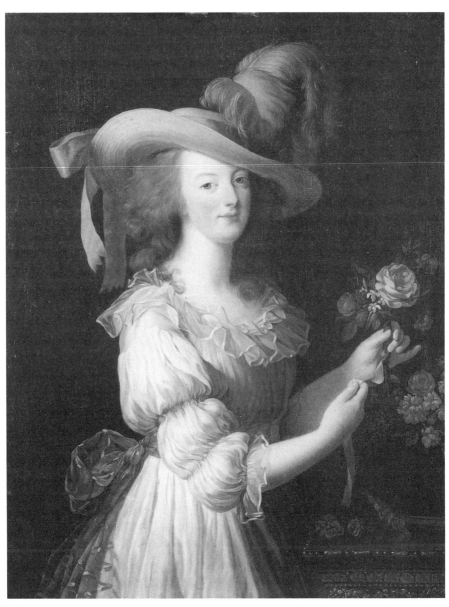

Figure 18 Elisabeth Vigée-Lebrun, *Marie-Antoinette en chemise*, Salon of 1783. Private
Collection, Germany

outside the boudoir or private chambers, such dress was usually reserved for walks in the park, for picnics, or for playing milkmaid with a few friends. Because this dress became closely associated with Marie-Antoinette, many called it the *chemise à la reine*.[1] As simple as these lingerie frocks might seem, they were—at least in the early 1780s—still a luxury garment made from very fine cotton fabric purchased only at considerable expense. It is unlikely that Vigée-Lebrun wore such a cotton dress when she painted in her studio, as her *Souvenirs* claim.

The *Correspondance littéraire* suggests that some Salon visitors were shocked by the impropriety—the immodesty—of the queen appearing publicly in such attire: "Earlier one noticed among the portraits of this amiable artist that of the *Queen en lévite*, but because the public seemed to disapprove of a costume unworthy of Her Majesty, [Vigée-Lebrun] was pressed to substitute for it another with an attire more analogous to the dignity of the throne."[2] The *Mémoires secrets*, always quick to publish the latest gossip on Vigée-Lebrun, complained about her showing an august person in garments reserved for the palace interior. The article went on, however, to shift the blame away from the artist, assuming that the painter was not authorized to take such a "liberty," without the consent of her sitter.[3]

Other pamphleteers were more clever in their criticism. In *La Morte de trois mille ans*, for example, comments about the queen's attire *en chemise* were indirect, but nonetheless censorious. Simultaneously reporting and commenting on the reactions of the Greek maiden Dibutadis visiting the sculpture court, the narrator tells his reader that:

> although it was an ancient practice, she found the fierce Achilles a bit too familiar for appearing nude before the ladies. He draws his sword undoubtedly to frighten those who would disapprove of his nudity. At least his attitude pleases. The ladies who appear in public *en chemise* cannot be overly critical of his attire. Their own contrasts with the noble simplicity that was the adornment of the beautiful Greek maiden.[4]

Seen in public and in mixed company, a woman garbed *en chemise* is as inappropriate as a nude man—and much less pleasing. Her dress is no more modest than his nakedness, and it stands in pointed contrast to the Greek maiden's "noble simplicity." Armed with his sword Achilles can fend off all critics, but the woman *en chemise* is defenseless; she cannot even point a finger at the warrior's undress.

A second pamphlet, *Momus au Salon*, is even more subtle, including a character described as a "marquise en chemise." The marquise plays the role

of fashionable woman, at least as that role was described in moralizing tracts: she goes to the theater, sleeps until noon, and seduces the men around her. At one point while she is boasting about her ability to judge painting, the marquise declares herself "not modest," a comment that has a resonance beyond claiming her expertise as a connoisseur. As to her preferences, the marquise loves the soft touch that is perceptible in works by Vigée-Lebrun, and she is particularly fond of La Grenée's "little paintings." Her taste is thus far distanced from the "noble simplicity" favored by the Greek maiden.[5]

Years later, Vigée-Lebrun described the controversy surrounding this portrait of Marie-Antoinette. Writing in her *Souvenirs* of the many images she made of the queen, she focused her attention on this one: "One among the others represented her donning a straw hat and garbed in a dress of white muslin with sleeves folded up, but quite orderly; when it was shown at the Salon, the malicious did not refrain from saying that the queen was represented in her underwear."[6] These reports of negative responses, however, contrast with other recorded ones, underlining the obvious point that reaction to the queen's portrait depended on who was looking when and where. The queen herself apparently admired the work; she sent three versions of it to close women relatives and in 1786 judged it as the most resembling of all her portraits.[7] Vigée-Lebrun's *Souvenirs*, in addition, include a report of another public's response to the image:

> This portrait in any case was not less of a great success. Toward the end of the exhibition there was a little play at the Vaudeville which, I believe, was titled "The Union of the Arts." Brongniart, the architect, and his wife, whom the author had taken into his confidence, had reserved a box in the front and came to find me on the opening day to take me to the spectacle. As nothing prepared me for the surprise that awaited me, you can imagine my emotion when Painting arrived, and I saw the actress who represented her imitate me in a surprising manner in painting the queen's portrait. At that moment everyone in the parterre and in the boxes turned toward me and broke into applause. I do not believe that anyone could ever be so touched, so recognized as I was that night.[8]

Although the divergence of these responses leads to the obvious question of what these audiences saw when they looked at the queen's portrait, a more fundamental question might be, what did they expect to see in a publicly exhibited portrait of the queen? If a portrait of Caesar was Caesar, and a portrait of Louis was Louis, what then was a portrait of Marie-Antoinette, a particular queen of France? To ask this question is to call forth a narrative that aligns

Vigée-Lebrun's portrait of the queen and Louis Marin's *Portrait of the King*. I set these as companion pieces to explore the queen's portrait as it relates to Marin's chiasmus: representation of power and power of representation. I also aim to write the possible histories (and historical possibilities) of viewing Vigée-Lebrun's portrait of Marie-Antoinette.

The Representation of Power and the Power of Representation

In his now classic text, Louis Marin considered the face of absolute monarchy, Louis XIV, whose cultural ministers, historians, and painters deployed the power of representation to maintain a particular political imaginary suited to the pleasures/demands of the state.[9] Sustaining this imaginary was an official aesthetics that Marin summarizes in three statements: the king's motto, "L'état, c'est moi"; the Catholic maxim, "Ceci est mon corps"; and the Port Royalist's utterance, "Le portrait de César, c'est César."[10] Playing on Ernst Kantorowicz's notion of the king's two bodies as the essence of a medieval theological kingship, Marin proposes for classical absolutism:

> The king has only one body left, but this sole body, in truth, unifies three, a physical historical body, a juridico-political body, and a se-miotic sacramental body, the sacramental body, the "portrait" oper-ating the exchange without remainder (or attempting to eliminate all remainder) between the historical and political bodies.[11]

In attempting "an exchange without remainder," the portrait, the king's sac-ramental body, is the site where the physical body of a man-king and the theo-retical body of a nation-state are married. Indeed, the man-king is only "absolute monarch" in images. Marin concludes that a belief in the effective-ness of these iconic signs is obligatory, or the monarch is emptied of substance. The portrait is thus both semiotic, that is, constituted of signs; and sacramen-tal, a political Eucharist in which the king is truly present. Like the Host, the king's portrait is consumed by the faithful.[12]

Three terms: representation, power, and imagination emerge as central to Marin's thesis. As defined by Marin, the representational framework has both the "effect and power of presence instead of absence and death and the effect of subject, the power of institution, authorization, and legitimation."[13] Representation does not simply signify a preexisting subject who is else-where—it constitutes its own legitimate and authorized subject by exhibiting qualifications, justifications, and titles of the present. Power is the *ability* to exert an action on someone or something, and as Marin defines it power stands in a constant and shifting relation with its own potentiality, force, and

representability. Power valorizes potential as obligatory constraint, and "in this sense power means to institute potential as law."[14] More important to Marin's argument, force represented is potential and power, because representation, which has the power of presence and the power of institution, puts force in signs. In other words, the representation of force is doubly forceful; force is both the signified of representation and an attribute intrinsic to it. "Representation in and through its signs represents force: as delegates of force signs are not the representatives of concepts but rather the representatives of force, which can be grasped only in their representational effects; the power-effect of representation is representation itself."[15]

Marin considers representation a "delegate of force" because it institutes an imaginary order of relations between the king's subjects and the state. What gives power to power's discourse is the imagination's potential power; through imagination subjects internalize the master's discourse as a representation of obligatory belief. The portrait of the king, then, represents (constitutes and authorizes) the relations that different subjects imagine themselves to have with the king-state.[16]

At first glance, Marin's text, dealing as it does with Louis XIV and classic absolutism, may seem remote from the portrait of a reputedly frivolous queen made when the French monarchy, greatly desacralized, had lost much of its mystical power. Yet the framework in which this particular queenly portrait was presented mediates between the Sun King and the ill-fated queen. The portrait appeared in the Salon of 1783, a Salon conceived by d'Angiviller as a move in his plans to revive the *gloire* of French art during the reign of Louis XIV. Fashioning himself as the new Colbert, d'Angiviller wanted to restore power to representation, a power he perceived it had lost during the reign of Louis XV, and to make art once again an important instrument of state. In this Salon, however, hung a portrait of the queen exhibited by a woman, that both stole the show and embarrassed the monarchy. And this woman—Elisabeth Vigée-Lebrun—was herself a focus of interest, provoking panegyrists to rework the story of Alexander and Apelles for Marie-Antoinette and her painter. D'Angiviller could hardly miss or approve of the comparison made problematic because this queen was changing the meaning of Louis's domain at Versailles, or at least of a part of it.[17] Not only the power of the artist, but also the power of the queen was implicated when the *Mémoires secrets* pronounced that the scepter of Apollo had fallen to the distaff side. Take away the qualification "of Apollo," and the phrase is identical to that used to describe female rule. The scepter falls to the distaff side when a woman rules or when rule is inherited through the female line. Thus there is an implicit parallel between the reputed triumph of her woman painter and the imagined ascendancy of

the female monarch. This comment might have further resonated through the image of *Peace Bringing Back Abundance*, since the king, the traditional bringer of peace, is absent in this allegory. It focuses, instead, on a relation between the two naturalistically rendered (allegorical) women.

Marin's text provokes several significant questions when read with Vigée-Lebrun's portrait of Marie-Antoinette in mind. How does a portrait of the *queen* serve the aims of the state? What relations of representation, power, and imagination are at work in the queen's portrait? What does it mean to represent the queen? In his *Portrait of the King*, Marin explicated a system of power and representation in which each portrait of Louis XIV meant the same thing, and seemed to mean it absolutely—that is, for every viewer at every moment. The central chiasmus (representation of power and power of representation) figures a closed system, for it places the two terms as mirror, that is reversed, images of one another. (For Marin, when the king looks at his own portrait he contemplates himself, as if in a mirror). This closed figure that defines the aesthetic of absolute monarchy recalls the sort of chiasma discussed by Michèle Le Doeuff and explored here in Chapter 1.

The chiasmus/chiasma is a figure both authors deploy to show how all meaning can be reduced to one meaning in a totalized system. Eliminating any means of escape from the chiasmus, closing out the possibility of refusing the absolute monarch that it figures, Marin uses the chiasmus as a way to explicate how belief is structured by representation and to elucidate the repressive structure of absolute monarchy in colonizing the subject's (the subjected's) imagination. In Marin's text the chiasmus defines absolutism played out in/on the represented body—the portrait—of the king. Marin demonstrates how through representation the king is authorized as subject, as absolute transcendent Subject. In Marin's analysis there is an implicit filiation between "absolute monarch" and signifieds like Law, God, and Phallus. The absolute monarch's whole and self-sufficient body is of an entirely different order from the mutilated body of the castrated and pan-hysterized woman Le Doeuff sees figured by the chiasma of physiologist Pierre Roussel.[18] In Roussel's chiasma (as in later psychoanalysis) the representation of woman in no way authorizes her as Subject, but works to constitute her as lack, as absence, as that which cannot be shown because she has nothing to show. Woman has no means of identifying with the phallus and no synonymy with the divine.

Salic/Phallic Law

It should surprise no one that the French monarchy depended on the suppression of woman's claims to the scepter. Indeed, one could suggest three

other sentences that characterize this gendered side of absolutist aesthetics. The first of these comes from Antoine Loisel's maxims (1607) and condenses the Salic Law: "The kingdom cannot fall to the distaff side."[19] The second, drawn from Bignon's, *De l'Excellence des roys et du royaume de France* (1610), justifies that law: "This is not a written law but one that was born with us that we have not invented but drawn from nature itself."[20] And the third, from Guy Coquille, *Institution au droict de François* (1588), separates the queen—the king's wife—from the body of the king and hence from state power: "The king is monarch and has no companion in his royal majesty. External honors can be communicated to the wives of kings, but that which is of his majesty, representing his power and dignity, resides inextricably in his person alone."[21]

Salic Law determined kingship by the right of succession and excluded from succession females and males descended in the female line. Thus where there were queens of France, there were no French queens. The queen of France signified the wife of the king, and "queen" had no meaning except in relation to "king." Salic Law was considered first among the fundamental laws of France, which were laws perceived as anterior to all other laws and hence constitutional of the nation. Although by 1610 the Salic Law seemed to French-men "born with us," it was not "drawn from nature itself" but manufactured in the early 1300s by Philippe V during a disputed secession.[22] Confirmed by the Parlement and emphatically celebrated as "maintaining all others," Salic Law was early on contested by women like Christine de Pisan, who found it new and offensive. She observed that in earlier times the reigns of French queens were just and moderate, and that they were beloved by their subjects. Also in the sixteenth century, Marie de Gournay noted rightly that Salic Law, devised to decide a disputed succession, was enforced only in France.[23] And this is important to note: France was the only kingdom in Europe that prevented rule by women. Better a dynastic line should die out than the scepter fall to the distaff side!

Although the sacredness of monarchy and its mystical character was widely challenged in the Enlightenment—at least in philosophical circles—part of the Salic Law and its seventeenth-century justifications fit well with thinking on women that crossed political boundaries during the *ancien régime* and Revolution. Jurists such as Le Bret in his *Traité de la souveraineté du roi* justified the exclusion of women on the basis of natural law. Salic Law, he argued, conformed:

> to the law of nature which, having decreed woman imperfect, weak, and debilitated, as much in body as in mind, has submitted her to the power of man, whom she (nature) has . . . enriched with a stronger

judgment, more assured courage, and a stronger physical force. Also
we see that divine law wants a wife to recognize and render obedience
to her husband as to her master and to her King.[24]

The fundamental law of France, Salic Law, is thus justified along the same
lines as those laws that prescribed a wife's *état* as one of subservience to her
husband.[25] No exception can be made here—even for a daughter of the king.

When in the eighteenth century some public representations of monar-
chy were calculated to characterize the king as a benevolent father rather than
Roman *paterfamilias*, the queen's position did not change. She had long been
the first of the king's subjects, owing him obedience as husband and ruler. The
image of the benevolent father visible in royal monuments, however, was not
particularly evident in official state portraits, which continued to represent
kingliness and majesty.[26] State portraits of kings remained fairly constant in
type from Louis XIV to Louis XVI, and the same is true of the queen's official
portraits. A queen is a wife, and an official portrait of the queen shows the wife
of the king; it is always a (possible) companion piece to the king's portrait.

Carle Van Loo's portrait of Queen Marie Lesczynska (figure 19), com-
missioned for the Royal collection and shown in the Salon of 1747, represents
the type for the queen's public portrait. The painting is large-scale and shows
the full-length standing figure; the pose, although formal, is not stiff, and the
attitude suggests regal bearing in its straight lines and stability. Indeed, the
portraitist establishes a virtual line that runs the length of the body through
the boned bodice, which comes to a point at the center of the queen's waist,
and the highlighted crease at the front of her dress. The downturned folded
fan she clutches in her left hand emphasizes this line, which can also be imag-
ined as extending upward from the point of her bodice, through the middle of
her jeweled pendant and face. Thus centered, the queen becomes one of three
strong verticals that define the picture; she is as solid as the columns to her
right and left. In what is something of a tour de force, Van Loo manages to
associate the queen, standing before us in her elaborate and frilled court dress,
with these strong verticals, more than with the ornately carved rococo table
leg curving prominently in the left foreground of the composition. We imag-
ine her not as serpentine and seductive, but as standing straight and erect un-
derneath the mounds of costume. The overall shape of her dressed body,
moreover, tends toward a stable triangle, with the curve of her waist more or
less straightened out by the fall of her cape. Comparing this type of queen's
portrait to state portraits of the king, say Van Loo's *Louis XV* (figure 20),
shows a gendered contrast also at work. Kings look active and queens immo-
bile. Kings partake of the energy encoded in the agitated drapery that swirls

Figure 19 Carle Van Loo, *Portrait of Marie Leczynska*, 1741. Versailles:
 Musée du château

around them, and their taut leg muscles visibly protruding suggest the force
attributed to the male body.

 As is typical in official portraits, the queen, Marie Leszczynska, is dis-
played in elaborate court costume. Her dress bedecked with ribbons, lace, and
gold embroidery, and the gold tonalities in the dress and furnishings suggest
an opulence likewise marked in her jeweled hair, neck, and arms. The room is

Figure 20 Carle Van Loo, *Portrait of Louis XV*, 1741. Versailles:
 Musée du château

as ornamented as the queen, with inlaid marble floors, marble-top table elabo-
rately trimmed in gild rocaille, and other furnishings. Marin suggested that to
be elegant is to show that a great number of people have worked to produce
the effect. Hair, embroidery, ribbons, and the like are in the people's eyes
effects of force—signs of work at work to show how one can make others
work.[27] The queen's portrait, however, points not to her own force and power,
but to that of the king. The markers of high status are clarified by the attri-

butes of queenship—Marie's crown resting on a nearby table and her ermine trimmed cape with fleur-de-lys lining. The defining quality of queenship—her relation to the king—is signified twice, first because the image appeared as a companion piece to Van Loo's portrait of Louis XV, and second because Louis appears within the painting as a portrait bust on the table. The king seems to be gazing down at his queen as she looks out at the audience. Although viewers cannot share the king's gaze, they can imagine themselves exchanging glances with the queen. At the same time, they see him looking at her, and can envision him as re-presenting, or authorizing, or even authoring her. From the king's gaze the whole top half of the composition—the queen's face and upper body—is framed in a space defined by his triangle of vision.

The problem in making a public portrait of the queen is how to eulogize the absolute monarch through a portrait of his wife, how to show the king's force in a portrait of the queen. Marin has argued that in representation to be elegant is to show and to be one's appearance, and also to present oneself to others and by that to represent oneself through one's image in the gaze of others.[28] The queen here is represented through her image as the regal and elegant consort not only in the gaze of her subjects (those who are the real viewers of the painting), but also in the gaze of her husband, the king—who is the real Subject in and of the painting. Although Marin argues that to be elegant is to show and be shown, to assume both the subject and the object position, here the queen is the object of the king's showing. Marie Leszczynska is represented to us as queen, but the authority that allows her representation is vested elsewhere; her image always refers to that authority.

The portrait of the queen, then, creates a subject "queen of France" that refers to a position a woman holds because she is wife to the king of France. Not an accident of birth, but a legal contract changes the historical woman into a queen. For her there is no transubstantiation to bestow monarchical power. A different sacrament—that of marriage—determines her destiny by guaranteeing her subservience. The title (état) of queen, like that of wife, held no authority or right to govern. And the queen held no relation to the kingdom or to the state independent of her relation to the king. The wife of the king, a queen was expected to be the mother (or grandmother) of a king, and her function was to produce a son or sons. As Marie-Thérèse wrote to Marie-Antoinette: "to bear children, that is why you have been summoned; it is by bearing children that your happiness will be secured."[29] Here I am reminded of an engraved image depicting the young queen, Marie-Antoinette, that circulated with the inscription: "Marie-Antoinette, Archduchess of Austria, Queen of France. A Generation! You of small size bring such a fertile shoot

from the stock of your ancestors."[30] The motto was well chosen, for Marie-Antoinette's mother, her ancestor, bore sixteen children. Indeed, the Hapsburg women made fertile stock.

The queen's fertility was a major concern, but as royalty was conferred only by the father, she was the medium through which power was exchanged between father and son. After the line was ensured, the queen was superfluous. Kings who outlived queens satisfied themselves with unofficial wives (e.g., those married without public acknowledgment) as Louis XIV did with Mme de Maintenon, or with mistresses, as Louis XV did with Mme Du Barry. Power passed through the queen's body, but was not part of her. The king's majesty could not be shared with her, but it could not be passed on without her.

This point brings me back to the third and final proposition of the aesthetics of queenship: "The king is monarch and has no companion in his royal majesty. External honors can be communicated to the wives of kings, but that which is of his majesty, representing his power and dignity, resides inextricably in his person alone." In terms of the relation between king and queen, the third proposition is very significant. In some respects they did not have the same relation as other married couples, especially when marriage was conceptualized as a uniting of two individuals into one "body," with the husband as the head.[31] This view of marriage could not obtain for the king and queen, because only in *his* person, thought by tradition to be united to the state, resided majesty, power, and dignity.

The queen, moreover, did not share community property with the king. Another of the fundamental laws of France conceptualized the king's domain as an attribute of sovereignty, and sovereignty could not be subdivided or alienated, that is, shared with the queen or anyone else. What was acquired by kings went to the profit of his kingdom, which came to be thought of as the king's "most privileged spouse."[32] Thus the king had two spouses—the privileged one, or the kingdom, which shared his sovereignty, and the alienated one, or the queen, who was separated from it. Indeed, since the sixteenth century various marriage metaphors described the king's relation to the kingdom: "the king is the *husband and political spouse* of the *chose publique* (the kingdom) which brings to him at his *sacre* and Coronation the said *domain as the dowry* of this Crown. And kings swear solemnly at their sacre and Coronation never to alienate that dowry."[33] Later, under Louis XIII, the Coronation was figured as "a kind of sacrament through which the king is made the husband of the kingdom (*royaume*), which he marries that day by the ring . . . placed on his finger as a sign of spiritual marriage."[34] Perhaps to suggest a closer relation to

the king, queens (for example, Marie de Medici) sometimes appeared in allegorical representations in the guise of France, even though they could not be France.[35]

The marriage metaphor persisted through the eighteenth century, appearing, for example, in a 1771 satirical pamphlet burlesquing the parlementaires' claims to power. The pamphlet is cast as a protestation of Parisian women, who claim that the king, like a husband, should appear powerful and maintain the "external signs of sovereignty" over the nation, his wife, but real power should belong to the Parlements, likened to a cherished lover.[36] Finally, from the notion of a marriage between the king and the kingdom came the tradition of calling the dauphins the children of France.[37]

When the king is married to the nation, and his children are the children of France, the queen is—at least metaphorically—displaced as mother of the (future) king. There could be no coordination between the queen's body and that of the other wife—the *royaume*, or France.[38] Queens are theoretically and symbolically foreign to the kingdom, so the portrait of the queen operates no exchange between the real historical woman and the political body/state. Unless the presence of the king is indicated, nothing closes the representational play of the queen's portrait. This is perhaps why all queens, as Hunt and Revel respectively have said of Marie-Antoinette, have "many bodies" or are "paper queens."[39] Indeed, their queenship exists only on paper—on marriage documents.

Where then does all of this leave the queen of France? Although she had no right to rule, did not share the king's majesty, and was alienated from kingdom and state, the queen was not, in practice, powerless. Under absolute monarchy queens could take part in administration, primarily by sitting on the king's council comprised of his Court and other devoted servants. Although the importance of this Council declined between 1723 and 1789, Marie-Antoinette did gain permission to join it during the reign of Louis XVI. The queen could rule if and only if the king named her regent, but this was an office entirely separate from the fact of queenship, even though the two sometimes coincided. As regent the queen ruled by appointment of her husband the king, usually in the name of her son the king. This opening for female power, however, was closed during the Revolutionary period. In March of 1791, the National Assembly decreed that if the crown passed to an underage son, the king's closest *male* relative, as defined by the laws of succession, would become regent. The timing of this decree again reminds us that fear of female rule was particularly heightened by the specter of the "monstrous" Marie-Antoinette.[40]

Aside from the privileges connected to the monarchy's administrative

function, the queen also had certain powers associated with the honors of queenship. For example, when she made a solemn procession of entrance into a city, she was allowed to grant letters of remission to prisoners held there. Like the king, she could plead through the Procureur général. She was exempt from Chancellery dues, and on her private lands she enjoyed privileges accorded the Crown domain. She had her own household, but unlike that of the king, the household was dissolved at her death. Unlike the king, the queen could die.

Although the queen had no relation of her own to the kingdom, she was fated to live in the gaze of Court and populace. As the king's consort, she was the object of elaborate court rituals and spectacles of viewing, and she had little or no private life, in the sense of a life apart from her position as queen. At court, the queen did not own her own body. She was dressed and undressed in elaborate ceremony; her giving birth was a major public spectacle. Yet she was not as completely a public person, or as completely the public's person, as was the king, for her theoretical relation to Court and nation was that of outsider alien to the "chose publique."

As an outsider, the queen could raise fears of overstepping her boundaries, of having too much power over the king, her husband, or the king, her son. In the first case, her power could come from the place where women were perceived to exercise their authority—the bedroom. Historically, however, this sort of female power was divided, because the king took various official and unofficial mistresses. Holding a position at court, the official mistress could be much more than the king's sexual partner; she was often a friend, confidant, and trusted advisor. A wife, an official mistress, and a proliferation of unofficial ones helped ensure that female power was fragmented. Yet wives and mistresses did exercise power, if only covertly or behind the scenes, and as Lynn Hunt has recently reminded us, we must "insist that women were viewed as threats because they could act and not just because they were convenient figments of the male imagination."[41]

In conjunction with Hunt's point, it is important to note that in the late eighteenth century two women—Marie-Thérèse and Catherine the Great—wielded the scepter over large empires, and that a third woman, Madame de Pompadour, had earlier exercised considerable power in France as the *maîtresse en titre*. Louis XVI was not a womanizer and he had no official mistresses. Thus his queen, Marie-Antoinette, seemed the most influential woman in his life, and her influence was undiluted, a situation complicated by the perception that Louis was a weak ruler and man. Marie-Antoinette was an archduchess and daughter of an empress; she presented the real and imagined threat of allegience to her mother's house.

Marie-Antoinette Portrayed

In the French imaginary, royalty was incestuous. The dauphin, the child of France, fulfilled the Oedipal fantasy of marrying his mother, France, at his coronation, when she became his privileged spouse. In practice the historical woman who became queen of France, at least in the seventeenth and eighteenth centuries, represented a principle of exogamy. Because the importation of a (foreign) woman was necessary for the proper running of the monarchy, the queen of France can be construed as a sign of political alliance between two families or houses. The portrait of the queen can underscore and/or mask this meaning of queenship.

Consider, for example, what was arguably the most famous portrait of a queen available in eighteenth-century France, the image of Marie de Medici contained in *The Presentation of the Portrait* (ca. 1625) from Rubens's famous series. In that panel, Juno and Jupiter watch as putti present to Henri IV the portrait of Marie. Although in reality she was chosen as a wife because of political needs and in exchange for debt relief, the king seems immediately smitten with her image, gazing on it as a love-struck suitor. Marie's position in a dynasty is not visible in the bust portrait, and her personal attributes are left to attract the king. The portrait presents itself as a representation of Marie's charms, and it seems to elicit from Henri the effects of love. This image of love speaks Marie's attractive powers, but also the power of representation not merely to represent, but to create or induce attraction.[42] Rubens hides the exchange value of the queen and accrues power to her representation, not as dynastic symbol, but as desirable woman. She has the power that all beautiful women were traditionally reputed to possess. Bear in mind, however, that Marie de Medici's portrait was presented in a work designed for her; as regent, her interest was to underplay her outsider status and position as an object of diplomatic exchange. The image of a close and trusting relationship between herself and the deceased king could only help secure her position.

In relation to queenship as diplomatic exchange, the making and viewing of Marie-Antoinette's portrait has an important history. Before Louis XV would close the deal with Marie-Thérèse, a deal negotiated over four years, he wanted to see a portrait of the young archduchess. The one who must, so to speak, fall in love with the portrait is the father (or in this case the grandfather), which suggests that the girl Marie-Antoinette (only fourteen years old) was judged not only on her diplomatic value, but also on her potential as a woman. There seems to be a peculiar belief in the truth of the portrait or in its power to capture beauty, taken as a signifier of future fertility. But we can-

not really know why Louis insisted on having this portrait. Perhaps he understood it as his prerogative, since it was traditional to be supplied with such an image. Perhaps he, sly old fox, was also drawing out the negotiations, extending the courtship. For her part, Marie-Thérèse seems never to have been satisfied with any portrait, and she repeatedly delayed sending a definitive one, as if no artist could really capture the beauty of her daughter—always implying that there was more, something that could not be represented.[43] Always leaving something to the old king's imagination. Perhaps she knew the value of prolonging the anticipation. The entire business about the portrait seems to have been a diplomatic game between the lascivious old father- king and the virtuous empress-mother. Already impatient, Louis wanted to send France's most distinguished portrait painter, the academician Drouais. But Drouais overestimated the king's desire and asked too high a price. In the end, in late January of 1769, Louis sent the painter Ducreux—who was not even an academician— to do the job. A hairdresser went with him, because Marie-Thérèse wanted to ensure that her daughter would look as French as possible.[44]

The portrait that sealed the deal is now lost, but Gautier-Dagoty represented it in another image, an engraving, which shows the Duc de Choiseul, who brokered the marriage, holding the long-sought likeness (*Louis XV Presenting to the Dauphin the Portrait of Marie-Antoinette*, 1769; figure 21). The success of frenchification is evident here, as the woman seen in the portrait— Marie-Antoinette—is nearly the mirror image of the court lady—the king's sister?—standing next to the portrait. Although this similarity can easily be chalked up to the artist's mediocre skills, the effect on the viewer, the effect of sameness, is appreciable, whether or not the artist intended to make it so. Not only does the young woman look like the image of Marie-Antoinette, but her hands and fan are held in such a way as to frame her upper body in an oval shape mimicking the portrait's format. Glancing back toward the Dauphin, she assesses the effect of her portrait-double, even as the other women seem to evaluate the sitter's looks. But all this builds from the periphery inward. Louis XV holds the center, seated, with his grandson the dauphin standing alongside him. They are holding hands—a sign of dynastic continuity—and behind them hangs a portrait of the deceased queen surmounted by a double portrait of king and queen. Busts of Henri IV and Louis XIV are also evident in the background. Gautier-Dagoty's work is much more a portrait of dynastic succession and diplomatic mission, than a portrait of falling in love. The work focuses on Louis XV who appears not only as the leading character, but also as the principal spectator of the event. If one speculates that not only Marie-Thérèse, but both aging monarchs pinned their hopes for peace and stability

Figure 21 J. Gautier-Dagoty, *Louis XV Presenting the Portrait of Marie-Antoinette to the Dauphin*, 1769. Paris: Bibliothèque Nationale

in Europe on the alliance between their houses, this painting represents the last great diplomatic initiative of Louis XV's reign. The king must be central to his own accomplishments.

If the history of making Marie-Antoinette's portrait is bound on one side by the French king, it is determined on the other by the Hapsburg empress. The approval of Marie-Thérèse, the queen's mother, seems to have secured Vigée-Lebrun her position as favored portraitist. The correspondence of Marie-Thérèse, her agent Count Mercy, and Marie-Antoinette shows the empress anxious to have appropriate images of her daughter. As a mother, she wanted private portraits to remind her of the child sent away; as empress, she wanted public statements of queenship. It was in conjunction with the latter that Vigée-Lebrun was first successful. The artist began making the queen's image by copying for the Menu-Plaisir portraits that other artists had painted of Marie-Antoinette (a steady supply of such copies was needed to meet diplomatic requests). Why and how Vigée-Lebrun was called to paint the queen

from life is not clear, but it is evident that both queen and empress were exasperated by the official images made by other painters.

Marie-Thérèse spent nearly a decade trying to obtain an official portrait of her daughter that pleased her.[45] After commissioning a work from the painter Liotard, she wrote to Marie-Antoinette in December of 1770: "I await the painting of Liotard with great expectations, but in your finery (parure) not in casual dress (négligé) nor in a man's outfit. I want to see you in your proper place."[46] The work has been lost, but we know from correspondence that Liotard, a portraitist frequently employed by Marie-Thérèse, did not satisfy the empress's expectations. Her comment, however, also points to another aspect of the story. Smaller, private images of Marie-Antoinette did satisfy the mother who, making a distinction between them and official portraits, allowed them more leeway in terms of costume. She even tolerated in painting what she disapproved in real life. Her remark about not wanting to see her daughter in a man's outfit recalls Joseph Krantzinger's famous portrait of Marie-Antoinette en amazone, that is, in a costume resembling a man's riding coat (1771; figure 22). Marie-Thérèse expressed her pleasure even at this portrait since it represented her daughter as she was, enjoying her activities.[47] Thus, even as she warned Marie-Antoinette against the dangers of horse riding—especially of riding en homme, which she found hazardous for future fertility—she relished these images and she used them in her private spaces.[48] In August of 1771, she wrote to her daughter, "I have received your portrait in pastel, it is quite resembling and it pleases me and the whole family. It is in the cabinet where I work, and the [second] framed image is in my bedroom, where I work in the evenings, so I have you with me before my eyes, and you are always profoundly in my heart."[49]

The search for a suitable official portrait, however, went on for years, much to both women's exasperation. In 1774 Marie-Antoinette wrote to Marie-Thérèse: "It quite saddens me not to have been able to find a painter who catches my resemblance; if I found one I would give him all the time he wanted, and although he would be able to make only a bad copy, I would have a great pleasure in dedicating it to my dear mama."[50] The letter responds to the unrealized desire of the mother, and three years later the daughter wrote to her in a similar vein on 16 June: "I put myself at the discretion of the painter, for as long as he wanted and in the attitude that he wished. I would give everything for him to be able to succeed and to satisfy my dear mama."[51] Several days later, Marie-Thérèse wrote to Marie-Antoinette about two official portraits—one as wife of the king, the other as queen of France and daughter of the empress—that she had requested:

Figure 22

Joseph Krantzinger,
*Portrait of Marie-
Antoinette en amazone,*
1771. Vienna:
Schönbrunn

Excuse my impatience for your large portrait. Mercy received today
the measurements for it. The [other one] will be for my cabinet, so
that you can be there with the King. But this large one will be for a
room where all the family is in large portraits. Must not this charming
queen also be there? Must her mother alone be deprived of this dear
daughter? I would like to have your face and court dress; even if the
expression is not too resembling. So as not to inconvenience you too
much, it satisfies me to have your face and demeanor, which I do not
know and with which everyone is pleased. Having lost my dear
daughter when she was such a small child, this desire to know how
she is formed must excuse my impatience, coming from a most lively
fund of maternal tenderness.[52]

Finally, two years later, a portrait arrived that suited Marie-Thérèse, a
portrait painted by Elisabeth Vigée-Lebrun (1778; figure 23). Here is the re-

Figure 23 Elisabeth Vigée-Lebrun, *Portrait of Marie-Antoinette*, 1778–79. Vienna: Kunsthistorisches Museum

sponse the empress sent Marie-Antoinette after receiving the work in April, 1779: "Your large portrait pleases me! Ligne has found it resembling, but it is enough for me that it represents your face, with which I am quite happy."[53] Given that Vigée-Lebrun's image succeeded where so many others had failed, is it any surprise that Marie-Antoinette became attached to the painter who finally pleased her mama?

The work sent by Vigée-Lebrun is well within the tradition of the queen's official portrait. The symbolic accessories duplicate many of those seen in Van Loo's portrait of Marie Leszczynska; in particular, the queen is standing near a table on which rests the crown placed on a pillow decorated with fleur-de-lys. The curving figure that usually signaled a woman's body is again presented in a more stable triangular form; on one side the queen's extended arm masks the round of her hip, and on the other a virtual diagonal runs from her plumed headress down the slope of her shoulders, and through her panier and skirt. That diagonal is emphasized by the direction of her gaze. As in Van Loo's portrait, the vertical accents—the straight arm and the hanging tassels adorning her dress—reinforce the stabilizing effect of the massive columns. Thus, despite the display of costume and surface, the queen's figure seems quite architectonic. Moreover, the artist uses to positive effect the long Hapsburg face. The right side is rendered in a sharp, straight profile; on the left her hair is pulled well back, and the vertical shadow cast along temple and neck stands out against the rounded and lightly rouged cheeks and chin. The hair, underplayed and kept in shadow, acts as a frame for the face. Despite her plumed headress and wavy hair, Marie-Antoinette's highlit face rises from her neck with a verticality nearly as regular and definite as that of the column beside her. Moreover, she holds the center of the composition easily. Her face is isolated against a rectangular space articulated by the doorframe in the background, and light reflected from her white neck and chest, which are bare of necklace, pendant, or other jewels, ensures her maximum visibility.

Marie-Antoinette's image in this work is simplified over that of Louis XV's queen, although it is still opulent enough to bespeak royal status. Similarly, the artist maintains certain traditional elements, such as the swag of drapery that both adds complexity to the composition and theatricalizes the sitter. However, even the drapery swag is made to seem less self-consciously dramatic by reducing the complexity of its folds and tracing a more or less vertical fall rather than a grand diagonal sweep. It is not enough to attribute this difference to a change in taste, since in other images Marie-Antoinette was even more decorated than Marie Leszczynska, as she was in versions of Gautier-Dagoty's portrait of 1775 (Versailles: Musée du château). Like the colored engraving made by Janinet in 1777, many of these isolated the cos-

tumed queen, removing her from the dramatic and allegorical setting imagined by the painter. Overly embellished images of her daughter drew criticism from Marie-Thérèse, who felt they made Marie-Antoinette look like an actress. In March of 1776, she found the dress and hairstyle of her daughter represented in a work by Drouais (now lost) outré and not befitting a queen. Writing to Mercy she warned: "I am going to write to her on this subject, I find these extraordinary ornaments too inferior for the rank of a great princess."[54] I prefer to believe that Vigée-Lebrun's simplifications represent the artist's appeal to the recipient of the portrait, Marie-Thérèse, who had repeatedly complained about overly decorated images. Given the numbers of painters called to represent the queen, the quest for the proper image of Marie-Antoinette could hardly have been news to the artistic community.

In her portrait of the queen, Vigée-Lebrun reduces the ornamentation by restricting the number of different elements in the painting (elements are repeated rather than varied) and by making these less decorative. She uses one dominant color for the costume, which makes this frilly dress seem more austere, more classic, and she restricts the color range of the entire composition, relying primarily on an overall white with strong red accents and more muted ones of gold and blue. Even the headdress is simplified, and because the hat's plume harmonizes in overall shape with the flowers on the nearby table, it seems integrated with the overall composition and not singled out as an attention-grabbing flourish. Vigée-Lebrun, moreover, has made the queen look serious and august. Marie-Antoinette does not engage the viewer; rather than acknowledge anyone's gaze she stares out of the painting. Her expression resembles that usually reserved for important male sitters—for example, the king. Focused as it is on some thing—or some history—we cannot see, her look recapitulates that which Vigée-Lebrun gives to a bust of Louis XVI positioned on a plinth represented in the painting's upper right corner.

"Malicious People Said the Queen Appeared in Her Underwear"

The portrait of Marie-Antoinette *en chemise* made by Elisabeth Vigée-Lebrun is obviously not a state portrait, although a successful state portrait was probably her license to make this one. There was certainly a tradition of depicting the queen more informally; I have already mentioned some of those portraits of Marie-Antoinette sent to Vienna for her mother's private enjoyment. Informal portraits of the queen, however, did not often appear at the Salon, "in public," as did the image of Marie-Antoinette *en chemise*. In this portrait, Vigée-Lebrun shows the queen standing at a table, but set against a blank background so it is not clear if the sitter is positioned in an interior or exterior

space. Marie-Antoinette poses as she wraps a blue satin ribbon around a small nosegay that includes her signature flower, the rose. A few flowers lie on the table top and a larger bouquet has already been arranged in a blue Sevrès vase decorated with a gilt satyr's head. For whom, one wonders, does the queen wind the ribbon as she looks out of the composition (at the viewer?) with a sideways and lopsided glance. Her person, moreover, is pushed up to the picture plane so that the viewer can fancy him or herself in intimate conversation with the monarch. The entire image is coded for informality and refers to the artful naturalness of the picturesque. Marie-Antoinette's face is skillfully framed in a C-curve subtly formed by arms, ribbon, and hat plume, and her straw hat breaks the contours of the long Hapsburg face in a pleasing way. Her soft, unpowdered hair, lack of jewelry, and seemingly simple costume also token a studied naturalness associated with the look *en chemise*.

The image that reworked the portrait *en chemise*, Vigée-Lebrun's *Marie-*

Figure 24

Elisabeth Vigée-Lebrun,
*Portrait of Marie
Antoinette*, 1784.
Versailles: Musée du
château

Antoinette with a Rose (1784 copy of lost 1783 original; figure 24) lacks the intimacy of close contact with the sitter as well as the naturalness implied by composition and dress. Although the portrait is set in the informal space of a garden where the queen wraps up a rose, the sitter is distanced from her audience, set back from the picture plane. Her eyes are bright and blue, but not as large or as inviting as those in the earlier version, and now it is decidedly more difficult to imagine exchanging glances with the figure. Her satin court costume; formal, powdered coiffure; and elaborate headdress change the tone of the piece, since the queen no longer wears the dress characteristic of private spaces shared with friends.

Why make the portrait *en chemise*? The letters between Marie-Antoinette and Marie-Thérèse suggest that even early on Marie-Antoinette wanted to see herself painted in her favorite costumes, undertaking her favorite activities. What does Marie-Antoinette want to be in the portrait *en chemise*? What desire is Vigée-Lebrun representing to her, what trap for her desire, as Louis Marin would say, is she presenting the queen? In showing the queen as a fashionable lady, Vigée-Lebrun has imaged, perhaps without realizing it, Marie-Antoinette's desire not to be queen of France. I am not suggesting anything like a wish for abdication, but a desire to separate herself, if only temporarily, from the demands of the office. I would like to distinguish this desire—if it is possible to do so—from the vision of Marie-Antoinette's escapist tendencies well represented in all kinds of writing, from serious historical studies to Hollywood movie scripts, and reworked every day for the visitors tramping through her private apartments at Versailles. Pierre Nolhac imagined these tendencies in his account of an allegedly "lost" portrait of the queen *en paysanne*, which he compares to the portrait *en chemise*:

> One day when she was at Trianon coifed in the cornet of a peasant for a performance of [the play] *Rose and Colas*, which Madame Le Brun attended, she asked the artist to paint her in this costume. It is too bad that the artist has not spoken of this episode, and the sketch made that day has been lost, according to the friend who recounted this to us. . . . One would like to believe that, become wiser and knowing better the demands of her rank, she would forego the amusing satisfaction that others accorded themselves around her. The portrait "en gaulle," whose affected simplicity provoked the Salon public to murmur, made her wary of a fantasy [that was] striking for a court beauty but puerile and misplaced for a queen.[55]

What I have in mind is a bit more sympathetic toward this admittedly spoiled woman; for although Marie-Antoinette likely wanted sometimes to

escape her position as queen, she certainly had no desire to be less than a queen, even for a day. She wanted to be what she—willful woman that she was—wanted to be, not what French etiquette would make her. It was a revolt of sorts, but hardly a profound political one. Jacques Revel has well articulated the dilemma of Marie-Antoinette in writing of her pretension to conduct her life as she wished, to create a private space for herself apart from the official world of public representation. Marie-Antoinette "forgot the maxim that royalty has no right to private life."[56] Revel goes on analyzing her wish to create a private space symbolized by Trianon: "In this case, the staging of the private sphere is at the origin of a degradation of the representation that it renders trivial, even ridiculous."[57] It is a joke, maybe even an outrage, a queen playing milkmaid with her Sèvres buckets and golden implements. We see class outrage; and anticipate the final dramatization of the distinction between the queen playing at being a peasant and the real state of the French people. It is easy to imagine the queen, dressed as a milkmaid, uttering that apocryphal line: "Let them eat cake!"

Yet we forget today what other messages other audiences might have constructed from this portrait and the remaking of the sacred space of Versailles. What if one looks at this portrait from a perspective other than that of the Revolution, which in 1783 was scarcely a gleam in its fathers' eye? How might a "public" of 1783 still attached to the monarchy, *patrimoine*, and *gloire* have read the desire encoded in the queen's portrait and at Trianon? How they might have read these could, for a segment of the public, have been directed by the queen's enemies at court, for libels issuing from the court forged the first caricatures that were to haunt the queen through the Revolution.[58]

If Trianon was an escape from anything, it was an escape from the Court with all its formality, rules, and, one imagines, tedium. In the portrait, Marie-Antoinette represents herself not in terms of a position at court, but in terms of a position in a larger society—as a fashionable woman. The portrait confuses boundaries; the queen *en chemise* is a queen in masquerade. If Vigée-Lebrun claimed a public role as a history painter, she allowed the queen the right to pose publicly as a private individual, a fashionable woman. Taking the authority not to occupy her position as queen, Marie-Antoinette defied the sacrosanct laws of French court etiquette.[59] Her only acceptable "escape" would have been that of Marie Leszczynska, a quiet retirement to her study, a refuge in religion. What Marie-Antoinette failed to realize, as many have pointed out, was that a queen could not do as she pleased. She was the first subject of the king and of France, the model of all others subjected to his power.

A Woman Judged

Although it is clear that Marie-Antoinette enjoyed close friendships with women at court and supported women artists, the queen showed no solidarity with women of different classes. This, however, does not mean that French women did not have some stake—no matter how remote—in the queen's status. At least some commentators argued that the Salic Law had a negative impact on all women. In his *Histoire des amazones anciennes et modernes* (1740), Abbé Guyon wrote that the Salic Law "which has excluded [women] from the throne of France, in our minds has made them lose a part of the esteem that several among them rightfully merit."[60]

Feminist historians and critics writing today increasingly draw attention to the relation between Marie-Antoinette's fate and that of all French women. Lynn Hunt, for example, writes: "The question of Marie-Antoinette and the issue of the status of women more generally were closely connected, even though Marie-Antoinette herself probably had no interest in women's rights and early French feminists had little concern for the queen."[61] Madelyn Gutwirth uses her analysis of Germaine de Staël's *Réflexions sur le procès de la reine* (1793) to demonstrate that Staël understood much of what was at stake for women in the queen's trial and execution: "Whereas the courtly code had maintained a semblance of social integration for the women of the privileged class, the new republican code promises women honor as mothers. Staël clearly perceived that in killing the queen, a people 'neither just nor generous' was expressing both the death of the old and the feebleness of the new dispensation."[62]

Indeed, Staël addressed her defense of Marie-Antoinette to women and stressed their common cause with her: "Oh! you, women of all countries, of all classes of society, listen to me with the emotion I experience. The fate of Marie-Antoinette contains everything that can touch your heart: if you are happy, so was she."[63] A few lines later, she continues: "Republicans, constitutional monarchists, aristocrats, if you have known unhappiness, if you have needed pity, if the future raises in your thoughts any sort of fear, unite yourselves, all of you, to save her!"[64] Throughout her *Réflexions*, Staël exonerates the queen of the many crimes—and especially that of being a bad mother—charged against her, and concludes by suggesting to women not their collectivity in difference (of class, nationality, politics), but their similarity in sharing a single fate: "I return to you, women whose lives are all sacrificed with [that of] so tender a mother, whose lives are all sacrificed in the outrage that would be perpetrated against weakness by the annihilation of pity. It is the end of

your dominion if ferocity reigns, it is the end of your destiny if your tears flow in vain."[65] Staël here panders to some of the most conservative clichés about woman's nature, but at the same time warns women of their precarious and vulnerable position in the social order. Marie-Antoinette's impending fate symbolizes that vulnerable position, and earlier in the pamphlet Staël had reminded her readers that the slander used to damn Marie-Antoinette— especially that aimed at her sexuality—was the sort that could be used to ruin any woman.[66]

A decade before Marie-Antoinette's trial constructed her as the quintessential bad mother, Vigée-Lebrun unwittingly showed her as an immodest woman, providing enemies with yet more evidence against the queen.[67] Showing the work was, at least for the queen, a tactical error on Vigée-Lebrun's part. Maybe the artist was so captivated by a certain image of the queen (or by her desire to please a patron captivated by a certain image of herself) that she "forgot" what everyone knew by 1783: that the Salon was becoming a school for virtue and morality increasingly intolerant of immodest depictions. Or perhaps she just counted on official art critics devoted to the monarchy to ensure the proper reception for her work.

Aside from these possibilities, Vigée-Lebrun likely considered a Salon entry as a portrayal of her talent. In relation to this point, consider the three modes of discourse analyzed by Marin in *The Portrait of the King*: the judicial, the lawyer's plea, which concerns the past; the deliberative, the politician's speech, which concerns the future; and the epideictic, the orator's eulogy or panegyric, which concerns the present. In the first two modes the auditor is a *judge* evaluating the content of what is said in terms of past or future. In the epideictic mode the auditor is a *spectator* who contemplates and judges, not what is said, but the potential (the talent) of the person speaking.[68] Vigée-Lebrun, I believe, imagined herself to be making a panegyric in an epideictic mode. The response she expected was the response of the spectator judging the talent of the person who painted. This is the response to the portrait *en chemise* of the circles she frequents, the response she represents in the *Souvenirs* as she is applauded at the Vaudeville.

In 1783, however, paintings were also judged according to the moral effect of their subject matter, according to how they could influence future action. That is to say, paintings were judged in the same way as the politician's discourse. In a Salon where critics found the most up-to-date history paintings those dedicated to great men, to heroic action, or to women sacrificed for their virtue, how would this portrait of the queen of France signify? How would it be judged in relation to *Virginius Killing His Daughter*, a story in which a moral ferocity shows no pity. What future did the queen *en chemise* suggest? Not the

future of the past—the *gloire* of the French monarchy—but a future symbolized by the world of Trianon. The emblem of Trianon was the dress *en chemise*, as commentators, including the royalist Rose Campan, have noted: "A dress of white percale, a fichu of gauze, a straw hat, these were the only adornments of the princesses."[69] It was as the queen of Trianon that Marie-Antoinette was displayed, judged, and condemned at the Salon of 1783. Although her condemnation then was not as consequential as it would be in '93, there is an underlying similarity in the charges against her. At her trial Marie-Antoinette was accused of damaging her son's—the former potential king's—sexual potency.[70] As the queen *en chemise*, she was castigated for feminizing a sacred space of the virile French monarchy with her society of women at Trianon. This violation—like that of her son—was all the more egregious because engineered by a foreign woman, by the Autrichienne.

Trianon

Both Trianons, the grand and the petit, were conceived as resting places for the king to shelter him during the summer's heat, but each took on other functions, both practical and symbolic. Marin has argued that in the "topography" of Versailles and its gardens written by Félibien in 1672, "Trianon is at the edge of the project, that is, of its design of symbolic politics and of the imagination's playful diversion in festivity."[71] The Grand Trianon was a stage setting for Louis XIV. There the Sun King entertained his Court, which was the privileged recipient of the prince's gracious gift. During a fête, the king offered himself to the Court as spectacle:

> A magnificence so rare stopped the eyes of the whole Court for a long time with pleasure. They could not tire of admiring the marvelous effects of these illuminations, whose images still appeared in the depth of the water as other Palaces and other figures larger than the veritable ones. All sorts of fish seemed to have arranged themselves at the edge of the water to watch the greatest King of the world pass by on their element as in triumph.[72]

The Grand Trianon in specific, and the gardens of Versailles, in general, raise several important points. They were used for the convenience and pleasure of the king, and they participated in the symbolics of royalty. They were the site where the king gave himself to the Court. Thus the Trianon reinforces the relation between the king and his Court, a relation constituted as subject/ privileged subjects and spectacle/privileged spectators.

The Petit Trianon has a different history, but it too participated in the French monarchy's symbolics. Its domain was carved out in 1750 with the

establishing of a botanical garden, which Louis XV entrusted to Claude Richard. The cultivation of different species of plants extended the symbolism of the seventeenth-century gardens in which Versailles contained the entire cosmos, represented symbolically in garden sculpture—the four elements, the four continents, the four seasons, and so forth. The botanist Bernard de Jussieu worked at the Petit Trianon and there applied for the first time the principles of his new system of classification. Gabriel designed the garden pavilion built in 1750, which again was the king's resting place, as Louis XV stopped there on his garden walks. The Château du Petit Trianon (1763–68), built by the same architect, allowed Louis more extended visits, and became the place where he met Mme de Pompadour and where they entertained. His next mistress, Mme Du Barry, later occupied the Trianon palace. Thus, although the domain of the Petit Trianon was generally associated with the symbolics of Versailles, its palace was associated with the king's pleasure.

In 1774 Louis XVI gave the Petit Trianon to Marie-Antoinette, who transformed the grounds into an English garden, which we can take as a symbol of the freedom and liberty she hoped to obtain there. With its aesthetics mimicking the look of natural growth through planned disorder, the English garden has long symbolized these values in contrast to the obviously regulated and trimmed formal French garden.[73] More important, perhaps, is that the English garden (like the English dress *en chemise*) was a foreign import into the heart of the French symbolic space. Replanting these gardens coincided with a general replanting of the estate after the trees had been cut down and sold for timber. As head of the Bâtiments, d'Angiviller was in charge of this project. Susan Taylor-Leduc has argued that the practical reason for the replanting was hidden under royal propaganda designed to influence public opinion. D'Angiviller wanted the replantation to be perceived as "a restoration of a symbolic space that would signal a return to a golden age of Bourbon rule under the young monarchs, Louis XVI and the queen, Marie-Antoinette."[74] D'Angiviller's fantasy of the replanting was hardly supported by the queen's *jardin-anglais* at Trianon with its serpentine paths, surprising views, and architectural follies, such as the hameau begun in 1782. Trianon's private function gave the lie to the image of public good cultivated by the Director; as Taylor-Leduc has argued, Trianon negated d'Angiviller's hope for restoring the park as a sign of royal and national power.[75] The English garden represented what was fashionable and modern, not French tradition and Bourbon rule.[76] One can imagine the Director's dismay as the reputation of the queen's project spread far and wide. The Court's malice took aim at these gardens, and accused Marie-Antoinette of changing the name of her domain to "little Vienna." Madame Campan recalls these rumors in her mem-

oirs, and although the particulars of the story may be unreliable, the tale jibes well with the other charges emanating from the Court:

> From the moment she was in possession of the petit Trianon, it was spread about in some societies that she had changed the name of the pleasure pavilion that the king had just given her and had substituted that of little Vienna or little Schönbrunn. A man of court, simple enough to believe the rumor and desiring to enter into her society at the petit Trianon wrote to M. Campan to ask permission of the queen. He had in his letter called Trianon little Vienna.[77]

The image of Trianon as "little Schönbrunn" may have been highlighted by copies of paintings that Marie-Antoinette had sent from Vienna and whose subjects recalled her childhood there. In particular, a copy by Wuchart (1778; Versailles: Musée du château) represented the opera and ballet performed by the young archdukes and archduchesses at the marriage of Joseph II. It pictured Marie-Antoinette as a young girl dancing a minuet with her brothers. The French accused her of still dancing to their tune.

In its association with Trianon, the portrait *en chemise* could be, and indeed was, read as indicating the queen's desire to escape being French, to bring what was alien into the heart of the French realm. Two other comments about the dress make this point. One appeared in a court libel, the *Correspondance secrète inédites sur Louis XVI, Marie-Antoinette et La Cour et La Ville de 1777–1792*, which reported that the queen's fashion angered the silk makers at Lyon, who charged her with ruining a national industry for the profit of her brother Joseph, the Hapsburg ruler. How they thought her brother would benefit from the change is not clear.[78] A second remark directed to the portrait retitled it: "France as Austria reduced to covering herself with straw."[79]

It is difficult to exaggerate how much clothing mattered in the symbolic economy; its importance for Marie-Antoinette was established with the elaborate etiquette designed to ensure that neither the Hapsburg Empress nor the Bourbon King would be slighted when the guardianship of an adolescent girl—the future queen of France—was transferred from Vienna to Paris. The transfer took place in 1770 on neutral territory, on an island in the Rhine under the domain of neither empire, where the French erected tents and other portable shelters. In one of those shelters the young Marie-Antoinette performed the ceremony of the toilette (or rather had it performed on her). She was divested of all her Austrian garb, stripped of all of her clothing, and redressed in garments fabricated entirely in France. She emerged from the tent, as if reborn, or at least converted.[80]

The portrait *en chemise* flouted the conventions of French dress and eti-

quette and exposed Marie-Antoinette to the charge that her conversion was not sincere. Even if she had fully assimilated French culture, however, Marie-Antoinette would always be alien, a point dramatized by the many engraved portraits that captioned her two titles in the following order: Archduchess of Austria and Queen of France.[81] The portrait *en chemise*—or the libels it provoked—brought to light what was fundamental about the queen of France: she was alien to the kingdom. Marie-Antoinette as Autrichienne was not invented by the revolutionaries or even by her enemies at Court. She was conceived with the fundamental laws of France. Even in the moments of the queen's greatest popularity, the Autrichienne was always there lurking in the shadows.

Recent French history is still haunted by this image of the queen. Here is a description of her from Furet and Richet's *The French Revolution:*

> Because she had a husband who was not able to counterbalance her mother's influence, she remained obsessed with her childhood, the simple and loving atmosphere of Schönbrunn. Hence her fondness for small family gatherings in the rustic setting of the Trianon . . . hence also the ardor with which she defended the interests of Austria, even when they were opposed to the interests of France.[82]

But more was encoded in Marie-Antoinette's portrait than the Autrichienne, and indeed, the portrait came to stand for some of the most common themes of the libels emanating from the Court: the queen's foreign character, her extravagant spending, and her uncontrolled sexuality. The association with her spending was evident in 1783, for the queen was reputed to have dispensed outrageous sums for the decoration of Trianon. The portrait appeared again in this context in 1785, connected to the Diamond Necklace scandal. It came out at the trial of Lamotte, the woman impersonating the queen, that she had devised her costume after that worn by Marie-Antoinette in the 1783 portrait by Elizabeth Vigée-Lebrun.[83] As to the queen's sexuality, the dress signaled the costume worn by Marie-Antoinette's friends characterized by libels as the "tribades of Trianon." This last association was damning not so much because people necessarily believed that lovemaking between women was actually rampant in the queen's circle, but because a location associated with the king and the French domain had not only been made foreign, but also was femininized by Marie-Antoinette and her female friends. Male sexuality was banished and replaced by an intimacy among women.

Although men were among the invited guests, Trianon was primarily peopled by women and children who made their own rules and lived together without the ceremony or etiquette normally associated with the Court. The

king regularly visited the queen at Trianon, but he never slept there. By representing Marie-Antoinette as the queen of Trianon, Vigée-Lebrun made a portrait of the queen for which one can imagine no companion portrait of the king, who was alien to that realm. Her companions at Trianon were her women friends. In fact, a counterpart to this portrait of the queen *en gaulle* could be found among Vigée-Lebrun's Salon entries in her portrait of the Marquise de la Guiche, a member of the queen's intimate circle, as a milkmaid.[84]

The image of Trianon, with its aura of female intimacy, lingered long after the Revolution, and, as Terry Castle has shown, women in the nineteenth century called up this myth to manufacture a lesbian identity:

> And yet one cannot help but feel in the end, perhaps, that there is also something bizarrely liberating, if not revolutionary, about the transmogrification of Marie-Antoinette into a lesbian heroine. It is true that there is a nostalgic element in her cult: women who thought they "saw" her, like Hélène Smith, the "Dream Romances" writer and Moberly and Jourdain, were in one sense flagrantly retreating into the past, into a kind of psychic old regime. But in the act of conjuring up her ghost, they were also, I think, conjuring something new into being—a poetics of possibility. It is perhaps not too much to say that in her role as idealized martyr, Marie-Antoinette functioned as a kind of lesbian Oscar Wilde: a rallying point for sentiment and collective emotional intransigence. She gave those who idolized her a way of thinking about themselves. And out of such reflection—peculiar as its manifestations may often look to us now—something of the modern lesbian identity was born.[85]

Other Possibilities

Castle's notion of the poetics of possibility, leads me to wonder if other women besides Smith, Moberly, and Jourdain saw other sorts of possibilities in the figure of Marie-Antoinette. I am thinking here of women like Olympe de Gouges, who dedicated to the queen her "Declaration of the Rights of Woman." This is not to argue that the queen in any way supported or sympathized with the political goals of the French Revolution or generally supported women's rights. With Olympe de Gouges and Mme de Montanclos (whom I take up below), advocates for women could imagine the queen as a potential ally. Moreover, Marie-Antoinette provided for some women during the Old Regime the image of an exceptional woman, a powerful woman descended from an even more powerful woman, who proved herself a supporter

of women's endeavors. Under Marie-Antoinette's protection, for example, the *Journal des Dames* reappeared in 1774, five years after its suspension. Mme de Montanclos (then the baronne de Prinzen) dedicated the new publication to Marie-Antoinette, who lent her support in late 1773, when she was still dauphine. Although Marie-Antoinette may not have advocated the political and moral stances taken by much of what appeared in the *Journal des Dames*, she maintained her patronage of the publication. Nina Gelbart speculates that the queen was grateful to Mme de Montanclos, who seemed eager to uphold her as "an intelligent and virtuous model for the whole female sex."[86] Gelbart finds signs of Marie-Antoinette's gratitude at the Bibliothèque Nationale in the gold-leafed copies of the journalist's later works, which carry the queen's personal arms.[87]

In the visual arts, not only did she advance the career of Elisabeth Vigée-Lebrun, but she was also a strong supporter of the artist Anne Vallayer-Coster. On 15 September 1779, Mercy reports to Marie-Thérèse that Marie-Antoinette left Versailles only to go to Paris to see the Salon. In that Salon was Vallayer-Coster's image of a vestal crowned with roses, which belonged to the queen.[88] The actress Rosalie Dugazon was apparently dedicated to the queen. During a performance of the *Evénements imprévus* in February 1792, she expressed publicly her devotion to Marie-Antoinette when she turned to face the empty royal seats, clasped hands to heart, and passionately sang, "Oh, how I love my mistress!"[89] Finally, today the Bibliothèque Nationale also houses many novels from the eighteenth century written by women and bound with the arms of Marie-Antoinette. It is not so important for the queen actually to have read the books; it was enough that she owned them to enhance a writer's reputation. French women, at least some of them, had a very specific stake in the queen's fate. Although women have long been patrons of the arts, queens who promoted women artists are rather more exceptional.

In view of this admittedly far less revolutionary poetics of possibility, it seems particularly ironic that those who wrote the first histories of representing this queen installed as her true portrait David's sketch of her on the way to the guillotine (1793; figure 25). Georges Duplessis, for example, believed he found her "authentic likeness" in David's work, particularly in the bone structure.[90] Writing at about the same time, other historians also selected David's work, finding the real queen in neither the portrait she found most resembling, nor the one her mother found most pleasing. These authors were perhaps led by the image of immediacy suggested by a rapid sketch; or maybe they were seduced by the reputation of the great male artist; or it could be that the tendency to view Marie-Antoinette primarily from the perspective of the Revolution motivated their judgment. On the other hand, David's drawing

Figure 25

J. L. David, *Marie-Antoinette*, 1793.
Paris: Musée du Louvre

may have seemed the most "resembling" because it so well fits the stereotype of a royal person as one who acts with great dignity even (or especially) in the face of imminent annihilation. Finally following the proper etiquette, in David's image Marie-Antoinette sits tall and erect, apparently resigned to her fate. Here is how Henri Bouchot characterized the work:

> David had the last sitting with the queen, he saw her for a few seconds before him more majestic and more sovereign than Madame Le Brun or the others had known her. No rouge on her cheeks, no powder in her hair. A linen bonnet has replaced the toque of velvet, a little white robe garbs her miserably; it is again a portrait "en gaulle," the last one this time.[91]

Finding David's portrait the most majestic seems to me a misogynistic and perversely royalist gesture. In this image, the woman-queen can be safely majestic and sovereign precisely because she has no power. Her hands tied behind her back, Marie-Antoinette is not threatening to the French Republic as the daughter of the Hapsburg empress, nor to her viewers as an unruly woman. She is here resigned to the role that, perhaps even more than the part

of mother, patriarchy has reserved for woman—that of victim. I am not suggesting that she was the Revolution's victim, as royalist sympathizers would portray her; rather, that she occupies the position of victim, the "feminine" place of the one destined to be attacked.[92] For some early commentators, perhaps, David's portrait was the most authentic not because of its "bone structure," but because it showed Marie-Antoinette as she should have been when she was queen—dignified and helpless.

From the standpoint of many French citizens in 1793, Marie-Antoinette certainly represented the indecent privileges of aristocracy and the bankrupted principles of a (more or less) absolute monarchy. It would be folly to deny that she is fully entitled to represent a share of that meaning. But such a reading of the queen's image can no longer be cited, at least not after the recent work of Hunt, Maza, Gutwirth, Colwill, and others, without also noting that she more than other likely candidates—and much more than the king—came to embody "the possible profanation of everything the nation held sacred."[93] In this context, David's sketch can be viewed as one more example of the interest focused on the queen's body, and more specifically as part of the attention that accompanied her on the road to the scaffold.

This is how Madelyn Gutwirth reads the image, pointing out that the king, garbed in court dress, rode to the guillotine in a closed carriage with his confessor. The queen, on the other hand, rode in an open cart, vulnerable to the eyes of all. Gutwirth sees in David's sketch the humiliation and abasement reserved for the woman-queen:

> David's excessively well-known sketch of her seems to reprove her proud, upright carriage as she sits bolt upright in the cart of her final journey. She looks like an aged hag (she was thirty-eight); her reduction could not have been represented as more abject. . . . The sketch declares that there were to be no more queens in France, and all should heed her fate.[94]

Vigée-Lebrun's portrait of Marie-Antoinette and David's sketch of her must be read according to the different political circumstances in which they were produced. Marie-Antoinette in 1783 posed a threat, not to the new French republic, as she would in 1793, but to certain interests at court and within the governing elite. What ties the two images together, however, is that in different ways each presents Marie-Antoinette not simply as the king's wife, but as the most notorious, dangerous, and powerful public woman in France. And a woman who acted in public—both in 1783 and 1793—not only raised fears of sexual de-differentiation, but also bore the blame for society's moral decline. Lynn Hunt reminds us that republican men were no more misogynis-

tic than their predecessors; her work demonstrates that neither were they less so.[95]

David's portrait pictures not so much an absolute monarch—for the queen could never be that in France—but a public woman vanquished, paying equally for her real and imagined political sins and gender bendings. In contrast is the 1783 portrait by Vigée-Lebrun, which transgresses first by showing the queen in a private role that did not suit the proper image of a king's wife, and second by showing her as a woman with the will to reconfigure associations within the elite, to ignore the rules of court life and etiquette, to reconsecrate part of the king's domain. Of the two images, I prefer the one made in 1783; it lends Marie-Antoinette not the political power of a monarch's wife anxious to quell a popular revolution, and not the authority of the austere queen-mother who sits with her children in the official portrait—a piece of royalist propaganda—Vigée-Lebrun made in 1787 (Versailles: Musée du château). I prefer the portrait that allows Marie-Thérèse's daughter the power to define herself against established norms of seemly, modest, queenly behavior. I prefer Vigée-Lebrun's unofficial portrait, the one the sitter chose as her image, the one that shows Marie-Antoinette as the tribade of Trianon.

SIX

The Portrait of the Artist

The Portrait of the Artist as a Great Man

Dear Lebrun, Glory has its perturbations,
Envy is always there laying in wait for talent.
Everything that pleases, everything of excellent achievement
Must endure the outrages of this monster.
Who more than you has ever deserved them?

A virile brush animates your portraits.
No, you are no longer woman, as opinion proclaims:
Envy is right, and its persistent cries
And serpents unleashed against you
Better than our voices declare you great man.[1]

So wrote the poet Lebrun-Pindare of Elisabeth Vigée-Lebrun, and so in-
scribed the artist in her *Souvenirs*. She recalls the poem while describing all
the calumnies she endured throughout the 1780s, and lists as those calumnies
the accusation that Ménageot painted her works; the rumor that Calonne was
her lover and paid her vast sums of state moneys; the scandal surrounding her
Greek supper and its allegedly excessive cost.[2] But, as is common in the *Sou-
venirs*, Vigée-Lebrun got the date wrong—or maybe she purposefully remem-
bers it as 1789 to direct the verse against all these rumors. The poem, however,
actually appeared in 1785 under the title: *Vers à Madame Le Brun sur les cri-
tiques imprimées lors d'exposition du Louvre en 1785*. It referred directly to none
of those scandals detailed by Vigée-Lebrun, even though the portrait of Ca-
lonne shown at the Salon of 1785 drew many pointed barbs. Rather, the "out-
rage" opinion proclaims in the poem is that Vigée-Lebrun is no longer a
woman, that she has changed her sex. The poem transforms this accusation
into a positive asset, exemplifying a strategy used throughout as, for instance,

the serpents of envy are taken as signs of the artist's talent. Lebrun-Pindare here calls on a well-worn conceit—that achievement and envy are inextricably bound together; that good work calls up slanderous opinion. To ask who better than Vigée-Lebrun deserves the outrages of envy is thus to ask who has achieved more than she. In agreeing with the particular opinion—that Vigée-Lebrun is no longer a woman—the poet also exploits the rule and the exception. "Great man" is usually a category reserved for those of the male sex, just as *gloire* is associated with masculinity. However, occasionally a woman can ascend to realms that the female sex, as a general rule, cannot obtain. The poem plays on the point that there is no gender-neutral term to convey the idea of a person who achieves *gloire*. Vigée-Lebrun must be a "great man" because there is no other category in which to locate her.

But is this the case? Given the poet's strategies of reversal, and given that he answers those who disparage Vigée-Lebrun for stepping outside her sex, there were obviously other categories in which to locate the exceptional woman, categories that represented the opprobrium from which Lebrun-Pindare strove to rescue Vigée-Lebrun.

Hermaphrodite, Tribade, Femme-Homme

Recently much has been written about the early modern discourse on hermaphrodites—individuals who appeared to possess functioning reproductive organs of both sexes.[3] These "real" hermaphrodites were hardly the incarnation of the mythical, bi-sexed god; instead they gave living form to the human "monsters" collected in writings during the sixteenth and seventeenth centuries. By the middle of the eighteenth century, scientists refused all belief in "real" hermaphrodites, arguing that if they could reproduce at all, those who seemed doubly sexed could do so *either* as men *or* as women, but not as both.[4] Moreover, in each case physicians found evidence for placing a person with ambiguous organs on one side—usually the female side—of the sexual divide. The real hermaphrodite had to be reasoned away; he-she naturalized transgression by upsetting the neat separation of all persons into the categories of male or female.

Although writers held that antiquity's mythical hermaphrodite, in uniting all the excellences of both sexes, imaginatively represented a perfect being, real hermaphrodites were anything but excellent or beautiful. A contemporary account of the hermaphrodite Drouart described her as having "a low voice, an insolent physiognomy, the gait of a man, a thick beard, much hair on her body, a thin and emaciated chest without any appearance of breasts, and no evidence of any periodic flow. . . . She was a girl aged thirteen and very ugly."[5]

Ugliness was often interpreted as a sign of moral degeneracy, and as Guic-
ciardi has shown, associations of the hermaphroditic with the monstrous com-
mon throughout the eighteenth century were transferred from the physical to
the moral plane.[6] Even if a beautiful hermaphrodite existed, it would represent
a deformity of the natural, the true, and the good.

Among the deformed monsters associated with hermaphrodites, the *tri-
bade* and the *femme-homme* are sororal twins. Of these two, only the tribade
made the medical books. She was placed by the anatomist Duverney in a cate-
gory of false hermaphrodites, comprised by those "girls *(filles)* who have a
clitoris much larger and longer than normal and who abuse it with other girls;
these are those that the Greeks called tribades, the French ribald women *(ri-
baudes)* or disguised men *(homme déguisée)*."[7] Long defined as a woman who
"undertakes the virile functions in the service of her own sex," the tribade
disguised herself as a man by usurping his sexual rights over women.[8] This
false hermaphrodite became the defining type for writers like the widely read
Dr. Tissot, who considered the tribade as the "origin" of the mythical her-
maphrodite because ignorant persons mistook her enlarged clitoris for a pe-
nis.[9] The learned abbés La Chau and Le Blond followed this opinion when
they wrote:

> One can no longer ask in this century if in the human species there
> exist beings who truly unite both sexes. Undoubtedly there have
> been, and there are still today, primarily in the warm countries,
> women in whom certain parts are excessively developed and pro-
> nounced, who have made inattentive observers believe that they
> were simultaneously females and males. But this is only deceptive
> appearance.[10]

Definitions of tribade and false hermaphrodite thus depended on seeming
(to be) and imitating rather than being. The enlarged clitoris, "ce monstreux
clitoris," as Jacques Gautier d'Agoty called it, looked like a penis, and in using
it the "disguised man" mimicked male sexual performance. As tribade, the
hermaphrodite was a disruptive figure, not because her sex was indetermin-
able, but because her miming of the man's sexuality threatened the coherence
of a sociosexual order regulated by reproduction.[11] Not only did the tribade
violate the heterosexual imperative, but her sexuality, focused on the clitoris
rather than the vagina, was situated in an economy of pleasure. The tribade,
or false hermaphrodite, was a mixed creature because she performed a sexu-
ality not proper (natural) to her *sexe*, taken in the doubled meaning of the
category woman and the woman's sex. The tribade raised the possibility that
sexual performance was not linked to essential sex, but based in mimicry (of

an organ she did not have, of a role that was not hers). The condemnation of the tribade was all the more pressing because moralists recognized that even a woman with a normally sized clitoris could overvalue that organ commonly called the *mépris des hommes.* [12]

The tribade's sororal twin, the femme-homme, did not appear under the medical definitions of hermaphrodite; she was neither defined by a monstrous clitoris, nor thought to make herself a man primarily by performing the virile role in the sexual act. I say *primarily* because the femme-homme was often accused of sexual commerce with other women, and just as often was confused and confounded with her sister, the tribade. The femme-homme, however, mimicked the virile position by performing the man's intellectual or political functions in the social order. She was a mixed creature, having the sex organs of a woman but acquiring or imitating the social characteristics proper to those with male sex organs. The profile of the femme-homme, as it developed in the late eighteenth century, owes much to the writings of Rousseau, in which social roles are so closely attached to the sex organs that one seems to flow naturally into the other.[13]

By the end of the eighteenth century there was a reaction against the femme-homme perhaps as violent as that of those peoples who threw hermaphroditic infants into the sea. Here is the republican Chaumette's warning to French women: "Remember that virago, that woman-man *(femme-homme)* the impudent Olympe de Gouges, who abandoned all the cares of her household because she wanted to engage in politics and commit crimes. This forgetfulness of the virtues of her sex led to the scaffold."[14] And using revolutionary rhetoric, Sade casts such immodest, impudent women as real hermaphrodites in his description of Charlotte Corday: "Marat's barbarous assassin, like those mixed beings whose sex is impossible to determine, vomited up from hell to the despair of both sexes, directly belongs to neither."[15] In bringing us back to the real hermaphrodite, Sade's comparison suggests the continued potency of that creature as a figure of monstrosity and demonstrates how social transgression (a woman acting like a man) was figured as sexual transgression.

In view of the discourse on hermaphrodites, Lebrun-Pindare's poem suggests that voices other than those condemning the exceptional woman as a femme-homme could be heard in the public sphere, at least in 1785. Some writers, however, invoked the hermaphrodite not to condemn the exceptional woman, but to mock the foolish one who imagined she combined the excellences of both sexes. A poem appearing in the *Correspondance littéraire* in 1782, for example, also turned on the contradiction that a great woman is a great man, but put the contradiction to a purpose distinct from that of Lebrun-

Pindare in defending Vigée-Lebrun. The poem "described" Mme de Genlis, a writer who was neither well regarded nor well liked by those associated with the *Correspondance littéraire*. The verses of this less-than-flattering poem implicitly posit the hermaphroditic existence of the female great man as a kind of ideal synthesis claimed fraudulently by Genlis. Indeed, the poem bites with references to the lady's gambling, lovers, superficial knowledge, and liaison with La Harpe. Entitled "L'Enigme, ou le portrait d'une femme célèbre," the poem is narrated by the celebrated woman, who is made to speak her enigma in portraying herself as a hermaphrodite:

> Physically I am of the feminine type
> But mentally/morally I am of the masculine.
> My hermaphroditic existence
> Often occupies the naughty wit.
> But satire and its venom
> Do not tarnish my worth.
> I have all talents,
> Without excepting that of pleasing;
> Look at the luxuries of Cythera
> And the list of my lovers.

If in the first six lines the narrator posits that witticisms aimed at her "hermaphroditic existence" are ineffective in sullying her worth, her next comments show her incapable of recognizing the self-satire she is made to speak. Like Don Juan, she offers a list of lovers to prove her worth, but for a woman to display her sexual conquests was hardly laudable practice. Despite her claim to a "hermaphroditic existence," her gifts itemized in the sections quoted below are hardly those of manly intellect. Her writing—her authorship—is reduced to orthography and her arithmetic skill to a proficiency at gaming. Her accomplishments, moreover, are not so different from those of the coquette, for the "instrument" she plays puns on La Harpe, the name of her reputed lover:

> I know quite passably
> Orthography and arithmetic,
> I read a little music
> And the harp is my instrument.
> I am a savant at all the games:
> From trictrac to thirty-forty.

The narrator's prowess as a teacher, moreover, is construed in terms of the gambling lessons she allegedly gives the children of the Orléans family, for

And by the lessons that I give
To the children on the play of *quinola,*
I very much hope that a day will come
When they can put them to good use.

It is hardly coincidental that this poem appeared in the same issue as a review of her pretentious (and politically conservative) educational tract, *Adèle et Théodore, ou Lettres sur l'éducation, contenant tous les principes relatifs aux trois différentes plans d'éducation des princes, des jeunes personnes et des hommes.*

In the concluding section of the poem the narrator announces that pleasure and duty are what occupy her all day long, but given what she has described as her activities, it is clear that she confounds the two. It follows, then, that the final lines speak another mistaken belief—that her head is clear and lucid in the morning, when she acts like a man in the classroom, but weak in the evening when she performs in the bedroom as a woman:

It is pleasure and duty
That occupy my days;
In the morning my head is sensible,
It becomes weak in the evening.
I am a gentleman in the classroom,
And a lady in the boudoir.[16]

To mock the "celebrated woman," the poem evokes an idealized hermaphrodite with the brains of a male and the sex of a female, but through satire it dispels fears about women acting like or rivaling men. The enigma, the indecipherable, is not the femme-homme, not the hermaphrodite with a man's brain in a woman's body, but woman *tout court.* Who could understand a soft-headed woman so foolish as to take her scribbling for writing; her gambling for mathematics; and her seduction for art? Initially held out as a celebrated figure, a woman who is a great man, Mme de Genlis emerges as self-deluded, a woman who mistakes her achievements for those of a man. This quality of self-delusion, however, she shares with other kinds of hermaphrodites—the tribade who fancies her clitoris a penis and mimics male sexual performance, and the femme-homme who imagines she has the cultural authority conferred by the phallus. Genlis thus is and is not the hermaphrodite she (as narrator of the poem) claims herself to be.

Painting It Like a Man

The discussion surrounding the hermaphrodite, and the derisory function of poems like "L'Enigme," make meaningful a curious aspect of Lebrun-

Pindare's poem defending Vigée-Lebrun. Recall that he wrote to Madame Lebrun: "A virile brush animates your portraits." Although this is *his* conclusion, it was not that of the critics he is allegedly refuting. Far from finding her brush—a common way of referring to how an artist touched the canvas— virile, from the Salon of 1783 critics overwhelmingly labeled it with adjectives that signaled the "feminine." Those who believed touch connected to the artist's sex found that "natural" to women painters at best soft *(moelleuse)* and at worst too soft, lacking in force, effeminate *(molle)*.[17] The touch "natural" to men, on the other hand, was bold *(hardie)*, vigorous, and virile *(mâle)*.[18] Beginning in the year she made her Salon debut, writers conceptualized Vigée-Lebrun as the feminine painter in relation to her reputed rival Adelaïde Labille-Guiard. Although not all commentary about these artists fell neatly into this pattern, from 1783 on Salon writers commonly positioned them as gendered opposites.[19] In that year some critics praised Vigée-Lebrun's touch as "moelleuse et suave,"[20] others saw too soft *(molle)* a touch as a peril she must avoid.[21] On the other hand, they said Labille-Guiard had a surprisingly virile touch, one firm as a man's. In contrast to Vigée-Lebrun, Grimm found her handling to have "plus de fermeté," and characterized her touch as "forte et vigoureuse."[22] Another critic called Labille-Guiard's brush "ferme et vigoreux,"[23] a third praised her touch "mâle et ferme," and found that she had "made herself a man."[24] Apelles visiting the Salon attributed to Labille-Guiard "a firm and bold touch that seems beyond the reach of her sex."[25] That she outstripped her sex, that she was nearly a man, surprised the critics pleasantly; this indicates, unsurprisingly, that the masculine touch was the more highly valued.

A second gendered opposition—that between the artificial (associated with the ornate and the decorative) and the truthful (associated with the natural and the beautiful) also structured the way critics viewed the art of Vigée-Lebrun and Labille-Guiard. The truthful seems to have had no overt sex; I take this as an instance of the masculine presenting itself as the unsexed, universal human category. The artificial was gendered as the feminine, and Jacqueline Lichtenstein has shown how since antiquity the problematic of ornament has never been separated from that of femininity.[26] Beginning at the Salon of 1783, commentary on Vigée-Lebrun's works either hailed them for their brilliant color or criticized them for their conspicuous artifice. The article in the *Mercure de France* was typical in citing the artist's tendency to make colors too brilliant, to make too great an "éclat."[27] The critic for the *Journal de Paris* was more precise. Vigée-Lebrun's colors are too "éclatantes," in fact they are untruthful, unnatural: "Nature is less brilliant and it is nature that one must try to render."[28] Grimm repeated this sentiment (which became

nearly a cliché in describing her work) in writing about the *éclat* of her *Peace Bringing Back Abundance*: "nature is less brilliant than art, and art that seeks to surpass nature lacks naturalness."[29] Apelles, however, spoke the most interesting comment on this aspect of her work as he evaluated her self-portrait, directly invoking the vices of the *toilette* and the coquette in his discussion of the painting. In the self-portrait, he said, Painting plays Beauty's dressing maid; "she [Painting] takes care to embellish her [Beauty] with all the arts of the most seductive coquetry," but does not see that "the art is in hiding the coquetry."[30] Here the "excessive" and obvious artifice (or coquetry) of the colorist painter is compared to the artifice of the dressing room, and both are assigned to the feminine.

In contrast, critics said Labille-Guiard painted nature and truth. She made perfect resemblances, faithful images. Her work was "naturel sans prétention."[31] Compared to the portraits of Vigée-Lebrun, hers opinion viewed as less flattering, but more vigorous and truthful and with a just resemblance.[32] Fréron says in the *Année Littéraire* (16:264) that she took nature as her guide. The remarks suggest that Labille-Guiard put a faithful representation of the object (truth) above display of her artifice (manner). The paintings of these two women, then, were gendered differently; Vigée-Lebrun's work was feminine in its soft touch and artifice; Labille-Guiard's masculine in its firm touch and truthfulness. The point is interesting on several counts. It suggests that, at least in the matter of execution, the sex of the artist and the gender of her painting need not coincide; no critic seems to be upset that Labille-Guiard paints like a man. Far from it, they use the observation as a way to praise her.

This opposition between the two women artists structured one of the most interesting critiques of 1785, perhaps the one that Lebrun-Pindare's poem addressed and challenged. In that pamphlet the anonymous writer presented himself as a woman artist, the better to comment on women's art.[33] In assessing the work of Vigée-Lebrun and Labille-Guiard, he lambastes the first in every possible way—her work appeals only to "some women"; the applause of clerks, servants, and the like made her reputation; she is "mistress" of her subject only when she paints Calonne. Moreover, although Vigée-Lebrun conceives grandiose paintings, she is not up to the task of executing her ideas. Her work is mannered and ill drawn, her "faire" is "mou, inégal."[34] Although the writer found some faults with Labille-Guiard's work, he hailed her *Self-Portrait* (figure 26) as bringing together "toutes les belles convenances de l'histoire" with "tous les agrémens d'un Tableau de genre."[35] But here is the most interesting comment, and it is addressed to Labille-Guiard as the "émule de Rosalba," a phrase frequently used to describe Vigée-Lebrun: "She's a man that woman, I heard it said unceasingly in my ear. What firmness

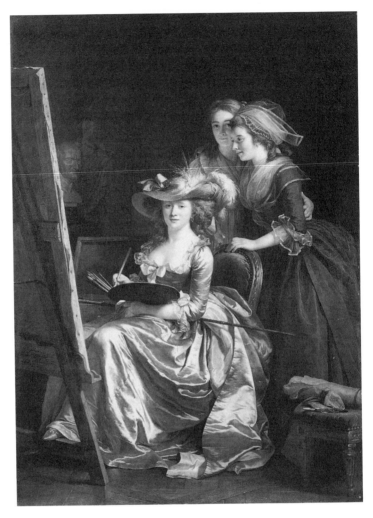

Figure 26 Adelaïde Labille-Guiard, *Self-Portrait with Students*, Salon of
1785. New York: Metropolitan Museum of Art

in her execution, what decision in her color, what knowledge of effects, of
perspective of the forms, of the play of groups, and ultimately of all the parts
of her art. She's a man, there is something superior, she's a man. As if my sex
was eternally condemned to mediocrity."[36] Speaking "as a woman" this critic
comments on remarks made to the effect that Labille-Guiard painted like a
man, made herself a man, and in doing so lays bare, although does not ac-

tually contest, the assumption of male superiority. At the same time, he shows her superior to her "feminine" rival, Vigée-Lebrun. In responding to these sorts of commentaries that demeaned the work of Vigée-Lebrun both directly and through a comparison with her "rival" Labille-Guiard, Lebrun-Pindare writes as if the positive side of painting like a man—the virile brush—was commonly attributed to Vigée-Lebrun, while suggesting that the slander issuing from envy's snaky tongues hints that she is not a real woman. Yet how could this most "feminine" of painters—the one with a soft touch and artificed manner—be thought manly? Why does the poet locate her manliness in her brush?

Portrait of the Artist as Hermaphrodite

For Labille-Guiard, making herself a man was equivalent to making herself an exceptional woman. The exception was unthreatening because her manliness was located in her craftsmanship, in how she touched the canvas. Since the founding of the French Academy, theorists had reckoned that there were two parts to painting, "la main" or execution and "la raisonnement" or reasoning.[37] The terms refer to body and mind synecdochically, and set up within painting a mind/body hierarchy. This division suggests why Lebrun-Pindare, contrary to other critical opinion, located Vigée-Lebrun's manliness in her "virile brush." When it was a question of execution, it was acceptable for a woman to make herself a man. In 1785, however, Lebrun-Pindare defended Vigée-Lebrun against the disdain directed at the various sorts of hermaphrodites. One particular response to her work is especially pertinent here, that of the critic who wrote the pamphlet *Le Triumvirat des arts* under the name Coup de Patte.[38] His discussion acknowledges that in her Salon debut of 1783, Vigée-Lebrun showed not only portraits, but history paintings. In fact, his comments are prompted by the artist's presentation of herself as a history painter, the only kind of painter thought to rank with the intellectuals.

Coup de Patte's evaluation of the Salon is presented as a conversation between a painter, a poet, and a musician. The trio pauses before Vigée-Lebrun's self-portrait (1783; figure 27), and the musician asks whom the work represents. The sitter must be a student of Duplessis, the poet speculates, giving the portrait to that established artist. The painter knows better; the work, he explains, is a self-portrait. "Indeed! this pretty person has painted herself!" exclaims the surprised poet. He is perhaps surprised because the work is magnificent; the painter thinks it would be difficult to make a more successful portrait. Nevertheless, the painter is troubled because the figure's hair is a

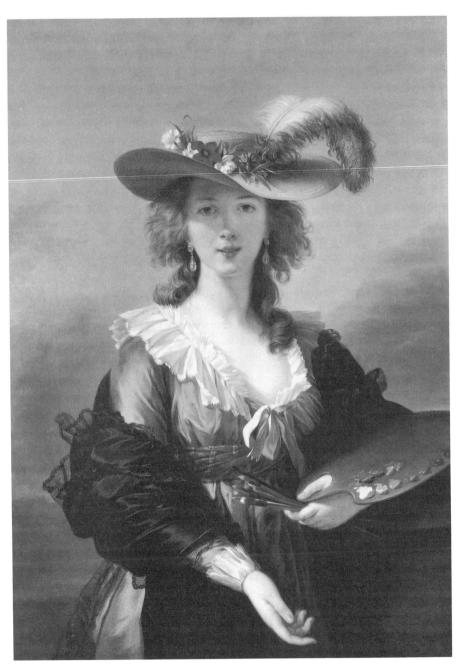

Figure 27 Elisabeth Vigée-Lebrun, *Self-Portrait*, After 1783. London: National Gallery of Art (Autograph copy of work exhibited in 1783 and now in a private collection)

little *négligé.* The musician takes this as a sign that she has the "taste" of great artists not focused on mundane details. Addressing himself to the painter, the musician asks, "Is she a history painter?"[39] And the painter replies:

> No. The arms, the head, the heart of women lack the essential qualities to follow men into the lofty region of the fine arts. If nature could produce one of them capable of this great effort, it would be a monstrosity, the more shocking because there would be an inevitable opposition between her physical and mental/moral *(morale)* existence. A woman who would have all the passions of a man is really an impossible man. So the vast field of history, which is filled with vigorously passioned objects, is closed to those who would not know how to bring to it all the expressions of vigor.[40]

I take the hermaphrodite to be the governing image throughout this passage. In characterizing the woman history painter (the woman "capable of this great effort") as a monstrosity, the text evokes the long history of considering the hermaphrodite among the marvels and mistakes of nature. It is significant that the writer prefers the feminine *la monstruosité* to the masculine *le monstre.* Yet it is the other parts of the text that clarify the particular nature of this monstrosity—this femme-homme. The woman history painter tries to assume the man's role; she tries to imitate men, to follow them. If her imitation were possible, it would produce an impossible opposition between the woman's physical and mental/moral existence. She would combine the female sex with male cultural performance, and this combination is held to be as impossible as the doubled sex of the real hermaphrodite. A woman who had the force to produce significant works of art would be neither woman nor man, but impossible man. Woman's arms, head, and heart "lack the essential qualities," the qualities needed "to follow men into the lofty regions of the fine arts." This dismembering of the body, this metonymic use of body parts—of arms, head, and heart—to substitute for moral and physical qualities—strength, reason, passion—confirms the connection between the (sexed) body and cultural achievement. It also recalls the unmentioned body part, the master piece, that could organize and give meaning to the whole. For what women lacked was not in their arms, head, or heart. It was (or rather was not) between their legs. What women lacked was the penis, guarantor of physical, mental, and emotional force.

Thus, for the enlightened critic, the woman history painter is as chimerical as the true hermaphrodite was for the enlightened scientist. Throughout this passage of criticism the femme-homme intersects with the hermaphrodite and is every bit as impossible a figure. The text defines the woman history

painter, the femme-homme, as impossible through a strategy of denial that first posits and illustrates the category (of woman history painter) by pointing to Vigée-Lebrun's self-portrait. The positing and illustrating, however, are only preparatory to the denying. No real being could actually fill the category of woman history painter.

We can compare this textual strategy to the one used in some eighteenth-century discussions of the hermaphrodite, in particular those in the anatomies of Gautier d'Agoty as well as those in the *Encyclopédie*. In these texts the category of the hermaphrodite is posited in the engraved images (which show the abnormal sex organs), but denied in the written descriptions. The illustrations present, in an artful, but clearly rendered visual language, the double sexing of these monstrous individuals (*Encyclopédie;* figure 28). They represent visually a

Figure 28

"Hermaphrodites." From the
Encyclopédie

real hermaphrodite, at least to uneducated viewers who believe what they see. In describing how the hermaphrodite is not really doubly sexed, and in situating him-and-her as he *or* she, the text educates the viewer, now turned reader.[41] In the Salon, the paintings of Vigée-Lebrun—her mythologies, her allegories—appeared to be history paintings, and her self-portrait suggests that she is a painter with the "taste" of the great masters. The ignorant viewer might be tempted to believe what he sees. The musician, after all, takes Vigée-Lebrun for a history painter based on how she appears in her self-rendering. In believing what he sees, the ignorant Salon viewer is like the reader who looks at the pictures of hermaphrodites without reading the text, and if viewers of anatomical illustrations needed the scientist, Salon-goers needed the critic. Like the scientist, the critic will define the categories and impose his words over Vigée-Lebrun's mute images. Coup de Patte's text denies her works the status of history painting by showing them to be false history painting.

Recall that Coup de Patte's text contained two misrecognitions—the poet took a woman portrait painter for a man portrait painter, and the musician took a woman for a history painter. Significantly, the first mistake produces only pleasant surprise; a woman was allowed to paint like a man when it came to executing a portrait. In theory, portraiture did not tax the mental powers of imagination and judgment, central components of reason; it required only manual skill and the ability to copy or mimic nature. Mimicry was "natural" to woman, and it is ironic that this natural propensity was also the basis of woman's hermaphroditism as tribade or femme-homme. Mimicry was allowed only within certain limits; it was not "natural" for women to mimic men in most circumstances.

The second mistake—that of taking a woman for a history painter— elicits the outraged response. Vigée-Lebrun can only be a history painter *manqué*. Yet she tries to become (and many say she succeeds in becoming) a history painter, and it is as a history painter that she presents herself at the Salon. Seen in this light, her self-portrait as read by the musician shocks; it shows trouble lurking underneath her slipping chemise, beneath her reassuring femininity. And the painter raises the specter, shows the musician the monster, the woman with "force," the intellectual woman, the woman with a penis. The monster must be slain, and the painter does it easily by denying that Vigée-Lebrun's history paintings are history paintings. The violence is done by definition. The critic avoids the *direct* suggestion that Vigée-Lebrun herself was less than a "real" woman, although this is implied throughout the text in its figuring of the woman history painter as a hermaphrodite. Rather than take this tack overtly, Coup de Patte argues that her history paintings are not "real" history paintings. No matter how much she may think herself one,

Vigée-Lebrun is not a history painter because a woman history painter cannot be.

I want to linger a moment over Coup de Patte's method of putting Vigée-Lebrun in her place, for it is one small part of a much larger process through which certain bodies are urged to assume their "normal" and "proper" identities. In her recent book, *Bodies that Matter*, Judith Butler has clarified the practices through which regulatory regimes operate. Central to her discussion is a notion of performativity in which performance is construed "not as a singular or deliberate 'act,' but, rather, as the reiterative and citational practice by which discourse produces the effects it names."[42] A performative notion of identity does not presume a voluteerist subject, since performativity "cannot be theorized apart from the forcible and reiterative practice of regulatory sexual regimes."[43] Thus, for example, one way women became women in the eighteenth century was through repeatedly performing the flirtatious games of the coquette; one "became" a woman-coquette by acting out or citing a particular discourse, which through individual performances (of it) came to produce the effect it named. Based on Foucauldian ideas, Butler argues that it is through various threats—of ostracism, of psychotic dissolution, of punishment figured as castration, even of death—that individuals are pushed to cite or reiterate certain behavioral norms while refusing or rejecting other possibilities. Those rejected possibilities Butler labels as "inarticulate" or "abject." Her larger point is that individuals become men or women not only by citing certain norms, but also—and even more primarily—through rejecting or excluding those positions that are abject or not recognized in the system.[44]

Coup de Patte's discussion of the woman history painter, particularly when viewed together with the contemporaneous discourse on the tribade and femme-homme, illustrates on a small scale the practices of regulatory regimes. He urges a rejection of the woman history painter by defining the position as both abject and inarticulate—abject because if such a thing existed it would be a monstrosity, and inarticulate because such a thing cannot exist (that is, be named) by the current regimes regulating the production of sexed persons (and also the production of art works). The woman history painter is forced into the domain of the culturally impossible. It is of particular interest that Butler focuses much attention on the horror provoked by the abject figure of the phallicized dyke. Although the eighteenth-century categories of tribade and femme-homme are not equivalent to that of the dyke, there is still a similarity in the threatening character of women who mimic men either in their sexual desire for women, in their phallic sexual performance, or in their social behavior. And feminine behavior was certainly regulated by threats—the tribade, as well as the woman with excessive clitoral sexuality, was threatened not

only with social and moral censorship, but also madness, nymphomania, and even clitorectomy. The woman who forgot the cares of her household, faced the specter of the guillotine. Those women whom some deemed "exceptions" to some of the laws regulating sexuality and behavior were still subject to derision, slander, and scorn, and their exceptional position did nothing to ease the laws for everyone else. Indeed, when Butler explains how the isolated willful act performed outside normative boundaries does not actually subvert the law because that act cannot be registered or named until repeatedly performed, she inadvertently describes the position of the eighteenth-century exceptional woman whose isolated freedoms did not challenge the constraints under which other women lived, but who could potentially become a real "threat" to the law if joined by too many other exceptional women, all acting improperly.

A History Painter Manqué

It is assumed throughout Coup de Patte's text that women are lacking in reference to men. To prove they cannot be history painters, however, history painting must also be gendered masculine so the argument can rest on the necessary coherence of sex and social role. This may seem easily done. Because history paintings displayed and required imagination and judgment— two central components of reason—they traditionally belonged on the side of the masculine. This aspect of history painting is assumed when the painter says that women do not have the "head" to follow men into the highest regions of the arts. Critics, however, had no need to rant against women entering the highest genre; they simply argued that Vigée-Lebrun's history paintings were imperfect—scarcely history paintings at all—because they lacked evidence of the higher artistic processes.

Coup de Patte's painter complained that her rendering of themes from Homer was inept, even disrespectful; more commonly cited was her failure to idealize properly the figures of her goddesses.[45] Some critics suggested that she merely copied them from Flemish art, which explained their "courtes et lourdes" proportions.[46] Others accused her of copying, rather than imitating or idealizing nature. At least one commentator excused her these faults because she (as a woman?) could not be expected to understand the ancients: "It would be unjust to expect of the estimable artist of whom we speak those grand and sublime forms that one only acquires by a profound study of the masterpieces of antiquity. The heads in the paintings of Vigée-Lebrun are very pretty surely, but they are pretty French heads."[47] Idealizing nature required that one enter into the mindset of the ancients, not merely to copy their

works, but to invent new ones based on their principles. Put in psychoanalytic terms, idealizing nature required that the artist enter into a symbolic—rather than imaginary—order relation with his ancient forebears. In such a relation the artist would take the place of the ancients by mimicking the norms of their art. Vigée-Lebrun, however, is here held incapable of such a relation to antiquity; to identify with its masters required that one have, not be, the phallus. Hers, on the other hand, is an art of the pretty, an art of the here and now; she can identify with "pretty French heads" because she has one.[48] Her inability to mime the ancients was perhaps most effectively articulated by the narrator of *Apelle au Sallon* who tells us what the Greek painter noticed in looking at her *Juno Borrowing the Belt of Venus* and *Venus Binding Cupid's Wings:* "The artist [Vigée-Lebrun], he [Apelles] said, should have joined the color of the one to the elegance of the other to form a single whole; I assembled all the beautiful women of Greece, and I painted only my Venus coming out of the water."[49]

Perhaps even more serious was the criticism of her reception piece, *Peace Bringing Back Abundance.* Some critics intimated she had not invented the composition, but merely copied it from another work of art. Such remarks provoked a proper defense from others reviewing the same Salon: "To diminish the glory of the artist, some critics say that Vigée-Lebrun, who is more able than others to consult excellent models, has here only copied them. They claim to recognize in her painting Guido Reni, Pietro da Cortona, Cignani, Santerre, etc., but all that proves she has copied none of them. If she has sought to imitate them, nothing is more permitted, it is even a precept of art."[50] This last quotation suggests that the works of Vigée-Lebrun, and especially her history paintings, were by no means universally condemned. In fact, they had drawn quite a bit of positive notice since her first exhibition in 1774. And this positive notice may in part have provoked the negative evaluations that appeared in 1783 and continued until she stopped exhibiting history paintings in 1789.[51]

All the criticisms thus far cited concern the "head" that women did not have. Although Coup de Patte mentions the head, he does not actually emphasize it. Rather his passage reaches this conclusion: "So the vast field of history, *which is filled only with vigorously passioned objects,* is closed to those who would not know how to bring to it all the expressions of vigor" (my emphasis). History paintings, then, must show vigorously passioned, i.e., male, objects. The category here excludes not only female practitioners, but many of the subjects drawn from mythology that rococo painters represented under the rubric of *la fable.* Which is to say that both the subject and object of history painting must now be male. The history painting cannot be a hermaphrodite.

It cannot combine the active male subjectivity of the artist with passive female bodies as objects of representation, nor can it combine the delicate sensibility of a woman artist with vigorous male bodies as objects of representation.[52]

The objects shown in the history painting must now express the reason and vigor of the male subject who made the painting. And this is a very important point. Coup de Patte is here operating from an expressive theory of art in which the essential self of the artist is visible and readable in the work of art, in which there is a real connection between the marks the artist makes on the canvas and the artist's state of mind in making those marks. The coherence of subject and object in a painting could only be demanded from such an essentialist notion of artistic expression. This theory competed with a rhetorical notion of art prevalent throughout the eighteenth century and fostered (if only inadvertently) by academic ideas. Academic painters learned a repertoire of artistic moves (styles, paint handlings, etc.) tied to specific subject matters, and these moves could be put on and taken off for the occasion. Whereas a rhetorical conception of art assumes the artifice of representation, Coup de Patte's expressive or essentializing notion of artistic production is congenial to the mentality that essentialized social roles and sexed bodies.

In presenting herself as a history painter Vigée-Lebrun was clearly operating from a conception of woman different from that assumed by Coup de Patte. She was also working with a less restrictive definition of history painting and a different theory of art making. As we have seen, Coup de Patte was hardly alone in advocating a kind of history painting that would in theory and in practice close the genre to women. The reform of history painting was part of the program undertaken by d'Angiviller, who wanted to rescue the highest genre from the depths into which it had fallen in the hands of rococo painters, who by 1783 had already been castrated by reforming critics. The noble male genre was corrupted—made hermaphroditic—by its attachment to bodies marked as feminine.[53] Despite the critics' attempts to invalidate Vigée-Lebrun's history paintings, the issue of the woman history painter was not so easily shoved aside. "Is she a history painter?" The question Coup de Patte put in the mouth of the ignorant musician still lingers. As much as the text tries to describe Vigée-Lebrun as a chimera, comparing the woman history painter to the hermaphrodite, her works argue that she—the woman history painter—does exist.

Beauty and the Beast

In looking at Vigée-Lebrun's self-portrait, what might first strike modern viewers is that the artist shows herself as a beautiful and fashionable woman,

which suggests that Vigée-Lebrun is representing herself within what we consider traditional conceptions of femininity. Indeed, beauty is coded not only in the regularizing of her features and in the sensuous paint handling and color harmonies, but also in her choice of a model on which to base her work. By Vigée-Lebrun's testimony, the painting that inspired her was Rubens's portrait of Susanna Luden, believed in the eighteenth century to represent his wife (called *Le Châpeau de Paille*, 1620–25; figure 29). Since the time of Roger de Piles this work had been held up as the model for representing beautiful women.[54] Does this aspect of the work, however, fix its meaning, type Vigée-Lebrun's image as representing nothing more than a feminine object?

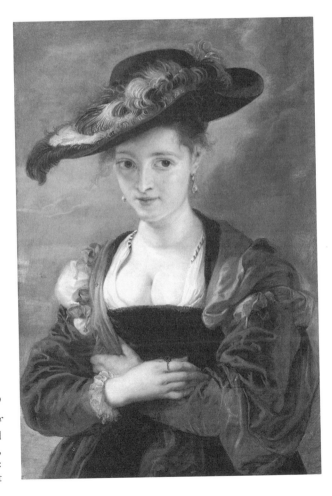

Figure 29

P. P. Rubens, *Portrait of Susanna Luden (?)* (called *Le Châpeau de Paille*), 1620–25. London: National Gallery of Art

I raise this question because the only feminist reading of the work has understood it precisely in this way. For Rosizka Parker and Griselda Pollock, the artist presents exactly the unproblematic fit of biological sex, sexual identity, and social role that Coup de Patte wanted to see. Wanted to, but did not, see, since his consideration of the work evolved as a diatribe against the femme-homme. Parker and Pollock, on the other hand, direct the analysis toward what they perceive as Vigée-Lebrun's total complicity with or capture by the prevailing norms for woman. In describing her appropriation of Rubens's work, Parker and Pollock note, "The coquetry and sensual feeling of that painting is hardly an appropriate model for an artist to use as a basis for a self-portrait, but it is a typical representation of woman, not just a woman, but Woman, sexual, physical, the spectacle of beauty."[55] Consider first that this argument turns on an opposition between representing sensual beauty and representing the artist, an opposition that they do not root in any specific conceptualizations of either one or the other. In deeming Rubens's work "hardly an appropriate model" for a self-portrait, the authors implicitly endorse the truth of that opposition and pose the issue as one of Vigée-Lebrun's bad choice.

Although the conclusion they draw is very different, the opposition Parker and Pollock read in Vigée-Lebrun's self-portrait here resembles the dissonance that analyst Joan Rivière noted in the patient whose case she told in "Womanliness as Masquerade" (1929).[56] A Freudian analyst, Rivière positioned her essay in the context of the psychoanalytic debate over female sexuality, and was concerned with an intermediate type of woman who, although "mainly heterosexual" in her development, displayed "strong features of the other sex."[57] In such women, she argued, one could see that "femininity" was a mask to cover traits accepted as masculine, and that mask both allayed a woman's anxiety about her unconscious masculinity, and warded off the (real and fantasied) threat of male retribution for "improper" or masculine female behavior. Rivière reached this last conclusion by observing how her patient (and other women) reverted to stereotypical "feminine" behavior after a particularly compelling intellectual performance (for example, her patient openly flirted with "father figures" after giving an impressive lecture).[58] Thus the masquerade explained the coexistence of two differently gendered characteristics, a coexistence that, at least superficially, resembles what we might imagine in Vigée-Lebrun's self-portrait: the proficient artist playing the part of the beautiful woman. Rivière, however, does not see this masquerade as a simple choice; as is well known, she posits that masquerade coincides with "normal" womanliness: "The reader may now ask how I define womanliness or where I

draw the line between genuine womanliness and the 'masquerade.' My sug-
gestion is not, however, that there is any difference; whether radical or super-
ficial they are the same thing."[59]

What Rivière suggests the feminine masquerade conceals (from both the
woman and the men around her) is precisely what Coup de Patte so fervently
denies and fears in women—masculinity as intellect, force, and desire. Coup
de Patte seems to have read this hidden masculinity in Vigée-Lebrun's Salon
entries, and here it is significant that he articulated them in reference to an
image of the "pretty person" who had painted herself. Although Rivière might
have understood this image as one of masquerade in which the "feminine"
traits cover over an impressive professional performance, Parker and Pollock
do not see any sort of positive performance or achievement lying behind the
allegedly feminine image. Standing before Vigée-Lebrun's work, they allow
the spectacle of Woman to eclipse any possibility of seeing or imagining an
artist:

> Her self portrait . . . carefully depicts the rich stuffs [?] of her dress,
> the neat pleats of trimming, the textures of her soft hair and feathers.
> She holds the brush and palette with an elegant and unworkmanly
> gesture, the paint colors neatly arranged to echo the decorative ar-
> rangement of flowers on her hat. She offers herself as a beautiful ob-
> ject to be looked at, enjoyed and admired, but conveys nothing of
> the activity, the work, the mindfulness of the art she purports to
> pursue. As an image of an eighteenth-century artist it is wholly
> unconvincing.[60]

But unconvincing to whom? Most critics who commented on Vigée-
Lebrun's self-portrait in 1783 saw the artist very clearly. Fréron, for example,
described the work as her "masterpiece" because it showed her "genius" van-
quishing the difficulties of art.[61] Another said she was represented in "an atti-
tude of painting," that she held in her hands "the instruments of the art that
she practices with so much glory."[62] Even Coup de Patte, in denying that
women could be history painters, suggested that Vigée-Lebrun represented
herself as one. The judgment of "wholly unconvincing" needs rethinking not
only in light of more recent strategies of feminist interpretation (strategies
that Parker and Pollock themselves have helped to produce), but also in view
of the conventions for artists' self-representations as well as more current con-
siderations of eighteenth-century French art.

In looking at self-portraits and portraits of artists produced throughout
the eighteenth century, it becomes clear that a display of beauty did not nec-
essarily produce an unconvincing *image* of an artist. Such a (self-) presentation

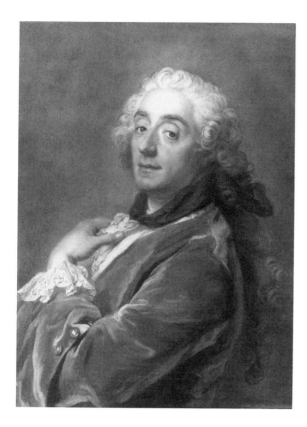

Figure 30

G. Lundberg, *Portrait of François Boucher,* 1752. Paris: Musée du Louvre

would have been advantageous to any artist—male or female—as La Tour's self-portrait (1751, Amiens: Musée Picardie), Lundberg's portrait of Boucher (1752; figure 30), or Labille-Guiard's self-portrait (1785; figure 26) show. This is perhaps because viewers understood that the effect of beauty was created by artifice. In other words, Vigée-Lebrun could only appear ravishing and sensuous because she made a ravishing and sensuous work of art. The beauty of the beautiful artist's self-image is thus inseparable, not from the woman's person, but from the artist's work. Indeed, some Salon critics found Vigée-Lebrun's self-portrait to be her most stunning painting, even though as a portrait it did not resemble her. Fréron, for example, ended his discussion of her works and those of Labille-Guiard with this comment: "I cannot speak of the self-portrait of Labille-Guiard without remarking on something that seems striking to me. This portrait seems to me inferior to all those that she has shown at the Salon. That of LeBrun, on the contrary, is superior to her other works. Both women paint themselves holding a palette in their hand, but

Labille-Guiard's portrait resembles her very much and LeBrun's so little that one can scarcely recognize her."[63] Fréron here judges these works not as portraits (that is, not on resemblance) but as works of art; the comment suggests that when he looked at Vigée-Lebrun's image he saw not the spectacle of Woman, but a beautiful painting made by a woman. Especially given that this work was labeled a self-portrait in the Salon livret, pamphlets, and periodicals, and was displayed with those Salon entries designed to present Vigée-Lebrun as history painter and protégé of the queen, it is difficult to see how the artist could be ignored.

This is not to deny, however, that it was possible for an eighteenth-century viewer to read this portrait as that of a beautiful woman. Vigée-Lebrun's display was certainly not entirely lost on her contemporaries. Standing before the portrait, the critic Grimm responds as a particular ideal of masculinity is supposed to respond to a particular ideal of femininity. Grimm begins his commentary on Vigée-Lebrun's portrait by summarizing all the negative evaluations offered by other critics, an interesting tactic in itself. His move to deflect these criticisms is addressed to the artist's detractors:

> Notice there are thousands of defects more, but nothing can destroy the charm of this delicious work. . . . I have seen even alongside of this work beauties of a superior order, but never have I seen any work that better breathes the *je ne sais quoi* which pleases. . . . One senses that only a woman, and a pretty woman, could have conceived of this charming idea and could have rendered it with a grace so brilliant and so naive.[64]

This discussion reveals many of the same contradictions and tensions that characterized Miramond's verses to Vigée-Lebrun. What Grimm has written as an extravagant compliment to the artist's person, works to remove her "vrai chef-d'oeuvre" from the sphere of intellectual calculation. Vigée-Lebrun knows intuitively how to make this portrait pleasing because as a pretty woman she knows how to please. These comments are particularly pointed because they follow what can only be called a mixed review of her history paintings. Thus Grimm uses the work to put the woman artist in her place, as a portrait painter and as a woman. In Grimm's discussion there is an unpleasant eliding of woman and (art) object, with both held under the scrutiny of the male viewer. The eroticized aesthetic discourse widely applied to all sorts of colorist paintings during the eighteenth century, here is applied to the artist as well (only a delicious woman could have made this delicious painting). But despite himself—and we should not lose sight of this point—Grimm responds to the portrait as a successful work of art by a talented artist, for the whole

discussion resonates with the influential writings of Roger de Piles, who saw the highest merits in painting as those of attracting, seducing, and fooling the eye of the beholder.[65] As much as Grimm might like to see only the woman, the artist keeps intruding. He uses Vigée-Lebrun's reputed and represented beauties to naturalize the fit between performing as an artist and performing as a woman, but his need to naturalize this fit reminds us that any woman painter—but especially one who performed at Vigée-Lebrun's level—stepped outside woman's proper role. Other critics, moreover, used the image's beauty to demean its maker from another direction. The anonymous author of the pamphlet, *Marlborough au Sallon du Louvre*, found in the portrait's obvious idealization an excuse to insult the artist's person, writing a "pretty verse" to go with the painting:

> In seeing this portrait, I believe I see the person,
> It is Lisette, herself; she steps out of the painting.
> But if I dare to say it, one thing astonishes me.
> It is that Lisette is ugly and her portrait is beautiful.[66]

It is important to realize that there were many interpretations of Vigée-Lebrun's self-portrait available to and expressed by eighteenth-century viewers, and, judging from the entire corpus of Salon criticism, there was no uniform response to the work. And this is to be expected. Representational codes are hardly stable, and viewers come to them with different experiences and expectations. Each gesture and expression, each coded fragment potentially has many (but not unlimited) possible meanings within the visual language, so that references in a painting usually remain multiple and mobile. Artists, however, sometimes try to fix the play of the visual language, especially in a work designed for a didactic, moralizing, or propagandistic purpose. (J. B. Greuze's *The Punished Son* [1777], Paris: Musée du Louvre; and J. L. David's *Oath of the Horatii* [1784], are pertinent examples.) At other times artists capitalize on the multivalence of representational codes. This seems to be the case for Vigée-Lebrun's self-portrait, which is saturated by the many competing and conflicting codes—by the discontinuities—that run rampant through this image.

Performing (as) the Great Artist

I have already suggested that in terms of eighteenth-century French art the representation of physical beauty in a sensuously beautiful painting was not at odds with depicting "the artist." Now I want to explore elements of the image that could have signaled "artist" to anyone even a little familiar with the eighteenth-century codes of self-portraiture and to play those elements with

and against other possible interpretations of Vigée-Lebrun's painting. Those features of the image related to self-portrait convention, however, are hardly frozen into a consistent picture of artistic production: they point to various moments in the artistic process, as well as different modes of performance and different social roles for an artist. But the significant point here is that all are citations, in the sense that Butler, following Derrida, uses the term:

> Could a performative utterance succeed if its formulation did not re-peat a "coded" or iterable utterance, or in other words, if the formula I pronounce in order to open a meeting, launch a ship or a marriage were not identifiable as conforming with an iterable model, if it were not then identifiable in some way as a "citation?" . . . In such a ty-pology, the category of intention will not disappear; it will have its place, but from that place it will no longer be able to govern the entire scene and system of utterance [*l'énonciation*].[67]

As I shall argue, Vigée-Lebrun's image, taken as a performative utterance, cites the formulas for representing the artist as frequently and as forcefully as it cites those for representing a desirable woman. The painted image, more-over, is both a performative utterance and a representation of identity. But if, as Butler argues, identity is created by performances accumulated over time,[68] we must imagine that in representing her identity Vigée-Lebrun condensed her real and fantasied performances into a single image and signified them on the surface of her fictive body. The layering or imbrication of signifiers suggests various temporal moments or actions condensed into one pictorial space. This condensation seems to produce a coherent identity because artful arrangement fits the signifiers into a pleasing aesthetic structure. This coher-ence, however, is as fictional as Butler claims the coherence of identity to be. In *Gender Trouble: Feminism and the Subversion of Identity*, Butler argued that the construction of gender as internal and coherent is itself a regulatory fic-tion, for it encourages actions that approximate the ideal of a substantial ground of identity. In practice, what we do does not have the coherence that being this or that gender theoretically suggests: "The construction of coher-ence conceals the gender discontinuities that run rampant within hetero-sexual, bisexual, and gay and lesbian contexts in which gender does not nec-essarily follow from sex, and desire, or sexuality generally, does not seem to follow from gender—indeed, where none of these dimensions of significant corporeality express or reflect one another."[69] Butler's analysis, moreover, can be extended into areas that have not concerned her directly; one could ask how individuals take on class identity or social status, or how they become this or that race or ethnicity, or, as Michèle Le Doeuff asks, how they assume this or

that professional identity. The broader and more complex the array of factors considered, the less the coherence of identity can be maintained. In other words, the more the factors, the less likely they will cohere in the pattern of associations considered "normal."

To begin with social status, Vigée-Lebrun's work recalls those artist's portraits where painters are shown as affluent, fashionably dressed, and carrying themselves with grace and assurance. Although these types are more frequently associated with the earlier part of the century, they are often found in the later. Roslin's *Self-Portrait* of 1790 (Florence: Galleria degli Uffizi), Vestier's 1786 portrait of Nicolas-Guy Brenet (figure 31), Louis-Michel Van Loo's 1763 self-portrait with his sister (Versailles: Musée national du château), and Labille-Guiard's *Self-Portrait with Two Students* (figure 26) are all good examples. Images of this sort make visible the desire of artists to disassociate themselves from the manual labor then believed to degrade the fine arts and to identify themselves with the "noble" aspects of painting. These representations are particularly interesting because in each the artist, dressed in fashionable garments, is posed before an easel or with palette and brushes. Thus

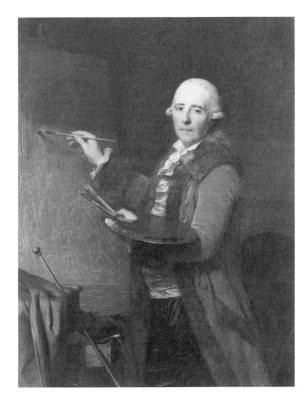

Figure 31

Antoine Vestier, *Portrait of Nicholas-Guy Brenet*, 1786. Versailles: Musée du château

codes that seemingly conflict could be joined unproblematically, as in the elegantly attired "working" artist. Elegant attire, moreover, points beyond the easel and studio to the artist's performance in other social scenes. The alleging of high social status is related, as always, to the nobility of the art enterprise and becomes a marker of art's "value," measured within the prevailing norms of the social economy.

Although the fashionable Vigée-Lebrun does not show herself before the easel; she presents herself through other well-known conventions. These make in a different way the same point as the elegantly attired working artist. In her left hand she holds the attributes of her art, with her right she makes a rhetorical gesture. This configuration was common in portraits of artists (e.g., Louis-Michel Van Loo, *Self-Portrait with Sister*) and pointed to the twofold nature of painting—*le faire* or the hand indicated by the tools of the trade; mind or reasoning indicated by the rhetorical gestures.[70] Indeed, the gesture made by Vigée-Lebrun in her self-portrait is a common one that appears in manuals (Bulwer's *Chirologia*, for example) and refers to the artist's reasoning. The gesture is made in self-portraits throughout the century, by Antoine Coypel in 1707 (Florence: Galleria degli Uffizi) and by Anton Raphael Mengs in 1774 (figure 32). And in 1783 Vigée-Lebrun also called on the gesture to present herself as a painter engaged in rational discourse. This doubled aspect, however, is especially important for the woman artist, since women were usually denied intellectual prowess. Given the placement of the hand near her pubic area, can it not also be read as a dangerous substitute for the member she lacks?[71] Having that member entitled the bearer to the gift of reason, rather than the "gift" of modesty. Vigée-Lebrun is here no modest Venus turning her hand backside up to cover her pubic area; in making her gesture of reasoning her hand figuratively takes the place of the penis, which guaranteed power, will, and reason to the male sex. She is, moreover, a painter to be heard as well as seen, for with lips parted she appears about to address her audience, perhaps to make an observation about the art of portraiture. (It is interesting to note that much later Vigée-Lebrun wrote a short treatise on portrait painting.)

But this Vigée-Lebrun who is about to speak is also a Vigée-Lebrun who appears to look through, not at her audience. She is an artist whose attention seems focused elsewhere, on something, on some mental image, perhaps, that we do not see. This hybrid artist type was not unusual. The image of the speaking, gesturing artist in the eighteenth century was often combined with that of the artist distracted (i.e., concentrating on some mental conception; staring ahead or to the side; or looking through or past the viewer) and garbed in studio *déshabillé*. Tocqué's portrait of Galloche (1734; Paris: Musée du

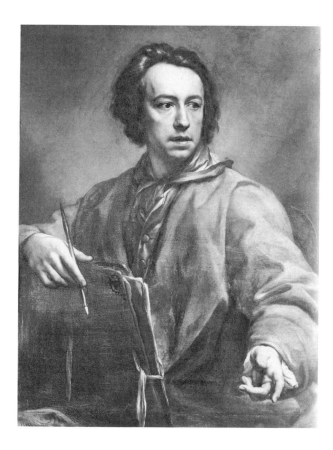

Figure 32

Anton-Raphael Mengs,
Self Portrait, 1774.
Florence: Uffizi

Louvre) and Largillière's portrait of Coustou (1710; figure 33) come readily
to mind. Moreover, the distracted artist or the artist-as-genius often stared
directly out of his or her self-portrait, as does Elisabeth Vigée-Lebrun. A
viewer can see in her work clear parallels with David's self-portrait (1794;
figure 34) not only in the disheveled hair and clothes, but also in the full-face
frontal view and distracted gaze. Her work, however, was adjusted to fit the
conventions to a "feminine" register; *convenance* demanded at least this
much—that she be shown as both artist and woman. In bringing together
these various conventions, I stress that "the artist" was neither a stable nor
monolithic category. New types never simply obliterated older ones, and a
single painting could and indeed often did combine various codes for self-
portrayal. Sometimes codes that we might find conflicting were conjoined un-
problematically (for instance, the elegantly attired working artist; the dis-
tracted speaking artist; the beautiful woman history painter). There were and
are many "convincing" representations of the artist.

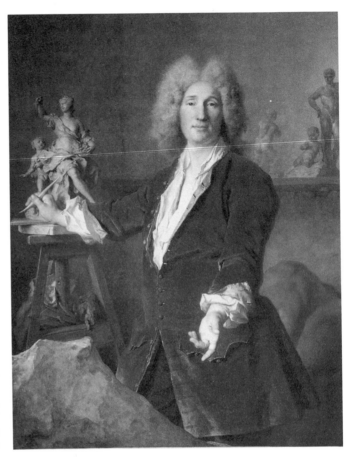

Figure 33

Nicholas Largillière,
*Portrait of the Sculptor
Coustou*, 1710. Berlin:
Staatliche Museum

Portrait of the Artist as Peter-Paul Rubens

In considering Vigée-Lebrun's use of Rubens's portrait, we might say that she rewrites it to suggest that the beautiful woman is an artist inventing, speaking, reasoning, painting. Her citation, in fact, shows a considerable gap between model and copy, a gap more significant when one considers how other women used Rubens's image. As Ribero has shown in her work on eighteenth-century masquerade costume, the *Chapeau de Paille* provoked many women to dress up for masquerade in some variant of the dress worn by Rubens's paradigmatic beauty.[72] These women identify themselves with the sitter, as if she had just stepped away from her portrait sitting to attend some gala event. Vigée-Lebrun, however, breaks any such association by obviously and radically altering the costume. She wears the fashionable dress of 1783, and if she ap-

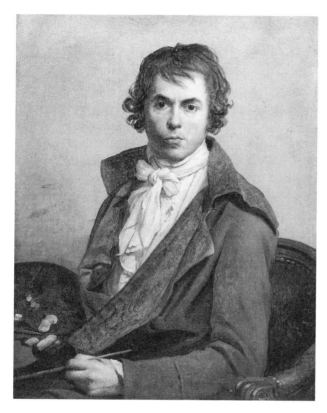

Figure 34

J. L. David, *Self-Portrait,*
1794. Paris: Musée du
Louvre

peared publicly in that garb one would never imagine her a figure depicted
by Rubens.

In comparing her portrait to its model, notice that Vigée-Lebrun also
significantly diminished its more overt display of the body. She changes the
position of the arms that in Rubens's portrait emphasizes the protruding bo-
som. She also significantly changed the gaze of Rubens's sitter in making her
self-portrait. In the *Chapeau de Paille* the figure casts her eyes down coyly,
perhaps showing us false modesty at work in exciting the viewer's desire. The
viewer has free license to explore Rubens's image, for with eyes averted the
woman cannot be imagined as confronting, challenging, or even acknowledg-
ing any viewer's gaze. Moreover, Rubens has pushed the figure so close to the
picture plane that she seems in close intimate contact with and available to
those who look at her. Vigée-Lebrun, on the other hand, sets herself at more
of a distance from the viewer and shows herself looking directly out of the
painting. There is nothing coy (or even coquettish) about the presentation
which, as we have already seen, invokes specific conventions for representing

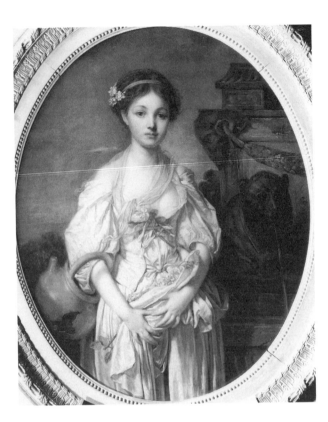

Figure 35

J. B. Greuze, *The Broken
Jug*, 1773. Paris: Musée du
Louvre

the artist. Some eighteenth-century critics, however, lambasted the "expres-
sion" of the work. One said it reminded him of *The Broken Jug* by Greuze
(1773; figure 35) in its immobile attitude and stupefied and vague expression.[73]
The choice of comparison is not, it seems, innocent. The young girl in
Greuze's painting is not receiving inspiration; the *Broken Jug* has a loss of
virginity theme. In comparing the two, the critic perhaps suggests that the
lack of modesty, the lack of traditional feminine morality, can also be taken to
characterize Vigée-Lebrun and her self-portrait. His reading demonstrates
again how codes overlapped, gaped, and opened possibilities for multiple
interpretations.

 Thus far we have only concentrated on Vigée-Lebrun's appropriation of
a figure represented by Rubens. Her work even more emphatically urges
a comparison with the artist who made the representation—with Rubens.
Competing with an established master was a standard exercise for would-be
academicians who could use such competition to identify with their ideal.
Reynolds did this cleverly by presenting himself as Rembrandt contemplating

the bust of his (Reynolds's) ideal, Michelangelo (*Self-Portrait*, ca. 1775; London: Royal Academy of Arts).[74] The work establishes Reynolds's attachment to two painters: Rembrandt (his real model) whose place in the artistic order he takes, and Michelangelo, to whom he remains attached as an unattainable ideal. Vigée-Lebrun's self-portrait, however, brings together the actual and ideal models and emphasizes her connection to one artist: Rubens.

The work also refuses oppositions and suggests the criss-cross patterns of identification that disrupt any notion of coherence. In using the *Chapeau de Paille* as her model, Vigée-Lebrun becomes both the subject Rubens—the one who loves—and the object, Rubens's wife—the one who is loved.[75] Based in love, the portrait recalls the myth of painting's origin in which love inspires Dibutadis to trace the profile of her amour. Vigée-Lebrun, however, does not declare her love for Rubens by literally painting *his* profile in the way Rubens drew his wife or in the way Reynolds showed the bust of Michelangelo. Rather, Vigée-Lebrun both substitutes herself for the one Rubens loved and for Rubens. She becomes his Other, the object he desires, and takes his place as desiring, speaking subject by citing his artistic practices. Which brings this discussion back to the notion of imitation.

As imitator, Vigée-Lebrun does not merely copy, but she makes a work of art as if she were Rubens, substituting herself for him. Here Vigée-Lebrun becomes Rubens not just by using his portrait as her model, but by making her composition and arranging her colors using the same procedures as Rubens. Most important here is that she has mimicked in her painting the singular light effect that characterizes Rubens's portrait. She describes that effect in her *Souvenirs:* "Its great effect lies in the two different lights that represent the simple daylight and the glimmering of the sun, so the lights (*clairs*) are in the sun; and that which it is necessary to call the shade, because there is no other word, is the daylight."[76] Vigée-Lebrun achieves similar effects in her self-portrait where her face, shaded by her hat, seems to be clearly lit even though it is actually bathed in shadow, as the line falling across her cheek and neck indicates. When Fréron noted that this portrait showed her "genius" vanquishing the "difficulty" of art, it was to this difficult effect that he referred.[77]

Moreover, when the hat travels from Rubens's image to an artist's self-portrait, it takes on different significations, and the shadows become more than an exemplification of *difficultas*. In his recent *Memoirs of the Blind*, Derrida has drawn our attention to the tradition in which artists show themselves wearing hats, visors, or sunshades to protect their sight. Derrida particularly focuses on Chardin's late pastel self-portraits of the 1770s (figure 36), images that both shelter and show the eyes, and he also draws our attention to Fantin-

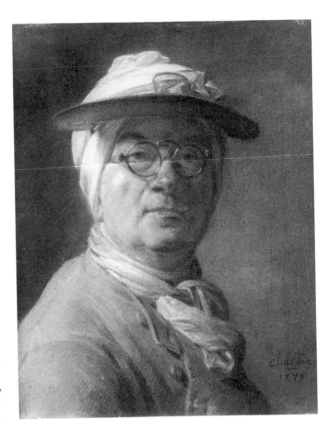

Figure 36

J. B. Chardin,
Self-Portrait, 1775.
Paris: Musée du Louvre

Latour's later self-portraits that engage the convention in a compelling way.[78] We can add to this tradition images like Reynolds's early self-representation where he holds hand to forehead, shading his eyes so he can see into the bright light that illuminates his face (1753–54; London: National Portrait Gallery).[79] It is not coincidental that in her *Souvenirs* Vigée-Lebrun refers repeatedly to safeguarding her eyes and to the various shades she "invented"—in Naples to guard herself from the blinding sun; in St. Petersburg to protect her eyes from the blinding snow; and in Vienna to save them from the lamps and candles beneath which women were doomed to lose their sight making tapestries.[80] Two of these instances are particularly illuminating. In Vienna women lose their sight because they engage in the acceptable—even paradigmatic—"feminine" activity of needlework. Vigée-Lebrun not only rejects this activity, but sees it as symbolically castrating. Forced feminine virtues blind women, take away their power. Rejecting debilitating codes of feminine behavior in Vienna, Vigée-Lebrun embraces fashionability in Naples where she invents a

sunshade, a green cloth draped over the eyes, that became popular wear among women.[81] Thus it is the fashionable—could one say immodest?—woman moving in society who protects her eyes while the domestic woman, properly behaved, loses her sight. The hat Vigée-Lebrun wears in the 1783 self-portrait, her *chapeau de paille*, refers to Rubens's image, sets up a difficult artistic problem, acts as the artist's sunshade, and becomes a fashionable accessory of the elegant woman, one associated with the queen's circle.

Although not all of Vigée-Lebrun's audience could be expected to know the "source" of her self-portrait, the association with Rubens would have been otherwise available, as well. For example, her color tonalities were thought comparable (but not equal) to those of the Flemish master: "I do not think that any woman [other than Vigée-Lebrun] has yet carried to as exalted a degree the seductive and true color tonality that would not displease the immortal *Rubens*."[82] Another wrote that her *Peace Bringing Back Abundance* was painted with all the force and brilliance of the Flemish,[83] and in the *Mémoires secrets* her figure of Abundance was called a superb woman *à la Rubens*.[84] Other critics repeatedly cited her adherence to the principles of the Flemish school, either to praise or to damn her.

If Rubens's *Chapeau de Paille* provided one subtext for Vigée-Lebrun's image, the self-portrait was also connected to a whole set of women's portraits executed by Vigée-Lebrun and keyed to her depiction of the queen *en chemise* that caused such a scandal at the Salon. Vigée-Lebrun reserved the dress *en chemise* primarily (but not exclusively) for a small circle of women including the queen's favorite, the Duchesse de Polignac (figure 37). And several times she portrayed herself *en chemise*, constructing her own identity through her idealization of and association with this circle of powerful women (see, for example, her self-portrait in the Kimball Museum, Dallas–Fort Worth). The self-portrait shown in 1783 invokes that fashion—at least obliquely—with its sash at the waist, bow at the front, scalloped collar, and simple fabric. The plumed straw hat she wears was a favorite accessory, and one also sported by Marie-Antoinette in Vigée-Lebrun's 1783 portrait *en chemise*. Vigée-Lebrun later repeated the composition and costume of her self-portrait for a portrait of Polignac (figure 38), confusing the identity of the Duchess with her own. In associating her self-portrait with her portrayals of the queen and her circle, Vigée-Lebrun suggests not only her attachment to Marie-Antoinette, but also an intimacy among women. That intimacy was also implied by another of Vigée-Lebrun's Salon entries, a portrait of Marquise de la Guiche painted as a milkmaid. Such pastoral disguises, by 1783, were associated with the queen's circle of female friends at the Trianon.

Having explored various potential readings of the elements in Vigée-

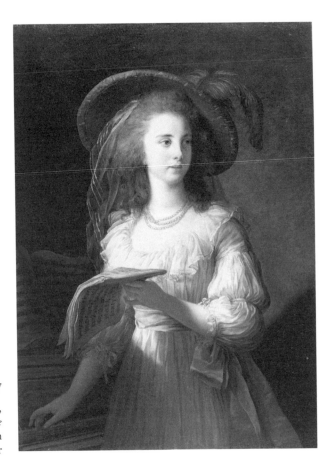

Figure 37

Elisabeth Vigée-Lebrun,
*Portrait of the Duchesse de
Polignac.* Waddesdon
Manor

Lebrun's self-portrait, I conclude that the portrait assumes no single coherent style or posture, posits no essential identity. It presents no contradiction between or among the sorts of performances cited, and no coherence of sex, sexuality, and social role. In her self-portrait Vigée-Lebrun identifies herself all at the same time as intimate of the queen, the painter Rubens, his beloved wife, a painted figure made by Rubens, a history painter, a hermaphrodite, an inspired artist, an intellectual making a reasoned point, a speaking subject, a beautiful woman, an objectified commodity, an immodest woman/artist pleasuring in self-display. We see in Vigée-Lebrun's self-portrait an artist distracted, about to speak, and making a reasoned point, all at the same time. Thus she seems conceptually dis-unified, composed of discontinuous gestures or expressions all of which are cited from other images. She is also disunified through time—presenting herself as various seventeenth- and eighteenth-

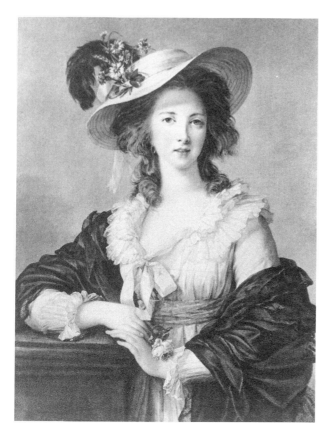

Figure 38

Elisabeth Vigée-Lebrun, *Portrait of the Duchesse de Polignac.* Private Collection

century figures (Rubens, Rubens's wife, Vigée-Lebrun, Marie-Antoinette's intimate)—through position (subject, object), and through sex and gender identity. These visual fragments and associations are framed together in a coherent pictorial structure, which perhaps encourages many viewers to imagine them in conformity with the dominant notion of a coherent self, even though the image in many ways resists this reading.

Self-Portrait, Mimetic Theory, and Gender Performance

Vigée-Lebrun's self-portrait assumes a theory of art within which paintings are not expressions of an artist's inner self, but skillful artistic performances dependent on the ability to mimic signifying codes, gestures, and styles. Diderot identified this aspect of art in his *Paradox of Acting*, in which he described how actors fooled the audience by making signs of emotions they did not feel, thereby effectively severing not signifier from signified, but signified from any

"real" referent. The actor, and by extension the artist, is characterized precisely as having no self save the ability to imitate.[85] That the painter was marked as imitator is evident in eighteenth-century emblems for the artist—the ape and the parrot. Although this mimetic conception of art proclaimed art to imitate "nature," in practice artists mimicked the codes through which nature was represented. That is, they imitated conventional (and illusory) structures.

An artist's training implied this procedure for making art; prior to "imitating nature" artists learned the conventions by copying engravings and plaster casts and using recipe books like Charles Le Brun's treatise on the passions. Eighteenth-century paintings often displayed this dependence on previous artistic styles and conventions as artists overtly played at being this or that great past master, either by redoing a painting in parody-homage, or by working self-consciously in an identifiable manner. In such works the artifice of art was immediately apprehensible. This artifice was a target for writers like Rousseau and critics like Coup de Patte who longed to see through a representation to reality—to the essential self of the artist or to the truth of nature. Their critiques deny, and try to suppress, the artifice of art. The contemporaneous critique of society incorporated a similar fear of illusion—of people who seemed to be what they were not, of people acting outside their "natural" role. That such a critique already assumes the reality of natural roles is obvious.

That artifice, especially overt artifice, makes evident its illusory status, is a point that recent theorists have put to advantage, and it seems appropriate that in analyzing the structure of gender performance, Butler turned to cultural practices such as drag, cross-dressing, and the sexual stylization of butch/femme identities.[86] Although a more conscious choice and deliberate artifice may differentiate such performances from the performativity of what Butler calls assuming a sex, the two sorts of performances are analogous both in what is imitated and in the phantasmatic structure (identity) produced through imitation. Through parody, cultural practices such as drag call into question all essentializing notions of sex, gender, and self, and, like Diderot's actor, the drag performer severs the connections between signifieds and real referents. Indeed, the drag performer severs these connections, or, perhaps better said, renders them ambiguous, in particularly complex ways, because the performer's sex is male but his performance signifies femininity. Therefore the drag performer can be read as meaning *simultaneously* (1) My sex is male but my essential self is gendered feminine and that is what my performance signifies, and (2) I am a man and my essential self is masculine; my performance signifies that I am merely pretending to be a woman by making the appropriate signs of femininity. Moreover, in drag the performer's sexuality—the direc-

tion of his desire—is always in doubt. Is it motivated by his sex, by his gendered self, or by his performance?[87] Butler takes practices such as drag to imply that the structure of gender performance is imitative (and later, citational), but she is quick to add that "the original identity" (i.e., the gendered self) that gender performance imitates is "an imitation without an origin."[88] Gender performance is thus mimetic art that imitates other performances in endless recession.

A similar structure is evident in the self-portrait displayed by Vigée-Lebrun in 1783 along with Salon entries that marked her as a history painter. That her outward appearance in this self-portrait is seemingly consistent with that expected of her sex made her entire performance all the more troubling. I have argued that many in 1783 wanted to see a painting as revealing both the artist's true inner self and the truth of the subject portrayed (of nature). As Vigée-Lebrun here is both artist and subject portrayed, her "truth" should be doubly encoded in the painting. Thus her appearance was distressing, since it indicated that a womanly woman could play a man's role—could be Rubens, or a history painter, or an inspired artist. This inconsistency would have to be argued away; either Vigée-Lebrun was not a woman but a man in disguise (Rubens in drag?) or her performance was not masculine. We have examined Coup de Patte's unsuccessful attempt to make precisely these arguments. His attempt was and is unsuccessful because the painting is a parody of truth as Vigée-Lebrun shows herself as what she is and what she is not; as she mixes what is seemingly true about her, with what is overtly fantasized; as she combines her proper social role, with one that was reserved for men; as she shows herself as both a desired wife and a tribade of Trianon; as she over and over again cites artificial constructions, primary among them Rubens's *Chapeau de Paille*.[89] It is not clear that she saw any contradiction among her various represented performances, but it is certain that she was working against an ideology that would view her as contradiction itself. To reconfigure her in terms of another contradiction—be it that between masculine and feminine, that between woman and artist, or that between beauty and intellect—is to recapture her in a binary opposition that she is constantly eluding.

If Butler's earlier work addressed the mimetic basis of gender performance, her more recent writing speaks to our own notions of contradiction, notions that also surface in feminist analyses of self-portraits by women artists, such as that by Elisabeth Vigée-Lebrun. Butler takes up the problem of contradiction in relation to identity, addressing the coalitional politics that asks individuals to choose one identification at the cost of another: "What this analysis does suggest is that an economy of difference is in order in which the matrices, the crossroads at which various identifications are formed and dis-

placed, force a reworking of that logic of non-contradiction by which one identification is always and only purchased at the expense of another."[90] How we analyze Vigée-Lebrun's self-portrait—her picture of identity—may seem distant from the pressing issues of identity politics. Yet in reading, under-standing, and even censoring images, critics sometimes draw on a logic of noncontradiction quite similar to the one Butler questions. Basic to Butler's argument is analyzing a "logic of repudiation" through which coherent iden-tity is instituted.

As a case study, Butler considers this logic in Lacanian (and Lacanian feminist) accounts of the relations that constitute cultural life. In particular, she examines the threat of castration that promises to punish by dooming the noncompliant individual to one of two abject positions: feminized fag or phal-licized dyke. The Lacanian scheme "presumes that the terror over occupying either of these positions is what compels the assumption of a sexed position within language."[91] According to Butler, to institute a coherent heterosexu-ality, psychoanalysis requires that identifications "be effected on the basis of similarly sexed bodies and that desire be deflected across the sexual divide to members of the opposite sex."[92] But, she argues, if psychoanalysis also pro-ceeds from the assumption that in the imaginary and mirror stages the little boy can identify with his mother, whom he desires, this already confounds the issue. She suggests that identifications are multiple and contestatory and ar-gues persuasively that identification does not oppose desire, but provides its momentary resolution when through identifying one territorializes the de-sired object, in other words, takes its place. Identification, moreover, can be made to ensure a *dis*identification with other positions that seem "too satu-rated with injury" or "occupiable only through imagining the loss of viable identity." It is through disidentification that psychoanalysis secures sexed po-sitions, assuming that abject positions will be repudiated.[93] The Lacanian sym-bolic fortifies its binary frame by foreclosing "complex crossings of identifi-cation and desire."[94]

Focusing on the process of identification allows Butler to question Lacan's separation of the imaginary from the symbolic.[95] As phantasmatic forms of alignment, identifications belong to the imaginary; according to Lacan's own logic, they are "the structuring presence of alterity in the very formulation of the 'I.'"[96] Because mirror-stage identifications are repeated throughout life, no identification is ever final or complete. The "law" of the Lacanian symbolic is, for Butler, only the effect of imaginary identifications that *seem* compul-sory, and it is only compliance with the law that enables the law to appear as prior to its citation. There is, however, always some critical distance, some slippage, between the citation and the "law" or "norm" or "model" that is

cited. And this proposition is as true for identifications the law compels, as it is for those it proscribes. "If to 'assume' a sexed position is to seek recourse to a legislative norm, as Lacan would claim, then 'assumption' is a question of repeating that norm, citing or miming that norm. And a citation will be at once an interpretation of the norm and an occasion to expose the norm itself as a privileged interpretation."[97]

With Butler's notion of identificatory processes and her deconstruction of exclusionary logic, I want to return again to Vigée-Lebrun's self-image. As I hope I have demonstrated, this self-portrait represents a complex networking of identities. What Butler's analysis helps clarify are the exclusions and imbrications embedded in that network. To exemplify the point, I want to reconsider first how in this self-portrayal class identity is negotiated through exclusion and in relation to sex, and second how heterosexual identity is articulated without a repudiation of homosexual desire. As we know, Vigée-Lebrun came from a relatively modest social background and from a guild family. By 1783, when the Academy received her, she was an acknowledged fashionable hostess and well-to-do portrait maker with protection in the highest social ranks. In dress and pose, her self-image associates her with well-born circles, although she herself had no claim to high social status and was, in fact, a maker and purveyor of luxury goods (e.g., portraits). Yet as her ambition to be a history painter indicates, she wished to be considered a noble artist rather than an ignoble craftsperson. This identification was complicated because, as I have argued, the *état* of being a wife/woman was, in and of itself, associated with a servitude incompatible with the "noble" practice of the arts. Any identification with "noble artist" required a repudiation of labor and artisan status, but did so doubly for a woman. Anxious to make a name as an artist, yet saddled with the stigma of woman's *état* as well as the label of "art dealer's wife," Vigée-Lebrun may very well have felt particularly compelled to disidentify with the worker-artist, with her guild-member father, and with her modest beginnings. It would be simple enough to read her aristocratic presentation as wish fulfillment, but for a woman the issues were more complex. After all, despite representing herself as a noble artist, she was not able to escape that other position problematic for her identify as an artist entirely; for where she could appear as not a manual worker, she could not show herself literally as other than a woman. If she was forced to appear as a woman, it was in her interests—both as a woman and as an artist—to make her image look beautiful. On the other hand, she could figuratively show herself as not-woman by identifying herself with a great man—Rubens. Thus if her simultaneous disidentification with her father's status and representation of herself as elegant and well born can be read as a sort of family romance, as a fantasy of some

higher birthright, Vigée-Lebrun refracts that fantasy through a master artist–substitute father (Rubens) considered both intellectual and aristocratic.

A second sort of complexity resides in simultaneously claiming a heterosexual identity while not repudiating a homosexual desire. Vigée-Lebrun associates herself with a heterosexual object of desire, Rubens's beautiful wife. However, her image suggests at the same time an intimacy with other women, for its costume and pose, which have little in common with Rubens's *Chapeau de Paille*, signal an allegiance to the queen's circle at Trianon. At the very least the image embraces the erotic elements of female friendship, and thus does not rely on the abjection of homosexual desire.[98] Although the terms *tribade* and *femme-homme* had different connotations in the eighteenth century, they were, as we have seen, viewed as mutually reinforcing. Vigée-Lebrun's attempt to achieve public acclaim as a history painter—her desire to have the phallus—likely underscored the suggestion that her desire was directed toward other women, at least for some viewers.

The question is not whether Vigée-Lebrun's self-representation presents an appropriate identity for a woman artist. To see this image as anything but appropriate is not merely to ignore the eighteenth-century codes and conventions within which the image signifies. It is also to assume coherence in the face of obvious noncoherence; to privilege one notable identification (e.g., with beautiful woman) while denying other equally notable ones (e.g., with Rubens) because they seem incompatible with the first. It is finally to prefer retroactively judging and policing identity to analyzing the circumstances under which a woman artist constituted a particular self-representation. Even in the conscious performance of making a self-portrait the artist is not completely freed from the forced performativity of assuming an identity. The self-portrait fabricates a theatrical and artificial image, but because that image reflects back on the artist's person it too is subjected to legislative codes whose iterability, nonetheless, can occasion an improper or unauthorized identification. Coup de Patte's musician unwittingly recognizes such an occasion in Vigée-Lebrun's self-portrait, and he marks it with the naive question: Is she a history painter?

PART III

Staging Allegory

SEVEN

Elisabeth, or Italy

A Belated Education

Every serious artist goes to Italy, or at least he did in the eighteenth century. Such travel was encouraged by the Academy, which sent its most promising young history painters—the Prix de Rome winners—to study art at their branch campus in Rome. Direct contact with antique and Renaissance works was a formative and legitimating experience for history painters, and, of course, it was an experience women artists were usually denied. Elisabeth Vigée-Lebrun, however, did go to Italy, but she traveled under extraordinary conditions. A revolution and (perceived) physical danger urged her to leave France, and, with daughter in tow, she embarked in 1789 on the rite of passage that was an Italian sojourn. When her husband later defended her travel before the Revolutionary authorities, he argued that his wife had not abandoned her country, that she was not an émigré. She merely did what all great artists had always done: "On account of her love for her art she left for Italy in the month of October, 1789. She went to instruct and improve herself."[1]

In making his argument, Lebrun invokes an exception appended to the law that no citizen was to leave France: "Excepted are those who can prove they have devoted themselves to the study of the sciences, arts, and trades; who have been known for being dedicated exclusively to these studies, and who are absent only for the purpose of acquiring new knowledge in their profession."[2] Lebrun, however, did not convince the authorities, who scoffed at the possibility that Vigée-Lebrun should or could have traveled to acquire a "new knowledge of her profession." She was, they said, hardly a student, and in any case her timing was suspicious, coinciding as it did with the first wave of émigrés.[3] She had chosen a bad moment to leave France, just as she had chosen a bad moment to associate herself with French aristocracy. From another point of view, Vigée-Lebrun's timing was perfect: in 1789 her close

friend Ménageot was director of the French Academy in Rome, and he was more than willing to welcome her there.[4]

If Revolution and calumny chased the artist from France, it also seems likely that professional considerations urged her to Italy.[5] Vigée-Lebrun did use this trip to experience at first hand the antique and Renaissance, and to establish herself as an artist formed through the Italian experience. An official correspondence between Ménageot and d'Angiviller record her progress and, however belatedly, substitute for the letters typically exchanged between Rome and Paris to monitor student achievement. Although the Italian experience helped legitimate Vigée-Lebrun as an artist, her *Souvenirs* apologize for her lack of artistic progress in Italy, a lack measured by missed opportunities, financial necessity, and a weak character:

> I regretted at Naples, and I regretted above all in Rome, not having used my time to make some paintings of subjects that inspired me. I was named member of all the academies of Italy, which encouraged me to be worthy of such flattering distinctions, but I was going to leave nothing in this country that could add much to my reputation. These ideas occurred to me often; in my portfolio I had more than one sketch that could prove it. But sometimes the need to earn money, since I retained not a penny of all that I had earned in France, and sometimes the weakness of my character led me to take commissions, and I wore myself out making portraits.[6]

Regardless of whether Vigée-Lebrun actually wrote, spoke, or even thought these thoughts, the passage suggests a position that prevailing gender ideologies urged on women: to assume that "weak character" accounted for disappointed ambitions. "Weak character" suggests an innate "feminine" flaw, a lack of force in pursing goals.[7] The artist, however, continues by reminding her readers that only through a devotion to work believed alien to women did she achieve those few accomplishments that satisfied her: "The result was that after having devoted my youth to work with a constancy, an assiduity quite rare in a woman, after loving my art more than my life, I can scarcely count four works (portraits included) with which I am truly happy."[8] Her youthful constancy and diligence thus contradict the "weak character" she holds responsible for her later failings.

The positioning of these two explanations is such that the second calls the first into question: was it really *her* failing, she who as a youth was so devoted to her art? Or was it the failing of a society that led her to believe women not capable of dedicated work? Missing from Vigée-Lebrun's self-revelation is any overt acknowledgment of the limitations imposed on women, an aspect of

her experience that she does mention in describing her admission into the Academy. What intervened between her youthful "constancy and assiduity" and her later "weak character" were the strictures that circumscribed a woman's artistic development and limited her practice to genres such as portraiture. Her story articulates only indirectly what Stendhal said quite openly—the world lost every genius who happened to be born female.[9] Her acknowledgment of failure and apparent self-revelation are rare occurrences in the *Souvenirs*, which are much less a story of disappointed ambitions than a vindication of her life and talents. Despite the exclusion of woman from categories such as "artist" and "genius," the *Souvenirs* both reiterate and represent Vigée-Lebrun's attempts to place herself in those categories. In her paintings, those attempts were sometimes both veiled and staged as allegory. Although today readers can interpret her attempts as resistance to a particular gender ideology, or as revealing the very constructedness of "artist" and "genius," these were not necessarily her concerns. She was much more immediately preoccupied with the challenge of putting herself inside those constructions. If at some moments Vigée-Lebrun could be successful in meeting this challenge, her place as an "exceptional woman" was much like that of an *académicienne* prevented from taking the Academy's oath: a place of one "foreign" to the category as a whole. Not a place, but a disorienting atopia. From my perspective, hers is less a drama of disappointed ambitions—after all, she produced many compelling works of art and garnered international fame—and more one of compulsive self-justification as an artist, as a woman, and as a woman artist. But perhaps these are, in the end, the same drama—a self-justification proceeding from some imagined failing or lack. It is in this light that incidents like the one that happened in Parma play as tragicomedy.

What Happened in Parma

In chapter one I interpreted a scene from the artist's 1792 visit to Florence, which the *Souvenirs* set in Fontana's cabinet. I argued that there Vigée-Lebrun both upholds the "divinity" of artistic genius and talks back to a medical-philosophical discourse that disparaged woman's intellectual and creative powers. That scene prepares the reader for an incident that Vigée-Lebrun recalls in the same chapter of her *Souvenirs*, a second encounter with Italian artists, which takes place at another stop on her 1792 itinerary. The artist explains how in leaving Florence she traveled toward Turin with the intention of crossing back into France. Along the way she stayed a few days in Parma, long enough to be accepted into the Academy there. She had brought with her (what she calls) "the painting of the Sibyl that I had made at Naples, after

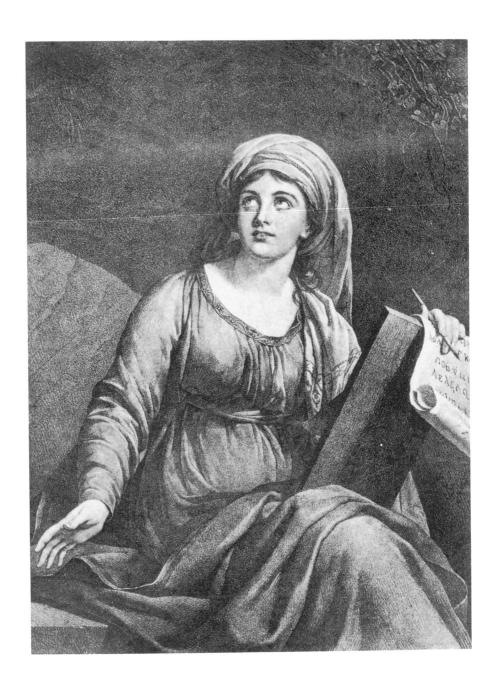

Figure 39 Elisabeth Vigée-Lebrun, *Portrait of Lady Hamilton as a Sibyl*, 1792. Private
Collection

Lady Hamilton" (1792; figure 39). The pigments were still freshly applied, and so as not to yellow her sibyl, Vigée-Lebrun set it unframed in a room flooded with daylight. With the stage set, the action unfolds:

> One morning I was at my toilette when it was announced that seven or eight student painters had come to pay me a visit. They were shown into the room where my Sibyl was located and some minutes later I went to receive them there. After having declared that they had wanted to meet me, they told me it would make them happy if they could see some of my works. Here is a painting that I have just fin-ished, I responded, in pointing out my Sibyl. All displayed a surprise much more flattering for me than the most gracious words would have been. Several cried out that they had thought this painting had been made by one of the masters of their school, and one of them threw himself at my feet, tears in his eyes. So much was I touched, so much was I ravished by this proof, that my Sibyl has always been one of my favorite works. If my readers, in reading this story accuse me of vanity, I ask them to consider that an artist works all her life to have two or three moments similar to that of which I speak.[10]

There is no doubt that this "memory" is devised to recognize Vigée-Lebrun's artistic talent, and the student who throws himself at her feet pros-trating himself before her, reinforces her representation of the divine artist— the genius—earlier set forth in Fontana's cabinet. Like so many other parts of these *Souvenirs*, this scene also recalls comments spoken elsewhere and stories already told. In this case, the anecdote develops a context for the line recorded by the Prince de Ligne in assessing the same painting: "You see her Hamilton-Sibyl and fall on your knees."[11] The context, moreover, is scarcely original. Her encounter with the art students transforms other stories of mistaken iden-tity culled from academic history/mythology, stories like that of Chardin's ac-ceptance to the Academy when the academicians mistook for the work of some Flemish master two of his canvases placed unnamed in the gallery space. Her story, like that of Chardin, emphasizes how the artist assimilates a tradition so successfully that other artists, already conceived as connoisseurs, misrecognize the work's author and filiation. That in Vigée-Lebrun's tale the students be-lieve her work made by a "master of their school" plays into a campaign to associate her talent with Italy.

It Happened in Rome

Replacing one scene of artistic (mis)recognition with another hardly stops in Parma. Vigée-Lebrun's triumph in that city recalls what happened in Rome in

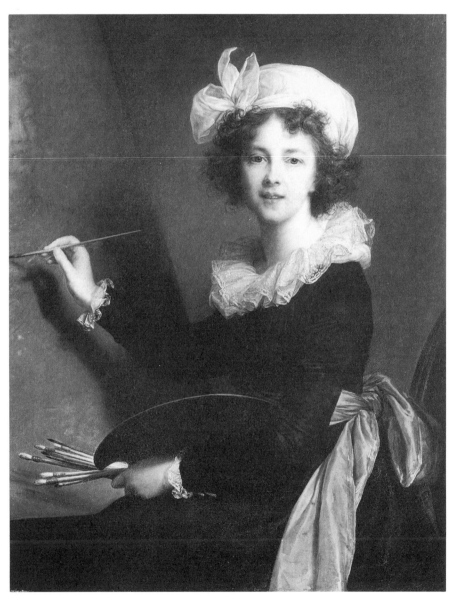

Figure 40 Elisabeth Vigée-Lebrun, *Self-Portrait*, 1790. Florence: Uffizi

1790 when she exhibited there a different painting: not her *Sibyl* but a *Self-portrait* (1790; figure 40) that shows her at the canvas sketching in the portrait of Marie-Antoinette. Here is what the artist says about the work in a letter of 16 March 1790, addressed to Théodore Brogniart and Hubert Robert:

> My painting for Florence enjoys the greatest success. I would seem fatuous if I explained to you the details of its complete success. Never in my life have I been encouraged this much. I have enjoyed it all the more because the Romans accord nearly no attention to our school [of painting], or so it is often said. But still, they have for me that which they have never had, the greatest enthusiasm. All the artists have come, come again; the princesses of all countries, the men even. Finally it is to the point that for ten days my mornings have been occupied by sixty or eighty persons of all ranks [who come to see the painting]. They call me Madame Van Dyck, Madame Rubens.[12]

Apart from the broad similarities between the incidents in Parma and Rome, which both stress the opinion of Italian artists, a curious absence suggests that her *Souvenirs* substituted one for the other. Even though that text quotes a lengthy letter to Robert dated 1 December 1789, it omits the one sent in 1790, and makes no mention whatsoever of the admiration accorded her self-portrait. Comments about the painting, moreover, are perfunctory: "Soon after my arrival in Rome, I made my portrait for the gallery of Florence. I painted myself with palette in hand before a canvas on which I am drawing the queen's visage with white chalk. Then, I painted Miss Pitt, the daughter of Lord Camelfort. She was sixteen years old, and she was very pretty."[13] In fact, Vigée-Lebrun's comments are suspiciously perfunctory given the work's success, and given that a woman artist could scarcely afford to overlook so obvious an opportunity for self-affirmation. Indeed, making the portrait was itself a gesture of self-affirmation.

Vigée-Lebrun undertook the work at her own initiative, intending to give it to the Grand Duke of Tuscany for his gallery of self-portraits. In that gallery hung the resemblances of celebrated artists who had traveled to Florence, artists whose rank Vigée-Lebrun wanted to join. Since many of the self-portraits that hung in this gallery had been commissioned for the space, it is significant that Vigée-Lebrun undertook the work on her own initiative. Writing to the Duke's agent Chevalier Pelli on 26 August 1791, Vigée-Lebrun asks that her "foible production" be presented to Ferdinand III as a tribute to his protection of the arts.[14] And in a letter to the duke himself she says, in language befitting a courtier, that she has taken the liberty of enjoying the privilege of leaving a

self-portrait for his gallery.[15] Moreover, the artist made sure that her image would be noticed, executing it on a scale (100 cm × 80 cm) that rivaled the larger images in his collection.

With this work the artist hit her mark. The painting was indeed much acclaimed, a point her letter to Robert perhaps embellishes, but does not fabricate entirely. Chevalier Pelli described the image as painted with a freshness (franchezza) and "a singular intelligence," adding "so that it seems more from the brush of a man of highest merit than from that of a woman."[16] The omission of any significant commentary on this work in the *Souvenirs* becomes all the more glaring when we recognize that its success was also recorded in the Academy's archives. Letters from Ménageot to d'Angiviller in March of 1790 accord with Vigée-Lebrun's account, at least in spirit, and these letters made her alleged success officially known to the art community.[17] On March 10, 1790, he wrote:

> The painting that Madame Le Brun has just finished has the most complete success. There is only one voice in all Rome, that which admires her talent and puts this portrait in the rank of the most beautiful works. [This praise] justifies the reputation that had preceded her, which one could perhaps doubt because one supposes [everyone] inclined to exaggeration in praising the talents of a pretty woman. But this leaves no doubt, because the Romans are not praisegivers and above all not praisegivers for foreigners.[18]

The work not only bought Vigée-Lebrun a place in the Grand Duke's Gallery, it also secured her a position in the Roman Academy. On 7 April 1790, the artist's friend wrote once more to the Director: "The Academy of Saint Luke has just sent a deputation to her and has sent her letters of reception based on the brilliant success of this painting, a tribute quite flattering for this artist and equally honorable for her country and her sex."[19] The work's success and notoriety continued into the next century; it was a famous image even when the artist published her *Souvenirs*. Her friend Jean Gigoux wrote in his *Causeries sur les artistes de mon temps* (1885) that the portrait in Florence pleased everyone and was copied continually by a crowd of artists young and old.[20]

On Stage

Standing before Vigée-Lebrun's portrait in 1993, I found its absence from the *Souvenirs* an even more spectacular omission. Before exploring the web of substitutions that entangles this work with her depictions of Lady Hamilton and Germaine de Staël, I want to explore how this self-presentation restates

themes that had occupied the artist for nearly a decade. Like the self-portrait displayed in 1783, this is an image that Vigée-Lebrun designated as her public face. Yet more than the one shown in Paris, the self-image exhibited in Rome is patently immodest in the artistic role it assigns her.

The Uffizi self-portrait trades on the idea that Vigée-Lebrun is rendering Marie-Antoinette from memory, for the painting includes no sitter and omits the scattered sketches common in depictions of artists at work. It is possible, however, to read the painting as suggesting that the sitter *is* present, that she is somewhere outside the image frame. Vigée-Lebrun's look even appears to engage someone on the other side of the canvas. But other aspects of the painting complicate any imagining of the sitter's presence. Although Marie-Antoinette's portrait is only lightly drawn on the pictured canvas, her eyes are clearly cast to her left, and she is made to look at the artist. Reversing the viewer's expectations, this configuration poses the artist as object of her sitter's gaze, and so suggests that queen and spectator occupy the same position in the viewing structure. In becoming a viewer, the queen is transformed from object of representation to audience for the artist's activity. Indeed, the performing painter is the object to be looked at, a spectacle displayed in a spot light bright enough to cast onto the canvas her arm's clear, sharp shadow.

The artist puts herself stage center, and the painting evokes the performance at the Vaudeville described in her *Souvenirs*. Recall that there Vigée-Lebrun saw herself represented on the stage by Painting making the portrait of Marie-Antoinette *en chemise*. Taken together, the self-portrait and Vaudeville story again demonstrate a complex interweaving of Vigée-Lebrun's painted and textual self-images. Is the story, written down in the 1820s (when the *Souvenirs* were constructed) but attached to 1783 (the date of the portrait *en chemise*), merely an interpretation of the image made for the Grand Duke of Tuscany in 1790? It is, after all, suggestive that Vigée-Lebrun wrote of this work's triumph to Brogniart, the architect who allegedly arranged her surprise at the theater. Or does the passage in the *Souvenirs* conflate two memories— one of a stage performance (1783), another of a self-image (1790)? Or is it perhaps that in 1790 Vigée-Lebrun, consciously or not, constructed her self-portrait by visualizing her triumph at the Vaudeville? In one way or another these questions all raise the issue of painting and its relation to memory.

Although she holds her palette, Vigée-Lebrun seems to be at work on a preparatory design, and in the *Souvenirs* she refers to herself sketching the queen's portrait with white chalk. As I have argued, the audience catches her between remembering and representing. She is also caught between the parts of painting—between sketching the design and laying on the color—a position not unrelated to the first. Color is signified by the palette and by the

brushes already loaded with pigment, and design by the chalk and outlined forms on the canvas. Colored pigment represented on her brushes is, and is seen as, real paint. The viewer's perceptions, however, are more fully challenged when line, usually invisible in a painting, appears as the lighted edge of her palette turned so its painted face cannot be seen. For the paint-daubed surface familiar in portrayals of artists at work, Vigée-Lebrun has substituted a line of Apelles drawn in light. The palette's lighted edge answers the shadow line that crosses the left hand held beneath it. Yet in neither case do we actually see a line, only the coming together of bright and darkened areas, the illusion of a line made by manipulating shadow and light. A painting may begin with a drawing, as her sketch on the depicted canvas suggests; however, on the real canvas it is not drawing, but the manipulation of light and shade that brings forth the illusion.[21] Drawing emerges not so much as a part of painting, but as a preliminary process, one more closely connected to memory and visualization (here, that of Marie-Antoinette) than to painting and coloring a sensual image. To explore these connections, I return to the artist's shadow so clearly thrown onto the canvas beside her.

A New Dibutadis?

Although it is not unprecedented for an artist to render her shadow in a self-portrait, neither is it a typical inclusion.[22] Rarely, if ever, in self-portraits of this period does a shadow take on the specific, clear articulation that Vigée-Lebrun gives it. This element suggests painting's mythical origin, which two stories locate in the tracing of a shadow. In one a shepherd marks the outline cast by his own shadow on the ground. In the other, the Corinthian maiden Dibutadis invents painting by tracing on a wall the shadow of her sleeping lover, soon to depart for distant shores.[23] For eighteenth-century French painters, the story of Dibutadis came to allegorize the origin of their art, as is evidenced by the many representations of the theme produced after 1770.[24] Cast so prominently on Vigée-Lebrun's canvas, the shadow suggests the origins of painting, even if the painting does not show the originary myth.

The reference to Dibutadis leads beyond a consideration of drawing as preparation for painting, which by itself the sketch of Marie-Antoinette on Vigée-Lebrun's canvas might imply. The Greek tale shows that drawing encapsulates painting's motivating or originary force insofar as drawing can be imagined as belonging to the history of illusionistic representation. In that history, drawing stands as the invention that allowed someone (or something) to be memorialized in a two-dimensional image. It is the desire to remember that prompts Dibutadis to preserve her lover's shadow. Her drawing shows

that at the origin of painting is the desire to preserve a memory. That desire or love fuels the wish to memorialize is also part of the story.[25] Although theoretically a lover's desire motivates the Corinthian maid's drawing, in practice a drawing or painting often represented the patron's desire to remember—or the sitter's desire to be remembered. In these instances the artist plays only an instrumental role. By invoking the story of Dibutadis, however, Vigée-Lebrun suggests that her desire to remember Marie-Antoinette has instigated the image she draws. For viewers who knew that Regnault had painted an overdoor depicting Dibutadis for the Salon des Nobles de la Reine in the queen's apartments at Versailles, the Corinthian maid might have been even more closely connected with Marie-Antoinette. I will take up below how representing the painter's desire to remember her patron is put to larger purposes in this self-image.

Not every drawing encodes the artist's desire to remember something, but memory is nevertheless basic to every drawing, since drawing represents—at least in French academic theory—not the thing itself, but the artist's mental image of it. The relations of mental image, memory, and drawing are also connected to the Dibutadis theme. Although since Pliny and Quintilian tracing shadows was considered a degraded activity in which "nature was the artist" and the artist a mere copyist,[26] French academicians reinterpreted the shadow so they could make Dibutadis the emblem of painting's origin. Cochin's image of Dibutadis etched by Prévost in 1769, carries this caption: "Draw in your mind, that is the primary canvas" (Bibliothèque Nationale).[27] In the image, Dibutadis appears to be tracing the shadow, as she does in all standard renderings of the story. On the other hand, the caption taken from Lemierre's poem "La Peinture," exhorts the artist not to trace the outlines of objects on some physical surface, but to draw them in the mind. Image and text do not seem so different, however, if we understand the shadow—as Derrida does—as a simultaneous memory physically separate, but temporally congruent with the object it recalls.[28] In this sense, the shadow parallels—and can be taken to figure—drawing in the mind. Mental images produced at the moment of sensation are also simultaneous memories, but unlike shadows they can be recalled by the artist's imagination in the absence of objects.[29] Baudelaire later claims that all good and true draftsmen draw not from the image before their eyes, but from the one imprinted on their brain.[30]

That Vigée-Lebrun's hand does not trace the shadow cast on the canvas is particularly significant in terms of the relation between drawing and memory. This deviation from the Dibutadis legend emphasizes the point that Vigée-Lebrun sketches from memory the image of Marie-Antoinette. Although the image of the mythical (and allegorical) Dibutadis could, without

contradiction, carry a caption exhorting (male) artists to draw in the mind, real women were not thought capable of such imaginative art-making activity. When Dibutadis is instantiated in a real woman, or when she is called upon to represent the woman artist, she becomes a mere copyist, a tracer of shadows.[31]

We have already met up with Dibutadis when she appeared in one critic's dream at the Salon of 1783.[32] For that Salon, she is metamorphosed into a woman painter and made to refute the claim that she is the inventor of painting. She associates herself only with copying, and claims herself as mother of the mechanical physiognotrace. Thus in Vigée-Lebrun's self-portrait any reference to the shadowy origin of painting could be construed as problematic; mimicry, not invention, was "natural" to the *sexe*. The self-portrait, however, finds an inspired solution to the dilemma. The work thwarts any suggestion that the woman artist merely copies, for projected on the canvas pictured in Vigée-Lebrun's self-portrait is a distinct shadow, which she does not trace, and the tracing of a memory that she cannot see. Here she works from that other sort of shadow, a mental image whose fading is emblematized in the evanescent sketch hovering on the canvas.

The Self-Portrait of Painting

Marie-Antoinette remembered in a sketched image, a shadow referring to the origin of painting, a seated woman at the canvas holding a palette—these introduce the self-portrait of Painting into the self-portrait of Vigée-Lebrun.[33] Part of this self-portrait is allegorical and recalls traditional depictions of the art, depictions like the one Joseph Baillio attributes to the young Mlle Vigée in which Painting as a female figure sits before an easel holding palette and brushes.[34] Although Vigée-Lebrun's self-portrait contains an allegory, it cannot be reduced to one. Even if Painting is here represented as Vigée-Lebrun in the act of painting, the work is also not an allegorical portrait, since the artist is represented as herself in one of her usual activities. The allegory of Painting (its depiction as something else, as a woman) and the self-portrait of Painting (its depiction as itself, as a painting) are, however, complexly insinuated in this self-portrait of a woman artist. Again it is the projected shadow that draws attention to this point.

Apart from the story of Dibutadis, this projected shadow refers both indexically and metonymically to the artist. An image of the artist's hand, the shadow represents a metonym (or better perhaps, a synecdoche) for the image maker. As a picture of the artist's shadow, it is the picture of a natural sign (or to use Shiff's terms, the icon of an index) for the artist's presence.[35] Here the shadow is particularly significant because it disappears at precisely the point

that shows apparent physical contact between the pictured canvas and the pictured chalk. Lying beneath the artist's chalk, the point of touch is only barely visible in Vigée-Lebrun's image. In fact, this point is not so much seen as imagined. Yet like the paint represented on the tips of the brushes, the point of touch *is* what it represents, since the artist touched real chalk or paintbrush to real canvas at that point (and, by the way, at all others). Positioned at the far left edge of the real canvas, the point of touch also marks a place where real canvas and fictive one converge. Not only does this positioning suggest the congruence of represented and real touching, but the artist's tool threatens to break out of its fictive space and slip into the actual space of the beholder. Touching the edge of the canvas, moreover, figures the liminal position of touch, which marks both a connection between artist and canvas, and also their separation. A memory of the artist's physical contact with the canvas, touch was a special sort of natural sign; in 1790 touch made any image a self-representation, so individualized was it believed to be.

In her image made for the Duke's gallery, Vigée-Lebrun merges her self-portrait with both the allegory and self-portrait of painting, the latter articulated in pictorial terms as well as through symbolic attributes. It is in reference to the self-portrait of painting that the visual subtleties of this work gain significance. For example, consider the notable play of abstract and illusionistic forms. At the lower left corner of the painting the forms are flattened out and simplified, and the depicted canvas loses nearly all its three dimensionality as it fades into the real canvas support. The lower right side, in contrast, is marked by a plasticity and complexity of forms. There the solidity of the chair and the complicated shadowing and folding of the drapery are set in opposition to the abstract simplicity of the other side. This play back and forth between two- and three-dimensionality makes the viewer acutely aware of painting's illusionistic potential, as well as of the particular artist's control over that potential. The fading of depicted canvas into real canvas, moreover, not only suggests that painting is both object and illusion, but also thematizes the play of presence and absence that characterizes the artwork. The visual pleasure taken from painting in general, and from this painting in particular, is organized by the artist's hand, both literally and figuratively, as the hand's shadow guides and structures the process of making meaning.

The artist's hand also acts as a pointer here, a visual signal drawing our attention to what or whom is being represented on the canvas. For here Dibutadis becomes painter to the queen Marie-Antoinette, who substitutes for the maiden's beloved. Love and loss are at the origin of painting, but in this case, prestige is also a factor, for the image memorializes the association of painter and queen, remembers it for posterity. That association is articulated

visually as Vigée-Lebrun ties herself with the queen through rhyming their reddened lips, which are the only striking accents of this tone apart from her prominent sash.

Mirror Images

Although it is common to assume that a self-portrait records the artist's encounter with herself in a mirror, this painting poses as an image of Vigée-Lebrun making the portrait of Marie-Antoinette. Vigée-Lebrun disavows the look in the mirror by effacing the stare, the intense concentrated gaze that conventionally points to the artist's self-specularization. Viewers, moreover, can infer from this image of her, Vigée-Lebrun's ability to paint from memory, a talent through which she could produce not only the queen's portrait, but also her own. Yet, the self-portrait cannot evade the mirror. Even if Vigée-Lebrun here paints from memory, behind that memory, somewhere, is self-specularization. In this image the nearly full-face view suggests the direct confrontation of self in mirror. Moreover, because the mirror dramatizes the double-sidedness of the human visage, the memory of self-scrutiny is recorded on Vigée-Lebrun's face as her features are bifurcated by a virtual line created as light meets dark. The shadow falling on the right half of her face grows ever darker as it moves toward the outside of her head, but the left side is only lightly shaded to bring out the chin's contour line. The features, moreover, are slightly asymmetrical, with eyes irregular in their set and mouth pulled up a bit to the right.

Derrida has pointed out that since the self-portrait depicts the image reflected in the mirror, the spectator facing the self-portrait stands before the mirror image and thus substitutes for the artist. Derrida puts it that the spectator gouges out the artist's eyes replacing them with her own, which is another way of saying that, in making a self-portrait, the artist anticipates the spectator's look, and what she sees in the mirror is what she wants to become for the spectator, to satisfy the spectator's gaze.[36] Vigée-Lebrun's image makes visible the artist's desire to satisfy the gaze, for we see her performing in a spotlight, not painting before a mirror.

Considering together the self-portrait and its fiction, the viewer sees Vigée-Lebrun as she imagines herself being seen, seen by an audience, seen by the queen, seen by herself. And this self-imagined-as-seen is constructed— at least in the fiction spun by the painting—as a Vigée-Lebrun who paints a remembered image of Marie-Antoinette. The queen, however, functions less as the object represented, and more as the one who authorizes the artist's self-image. It is as painter to the queen, kinswoman to the Grand Duke of Tuscany,

that Vigée-Lebrun re-presents herself in this self-portrait. These are the cre-
dentials that she shows to her viewers. The queen is given a validating func-
tion not unlike that served by the king's bust in Van Loo's portrait of Marie
Leczynszka. The viewer also validates the image by acknowledging the asso-
ciation between artist and queen, an association that is more than one of
painter to patron. Vigée-Lebrun constructs herself through an identification
with her ego ideal, Marie-Antoinette, but she wants to take the place of her
ideal ego—the great artist honored by the ruler's love, by the ruler's desire to
be portrayed by her. Reaching into the imaginary of painting, she again plays
Apelles to the queen's Alexander. But simultaneously, she poses as a new Di-
butadis who invents painting not as the physiognotrace, but as the commemo-
rative portrait. Placing herself at the origin of painting, Vigée-Lebrun pro-
poses that her work represents the art of painting. In making her self-portrait,
she makes the self-portrait of painting itself.

Italian Authorities

Who authorizes, who re-presents the artist? This question is also posed in an
aquatint made after the Uffizi portrait by the artist's friend, Dominique
Vivant-Denon (figure 41). Vivant-Denon substituted for the image of Marie-
Antoinette sketched on the canvas a self-portrait by Raphael. Although he
probably effaced the queen's image for political reasons, why did he replace it
with Raphael's self-portrait rather than some other work? Has the queen's
painter—the political émigré—been transformed into an art student seeking
to learn more about her profession? As the picture within the picture, is Ra-
phael the master validating the student Vigée-Lebrun, in the way the king
validated the queen and the queen, the artist? The appeal, however, is equally
to the validating function of the spectator, for here both artists—the one
shown making the copy and the one shown on the easel—engage the viewer's
gaze. Is it that Vigée-Lebrun (like any other painter) is authorized as artist
only by her viewers, be they her contemporaries who represent public acclaim,
or posterity, which will write her into art's history as a student of Raphael?
Viewers of the present and future must both applaud her work and recognize
its relation to tradition. If this is the case, then Vigée-Lebrun in making a copy
of Raphael also functions as a viewer authorizing her predecessor. Thus the
image presents a circuit of affirmations as each component part can be seen as
justifying the other. The image also positions the viewer as one who appreci-
ates tradition and its role in the formation of art. Viewers are only justified as
connoisseurs, as of the "enlightened public," when they recognize Vigée-
Lebrun's taste in choosing Raphael as her model, and when they can see the

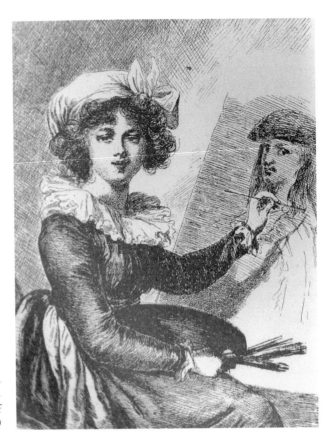

Figure 41

Dominique Vivant-
Denon, after Vigée-
Lebrun's *Self Portrait* of
1790

relation between the two artists. The image of Raphael is the very one that
Vigée-Lebrun claims in her *Souvenirs* (1:237) to have copied on that trip to
Florence, and one wonders if the idea of including Raphael's self-image in this
copy came to Vivant-Denon from her practice, or if her *Souvenirs* were pro-
voked by Vivant-Denon's image, or if both possibilities are in play.

 The image made by Vivant-Denon not only shows Vigée-Lebrun as con-
nected to Raphael rather than Marie-Antoinette, it also changes her allegiance
in other ways. In her self-portrait, Vigée-Lebrun casts herself as painter to the
queen of France, as a French painter, even though she claims that admirers
compared her to Flemish artists who worked in Italy (recall she was named
Madame Rubens, Madame van Dyck). In Part 2 of her *Souvenirs*, however,
there is a notable tendency to associate herself with the Italian tradition, es-
pecially as she travels through Italy. Just as Vivant-Denon substituted Raphael
for Marie-Antoinette, preferring the Italian artist to the queen of France, so

Vigée-Lebrun substituted her *Sibyl* for her self-portrait in demonstrating her Italian triumph. That at Parma the Italian students mistakenly attribute her *Sibyl* to a master of their school is a key point in her Italian narrative, and her self-portrait of 1790 could not have provoked the requisite misidentification. Why the painting chosen was the *Sibyl*, well that leads to another staged allegory.

The New Corinne?

In preparation for further allegorical posturing, the *Souvenirs* folded Vigée-Lebrun's self-portrait as Painting into her image of Lady Hamilton as a *Sibyl*. A logic of similarity allowed the mix-(up). The first image evokes Dibutadis not as copyist, but as inventor of painting; the second recalls the Sibyl as inspired writer, rather than as medium. No matter how imperfect those models may have been, both Dibutadis and the Sibyl typified exceptional women—the woman artist and the woman writer. Vigée-Lebrun, moreover, used her *Sibyl* as she used her self-portraits—to advertise her talents.

The artist displayed her *Sibyl* throughout Europe, first in 1792 in Venice at Vivant-Denon's apartment, where, according to her recollection, many "foreigners came to see the work."[37] Later that year Prince Kaunitz showed it in his Vienna salon, and she remembered that for fifteen days it was honored by city and Court. After this success, she exhibited the painting at her house, later observing: "I imagine my Sibyl, which people came in crowds to see at my house, contributed more than a little to many people's decisions to ask me to portray them, because I worked a lot in Vienna."[38] The comment, however, may be misleading, since it's likely that Vigée-Lebrun was sought in the Hapsburg capital not as the sibyl's painter, but as the portraitist to Marie-Antoinette. The comment inadvertently points back to the self-portrait in which Vigée-Lebrun shows herself to the queen's relative, the Grand Duke of Tuscany, as the queen's painter.

If many travelers saw the self-portrait in the Grand Duke's gallery, the Sibyl was seen by many as she traveled. In 1794 the Elector of Dresden allowed her to hang the *Sibyl* in a gallery alongside paintings she described as "masterpieces," including works by Raphael, Rubens, and Rosalba, three artists with whom Vigée-Lebrun consistently identified herself.[39] In 1798, she sent her Sibyl to the Salon in Paris, and it traveled with her to London in 1802.[40] The work is mentioned in Vigée-Lebrun's *Souvenirs* more often than any other painting. That the artist identified "her Sibyl" not so much with Lady Hamilton, as with her own talent seems obvious enough. Also obvious is that in constructing the incident in Parma the *Souvenirs* stressed the Italian heritage of the work, which recalls works like Domenichino's *Cumean Sibyl*

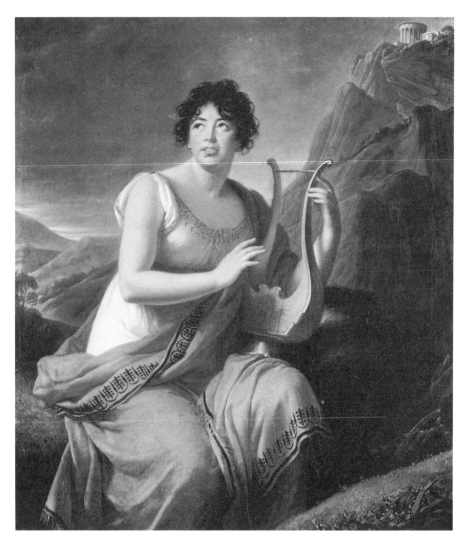

Figure 42 Elisabeth Vigée-Lebrun, *Portrait of Madame de Staël as Corinne*, 1807–8.
Geneva: Musée des Beaux-Arts

(ca. 1615; Rome: Gallery Borghese). What is not so obvious is that this Sibyl
ties together, not two, but three exceptional women: not just Vigée-Lebrun
and Lady Hamilton, but Vigée-Lebrun and Germaine de Staël through this
image of Lady Hamilton. Moreover, it is the Italianness of the *Sibyl* that en-
ables her to act as a relay point between Vigée-Lebrun's self-portrait of 1790
and her 1807 image of Germaine de Staël as Corinne (figure 42), title char-

acter of Staël's enormously successful novel *Corinne, or Italy* (1807). That novel, too, contains many allegories.

In Staël's novel, Corinne closely identifies herself with the Sibyl as allegory of female inspiration and genius. This identification, moreover, is represented by a painting, and Staël describes Corinne as imitating one of the Italian works that Vigée-Lebrun recalls in her signature piece: "She was dressed like Domenichino's Sibyl, an Indian turban wound round her head, intertwined with hair of the most beautiful black."[41] And it was as both sibyl and Corinne that Staël saw herself allegorized in Vigée-Lebrun's painting. On 18 September 1807, she wrote to her friend Henri Meister: "Madame LeBrun has made a portrait of me that [every]one finds very remarkable. She has brought it to Paris. It captures me as a sibyl or as Corinne, if you like that better."[42] The tripled identity—sibyl, Corinne, and Madame de Staël—not only allows the viewer/reader to choose a more or less specific interpretation, but also stresses the interplay among the real sitter, her fictional character, and the generic type. This interplay repeats that of Vigée-Lebrun's self-portrait, where she is shown as herself, as Dibutadis, and as Painting. In interpreting *Corinne*, Marie-Claire Vallois has suggested that against the neoclassical backdrop of the Consulate and the Empire, Madame de Staël's choice of the sibyl as a literary model was an act of provocation. She contends that the celebration, even in the mode of fiction, of these inspired women ill-accorded with the new worship of those ancient Roman gods of the hearth, the Penates, recently reinstituted by the Napoleonic Code.[43] Elisabeth Vigée-Lebrun not only joined in this celebration/provocation, she was one of its pageant masters.

Reading Staël's *Corinne* suggests why Vigée-Lebrun's *Souvenirs* select her *Sibyl* to be honored by Italian painters, substituting it for a self-portrait. The emotional admiration rendered the painter by the Italian students and recorded in the *Souvenirs* recalls, albeit in a radically condensed and transposed way, the sequence in Madame de Staël's novel, in which Oswald, a Scottish nobleman, first encounters Corinne, the improvisational poet with whom he is destined to fall in love. As Oswald—and along with him the reader—see Corinne for the first time, she is being fêted in Rome as one of Italy's great writers. The spectacle of the sibyl Corinne is more public, more extravagant, and more grandiose than the private triumph of either Vigée-Lebrun's self-portrait, which she described for Robert, or her *Sibyl*, which she described for her *Souvenirs* readers. These private triumphs are only echoes of that accorded Staël's sibyl:

> At last four white horses drawing Corinne's chariot made their way into the midst of the throng. Corinne sat on the chariot built in the

ancient style, and white-clad girls walked alongside. Wherever she passed, perfumes were lavishly flung into the air. Everyone came forward to see her from their windows. . . . Everyone shouted: *Long live Corinne! Long live genius! Long live beauty!*" (21).[44]

And the scene continues: "A fresh burst of music was heard as Corinne arrived; the canon roared, and the triumphant Sibyl entered the palace that had been made ready to receive her" (22).[45]

Reading this segment of *Corinne*, moreover, validates the choice of an *Italian* anatomist (e.g., Felice Fontana) to acknowledge Vigée-Lebrun's gifts, and *Italian* art students to display an extravagant response to them. In Staël's work, Oswald reckons as he contemplates the festivities in honor of Corinne: "Nothing could have been more opposed to an Englishman's customs and opinions than focusing the public eye on a woman's fortunes. But, for a time at least, foreigners are caught up in the Italian enthusiasm for all the gifts of the imagination; and living among a people who so vividly express feeling, they forget the prejudices of their own countries" (19).[46] For the Italians, it seems, the imagination has no sex.

Insofar as we can read *Corinne* as representing in its title character, something of Staël's imagined, idealized self (and commentators have agreed that to some extent we can) the sibyl's fête is Staël's celebration, an honoring of her self-portrayal. Moreover, we know that many of Staël's women readers understood Corinne as a model for the woman genius, a point to which I shall return. In framing both Vigée-Lebrun's Italianness and her acclaim around her *Sibyl*, the *Souvenirs* associate with that signature piece, and hence with the artist herself, Staël's allegorical portrait of Corinne—at once Italy, genius, and sibyl. Vigée-Lebrun's nephew-in-law and biographer, Tripier le Franc, noted in his life of the artist that her 1807 visit to Madame de Staël at Coppet brought back memories of Italy.[47] Many of her Italian "memories," however, owe much to the travelogue that structures large sections of Staël's novel.[48] It is through those "memories" recorded in her *Souvenirs* that Vigée-Lebrun both poses as an Italian painter and identifies with the Germaine de Staël who gave birth to the sibyl Corinne.

EIGHT

Germaine, or Corinne

Artists and Their Sibyls

A varied pattern of resemblance, allegory, and substitution subtends the relation between Vigée-Lebrun and Madame de Staël, as that relation shaped, and is (retrospectively) shaped by, painted and textual images.[1] Some of these images, moreover, show not artist or writer, but their sibyls—Lady Hamilton and Corinne—who mediate the real and imaged ties between the women who created them. In the artist's portrait of Madame de Staël, the sitter plays the improvisational poet Corinne in the midst of an inspired performance. Through this improvisational talent, the novelist resembled her character. Madelyn Gutwirth, who has written so insightfully on Staël, views Corinne's talent as a projection of the author's famed skill at conversation.[2] Vigée-Lebrun perceived a more literal resemblance, as her description of the author at Coppet suggests: "One saw her then walking into her salon, holding in her hand a small branch of greenery; when she spoke, she agitated this branch, and her words had a warmth that belonged only to her alone; [it was] impossible to interrupt her; in this moment she seemed to me an *improvisatrice*."[3]

Improvisation also connects Staël, through Corinne, to Lady Hamilton. A former actress and artist's model, Lady Hamilton was known for her "attitudes," she artfully performed mythological characters or famous art works by giving her features different expressions and by striking marvelous poses. Spontaneity and quick change were key to these performances. Gennari has argued that Lady Hamilton was the most important "model" for Corinne's physical movements, her talent for freezing in sculptural attitudes, her knowledge of antique poses, her recall of the Herculaneum dancers, and her ability to generate a thousand new ideas for painting and sculpture.[4] Corinne, moreover, shares in Lady Hamilton's physical assets. By all accounts, Lady Hamilton's appearance abetted her success; supporters and detractors alike found her

"beautiful as an angel."[5] Outside her attitudes, however, many described her as a common, even coarse woman, an assessment repeated in Vigée-Lebrun's *Souvenirs* (1:199–202). Contemporaries thus perceived a wide gap between Lady Hamilton as performer and Lady Hamilton as social being. Madame de Staël, on the other hand, presented no such disjunction. Known for her conversation, intelligence, and wit, Madame de Staël was in every way an exceptional woman.

Although Madame de Staël resembled her self-projection Corinne in improvisational talents and intellectual abilities, she was unlike her in physical appearance. Staël was not by any means reputed to be a beauty. Her detractors found her plain at best, manlike at worst. To her enemies she was the monstrous modern hermaphrodite; Bonaparte, for example, remarked that Staël was not even a woman in her genitals.[6] She also raised anxiety in some of her supporters, as is suggested by their search for attributes to compensate for beauty and to signify her natural womanliness. Most often cited was her expressive physiognomy.[7] Vigée-Lebrun summarized many similar descriptions when she wrote, "Madame de Staël was not pretty, but the animation of her face could take the place of beauty."[8] Mobility and expressiveness substitute for beauty because they, too, were established signifiers of femininity.[9]

If Madame de Staël's gender performance both exceeded and revealed those attributes that belonged to her sex, Lady Hamilton also disrupted the truth of gendered characteristics. The mobility and expressiveness viewed as naturally feminine in the manly woman, the womanly woman artfully exaggerated in her performances. Indeed, it is this aspect of "woman" that Lady Hamilton mimed most successfully as she moved rapidly and imperceptibly from one attitude to the next, sometimes even enacting opposing emotions in quick sequence.[10] As an improviser, however, Lady Hamilton subverted any separation of her performance into "naturally" feminine or masculine traits. Not only was her expressiveness artful, but her art was based on a cultural knowledge of antiquity, and she spoke in a conventional—if visual—language, not a natural, gestural one. Contemporary observers such as the Comtesse de Boigne pointed out that Lady Hamilton was inspired by ancient statues, but never copied them slavishly, and always presented the most admirably composed work. Here Lady Hamilton resembles the great artist—she can imitate without copying, she can find the most expressive composition. Moreover, like the genius, Lady Hamilton was inimitable. Boigne noted that many others tried to imitate Lady Hamilton, but none could mimic her singular talent. The Comtesse added that artists said if they could have drawn after Lady Hamilton's attitudes, art would have found nothing to change.[11] Thus Lady Hamilton threatens to obliterate the distinction between the model—or the object

represented—and the artist—the subjectivity that represents, or put into other terms, to reduce the artist to a mere copier, reserving for herself the role of conceptualizer. As artist, Lady Hamilton becomes a most dangerous model—the muse who rather than inspiring the painter steals her thunder.

Who Is the Sibyl Here?

In her *Souvenirs*, Vigée-Lebrun is at pains to deny that she painted her *Sibyl* from one of Lady Hamilton's improvisations. Rather, she makes clear that her painting transforms Lady Hamilton (then Madame Hart), the common woman:

> I remember that when I made my first portrait of her as a sibyl, . . . the Duchess de Fleury and the Princess Joseph de Monaco attended the third sitting, which was the last. I had coifed Madame Hart with a scarf turned around her head in the form of a turban, with the end falling down in a drape. This coiffure embellished her to the point that these women found it ravishing. The Chevalier had invited us all to dinner, and so Madame Hart passed into her rooms to make her toilet. When she returned to us in the salon, this toilette, which was most common, had changed her so disadvantageously that the two women had infinite difficulty in recognizing her.[12]

In this scenario Lady Hamilton takes her appropriate and subordinate role as raw material to be posed and dressed according to the artist's fancy. Vigée-Lebrun confirms her art by repressing that of Lady Hamilton, even to the point of appropriating entirely for herself the scarf, which was a standard prop in both her paintings and her model's improvisations. But here the scarf also has a more subtle purpose: it ties this passage to Vigée-Lebrun's image of the sibyl. By emphasizing the turbaned headpiece, which is a distinctive feature of her sibyl's costume, Vigée-Lebrun suggests herself at work on that painting. The turbaned headpiece, moreover, was a typical attribute in the Italian sibyl paintings the artist elsewhere cast as her real models.

In the *Sibyl*, moreover, individualized traits all but disappear in an idealization that breaks the association with a particular model. Any resemblance of this sibyl's activity to Lady Hamilton's improvisations is denied by the compositional structure, which does little to suggest the mobility and spontaneity typical of her performances. The artist catches her sibyl, or so it seems, seeking inspiration; with eyes rolled upward and head turned slightly away from her body, the sibyl conforms to conventions long used to represent that state. Yet the moment of inspiration hardly seems momentary. An ample, weighty

figure, the sibyl's form is rendered in a stable triangular shape. The rolled up scroll neither flutters nor unravels, and it seems as static and immobile as the stony writing table. Temporality is banished by her classicizing dress and idealized features. Thus the sibyl seems suspended in time, incapable of change. Even if she could alter her state by moving one way or the other, in the next instant she would return to her writing. The sibyl would not metamorphose—as Lady Hamilton might—into Medea or Niobe. The portrait does little to empower the model—the model is not even allowed the status of a sitter—because in submerging her identity into the sibyl it actually forecloses any attempt to form associations between an individual, Lady Hamilton, and a symbol for female genius and inspiration. Just as the artist could transform the common model into a Cornelia, or an Agrippina, or even the blessed Virgin, so Elisabeth Vigée-Lebrun could transform Lady Hamilton into a sibyl.

Although Vigée-Lebrun claims she successfully used the *Sibyl* to advertise her trade, it is not a portrait-like work.[13] The sibyl is generalized to the point that she looks like no particular individual, and that very quality makes the image open to every woman's imaginative projection. The sibyl is an empty pattern, but as one inspired by Lady Hamilton's looks, it is also a pattern in which other women might want to see themselves. As we know, Vigée-Lebrun many times filled the pattern with individualized portraits, idealizing physiognomies but preserving a distinctiveness of feature. In many portraits, such as that of the Princess Dolgorouky (1797; Private Collection), she achieves that difficult balance between the "real" and the "ideal."[14] The two are distinct, but harmonized, and one sees both the sitter and the fictive type. The sibyl was a popular guise for women with literary or intellectual ambitions, like the Princess Dolgorouky, a beautiful *salonnaire* whom Vigée-Lebrun shows meditating on her reading.[15]

That Vigée-Lebrun often used the sibyl to portray women with literary ambitions points to a major difference between Vigée-Lebrun's depiction of Lady Hamilton as a sibyl and her portrait of Germaine de Staël as the sibyl Corinne. Whereas Lady Hamilton could successfully (and beautifully) play the role of enthused writer, Madame de Staël *was*, at least in the estimation of many women, an inspired author. In the case of the writer's portrayal, there is a basis for comparison between two distinct individuals (one real, one fictive), and the symmetrical property of resemblance is fulfilled. This is to say that Staël resembles Corinne and Corinne resembles Staël. And in terms of intellect and talent, they resemble one another whether or not Staël is dressed in antique garb and whether or not she looks the part. The effects of allegory do not disempower Staël, any more than the allegory in Vigée-Lebrun's Uffizi self-portrait disempowered the painter.[16] Thought "in reality" a coarse and

common woman, Lady Hamilton lacks the requisite qualities that would warrant comparison with the sibyl (we do not even know if the sibyl was sensuously beautiful). She cannot resemble the sibyl; she can only mimic the gestures conventional in sibyl pictures. She can only assume an attitude. Thus in Vigée-Lebrun's *Sibyl*, viewers do not easily perceive two separate, but resembling terms (Lady Hamilton and the sibyl) set into analogy. The person Lady Hamilton—all her physical individuality and historical specificity—has been effaced. What Vigée-Lebrun shows is one term well disguised as the other. That disguise was, or so Vigée-Lebrun tells us, an effect of the painter's art.

Novel Painting

If Vigée-Lebrun denied that she was inspired by Lady Hamilton playing the sibyl, she leads her readers to believe she was moved by the sight of Madame de Staël reciting tragic verse. Painting the novelist did not have the same dangers as painting Lady Hamilton. No one would suggest that Staël had struck just the right pose or held her body in the most beautiful composition. In describing her sitting with Germaine de Staël, Vigée-Lebrun plays to her sitter's reputation and claims to have painted her as she declaimed from Racine and Corneille. However, so absorbed was the artist in how Madame de Staël *looked*, she confesses to having heard scarcely a word of what the writer said.[17] Words do not make an impact, do not move the portraitist: even here the visual impression provoked in the imagination is paramount. Vigée-Lebrun occupies herself conceiving Staël with an "inspired appearance." Although words were the stock in trade of both Staël and her double Corinne, the portrait impresses by its visual impact, by the illusion of physicality. The sitter is presented as a monumental figure with sculptural limbs; large, expressive features; and a markedly individualized physiognomy. The artist makes her statement on an epic scale in this oversized portrait, which strives for grand—even sublime—effects.[18]

If the portrait impresses with its sublime effects, it can be read more subtly through attention to its details, such as the Temple of the Sibyl at Tivoli represented in the background.[19] The inclusion of this element was, as their correspondence indicates, a point of discussion between sitter and artist. Vigée-Lebrun wanted to place the Bay of Naples in the distance.[20] This feature would have situated the painting in the countryside surrounding Naples, and the landscape could include a view of the city's most famous monument—Vesuvius. Madame de Staël's friends, however, apparently convinced her that the temple and waterfall at Tivoli would be more appropriate. Not only were these also recognizable monuments, but in her story the temple sits above

Corinne's villa near Tivoli. The novel claims the temple as Corinne's most appropriate symbol. Writing to Madame de Staël, Vigée-Lebrun seems to acquiesce: "if the temple can be arranged with the composition and the lines that form the pose, I will choose that which you desire."[21] It seems to be a question of the painting's formal dynamics, and indeed in other portraits Vigée-Lebrun carefully planned the relation of sitter to landscape.[22] In contrast to her usual practice, the temple that appears in Staël's image is not particularly well harmonized with the composition. Stuck high atop the cliff, it seems distant from Corinne-Staël, and neither its shape nor its placement provoke any association between its form and the sitter's pose or figure. In terms of formal structure, nothing (or in any case very little) would be lost if this detail were effaced. In terms of iconography, however, the temple at Tivoli is a most significant detail.

Had Vigée-Lebrun included only the Bay of Naples (as she intended), the landscape would more easily have restricted our reading to a specific moment in the story when Corinne performs an improvisation in the Neapolitan countryside near Cape Miseno. Only this improvisation is sung in a landscape setting. The temple from Tivoli expands the range of available references, since Vigée-Lebrun's portrait also retains elements of setting that point, not to Tivoli, but to the scene of Corinne's second improvisation outside Naples. The trees dotting hills in the background and the flowers in the foreground recall the novel's description of the area around Naples where trees, often missing in the Italian countryside, are plentiful, and the "earth is covered with so many flowers that here one can most easily get along without the forests."[23] The flowers attract attention in the painted image as its most visibly touched, most sensuously brushed elements. These small specks of color hold their own against the more dramatic features of this landscape: the detail balances the sublime. Moreover, the very obviously worked flowers in the foreground suggest the comparison of Corinne to flowers that enriches the imagery surrounding the second improvisation: "This lovely Corinne whose lively features and animated expression were meant to convey happiness, this daughter of the sun stricken with hidden sorrows, was like those flowers still fresh and sparkling, but threatened with an untimely end by the black dot of a fatal sting" (246).[24] Indeed Corinne, "daughter of the sun," who in Vigée-Lebrun's painting holds a lyre bedecked with the head of the sun god, Apollo, is poised in a landscape with steep and craggy rocks and gathering dark clouds. Her setting is at once verdant and ominous, flowering and threatening.

Corinne's specific anguish of losing her talent through her ill-omened love for Oswald, and her longing to have Oswald experience her genius one last time are imaged in painting and text as the melancholy of sunset. In her

work, Vigée-Lebrun renders the setting sun, and deepening shadows are apparent in the background and around the lyre balanced on Corinne's left knee. The surrounding landscape with its great contrasts, sets a heightened emotional tone appropriate to the feelings Staël describes:

> Still, Corinne longed to have Oswald hear her once more as she had been that day at the Capitol, with all the talent she had received from heaven. If that talent were to be lost forever, she wanted its last rays to shine for the one she loved before they went out. Through that desire she found the inspiration she needed, in the very ferment of her soul. (240–41)[25]

The theme that plays through Corinne's second improvisation is the association of the landscape with human memories, feelings, and passions. All bound up with the reminiscences conjured by the area around Naples, the improvisation begins: "Nature, poetry, and history challenge each other for grandeur in this place where a single glance embraces all times, all marvels" (241).[26] Vallois has observed that Corinne establishes at Miseno, in a sequence situated at the heart of the novel, the general equivalence that supports the novel's structure—nature as a reflection of the human soul.[27]

The theme of Corinne's second improvisation thus reaches beyond her impending personal tragedy, and the whole is inspired by images of death and loss. Along with Cicero and Marius, Corinne sings of Roman women—Cornelia, Agrippina, Porcia—abandoned by the death of their husbands: "Wandering like ghosts along the ravaged banks of the eternal river, these unfortunate creatures yearn to cross to the other side" (244).[28] She continues, in obvious reference to her own fate: "Love! the heart's supreme power, mysterious enthusiasm embracing poetry, heroism, and religion. What happens when destiny separates us from the one who held the secret to our soul, the one who had given us the life of the heart, the heavenly life? What happens when absence or death leaves a woman alone on earth? She languishes, she falls" (ibid.).[29] At the end of her improvisation, fearing the loss of both her talent and Oswald's love, Corinne grows mortally pale and nearly falls to the ground. The Italians gathered before her are surprised by the dark strain in Corinne's poetry; the English are delighted to see her express melancholy feelings with an Italian imagination. It is the English response to Corinne and the specifically Nordic melancholy they admire in her art, that ties this improvisation at Miseno back to an earlier scene at Tivoli, and allows an interpretation of Vigée-Lebrun's doubled siting.

Corinne performs no improvisation at Tivoli, but she moves Oswald to tears with a Scottish ballad sung in front of a painting. The song concludes a

segment of the novel set in the picture gallery of Corinne's villa, and it is performed before an image in which, Corinne opines, history and poetry are successfully combined with landscape. The combination of history, poetry, and landscape anticipates in painting the history, poetry, and nature that Corinne will braid in her second improvisation. In the picture gallery, nature represented as landscape provokes thoughts similar to those that "real" nature will elicit at Cape Miseno. The image that inspires Corinne, Staël based on an illustration from Ossian painted by the English artist Wallis. As she describes it, the scene is set in a stormy northern clime and depicts Calibar's son asleep on his father's grave. He has waited for three days and nights the arrival of the bard Ossian, who comes to sing the honors in memory of the dead. Which is, of course, what Corinne will do later in her improvisation at Miseno. In the distance of the painting Ossian comes down from the mountains, and Calibar's ghost hovers on the clouds above. The image conjures for Oswald thoughts of Scotland and of his father's grave, and his response to the painted landscape establishes what will be the theme of Corinne's second improvisation—memories recalled by particular places.

In its emphasis on memory, death, and mourning, and with its response to landscape elements, the scene in Corinne's gallery is remembered in her improvisation at Miseno.[30] Taken together, the improvisation at Naples and the painting at Tivoli assemble the forces and tensions that structure the novel—the contraries of North and South, Romantic and Classic, Ossian and Virgil, duty and love. Corinne herself, of an Italian mother and an English father, embodies these polarities, just as she embodies that perceived between the proper womanly woman and the genius. With its references to these contrasting forces, the painting transcribes not just a single scene in the novel, but something of the entire novel itself. And this point brings the discussion back to the scene at Tivoli, to Corinne's painting gallery.

The Sister Arts

In the gallery, Corinne expresses her attitude toward painting, which seems a mix of Lessing and Burke. She suggests the superiority of poetry over painting when the two treat the same subjects, as well as the greater suitability of poetry for expressing the sublime:

> When painting is devoted to subjects treated by great poets it is necessarily subordinated to poetry, for the impression left by the words obliterates everything and the situations they have chosen almost always draw their greatest strength from the eloquent development of

passion. Most pictorial effects, however, are born of serene beauty, simplicity of expression, a noble attitude; in sum a moment of repose worthy of enduring indefinitely, without the eye ever tiring of it. (155)[31]

Although this is her aesthetic credo, in the gallery it is before an impassioned and fantastical image drawn from Ossian, hardly serene or noble, that she is moved to song and tears.

It is tempting to view Vigée-Lebrun's portrait as a response to this aesthetic position. Hers is a painting devoted to a subject treated by a great poet, yet the impression of physicality, the sheer monumentality of the figure, and the shock that the image occasions could hardly be obliterated by the words of the novel. Tempting as it may be to read this painting as a response—a challenge—to *Corinne*, that reading is all tied up with a construction of painting and poetry not as harmonious sisters, but as jealous rivals. I prefer to figure the painter as an analytical reader of the novel. The pictorial effects Vigée-Lebrun achieves are opposed to everything Corinne overtly proclaims as proper to painting, and drawn from those Ossianic images that seem to elicit the strongest emotional response from the improvisational poet. If this portrait is a reading of *Corinne*, it is a reading that gets to the heart of the very paradoxes that structure the novel by using the aesthetic strategies suggested in the novel. For, all the while that Corinne is touting the virtues of the classic, the novel partakes of the emotional romanticism exemplified in works by writers like Chateaubriand.

Vigée-Lebrun's evocation of two distinct sites and moments forecloses any attempt to read the image literally as a scene from *Corinne*. As an allegorical portrait the work was never (dare I say it?) intended to have the illustrative value of an image like Gérard's later *Corinne at the Miseno* (1822; figure 43), which depicts the scene from the story complete with its mixed audience of Oswald, lazzaroni, and English gentlemen and ladies. In Gérard's work, as in the story, Corinne is presented under Oswald's gaze as he stands amid the crowd. Her lyre has fallen and she is searching for inspiration. Writing about Gérard's *Corinne* in 1824, Stendhal used the image to interpret Staël's text. He found Oswald the "weakness" of the novel, unable to accept Corinne's difference, yet unwilling to repudiate her. He sees the same Oswald in Gérard's painting: "So we quickly avert our eyes from this frigid northerner, the sad victim of prejudices which he has neither the strength to overcome nor the courage to surrender to."[32] But harsher words are still to come for other judges of Corinne, so different from the lazzaroni caught up by her expressive song. The Englishwomen in Gérard's image, Stendhal claims, are placed with

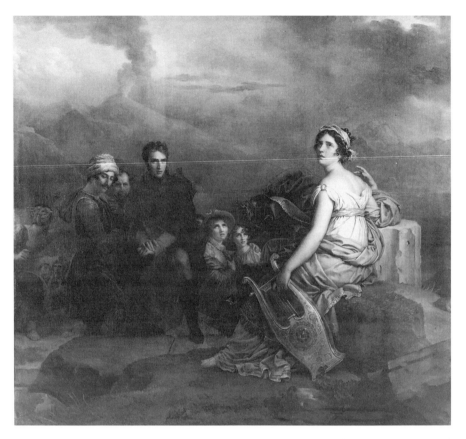

Figure 43 François Gérard, *Corinne at Miseno*, 1822. Lyon: Musée des Beaux-Arts

perfect artistry. Far from being delighted by the dark strain in Corinne's po-
etry, these women are prescient of her future fate:

> From their frigid, disdainful expressions I can foresee the fate in store
> for poor Corinne once she has left the beauties of Italy to go and
> bury herself in the chilly, northern land of propriety. Here the painter
> has given their full meaning to Madame de Staël's fine pages on
> those women from the North, with their respectability, class-
> consciousness, and tea making talents. In those two Englishwomen I
> can see Corinne's entire fate, and I can hear their expressions of dis-
> dain as they meet a person of their own sex with a supreme gift: Very
> shocking! Very improper![33]

Vigée-Lebrun provides no painted audience, no responses to Corinne-Staël that vary with the listener's position in the novel—and in society. Standing before the female bard, who even as she performs seems hardly aware of being seen, we viewers are on our own as we stand and listen. How will we respond to Corinne-Staël, and to Vigée-Lebrun? Will we be English ladies or Italian lazzaroni?

In responding to *Corinne*, we know that many women chose to identify themselves with Staël's woman genius, untroubled by the sorts of contradictions and complexities that recent feminist interpretations have articulated.[34] The novel was popular not only in France, but also in England (despite what Stendhal believed about English women) and in the United States, where Margaret Fuller, among others, remarked upon her strong identification with Corinne.[35] From my perspective, the most important identification suggested by Vigée-Lebrun's portrait is that between the artist and the writer. I imagine that Vigée-Lebrun longed to identify herself with the powers and fame of Staël, as she had already identified herself with Raphael, Rubens, Van Dyck, Rosalba, Domenichino, Dibutadis, Marie-Antoinette, Yolande de Polignac, and others. Moreover, a verse composed by the prolific *littératrice* Madame Beaufort d'Hautpoul[36] after seeing the work in Paris, suggests that it was relatively easy to perceive a relation between artist and writer. I quote the final lines of the poem, which complete a verse filled with similar associations:

> And the same crown entwines in this painting
> The inspiring mind and the immortal brush.
> Staël offers to Lebrun a talent worthy of her.
>
> LeBrun alone deserves so perfect a model.
> The universe astonished by this happy twosome,
> Without choosing falls in silence at their feet.[37]

The poem posits an exclusive relation between Staël and Vigée-Lebrun, adorning them with a single crown, separating them from everyone else, and rendering them only interchangeable with each another. The exceptional woman has given way to the genius. Staël is worthy of being painted by Vigée-Lebrun and only Vigée-Lebrun merits so perfect a model. The universe astonished by this happy ensemble, this duo of female genius, cannot choose between them. It can only fall prostrate at their feet.

Of Blind Men and Flawed Women

With lyre in hand, Corinne-Staël here substitutes for the blind bards Homer and Ossian, who represented original genius. In his recent *Memoirs of the*

Blind, Derrida has written himself into the history of illustrious blind men, and following the example of Milton, Wilde, Joyce, and Borges, he joins: "A singular genealogy, a singular illustration, an illustration of oneself among all these illustrious blind men who keep each other in memory, who greet and recognize one another in the night."[38] What does it mean that Vigée-Lebrun inserts into this history of great writers posed as blind men a woman in full possession of her sight, whose eyes are her most expressive characteristic? And that she does so at a time when women are represented alongside the gifted blind either as allegorical figures, as in Ingres's *Apotheosis of Homer* (1824; Paris: Musée du Louvre)[39] or as desirable attendants bearing tokens of homage, as in Girodet's *Ossian Receiving the French Generals into Valhalla* (Malmaison)?

Surely there is a simple answer to why Vigée-Lebrun paints Corinne-Staël as a sighted bard: Staël does not represent Corinne as blind, and even if she did, in a portrait an artist cannot extinguish a sighted sitter's eyes. At the same time that Vigée-Lebrun emphasizes the expressive eyes of the woman bard, however, their upward cast substitutes for blindness and, like it, indicates that the figure peers into her imagination rather than focusing on the sights of this world. This code for inward vision had several variants and was commonly used to represent artists of all sorts.[40] The convention of the upturned eyes hinders the possibility of seeing the eye as seeing because it allows viewers to look at the eye (as organ) instead of imagining that their glance either meets that of the sitter's or charts its look on some exterior object. Those representations that show the artist's eye staring ahead, blindly, function more emphatically in the same way, and that convention, too, helped form the artist's image, as in David's *Self-Portrait* (figure 34) and even more powerfully in later Romantic images of the artist.[41]

Women artists could be portrayed with eyes cast upward; that convention was traditionally associated with the ecstatic visions of sibyls and Magdalens as much as with those of evangelists and Sebastians. The blank stare, however, usually carries different connotations depending on whether it is worn by male geniuses or beautiful women. This is perhaps why the stare has proved difficult to read in Vigée-Lebrun's 1783 self-portrait in which she is both inspired artist and beautiful woman. It is simpler to interpret the blank stares that grace those who are presented as "beautiful woman" without other signs of learning, artistry, or the like (though it would be possible to read even those images against the grain). Madame Rivière (figure 44) and Madame de Sennones (Nantes: Musée des Beaux-Arts) as Ingres paints them could hardly be mistaken for representations of inspired geniuses. In the case of these women, their blank gazes suggest the object-like character of woman, her made-to-be-

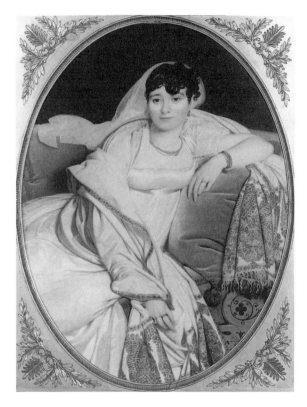

Figure 44

J. A. D. Ingres, *Portrait of Mme Rivière*, 1805. Paris: Musée du Louvre

seen-ness. They also suggest that the empty look is but the physical manifestation of an empty mind, and in some discourses, the sign of a mutilated body.

Even if, as Derrida disingenuously claims, Oedipus has become tiresome, we can't close our eyes to the long-standing cultural association between blinding and castration, particularly in this context. The tiresome Oedipus is writ large throughout Derrida's text, and he surfaces, for example, in the description of Borges writing his lineage: "Borges begins with Homer; he then ends with Joyce—and, still just as modestly, with the self-portrait of the author as a blind man, as a man of memory, and this, just after an allusion to castration."[42] If the illustrious blind male author is the castrated father of art (Chronos?), it is not simply by being blind, but through the privilege of *choosing* blindness/castration—as Borges claims Milton did and as Derrida does in his *Memoirs of the Blind*—that male geniuses identify with one another. In this context recall that Bryson, relying on Lacan and echoing Kristeva, similarly claimed that David became a great painter by accepting his castration, by

choosing the position of "blinded vessel." Although in the Lacanian scheme everyone is born castrated, born into language and controlled by the uncon-scious, clearly it is through the male's enhanced possibility of figuring castra-tion that members of the "stronger sex" can wield language even as they are spoken by it. The artist who accepts castration abdicates his fantasy of control, but he takes a privileged place on the side of the feminine as an outsider, a transgressor, a disrupter—a modern notion of the artist already prepared in the Romantic period.

Where, then, does that leave the *woman* bard Corinne-Staël, sighted and blinded at the same time? Is she the phallic mother as imagined by the male child? Does her sightedness signal her refusal to accept her castration? Is she then Freud's phallic woman, the "exceptional" woman achiever who still clings to her infantile fantasies and imagines she has a penis? In other words, is she still—as she was to Napoleon—the modern monstrous hermaphrodite, the femme-homme? Or is she the exception that disproves the rule, the one who bursts the fantasy of some natural connection between having a penis to lose and gaining cultural achievement? If, as some critics have claimed, "Who is Corinne?" is the central question of Staël's novel, then "What is Staël?" remains a central question posed by Vigée-Lebrun's painting.[43]

The Singular Genius

Barbara Stafford has articulated in terms of landscape painting the rise of "sin-gularity" as an aesthetic category, tracing the "complex development that led to the visual apprehension of natural objects as lone and strikingly distinct."[44] Although Stafford explicitly detaches the lone, natural object from any inter-pretation as a "human surrogate" (as in the paintings of Caspar David Fried-rich), the notion of a natural singularity is useful in articulating the relation-ships in Vigée-Lebrun's portrait. The artist shows, not the natural object as human surrogate, but the figure of a woman, Germaine de Staël, as a singular, natural formation. Bareheaded, hair tousled by the winds (of genius), and seated directly on a grassy hillock, she is presented as growing out of a particu-lar landscape as much as the great rock formation that rises alongside her as a parallel natural form. This association accords well with a novel that poses human passions and landscape as reflections of one another.

When in the eighteenth century "culture" was viewed positively and ele-vated above "nature" in a hierarchical relation, then culture was associated with the male and nature with the female sex (as in cultural production versus natural reproduction). However, when "nature" was taken as "truth" and posed against "artifice," as it was in ethics and art theory, then "nature" oc-

cupied the privileged position and "artifice" was relegated to the lesser, feminine side. Vigée-Lebrun's showing of Madame de Staël as a singular natural phenomenon does not designate her as passive feminine object. Far from it. The place of the genius, that singular creation of nature, was reserved for men and gendered masculine.[45] Viewing Madame de Staël as one of nature's sublime and singular creations transgresses the acceptable manifestations of woman as Nature. Woman, Nature, and Genius are merged in Vigée-Lebrun's image, which recalls her collapsing of the boundaries between natural "feminine" reproduction and "masculine" cultural production in her written and painted self-portrayals as artist-mother. Staël does not blend into the landscape, rather she stands out from it, massive and sublime.

Madame de Staël as Corinne is one of the few portraits by Vigée-Lebrun in which the artist attempts a sublime mode. She too seeks to influence her audience by not allowing her painting to have those characteristics most associated with woman's work—prettiness, fussy detail, soft handling, and a superficial and light exploration of surfaces. Taking his cue from reading Burke's treatise, W. J. T. Mitchell has pointed out that in romantic aesthetics sublimity signified in a "masculine" mode because founded on ideas of pain, terror, vigorous exertion, and power. Beauty, by contrast, Burke located in qualities that mechanically induced a sense of pleasure, such as littleness, smoothness, delicacy, and weakness—all "feminine."[46] Similarly, in relation to Burke's concept of the sublime as the monumental and the expansive, Naomi Schor has argued persuasively that in the eighteenth century the sublime was a category set at odds with the detail, which was gendered as feminine.[47] Vigée-Lebrun's portrait of Staël, however, deploys details such as the touched flowers, the braid around her costume, and the Apollo's head on the lyre, to set off the grander gestures of the image—its monumental scale, vertical elevation, craggy cliff, darkening sky, and powerful, vigorously expressive figure—all of which reach toward the sublime. By including details that disrupt an otherwise sublime image, Vigée-Lebrun's work muddies the clear and beautiful distinction between the sublime and beautiful.

In Burkean aesthetics, as in those embraced by Corinne in her painting gallery, the beautiful was associated with clarity, and through clarity connected to painting. Not easily grasped or understood, the sublime spoke of obscurity, and this obscurity linked it to poetry. In the painting of Madame de Staël as Corinne, a painting Staël called "more poetic than my work," boundaries (between the categories) are sublimely and poetically obscured. Neither smooth, nor little, nor delicate, nor weak, Madame de Staël is not beautiful, so she cannot be "Woman." She is a woman, so she cannot be sublime. She is not sublime, yet she is powerful, vigorous, and compared visually to the ir-

regular cliff that rises steeply beside her. Moreover, it is precisely her natural-
ness, her position as a singular natural wonder, that is stressed in this portrait.
Because women were dissociated from the power of the sublime, the portrait
seems doubly perverse—a sublime woman represented in a sublime mode by
another woman.

Looking at Vigée-Lebrun's portrait today might provoke the sort of re-
sponse that Battersby claims Staël's novel elicits; the tensions in the image,
like those in the prose, may seem to us "simple pretentiousness."[48] Indeed, the
portrait might seem as bizarre as that meteor, Madame de Staël, first appeared
to many of her acquaintances. Upon first sight, the Comtesse de Boigne found
the novelist "ugly and ridiculous." Her description of Staël recalls the sitter's
look in Vigée-Lebrun's portrait: "A large red face, without freshness, coifed
with hair that she called picturesquely arranged, that is to say badly pinned;
no head scarf, a tunic of white muslin cut very low, bare arms and shoulders,
no shawl, no wrap, no veil of any kind."[49] Not only does the description point
toward a woman lacking traditional womanly beauty, it also suggests a lack of
proper modesty. Wearing no "veil of any kind," the novelist eschews one of
the fundamental symbols of female *pudeur*. After an hour's conversation, how-
ever, the Comtesse was under the writer's spell.

Vigée-Lebrun's portrait also calls for conversation, especially to viewers
for whom this sort of allegorical masquerade seems particularly alien when
seen outside a postmodern context. Merely looking at this work may give little
pleasure, just as merely looking at Madame de Staël gave the Comtesse little
appreciation of her charisma. Yet it is one of the most challenging of all Vigée-
Lebrun's paintings. That challenge comes not only from replacing a blind
male bard with a sighted female poet, but also—and perhaps more force-
fully—from offering viewers a flawed and expressive Madame de Staël where
they expect a perfect and idealized woman. Vigée-Lebrun's *Sibyl* is more likely
what viewers anticipate in a allegorical portrayal, yet, as I have argued, that
work both disempowers and disembodies its model. With individualization,
the portrait of Madame de Staël as Corinne keeps the distance of the "as,"
allows Madame de Staël to distinguish herself from Corinne. What most pre-
vents her from dissolving into allegory is precisely her lack of idealized beauty.
In the face of *Corinne*, Vigée-Lebrun's portrait suggests that Staël could have
a profound influence on her audience, on her culture, even on history, without
that quintessential signifier of femininity. Madame de Staël is thus obviously
not Corinne.

I have argued that this allegorical portrait transcribes not just a single
scene in the novel, but something of the entire novel. Yet the painting is also
not a condensation of the novel, but a portrait of the novelist, Germaine de

Staël, whose distance from Corinne can be measured by the artist's refusal to idealize the sitter. Moreover, even as the painting refers to the scene of Corinne's waning powers, the monumentality, strength, and impressive force of the figure belies that Corinne whose tragic love for Oswald brings on the loss of her genius. If this scene evokes in the setting sun the last summoning of Corinne's creative powers, it represents an author capable of writing such a tragedy, but not necessarily susceptible to living it. What Vigée-Lebrun has painted is less Madame de Staël as Corinne, than Madame de Staël declaiming *Corinne*. In Vigée-Lebrun's monumental representation, the expressive Madame de Staël embodies what much late eighteenth-century thinking conceptualized as a natural, sublime force—a singular genius. As the artist wrote to her sitter, "To tell you the truth, one cannot paint you as one paints everyone else." [50] Vigée-Lebrun's monumental portrait reveals the effect of situating a woman in the pantheon of "genius." To represent the women genius seriously, as I believe the artist intended, is not only to confuse the assumptions that structure the categories. It is also to unmask, without perhaps realizing it, those grand illusions that have seemed natural idealizations when donned by men and ridiculous vanities when worn by women.

Coda

It is generally assumed that the learned Madame de Staël wanted to have herself painted as Corinne; the artist's statement that it was she who conceived the idea after reading the novel is easily ignored. It is common to assume that the sitter—the one paying for the image—dictated what the image would be. Yet in this case, the obvious scenario might not hold, and the souvenir writer who so often reworks incidents to Vigée-Lebrun's advantage, may indeed indicate from where the idea came. Reading Staël's letter to Henri Meister of 7 August 1807 might clarify the issue: "Why could you not come, with Madame Meister, to Coppet. I would like it very much if Madame Vigée-Lebrun came to Coppet. I do not know if I would dare have myself painted as Corinne by her, but Madame Récamier would be a charming model. In any case, the company of Madame Vigée-Lebrun is as pleasant as her talent and we would be enchanted to see her." [51] Although it is possible that Madame de Staël is totally disingenuous about not daring to have herself painted "en Corinne"; the letter suggests that she believes Madame Récamier would be a more charming model for Corinne, or that Madame Récamier would make a better portrait subject than herself. Récamier was a close friend of Staël, who often stayed at Coppet, but unlike Staël, she was a renowned beauty, one artists portrayed as sensuous and seductive. [52] In proposing Madame Récamier as

Corinne (or Corinne as Madame Récamier), Staël, it seems, is thinking not so much about her own portrait, but that of her heroine gifted with womanly beauty. Yet it was neither Récamier nor Corinne, but the singular Germaine de Staël whom Vigée-Lebrun was determined to paint.

What Staël thought of the image she painted is an open question. The evidence that she approved of it is primarily contained in letters to Vigée-Lebrun or to her daughter, Madame Nigris. For example, on 14 July 1809 the novelist wrote to the painter: "I finally received your magnificent painting, Madame, and without thinking about the fact that it is my portrait, I admired your work. All your talent is there and I very much wish that mine could be encouraged by your example. But I fear that my talent could not be greater

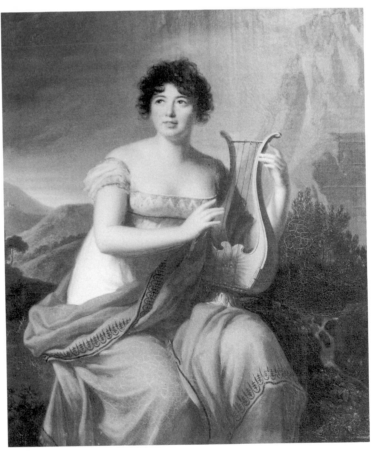

Figure 45 Copy of Elisabeth Vigée-Lebrun, *Portrait of the Madame de Staël as Corinne*, after 1808. Coppet: Musée du château

than [the talent one can read] in the eyes you have given me."[53] To Madame Nigris she wrote in 1809: "Madame your mother, Madame, has made me Corinne in a portrait truly more poetic than my work."[54] But there is also evidence, at least indirect evidence, to suggest the contrary.

Prosper de Barante wrote to Madame de Staël in a letter dated 27 July 1809: "I well knew that you would find this portrait by Madame Lebrun bad and lacking in grace."[55] Even more suggestive are the changes that were made when the portrait was copied for Madame de Staël after 1807 (figure 45), and although these changes can be explained by the reduced size of the work, a more private purpose, and a different hand, they nonetheless significantly reconceive the writer's image. In the copy now at Coppet, the figure is costumed in contemporary dress, which in its deep square neckline does not exaggerate the roundness of her face. Madame de Staël is much more idealized and much less expressive: her skin is smoother, her hair neater, her features more generalized, and her eyes notably less emphatic. The powerful, muscular arms, so conspicuous in Vigée-Lebrun's portrait, are now more hidden, and the muscles covered with a small off-the-shoulder sleeve. In other words, the elements that made her a sublime figure in Vigée-Lebrun's work have been erased. In the copy the distinguished writer is a distinctly more modest and pleasing woman.

Could Madame de Staël, in the end, not accept her imaginary projection, Corinne, projected back onto herself by Elisabeth Vigée-Lebrun? or did she still expect that painting should harmonize all the fissures and contradictions into a beautified aesthetic whole? What did she make of this copy, which, although superficially more pleasing, shows nothing of her power? In its generalized facial features, the Coppet portrait undercuts Staël's individuality, and in the change of scale all grandeur and sublimity is lost. Also lost in the smaller copy is the suggestion that Staël is more than an exceptional woman, that she is in excess of that category. At Coppet, Madame de Staël just looks like everybody else.

Epilogue

I have tried in this book not to make Elisabeth Vigée-Lebrun look "like everybody else." By rooting my analysis both in historical time and theoretical space, I have rendered her portrait in at least four dimensions. She appears simultaneously as a particular historical individual; a construction of her self-representations; a figure articulated in feminist discourse; and an allegory for (or if you prefer, a case study of) the exceptional woman in eighteenth-century France. I have had to use a variety of materials to make this portrait of the artist. Archival records, novels, doggerel, paintings, memoirs, pamphlets, engravings, scientific treatises, moral tracts, letters, legal codes, journals—all from the historical period—are interspersed with feminist philosophy, psychoanalytic theory, art-historical analysis, literary criticism, and cultural history. But these fragments of heterogeneous matter that I shaped into her portrayal, presented themselves in response to a single question: how could the woman Elisabeth Vigée-Lebrun make a career as an artist under a particular set of historical circumstances? But to say "make a career" is not enough.

There were many women who made careers as artists in the sense of supporting themselves with or simply practicing their work. The historical records of eighteenth-century French art are filled with women's names; in just looking casually you will find women who made flower illustrations, miniatures, pastels, portraits, and engravings; women who were guild members; women who were copyists; women who showed their work at Pahin de La Blancherie's Salon de la Correspondance, even though their sex prevented them from attending its regular meetings. Here are the names of women who exhibited their work at that Salon in the 1770s and 1780s:

Madame Avril	Madame Boucher
Mademoiselle de Beaulieu	Mademoiselle Capet
Madame Binzi	Mademoiselle Charpentier

Madame Chenut Mademoiselle Victorine
Mademoiselle de Chevalière Lemoine
Mademoiselle Augustine Delorme Madame Leroux de la Ville
Mademoiselle Destours Madame Lingée
Madame Fragonard Mademoiselle Martin
Madame Frémy Madame Montpetit
Mademoiselle Gabiou Mademoiselle Noireterre
Madame Gaucher Mademoiselle Pigalle
Mademoiselle Glachant Mademoiselle Ravenel
Mademoiselle Guerrier Mademoiselle Surrugue
Madame Guiard Madame Suvée
Mademoiselle Jouannon Madame Coster née Vallayer
Madame Lebrun Madame Ville
Mademoiselle Elisabeth Lemoine Madame Wetherith

From J. B. Lebrun's *Almanach historique et raisonné des architectes, peintres, sculp-teurs, graveurs et cizeleurs* (Paris, 1777), we can add to this list:

Mademoiselle Berthaud Mademoiselle Françoise
Mademoiselle Bocquet Ozanne
Mademoiselle Coulet Mademoiselle Marie-Jean
Madame Dehauré Ozanne
Madame Fixon Mademoiselle Marie Parrocel
Madame Glain Mademoiselle Thérèse Parrocel
Les Demoiselles Haussart Madame Prévost
Mademoiselle Navare Madame Vien

With just a bit more looking, one would find many more women artists prac-ticing in Paris—and elsewhere in France.

After scanning these lists, consider that Riballier includes in a *400-page* account of notable women appended to his *De l'Education physique et moral des femmes* (1779), only these contemporary artists living in France: Madame Vien, Mademoiselle Vallayer, the scientific illustrator Magdeleine Basseporte, and the young Madame Lebrun. In her *Les Femmes comme il convient de les voir* (1784), Madame de Coicy halves the list: only Madame Vallayer and Madame Lebrun are cited as contemporary women painters of note. My point, of course, is that French women could, and did, practice the visual arts, and they did so in large numbers throughout the eighteenth century. However, to prac-tice painting and to be considered an illustrious artist were two decidedly dif-ferent matters.

Elisabeth Vigée-Lebrun had the ambition to match her painterly talents,

and I imagine that at some level she must have recognized her extraordinary command of the trade. Beyond this speculation, I cannot say from where her ambition came, and I think it difficult to understand how a young woman in the 1770s could imagine herself becoming an illustrious artist. Difficult as it may be to imagine such a thing, Elisabeth Vigée-Lebrun's life indicates that she did. Her life also shows that when a chance came her way, she grabbed it.

In my introduction, I quoted Michèle Le Doeuff's observation about the contradiction or ambivalence that characterizes many women: "that a woman is oppressed on the one hand, and on the other has a chance, her chance, explains the hesitant or split character we find in many women."[1] Le Doeuff bases her observation on the lives of women whose biographies are known because they achieved a little fame. These women, she argues, had to accept enormous tension to carry out their work, a tension Le Doeuff locates primarily in the contradiction between what it has meant to "be a woman" and what it takes to pursue one's talents seriously. As Le Doeuff points out, these contradictions existed not only for (what I have called) exceptional women, but for all women—and they have not disappeared. Addressing herself to the current situation in France, Le Doeuff argues: "The inadequate number of crèches means that women must choose between motherhood and a job. And in any case, a woman continuing Marie Curie's work may be raped when she goes home late at night from her laboratory."[2] The same could be said for American women, with these qualifications: first, the choices and opportunities are often far fewer and the dangers far greater for women who are neither white nor middle or upper class. And second, a woman is not only vulnerable late at night; she could be raped in the afternoon inside her laboratory, as recently happened in Raleigh on the North Carolina State University campus.

If today a woman's choices, opportunities, and dangers are delimited by class and race (among other factors), so were those of her eighteenth-century predecessors. Elisabeth Vigée-Lebrun did not come from either an exalted social rank or from wealth, but neither did she come from the poor or dispossessed. Luck of birth positioned her so that she might have a chance, even if her sex made the odds of actually having one, let alone successfully seizing it, quite small. Le Doeuff's observation about historical women seems especially appropriate for Vigée-Lebrun, who was courtier and hairdresser's daughter, mother and painter, society lady and laboring artist. What price did this woman with artistic talent pay for seizing her chance in *ancien-régime* France? What paths were open to her before the Revolution? What paths did her choices close after 1789?

The path she took, quite clearly, was the one that led to royal favor, a path that had been familiar to French artists for more than a century. Vigée-

Lebrun, however, walked the path a bit differently than did her male col-
leagues. For them, admission into the Academy or its schools usually preceded
royal favor; in her case, royal favor secured her acceptance into the privileged
body of artists. Given the temporal moment in which Vigée-Lebrun first
made her mark as a noted artist, she chose neither the path of least resistance,
nor the difficult road that Hercules climbed to the temple of fame. She chose
the road most traveled, at least by male artists of renown. It was according to
the particular circumstances of the arts, and the structures governing their
practice, that this woman had to make her choices in pursuing her ambitions
in old-regime France.

When the Revolution came, it would not have been easy for her to change
course, even if she had wanted to. Not only did she draw her clients from the
aristocracy and the well-to-do, but, in 1789, Vigée-Lebrun was the only artist
working for the queen calomnied in print. A highly visible public woman com-
peting directly with men, Elisabeth Vigée-Lebrun was a perfect target for the
fears of dedifferentiation and feminization that were played out on the "many
bodies of Marie-Antoinette."[3] Regardless of her actual motives for leaving
France, exile brought her renewed opportunities for increased celebrity, as is
clear from the academies that welcomed her.

Like Rosalba Carriera, the woman to whom she was so often compared in
the 1780s, Vigée-Lebrun's career was marked by her moving from capital to
capital, from art center to art center, and this was the case even after she re-
turned to France. But perhaps this restlessness is less a mark of ambition and
more an indication of the peculiar position occupied by the celebrated woman
artist. She is welcomed everywhere as long as she does not stay too long. A
foreign woman is doubly foreign to a male-dominated Academy, but not half
as threatening as a local one. There is little danger that the foreigner passing
through will seriously disrupt the established patronage circuits, and even less
that she will actually want to meddle in the Academy's business. Under such
circumstances, the exceptional woman took in the Academy the place that
male discourse generally reserved for her, that of pleasing anomaly, charming
original, and—if she were also beautiful—sparkling ornament.

I would like to read Vigée-Lebrun's portrait of Madame de Staël as her
reaction to this construction of the exceptional woman, a protest against the
stifling of female ambition in favor of feminine charm. This, at any rate, is
what the painting has come to mean for me. Perhaps it is because this image
of Staël is the fitting pendant to my portrait of the woman who painted her.

Notes

Introduction

1. "Soutenir vaguement que les deux sexes sont égaux et que leurs devoirs sont les mêmes, c'est se perdre en déclamations vaines, c'est ne rien dire tant qu'on ne répondera pas à cela. N'est-ce pas une manière de raisonner bien solide de donner des exceptions pour réponse à des loix générales aussi bien fondées? Les femmes, dites-vous, ne font pas toujours des enfans? Non, mais leur destination propre est d'en faire." Jean-Jacques Rousseau, *Emile*. In *Oeuvres complètes*, ed. Bernard Gagnebin and Marcel Raymond (Paris: Gallimard, 1969), 4:698.

2. "*Exception*, est aussi quelquefois une dérogeance à la règle en faveur de quelques personnes dans certains cas: on dit communément qu'il n'y a point de règle sans *exception*, parce qu'il n'y a point de règle, si étroite soit elle, dont quelqu'un ne puisse être exempté dans ces circonstances particulières; c'est aussi une maxime en Droit, que *exceptio firmat regulam*, c'est-à-dire qu'en exemptant de la règle celui qui est dans le cas de l'exception, c'est tacitement prescrire l'observation de la règle pour ceux qui ne sont pas dans un cas semblable." Denis Diderot and Jean Le Rond d'Alembert, *Encyclopédie, ou Dictionnaire Raisonné des sciences, des arts et des métiers, par une société de gens de lettres*. Facsimile of 1751–80 edition (Stuttgart: Friedrich Frommann Verlag, 1967), 6:218.

3. Geneviève Fraisse, *La Raison des femmes* (Paris: Plon, 1992), 53–54. This concept is also developed in her earlier book, *La Muse de la raison* (Aix-en-Provence: Alinéa, 1989).

4. Fraisse, *La Raison*, 53.

5. Susan Faludi, *Backlash: The Undeclared War against American Women* (New York: Crown Publishers, 1991), xx.

6. Fraisse, *La Raison*, 51.

7. Ibid., 53. "L'exception, reconnue comme telle, convient aux régimes politiques à forte hiérarchie; elle est sans justification théorique dans une régime supposant l'égalité."

8. Lynn Hunt, *The Family Romance of the French Revolution* (Berkeley: University of California Press, 1992), 203.

9. Thomas Laqueur, *Making Sex: Body and Gender from the Greeks to Freud* (Cambridge, Mass.: Harvard University Press, 1990). Fraisse takes up this issue in *La Muse*, 81–109. See also, Hunt, 156–58.

10. Michèle Le Doeuff, *The Philosophical Imaginary*, trans. Colin Gordon (Stanford, Calif.: Stanford University Press, 1989), 138–70. This English version appeared nine years after the French edition (*L'Imaginaire philosophique* [Paris: Payot, 1980]), and is a careful, readable translation. All subsequent citations are to the English edition.

11. Sigmund Freud, "Femininity," *New Introductory Lectures on Psychoanalysis*, trans. James Strachey (New York: W. W. Norton & Co., 1964), 103.

12. Sarah Kofman, *The Enigma of Woman*, trans. Catherine Porter (Ithaca, N.Y.: Cornell University Press, 1985), 203–4.

13. For theorizing the performative I rely on Judith Butler, *Gender Trouble* (London: Routledge, 1991), and idem., *Bodies that Matter* (London: Routledge, 1993).

14. Michèle Le Doeuff, *Hipparchia's Choice*, trans. Trista Selous (London: Basil Blackwell, 1991), 128.

15. Toril Moi, *Sexual/Textual Politics: Feminist Literary Theory* (London: Methuen, 1985), 9.

16. Joseph Baillio, *Elisabeth-Louise Vigée-LeBrun, 1755–1842* (Fort Worth: Kimball Art Museum, 1982), 130. I am interested here in the *Souvenirs* as they were published with Vigée-Lebrun's approval. Even if manuscripts of the *Souvenirs* could "prove" that Vigée-Lebrun had initially remembered a certain event differently, or that certain changes had been made from first draft to final version, this would make a negligible difference to the particular line of analysis I pursue. It is the final version that has been accessible to posterity and upon which her image has been based. Joseph Baillio is preparing a critical edition of the manucripts of the *Souvenirs*, which will be indispensible for understanding more about their genesis. In addition, Baillio is preparing a *catalogue raisonné* of Vigée-Lebrun's works that will also be an invaluable aid for further study and research.

17. The concept of the painter's imaginary, I adapt from Le Doeuff, *The Philosophical Imaginary*. Also, on the traditional tropes of artist's biography found in the *Souvenirs*, see Jean Owens Schaefer, "The Souvenirs of Elizabeth Vigée-Lebrun: The Self-Imaging of the Artist and the Woman," *International Journal of Women's Studies* 4 (1981): 35–49.

18. "En écrivant mes Souvenirs, je me rappellerai le temps passé, qui doublera pour ainsi dire mon existence." *Souvenirs de Madame Louise-Elisabeth Vigée-Lebrun* 3 vols. (Paris: Librairie de H. Fournier, 1835), vol. 1, frontispiece.

19. I am suggesting that Vigée-Lebrun makes an "autobiographical pact" with the reader. For this concept, see Philippe Lejeune, *On Autobiography*, trans. Katherine Leary (Minneapolis: University of Minnesota Press, 1989), 3–30. There is a growing bibliography on autobiography, and recent examples that have shaped my thinking include Domna Stanton, ed., *The Female Autograph* (Chicago: University of Chicago Press, 1987); Felicity Nussbaum, *The Autobiographical Subject: Gender and Ideology in Eighteenth-Century England* (Baltimore: Johns Hopkins University Press, 1989); Françoise Lionnet, *Autobiographical Voices* (Ithaca, N.Y.: Cornell University Press, 1989); Sidonie Smith, *A Poetics of Women's Autobiography* (Bloomington: Indiana University Press, 1987); and Michel Beaujour, *Miroirs d'Encre: Rhétorique de l'autoportrait* (Paris: Seuil, 1980).

20. Butler, *Bodies that Matter*, 104–19.

21. Ibid., 108. I owe the term "cultural text" to William Ray, and use it to imply the whole range of regulatory laws, both written and unwritten, within a particular

society. These include actual legislation and rules of custom, laws enforced through legal codes, and other sorts of societal pressures, as well as norms of behavior represented in literature, the visual arts, and other media.

1. The Sense and Sex Organs

1. The Florentine anatomist, Felice Fontana (1730–1805), was a noted scientist and the keeper of the Cabinet of Physics and Natural History (Pitti Palace) of the Grand Duke of Tuscany. The wax models of the human body made under his direction were known throughout Europe, and were used for scientific instruction as well as displayed for visitors. Today, his models form the collection held at La Specola in Florence. In her *Body Criticism: Imaging the Unseen in Enlightenment Art and Medicine* (Cambridge, Mass.: MIT Press, 1991), Barbara Stafford has brilliantly contextualized these works in terms of both art and science. See her chapter 1, "Dissecting," 47–129. For discussion of the works from a feminist perspective, see Ludmilla Jordanova, *Sexual Visions: Images of Gender in Science and Medicine between the Eighteenth and Twentieth Centuries* (Madison: University of Wisconsin Press, 1989), 43–65.

2. The verb she uses is "se poursuivre," which carries the connotations of haunting, following, and pursuing. "Un souvenir de Florence, qui m'a poursuivie bien longtemps, est celui de la visite que je fis alors au célèbre Fontana." Elisabeth Vigée-Lebrun, *Souvenirs*, ed. Claudine Herrmann (2 vols.; Paris: Des femmes, 1986), 1:237.

3. "Ce fut pour moi une grande jouissance, dès que je me retrouvai dans cette ville, d'aller revoir tant de chefs-d'œuvre auxquels je n'avais pu donner qu'un coup d'œil en passant pour aller à Rome." Ibid.

4. "Il me fit voir son cabinet, qui était rempli de pièces d'anatomie, faites en cire couleur de chair. Ce que j'observai d'abord avec admiration, ce sont tous les ligaments presque imperceptibles qui entourent notre œil, et une foule d'autres détails particulièrement utiles à notre conservation ou à notre intelligence." Ibid., 1:237–38.

5. "Il est bien impossible de considérer la structure du corps de l'homme, sans être persuadé de l'existence d'une divinité." Ibid., 1:238.

6. What Gilman says is, "Prior to this use, this technique had been employed to create realistic relics in the form of mimetic human shapes for the bones of saints and martyrs." *Sexuality: An Illustrated History* (New York: Wiley, 1989), 184.

7. Nor are we free of the religious roots of art, of icons like the Pantocrator at Daphne where the eye of God is looking at us. Vis-à-vis such iconic depictions, Lacan describes how the gaze functions in society. He hypothesizes that such art affected its audience powerfully because viewers imagined that the god represented (an all-seeing God) was always looking at them. Also, the image was intended to please as well as to represent the Creator. Lacan goes on to follow the social function of art, which emerged first at the religious level, through the Renaissance and into modernity, when the painter claimed to impose his gaze as the only one. Jacques Lacan, *The Four Fundamental Concepts of Psychoanalysis*, trans. Alan Sheridan, ed. Jacques-Alain Miller (New York: W. W. Norton, 1978), 113–14.

8. On Scheuchzer, see Stafford, *Body Criticism*, 344–45.

9. The entire passage reads, "Il est bien impossible de considérer la structure du corps de l'homme, sans être persuadé de l'existence d'une divinité. Malgré tout ce qu'ont osé dire quelques misérables philosophes, dans le cabinet de M. Fontana il faut croire et se prosterner." Vigée-Lebrun, *Souvenirs*, 1:238. Another French visitor to

Fontana's cabinet, Charles-Marguerite-Jean-Baptiste-Mercier DuPaty, wrote in 1788 that Fontana feared excommunication for his anatomical work (*Lettres sur l'Italie en 1785* [2 vols.; Paris, 1788], 1:164-65). DuPaty here implicitly links Fontana with his forerunner, Leonardo da Vinci, who was known to have risked the Church's condemnation in pursuing his scientific experiments.

10. The all-seeing eye was a symbol appropriated by revolutionaries, for whom the eye of reason replaced that of God. For visual examples see the following prints, all illustrated and analyzed in James Cuno, ed., *French Caricature and the French Revolution, 1789-1799* (Los Angeles: University of California Press, 1988), 230-31, 244-45, and 247-48. (1) Jean-Baptiste Chapuy, *La Liberté armée du sceptre de la Raison foudroye l'Ignorance et le Fanatisme*, ca. 1793. The allegorical figure of Liberty wields the all-seeing eye attached to the scepter of Reason. Liberty with her phrygian cap here represents the Revolution; Ignorance and Fanaticism represent the counterrevolutionary forces allied with religion and monarchy. (2) Jean-Baptiste-Marie Louvion, *Les Formes acerbes*, 1795. This work shows how the eye also came to represent the vigilance (or surveillance) necessary to the Revolution, and as such was appropriated by forces hostile to the Terror. In this print the eye of Vigilance watches as Justice reveals Truth to the national convention. "Truth" is figured as a bloodbath presided over by Joseph Le Bon. (3) *Unité, indivisibilité . . . du crime et de la misère/Le Miroir du passé pour sauvegarde de l'avenir*, ca. 1797. This anonymous print is the most complex of these and is an allegory of the "cadavero-faminocratique" government of Robespierre. The print plays on the appropriation of religious symbols by the revolutionaries, portraying them as members of a perverse cult, complete with the "holy fathers" of the church of the Terror. The entire scene is structured as a church service in which Death is worshipped. Above this service hovers the familiar all-seeing eye surrounded by a burst of light, but now this burst metamorphoses into a lightening bolt that sets fires raging below. Set across the top of the print and flanking the eye is the inscription "Providence, or the Justice of Thermidor."

11. "En me rapprochant de la France, le souvenir des horreurs qui s'y sont passées se retrace à moi si vivement que je crains de revoir les lieux qui ont été témoins de ces scènes affreuses. Mon imagination replacera tout. Je voudrais être aveugle ou avoir bu du fleuve d'Oubli pour vivre sur cette terre ensanglantée!" Vigée-Lebrun, *Souvenirs*, 2:94.

12. "C'est dans l'église Santa-Croce que se trouve le mausolée de Michel-Ange. Là, il faut se prosterner." Ibid., 1:159.

13. This divine gift, this *je ne sais quoi* shared by artist and anatomist, brings to mind the characteristics Foucault ascribed to the clinical glance. Foucault argued that the transformation of gaze to glance marked the point at which a whole dimension of medical analysis was deployed, at the level of an aesthetic, so that "the sensible truth is now open, not so much to the senses themselves as to a fine sensibility." Michel Foucault, *The Birth of the Clinic*, trans. A. M. Sheridan Smith (New York: Vintage Books, 1973), 120-22.

14. Stafford, *Body Criticism*, 49-52. The *Anatomy Theater* is the frontispiece to Gamelin's *Nouveau Recueil d'ostéology et de myology* of 1779.

15. I thank both Nicholas Mirzoeff and Barbara Stafford for bringing this academic exercise to my attention. DuPaty's account of Fontana's cabinet suggests the individual corpse is part of an aesthetic whole: "You see all the most secret parts of this

very complicated machine, first isolated and dispersed, then reassembled, reunited, and . . . entirely ready to live. . . . This type in wax has consumed a thousand cadavers. What work! what patience! but also what a beautiful monument!" DuPaty reminds us that the complete figure, whether imagined from the perfect wax fragments or actually seen in the complete wax bodies, is an idealization based on the observation of particulars. Thus he applies to anatomy the Zeuxian model, wherein the artist creates a perfect woman by combining the most beautiful features of various individuals. He also invokes the Pygmalion story, the central myth of the godlike creator. Although it may be La Mettrie's "machine," the body made by Fontana is "entirely ready to live." Whereas the artistic models that DuPaty's recalls, Zeuxis and Pygmalion, create the perfect woman, in Fontana's cabinet, DuPaty sees only (generic) man: "But that which arrested my gaze, it is man." *Lettres sur l'Italie*, 1:161–62.

16. "Jusque-là je n'avais rien vu qui m'eût fait éprouver une sensation pénible." Vigée-Lebrun, *Souvenirs*, 1:238.

17. For a discussion of the feminine qualities, see Jordanova, *Sexual Visions*, 45.

18. "Fontana me dit de m'approcher de cette figure, puis, levant une espèce de couvercle, il offrit à mes regards, tous les intestins, tournés comme sont les nôtres. Cette vue me fit une telle impression, que je me sentis près de me trouver mal." Vigée-Lebrun, *Souvenirs*, 1:238.

19. "Pendant plusieurs séjours, il me fut impossible de m'en distraire, au point que je ne pouvais voir une personne sans la dépouiller mentalement de ses habits et de sa peau, ce qui me mettait dans un état nerveux déplorable." Ibid. The word *personne* can be translated either as the generic "person" or as "woman." Given the context and the choice of a generic term specifically gendered feminine, I have preferred "woman."

20. "Quand je revis M. Fontana, je lui demandai ses conseils pour me délivrer de l'importune susceptibilité de mes organes. —J'entends trop, lui dis-je, je vois trop et je sens tout d'une lieue. —Ce que vous regardez comme une faiblesse et comme un malheur, me répondit-il, c'est votre force et c'est votre talent; d'ailleurs, si vous voulez diminuer les inconvénients de cette susceptibilité, ne peignez plus." Ibid.

21. "On croira sans peine que je ne fus pas tentée de suivre son conseil; peindre et vivre n'a jamais été qu'un seul et même mot pour moi, et j'ai bien souvent rendu grâces à la Providence de m'avoir donné cette vue excellente, dont je m'avisais de me plaindre comme une sotte au célèbre anatomiste." Ibid.

22. Condillac noted that the physical cause of the mind's perceptions was something like a perturbation or movement of the brain fibers occasioned by the action of the senses: "I assume that the physical cause of the mind's perceptions is a perturbation of the brain fibers. Not that I regard this hypothesis as proven, but it seems the best way to explain my thoughts. If they are produced in some other way, it must not be very different. There can be only movement in the brain. Thus whether perceptions are occasioned by the perturbation of brain fibers or the circulation of animal spirits or some other cause, all these are the same from my viewpoint." Etienne Bonnot, Abbé de Condillac, *Essay on the Origin of Human Knowledge*. In *Philosophical Writings of Etienne Bonnot, Abbé de Condillac*, trans. Franklin Philip (2 vols.; Hillsdale, N.J.: Lawrence Erlbaum Associates, 1987), 2:451, n. 15.

23. To show how primitive imagination operated, Condillac cited the example of an animal who witnessed one of its own kind eaten by a predator. Upon seeing the predator a second time, the animal takes flight, because it recalls spontaneously the

victim's cries and the painful emotions connected with them. Condillac labels as instinct this process of imagination whereby perceptions are revived in the presence of an object to which they are linked directly. Ibid., 2:457–59.

24. Pierre Fabre, *Essai sur les facultés de l'âme considerées dans leur rapports avec la sensibilité & l'irritabilité de nos organes* (Amsterdam, 1785), 140.

25. For informed discussion of these ideas, see Jordanova, *Sexual Visions*, 19–56; Laqueur, *Making Sex*, 193–206; Fraisse, *La Muse*, 81–109; Londa Schiebinger, *The Mind Has No Sex?* (Cambridge, Mass.: Harvard University Press, 1989), 189–244; and Le Doeuff, *The Philosophical Imaginary*, 138–61.

26. Pierre Roussel, *Système physique et moral de la femme* (Paris: Chez Vincent, 1775), 24–30. On reason and reflection see Condillac, *Philosophical Writings*, 2:470.

27. "On dit aussi que son imagination, plus vive que soutenue, se prête peu à ces expressions vraies et pittoresques qui sont le sublime des arts d'imitation, et que, plus capable de sentir que de créer, elle reçoit plus facilement dans son âme les images des objets, qu'elle ne peut les reproduire." And, Roussel continues: "qu'enfin cette tournure d'esprit qui fait qu'elle se conduit presque toujours par des idées particulières, s'oppose en elle aux vues plus vastes, de la politique, et à ces grands principes de morales qui s'étendent à tous les hommes." Ibid., 31. Weakness is the principal character of woman, and Roussel notes that men who have a soft and delicate constitution also have the character and tastes of women. Whether inside determines outside or outside determines inside, there is a rapport between the two. Education, manners, and so forth can change and alter the physically determined moral attributes, but that does not make it less true that in general women are and must be sweet and timid. See ibid., 35–36.

28. On the relation between Condillac and later psychology, see especially Jan Goldstein, *Console and Classify* (Cambridge: Cambridge University Press, 1987), 64–119; and Le Doeuff, *The Philosophical Imaginary*, 168–70.

29. Condillac, *Philosophical Writings*, 2:503.

30. "Our ability to revive our perceptions in the absence of their objets enables us to combine and connect the most disparate ideas. Anything can take on a new form in our imagination." Ibid., 2:472.

31. Ibid.

32. Ibid., 2:478.

33. Blaise Pascal, *Pensées*, trans. A. J. Krailsheimer (Harmondsworth: Penguin Books, 1966), 38–42. See also, Marion Hobson, *The Object of Art: The Theory of Illusion in Eighteenth-Century France* (Cambridge: Cambridge University Press, 1982), 1–32.

34. Condillac, *Philosophical Writings*, 2:479. For a discussion of the relation between ornament, deception, and femininity in the rhetorical tradition, see Jacqueline Lichtenstein, "Making Up Representation: The Risks of Femininity." *Representations* 20 (Fall 1987): 77–87; and idem., *The Eloquence of Color*, trans. Emily McVarish (Berkeley: University of California Press, 1993), 169–95.

35. "Each family became a little society . . . and it was then that the first difference was established in the way of life of the two sexes, which until this time had had but one. Women became more sedentary and grew accustomed to tend the hut and the children, while men went to seek their common subsistence. . . . At this point one catches a slightly better glimpse of how the use of speech was established or perfected imperceptibly in the bosom of each family." Jean-Jacques Rousseau, "Discourse on the

Origin and Foundations of Inequality Among Men" (*The First and Second Discourses*, trans. Roger D. Masters [New York: St. Martin's Press, 1964]), 147. For a discussion of this idea, see Jacques Derrida, *Of Grammatology*, trans. and intro. Gayatri Spivak (Baltimore: Johns Hopkins University Press, 1976), 230–31.

36. Carole Pateman, *The Sexual Contract* (Stanford, Calif.: Stanford University Press, 1988), 96–97.

37. These divisions are interesting in light of Lacan's notions of the imaginary and symbolic phases of human development, which I take up below.

38. Condillac, *Philosophical Writings*, 2:472–77.

39. Pierre-Jean-Georges Cabanis, *On the Relations between the Physical and Moral Aspects of Man*, trans. Margaret Saidi, ed. George Mora, intro. Sergio Moravia and George Mora (2 vols.; Baltimore: Johns Hopkins University Press, 1981), 1:242. In his introduction to Cabanis's treatise, Moravia stresses the differences between Cabanis and Condillac. Cabanis's relation to Condillac's philosophy is complex, and it is not my intention to analyze the ties and differences between them in any detail. Cabanis was associated with the Idéologue enterprise, and Destutt de Tracy drew a distinction between Cabanis's "physiological ideology," and his own project of "rational ideology." On Cabanis's emending of Condillac, see Goldstein, *Console and Classify*, 49–55 and 94–96. A discussion of Cabanis's intellectual forerunners can be found in Martin Staum, *Cabanis* (Princeton, N.J.: Princeton University Press, 1980). What is particularly interesting for my purposes, however, is that, despite other differences, Cabanis shares Condillac's notions about woman. It is also noteworthy that Cabanis cites Rousseau and Roussel as his two great predecessors in his fifth memoir, "The influence of the sexes on the character of the ideas and of the moral affection."

40. Condillac, *Philosophical Writings*, 2:474.

41. Ibid., 2:475.

42. Pierre Edme Chauvot de Beauchene, *De l'Influence des affections de l'âme dans les maladies nerveuses des femmes, avec le traitement qui convient à ces maladies* (Montpellier, 1781), 13–14. To his physical account, Beauchene adds a moral lesson. In modern cities women cultivate their sensitivity and overwork their imaginations by reading novels, going to spectacles, and eating stimulating foods. Thus they aid the cause of their mental illness. He adds that he is surprised Rousseau did not use this argument in his writing against spectacles. In the end, Beauchene opts for a Rousseauian solution: raise children; be a mother (32–42).

43. Condillac, *Philosophical Writings*, 2:475.

44. Those who suggested these "cures" included Beauchene and Roussel, as well as Pierre Pomme, *Traité des affections vaporeuses des deux sexes* (Paris: Chez Desaint et Saillant, 1760), 26–27 and 174–77; Joseph Bressy, *Recherches sur les vapeurs* (Paris: Chez Planche, 1789); and D. T. de Bienville, *La Nymphomanie, ou Traité de la fureur utérine* (Amsterdam: Chez Marc-Michel Rey, 1778). Serious intellectual work was thought particularly dangerous because it impaired the reproductive organs.

45. In accounts derived from Condillac, madness was defined as a disorder of imagination—of externally derived impressions. Cabanis hypothesized that since in some cases of madness the nerves that comprised the senses were not affected, the mental contents must have originated in an internal source. Goldstein, *Console and Classify*, 52–53; Cabanis, *Physical and Moral Aspects*, 1: xxviii–xxix, 10–12, 50, 82–96; Staum, *Cabanis*, 177–206.

46. Cabanis, *Physical and Moral Aspects*, 1:93–96. Perhaps to Cabanis and his contemporaries the most convincing of these studies were those on nymphomania. In his influential treatise of 1778 (see n. 44), Bienville devoted the final chapter to the relation between imagination and nymphomania, and found throughout the treatise that a lively imagination heightened the disease, especially in adolescent girls. The awakening of sensitivity in the organs of procreation, it seemed, stimulated imaginative activity. Bienville, *La Nymphomanie*, 132ff.

47. Cabanis, *Physical and Moral Aspects*, 1:221.

48. Fraisse, *La Muse*, 87.

49. Cabanis, *Physical and Moral Aspects*, 1:227.

50. Ibid., 1:241.

51. I wish to thank Carol Blum for putting me on the track of Mlle Biheron. Daughter of an apothecary, Marie-Catherine Biheron was born in Paris in 1719. She abandoned natural history illustration for making anatomical waxes. Her works were exhibited in Paris in the late 1760s for an entrance fee of 3 livres. Denis Diderot, *Correspondance*, ed. Georges Roth (16 vols.; Paris: Editions de minuit, 1963), 8:211. See also Schiebinger, *The Mind Has No Sex?* 27–29.

52. "Il y a bientôt deux mois qu'elle est mariée, et elle a conservé et j'espère qu'elle gardera toute sa vie, la simplicité, la douceur, la modestie d'une jeune fille. La modestie, la pudeur; entendez vous, monsieur? et sçavez vous à quoi elle doit ce privilège si rare que les gens du monde remarquent en elle? A trois cours d'anatomie qu'elle avoit faits chez une demoiselle Biheron aussi recommandable par son talent que par sa sagesse, avant que de passer dans le lit nuptial." Letter to l'Abbé Diderot, 13 November 1772 (*Correspondance*, 12:164).

53. Beauchene, *De l'Influence des affections*, 8.

54. Bressy, *Recherches*, 141. For a discussion of breast feeding and representation in this time, see Madelyn Gutwirth, *The Twilight of the Goddesses: Women and Representation in the French Revolutionary Era* (New Brunswick, N.J.: Rutgers University Press, 1992), 341–68.

55. I take up the question of woman's art education below in Chapter 4.

56. Le Doeuff, *The Philosophical Imaginary*, 157.

57. Jordanova, *Sexual Visions*, 55.

58. Ibid.

59. Elizabeth Bronfen, *Over Her Dead Body: Death, Femininity and the Aesthetic* (London: Routledge, 1992), 99.

60. Ibid., 98–99.

61. Ibid., 99.

62. Le Doeuff, *The Philosophical Imaginary*, 117.

63. Luce Irigaray, *The Sex Which Is Not One*, trans. Catherine Porter with Carolyn Burke (Ithaca, N.Y.: Cornell University Press, 1985), 76: "There is, in an initial phase, perhaps only one 'path,' the one historically assigned to the feminine: that of mimicry. One must assume the feminine role deliberately. Which means already to convert a form of subordination into an affirmation, and thus to begin to thwart it. . . . To play with mimesis is thus, for a woman, to try to recover the place of her exploitation by discourse, without allowing herself to be simply reduced to it."

64. Ibid., 27. The term *masquerade* comes from Joan Rivière, "Womanliness as Masquerade," first published in 1929 and reprinted in *Formations of Fantasy*, V. Burgin,

J. Donald, and C. Kaplan, eds. (London: Methuen, 1986). See Chapter 6 for a discussion of Rivière.

65. Le Doeuff, *The Philosophical Imaginary*, 140. Common sense is a problematic term in English, one freighted with gender assumptions and often used to sanction actions approved by some reigning authority. I interpret Le Doeuff to mean the unlearned imagination—that is, the imagination prior to the acquisition of specialized discourses such as physiology or psychoanalysis—by "le sens commun," which appears in the French text on page 183.

66. Ibid., 161.

67. Ibid., 147.

68. Ibid.

69. Ibid., 169.

70. Ibid., 168–70.

71. Elizabeth Grosz, *Jacques Lacan: A Feminist Introduction* (London: Routledge, 1990), 144–45.

72. Le Doeuff, *The Philosophical Imaginary*, 148–49. For Roussel, beauty is "the secret whereby nature has designed to interest us in the conservation of the species."

73. "Coquetterie est un autre sentiment naturel, mais opposé à la pudeur, c'est un desir vague de plaire et de captiver l'attention de tous les hommes sans se fixer à aucun." Roussel, *Système physique et moral*, 173.

74. Le Doeuff, *The Philosophical Imaginary*, 149.

75. Ibid., 13. The analogy here is obviously to Lacan.

76. Ibid., 15.

77. Ibid.

78. For other "answers" to this discourse see, for example, *Opinions de femmes de la veille au lendemain de la révolution française*, with a preface by Geneviève Fraisse (Paris: Côté-femmes, 1989), and also *Qu'est-ce qu'une femme?* with a preface by Elisabeth Badinter (Paris: P.O.L., 1989).

79. Kofman, *The Enigma of Woman*, 14–15. What Kofman implies is that the intellectual woman, or the woman who participates in public culture, is constructed as "masculine"—as not-a-woman. Here is Cabanis on such women: "For the small number of women who can obtain true successes in these categories that are completely foreign to the faculties of their minds, [science, erudition, high art, politics, etc.] things are perhaps worse. In youth, in maturity, in old age, what will be the place of these ambiguous beings who are, properly speaking, of no sex?" Cabanis, *Physical and Moral Aspects*, 2:242. See Chapter 6 for further discussion of these non-women in eighteenth-century discourses.

80. Gerda Lerner argues that for centuries "individual women had to think their way out of patriarchal gender definitions and their constraining impact as though each of them were a lonely Robinson Crusoe on a desert island, reinventing civilization. Not for them the systematic story of progress . . . by which succeeding generations of male thinkers grew taller by standing 'on the shoulders of giants.' " *The Creation of Feminist Consciousness from the Middle Ages to 1870* (New York: Oxford University Press, 1993), 220. Lerner points to the situation of the woman intellectual unsupported by cultural institutions and thus unable to pass on her knowledge effectively. Only when learned women could cluster together in informal groups, which substituted for established institutions, could an alternative vision, or feminist imaginary, begin to take

root. With the recent institutionalization of women's studies, gender studies, and feminist theory in universities here and abroad, women's resistance to patriarchy is increasingly recuperated, narrativized, and theorized. Perhaps we are less intuitively, and more self-consciously, returning to earlier formulations, or in imagining ourselves original we may indeed be summarizing without knowing it. Our unconscious relation to a recent past (a past recent enough to share with us a *mentalité*) may become visible in the future, when contemplated by a third party.

2. The Mother's Imagination and the Fathers' Tradition

1. Roger de Piles, *Cours de peinture par principes*, intro. Thomas Puttfarken (Nîmes: Editions Jacqueline Chambon, 1990), 198.

2. This was her second pregnancy; her second daughter died soon after birth. The artist never mentions this in the text of the *Souvenirs*, and a note added in the 1869 edition clarifies the point.

3. "Laissez, laissez, dit la reine, vous êtes trop avancée dans votre grossesse pour vous baisser; et, quoi que je pusse dire, elle releva tout elle-même." Vigée-Lebrun, *Souvenirs*, 1:68.

4. "Quand il en vint à ces vers où l'éloge est si fort exagéré, et que j'entendais pour la première fois: Le Brun, de la beauté le peintre et le modèle, / Moderne Rosalba, mais plus brillante qu'elle, / Joint la voix de Favart au souris de Vénus, etc. L'auteur du *Warwick* me regarda: aussitôt tout le public, sans en excepter la duchesse de Chartres et le roi de Suède qui assistaient à la séance, se lève, se retourne vers moi, en m'applaudissant avec de tels transports que je fus prête à me trouver mal de confusion. Ces jouissances d'amour-propre, dont je vous parle, chère amie, parce que vous exigé que je vous dise tout, sont bien loin de pouvoir se comparer à la jouissance que j'éprouvai lorsque, au bout de deux années de mariage, je devins grosse. Mais ici vous allez voir combien cet extrême amour de mon art me rendait imprévoyante sur les petits détails de la vie; car, tout heureuse que je me sentais, à l'idée de devenir mère, les neuf mois de ma grossesse s'étaient passés sans que j'eusse songé le moins de monde à préparer rien de ce qu'il faut pour une accouchée. Le jour de la naissance de ma fille, je n'ai point quitté mon atelier, et je travaillais à ma Vénus qui lie les ailes de l'Amours, dans les intervalles que me laissaient les douleurs." Ibid., 1:57-58.

5. "Elle était à son secrétaire à deux heures après minuit, selon sa louable coutume. Elle dit, en griffonnant du Newton: *Mais je sens quelque chose!* Ce quelque chose était une petite fille, qui vint au monde beaucoup plus aisément qu'un problème. On la reçut dans une serviette; on la déposa sur un gros in-4°, et on fit coucher la mère pour la forme." *Les Oeuvres complètes de Voltaire*, ed. Theodore Besterman et. al. (135 vols.; Geneva: Institut et musée Voltaire, 1970), 95:154. For a discussion of Madame du Châtelet, see Elisabeth Badinter, *Emilie, Emilie, ou L'Ambition féminine au XVIIIe siècle* (Paris: Flammerion, 1983), and Erica Harth, *Cartesian Women: Versions and Subversions of Rational Discourse in the Old Regime* (Ithaca, N.Y.: Cornell University Press, 1992), 189–213.

6. Voltaire, *Oeuvres complètes*, 95:151.

7. Ibid., 95:155.

8. Ibid., 95:151.

9. "Madame de Verdun, ma plus ancienne amie, vint me voir le matin. Elle pressentit que j'accoucherais dans le journée, et, comme elle connaissait mon étourderie,

elle me demanda si j'étais pourvue de tout ce qui me serait nécessaire; à quoi je lui répondis d'un air étonné que je ne savais pas ce qui m'était nécessaire. —Vous voilà bien, reprit-elle, vous êtes un vrai garçon. Je vous avertis, moi, que vous accoucherez ce soir. —Non! non! dis-je, j'ai demain séance, je ne veux pas accoucher aujourd'hui. Sans me répondre, Madame de Verdun me quitta un instant pour envoyer chercher l'accoucheur, qui arriva presque aussitôt. Je le renvoyai, mais il resta caché chez moi jusqu'au soir, et à dix heures ma fille vint au monde." Vigée-Lebrun, *Souvenirs*, 1:58–59.

10. Simone de Beauvoir, *The Second Sex*, trans. and ed. H. M. Parshley (New York: Vintage Books, 1989), 707. "Instead of devoting herself generously to the work she undertakes, woman too often considers it as a mere adornment of her life; the book and the painting are merely some of her inessential means for exhibiting in public that essential reality: her own self. Moreover, it is her own self that is the principal—sometimes the unique—subject of interest to her: Madame Vigée-Lebrun never wearied of putting her smiling maternity on her canvases."

11. *Encore un Coup de Patte: Pour le dernier, ou Dialogue sur le Salon de 1787* (Paris, 1787). I consider Coup de Patte's writings in some detail in later chapters.

12. Paula Rea Radisich, "Qui peut définer les femmes? Vigée-Lebrun's Portraits of an Artist," *Eighteenth-Century Studies* 25 (Summer 1992): 452–54.

13. *Correspondance littéraire, philosophique et critique par Grimm, Diderot, Raynal, Meister, etc.* (Paris: Garnier Frères, 1880), ed. Maurice Tourneux, 15:525. See also Elie Catherine Fréron, "Salon de 1789," in *L'Année Littéraire* (Paris: Chez Mérigot, 1789), 16:227, and *Remarques sur les ouvrages exposées au Salon* (Paris, 1789), supplement, s.p.: "Une touche mâle en caractérise le grand mérite et prouve que cette Artist n'a pas seulement recours aux Graces, mais au génie, qui ne fait pas toujours société avec elles."

14. See, in particular, *La Morte de trois milles ans au Salon de 1783* (Paris, 1783). Collection Deloynes, 292:6.

15. Julie Plax has discussed the Greek Supper in "Elisabeth Vigée-Lebrun's Greek Dinner Party and the Two Faces of Classicism" (unpublished conference paper, presented as Associates of Art History Lecture, 1992).

16. Vigée-Lebrun, *Souvenirs*, 1:93.

17. Ibid., 1:85–88.

18. Marie-Hélène Huet, *Monstrous Imagination* (Cambridge, Mass.: Harvard University Press, 1993), esp. 1–77.

19. Ibid., 71–75. The example she gives is Benjamin Bablot, the king's physician and advisor at Châlons-sur-Marne, who in 1788 published his *Dissertation sur le pouvoir de l'imagination des femmes enceintes*.

20. *Monstrous Imagination*, 1.

21. Cited in ibid., 7.

22. Ibid.

23. "Pendant ma grossesse j'avais peint la duchesse de Mazarin, qui n'était plus jeune, mais qui était encore belle; ma fille avait ses yeux et lui ressemblait prodigieusement." Vigée-Lebrun, *Souvenirs*, 1:59.

24. Stafford, *Body Criticism*, 313–16. Reading Stafford also brought to my attention the importance of Lessing's *Laocöon* to the discussion of the portrait's relation to concepts of the maternal imagination.

25. Gotthold Ephraim Lessing, *Laocöon: An Essay on the Limits of Painting and Poetry*, trans. Ellen Frothingham (New York: Noonday Press, 1957), 10–11.

26. Ibid., 8–9.

27. Kofman, *The Enigma of Woman*, 52.

28. Ibid., 56.

29. Lichtenstein, *Eloquence of Color*, 120.

30. Wendy Leek discusses Ingres's association with Raphael in "Ingres Other-Wise," *The Oxford Art Journal* 9 (Winter 1986): 29–37.

31. Norman Bryson, *Tradition and Desire From David to Delacroix* (Cambridge: Cambridge University Press, 1984). Although I will not take up this aspect of Bryson's book, it is important to note that *Tradition and Desire* also refers to Harold Bloom's *The Anxiety of Influence: A Theory of Poetry* (New York: Oxford University Press, 1975).

32. Bryson, *Tradition and Desire*, 128.

33. Or rather to Kojève commenting on Hegel. The quotation Bryson choses from Kojève to exemplify "counter-presence" at work (quoted in ibid., 128–29) articulates Kojève's notion of Animal Desire. See Alexandre Kojève, *Introduction to the Reading of Hegel*, trans. James H. Nichols, Jr., ed. Allan Bloom (New York: Basic Books, 1969), 3–4. Human Desire, on the other hand, is always directed toward a nonnatural object, toward Desire itself: "Desire . . . is essentially different from the desired thing; something other than a thing, than a static and given real being that stays eternally identical to itself. Therefore Desire, directed toward another Desire, taken as Desire, will create, by the negating and assimilating action that satisifies it, an I essentially different from the animal 'I' " (Kojève, 4). Bryson's selected quotation also omits the significant point that Human Desire is interpersonal and social.

34. Bryson, *Tradition and Desire*, 129.

35. Ibid., 81. The analogy, of course, can only be inexact, given that in the Lacanian scheme acquiring and using language is fundamental to the shaping of every individual's identity. The artist comes to painting already sexed and acculturated (that is, having taken a place as a man or as a woman) in language. Also pointing to Lacan is Bryson's contention that, "When consciousness contemplates the world as presence, simply as a field of objects, it cannot describe a boundary within which it can be located: it is the sense of lack, of something being absent, that draws the line" (129). The "sense of lack" that "draws the line" evokes the Lacanian concepts of the lack-in-being and the crossed-through subject, as does his contention that "desire crystallises identity as this being, experiencing this lack: the human I is the I of a desire or of Desire" (ibid.).

36. Bryson, *Tradition and Desire*, 129.

37. This notion is explained in Jacques Lacan, "The mirror stage as formative of the function of the I as revealed in psychoanalytic experience," in *Ecrits*, trans. Allan Sheridan (New York: W. W. Norton, 1977), 1–7.

38. Lacan explains, "The demand for love can only suffer from a desire whose signifier is alien to it. If the desire of the mother *is* the phallus, the child wishes to be the phallus in order to satisfy this desire. Thus the division immanent in desire is already felt to be experienced in the desire of the Other, in that it is already opposed to the fact that the subject is content to present to the Other what reality he may *have* that corresponds to this phallus, for what he has is worth no more than what he does not have, as far as his demand for love is concerned, because that demand requires that he be the phallus." "The Signification of the Phallus," *Ecrits*, 289.

39. Ibid.

40. For an explication of the paternal function in relation to the law, desire, and the castration complex, see *Ecrits*, "The Subversion of the subject and dialectic of desire," esp. 310–11 and 318–24.

41. Lacan, "The Signification of the Phallus," *Ecrits*, 289.

42. Ibid., 285.

43. Grosz, *Jacques Lacan*, 71–72. Grosz derives this formulation from Lacan's statement that "to be the phallus, that is to say, the signifier of the desire of the Other" the woman will "reject an essential part of femininity, namely all her attributes, in the masquerade." Lacan, "The Signification of the Phallus," *Ecrits*, 290.

44. Michèle Montrelay, *L'Ombre et le nom: Sur la féminité* (Paris: Minuit, 1977), 64. She particularly develops this idea on pages 62–77.

45. Lacan writes, "In any case, man cannot aim at being whole, . . . while ever the play of displacement and condensation to which he is doomed in the exercise of his functions marks his relation as subject to the signifier. The phallus is the privileged signifier of that mark in which the role of the logos is joined with the advent of desire." "The Signification of the Phallus," *Ecrits*, 287.

46. Diana Fuss, *Essentially Speaking: Feminism, Nature and Difference* (London: Routledge, 1989), 8. For various perspectives on this debate, see "The Phallus Issue," Special Issue of *Differences* 4 (Spring 1992).

47. Jane Gallop, *The Daughter's Seduction: Feminism and Psychoanalysis* (Ithaca, N.Y.: Cornell University Press, 1982), 48–50. Reading together Lacan and Stephen Heath's reading of Lacan's 1972–73 seminar, *Encore*, Gallop posits that psychoanalysis is better read as a usable knowledge, one that "is not contained, but rather affords constant surprises," than one whose value lies in its possession and exchange. Gallop figures a feminist practice of undermining the Name-of-the-Father as infidelity—"the unfaithful reading strays from the author."

48. Bryson, *Tradition and Desire*, 74.

49. Ibid., 70.

50. Bryson goes much farther here than using psychoanalysis as an "orientation that may help in understanding the painting" (ibid., 70). Lacan is brought in to stand as the painting's meaning, and he argues that the "image exactly traces the negative consequences of the subject's insertion into language and gender" (ibid., 71).

51. Ibid., 73.

52. Here I am adapting an argument from Mary Ann Doane, *The Desire to Desire: The Woman's Film of the 1940s* (Bloomington: Indiana University Press, 1987), 11: "From this [Lacanian] point of view one might be led to believe that it is, in fact, disadvantageous to be a subject." But, she continues: "It is this illusion of a coherent and controlling identity which becomes most important at the level of social subjectivity. And the woman does not even possess the same access to the fiction as the man."

53. Carolyn Dean, *The Self and Its Pleasures: Bataille, Lacan, and the History of the Decentered Subject* (Ithaca, N.Y.: Cornell University Press, 1992), 56–57, 92–93.

54. Bryson, *Tradition and Desire*, 74.

55. Ibid., 70.

56. Dean, *The Self and Its Pleasures*, 58–97. And related to the decline of the family was the appearance of the New Woman, one of the "deviants" who threatened the return to normalcy after the war. Dean is interested in how female deviance came

to signify a crisis of male authority: "Countless satires and political tracts linked France's so-called loss of virility to depopulation and depopulation to feminism, to women's refusal of their designated social roles." Ibid., 59.

57. Dean, *The Self and Its Pleasures*, 86–95. Thus Lacan argued for this difference so that "father" remains the condition of normative identification regardless of the weaknesses (passivity) of real fathers, regardless of the lack of natural or scientific basis for his authority.

58. For an extended discussion of Rousseau, see Chapter 4.

59. On the conception of "father figures" during the French Revolution, see Lynn Hunt, *The Family Romance*, 17–52. Hunt also discusses father figures in relation to the "band of brothers," see especially 67–71.

60. This, of course, does not mean that David cannot be *read* through Lacanian theory. If I were to undertake such a reading I would not stress the "weakness" of the father's position. Where Bryson sees a "body who cannot sustain the weight of power" (*Tradition and Desire*, 70), I see a figure able to hold up three swords in a single grasp— and to hold them there immobilized in the center of the composition. Perhaps his knees are bent to support this weight, but his pose is hardly unstable (71). His one body carries more visual weight than the three sons combined, and in the ascending chore-ography of hands, his is held the highest. The three swords do not—like some trini-tarian phallus—so much stand "in place of the father whose strength has gone" (ibid.), they are rather supported by the father—or at least by his position—in the order of the painting. The position of the father thus underwrites the phallic signifier(s). The emblems of power circulate among the men, and their repeated poses suggest to me that they are all taking the same position—and not straying over to the feminine, ob-jectified side. For Lacan, it was the failure to identify symbolically with the paternal function that led to male homosexuality (Dean, *The Self and Its Pleasures*, 89–90). Not only is a symbolic identification with the father figured formally, but the father figure is a visual barrier that prevents the sons from joining the women; it is he who inexo-rably divides the composition. The father thus forecloses the sons' desire to identify with the (m)Other side. The women, by the way, do "speak" (even if they only do so by posturing in feminine masquerade); their expressive bodies speak the lassitude of grief. But is this all we can say for them? What do we imagine the woman saying to the two children, whispering in their ears? Is she praising or ridiculing the male gestures? What do we imagine the two women are communicating to one another as they sit head to head? (After all, it is we—the viewers, critics, interpreters, art historians—who speak for the image.) Are they cowed by their oppression, or are they so bored by male posturing that they have gone to sleep? It seems to me no more perverse to read the oppressed women as mocking the male masquerade (as I would like) than to read the male figures as oppressed by their power (as Bryson suggests).

61. Bryson, *Tradition and Desire*, 81.

62. Bryson's argument here is reminiscent of Julia Kristeva, for whom the avant-garde transgressor is male. Only men occupy this position because only they can ac-quire a stable position within the symbolic order and subject the symbolic to its own possibilities of subversion. For a feminist critique of Kristeva, see Grosz, *Jacques Lacan*, 163–66.

63. As Diana Fuss has written of Lacan, "Men (specifically male mystics for La-can) can also occupy the subject-position 'woman.' . . . But, importantly, the converse

is not true for Lacan: not all speaking beings are allowed to inscribe themselves on the side of the all, since only men have penises which give them more direct access to 'the phallic function' " (*Essentially Speaking*, 11–12). Tania Modleski has shown in her recent *Feminism without Women: Culture and Criticism in a "Postfeminist" Age* (London: Routledge, 1991), 3–12, how male feminist critics sometimes appropriate "femininity" and even "feminism" while continuing to oppress women.

64. Judith Butler, "The Lesbian Phallus," *Differences* 4 (Spring 1992): "Clearly the Phallus operates in a privileged way in contemporary sexual cultures, but that operation is secured by a linguistic structure or position which is not independent of its perpetual reconstitution. . . . If the Phallus is a privileged signifier, it gains that privilege through being reiterated. And if the cultural construction of sexuality compels a repetition of that signifier, there is nevertheless in the very force of repetition, understood as resignification or recirculation, the possibility of de-privileging that signifier" (162). Butler is not particularly concerned with the repetition of phallic authority in literary or art criticism, but her analysis can be extended to cover the effect produced in those arenas. Butler argues that the distinction between the symbolic and the imaginary must be deconstructed, and that the Phallus is "an imaginary effect (which is reified as the privileged signifier of the symbolic order)" (161).

65. Bryson, *Tradition and Desire*, 136.

66. Ibid., 133.

67. Because psychoanalytic theory—in which man wields the gaze and woman is object of the gaze—and the traditional polarities: active/passive; subject/object; masculine/feminine are imbricated with one another, Bryson can move from Ingres's display of woman as object-to-be-seen to a psychoanalytic reading in which woman represents the "gap" or the "lack" within tradition, which he has collapsed with language. The cut between signifier and signified that characterizes language in a Lacanian scheme is associated with castration and with the (little boy's) ability to imagine the absence or lack necessary to signification. My point here is not about this move, per se, but about the way Bryson analyzes Ingres's relation to tradition solely on the basis of these theoretical constructs without a consideration of historical practices that might contest or alter the theoretical assumptions.

68. Richard Shiff, "Representation, Copying, and the Technique of Originality." *New Literary History* 15 (1983–84): 337–38.

69. As quoted by Shiff, ibid., 343.

70. "Thus the Oedipal identification is that by which the subject transcends the aggressivity that is constitutive of the primary subjective individuation." Lacan, *Ecrits*, 23.

71. Judith Butler has recently discussed the thorny problem of identification in *Bodies that Matter*, 102–5. For a consideration of this aspect of Butler, see Chapter 6.

72. Lacan, *Four Fundamental Concepts*, 107.

73. Ibid., 107.

74. Le Doeuff, *The Philosophical Imaginary*, 2–6; 14. For an insightful discussion of this slippery concept see Elizabeth Grosz, *Sexual Subversions: Three French Feminists* (Sidney: Allen and Unwin), 185–97.

75. Le Doeuff, *The Philosophical Imaginary*, 18.

76. Ibid., 18.

77. Ibid., 19.

78. Ibid., 1–3.

79. Image here does not specifically mean visual image, but figured description or narrative inserted into the analytical text.

80. Lichtenstein, *The Eloquence of Color*, 37.

81. Ibid., 45.

82. Ibid., 123.

83. Ibid., 124.

84. Le Doeuff, *The Philosophical Imaginary*, 2.

85. Ibid., 3.

86. Ibid., 19.

87. In Pliny's classical story of artistic rivalry, Zeuxis and Parrhasios compete to see who can make the most resembling image. Zeuxis paints grapes that attract the birds. But Parrhasios wins the contest by painting a veil so lifelike that Zeuxis tries to lift it.

88. On the paradoxes of this theory and on the historical interpretation of the story of Zeuxis and Parrhasios, see Lichtenstein, *The Eloquence of Color*, 172–85. Lacan presents a different and provocative analysis of *trompe l'œil* and of Pliny's tale (*Four Fundamental Concepts*, 112).

89. Huet, *Monstrous Imagination*, 28-30.

90. It is interesting that in her *Souvenirs* (1:165) Vigée-Lebrun defends Raphael against the charges of libertinism, and shows how the Fornarina became his wife. Thus she legitimates not only Raphael's presentation of the Fornarina as the Madonna, but also her associating herself with the Fornarina.

91. Martin Rosenberg, "Raphael's *Transfiguration* and Napoleon's Cultural Politics," *Eighteenth-Century Studies* 19 (Winter 1985–86): 187.

92. The opinion that women are naturally disposed to subjects that require grace is expressed in Salon pamphlets such as *Le Triumvirat des arts, ou Dialogue entre un peintre, un musicien & un poëte, sur les tableaux exposés au Louvre. Année 1783. Pour servir de continuation au Coup de Patte & à la Patte de Velours* (Paris, 1783), Collection Deloynes, 305:28.

3. The Law, the Academy, and the Exceptional Woman

1. The Greek maiden was one of many fictive salon visitors invented by critics in the 1770s and 1780s. She appears in a pamphlet entitled, *La Morte de trois milles ans au Salon de 1783*, Collection Deloynes, 286. For an excellent discussion of these "carnavalized" Salon pamphlets, see Bernadette Fort, "Voice of the Public: Carnavalization of Salon Art in Pre-Revolutionary France," *Eighteenth-Century Studies* 22 (Summer 1989): 368–94.

2. "Si je suis inventrice, répondit-elle, c'est donc des portraits à la *Silhouette;* car je viens d'entendre nommer ainsi un *profil noir*, tracé d'après l'ombre d'une jeune personne. C'est positivement le même procédé que l'amour m'avoit jadis inspiré, & pour lequel vous affectez de m'admirer" (*La Morte*, 6–7). That this comment refers directly to Vigée-Lebrun is suggested by a poem written by her brother Louis Vigée, and published in 1783 as "Epître à ma sœur." The appropriate lines read: "apprends-moi parquelle magie / tu sais dans cet art si vanté / *qu'amour a, dit-on, enfanté,* / te frayer la route hardie / qui mène à l'immortalité" (my emphasis). Vigée-Lebrun, *Souvenirs*, 1:21.

3. Ibid., 23.

4. Although I cite this pamphlet only to suggest some of my major themes, *La Morte* is an interesting text that reflects on both the credibility and origin of its story/dream. On the one hand, the correspondent suggests he is merely the medium, or the body for a dream originating elsewhere, and on the other, he deems himself the mind that fabricated the fiction. The entire pamphlet, moreover, resonates with the myths of both Dibutadis and Pygmalion.

5. "En ouvrant la séance, *Madame Le Brun*, reçue Académicienne à la dernière assemblée, . . . a pris séance en cette qualité." Anatole de Montaiglon, ed., *Procès-verbaux de l'Académie Royale de Peinture et de Sculpture* (11 vols.; Paris: Charavay Frères, 1889) 9:158.

6. As Montaiglon notes, "Il y avait d'abord cette phrase: 'Et qui a fait aporter de ses ouvrages dont la Compagnie a été satisfaite,' mais elle a été effacée et surchargée de ratures." 9:158. In all quotations from the *Procès-verbaux* in French, I preserve the orthography of Montaiglon's text.

7. This did not always mean that they placed the painter in the rank suggested by the subject of the painting. The obvious exception is the case of Greuze, who presented his *Septimus Severus Rebuking Caracalla* (Paris, Musée du Louvre) for admission into the Academy in 1769. The academicians accepted Greuze, but ranked him as a genre painter based on his previous work. They found his *Septimus* an inadequate history painting.

8. Actually, the record shows that they chose on that day as her *morceau de réception* her portrait of Pajou sculpting the bust of Lemoyne (Paris, Musée du Louvre). They left to d'Angivillier the choice of the first reception piece—that is, the *morceau de agréement*. The record indicates that d'Angiviller was asked to select that portrait from among those Madame Guiard presented to the academicians on the day of her admission. Montaiglon, *Procès-verbaux*, 9:154.

9. *Correspondance littéraire*, 13:440. Vigée-Lebrun's activities were widely known long before 1783. At 19 she was a member of the Académie de Saint-Luc de Paris (her father, Louis Vigée, had also belonged to this guild). She showed at its exhibition in 1774 and received very favorable notices in the press. In 1775, the young artist presented portraits of Fleury and La Bruyère to the Académie française, and the flattering letter of thanks she received from d'Alembert was published both in the *Mercure de France* and *Mémoires secrets*. In 1779, 1781, 1782, and 1783, she entered works in the Salon de la Correspondance, an enterprise founded by Pahin de la Blancherie to provide a Parisian meeting place for the "citizens" of the Republic of Arts and Letters. She was called to paint the queen from life in 1779. By 1780, Vigée-Lebrun's talents, beauty, and wit had won her influential supporters, such as the Comte de Vaudreuil, the Duchesse de Polignac, the finance minister Calonne, and other members of the Court whom she often entertained at suppers. She became, most importantly, a favored painter of Marie-Antoinette.

10. "Peu de temps après mon retour de Flandre, en 1783, le portrait dont je vous parle et plusieurs autres de mes ouvrages décidèrent Joseph Vernet à me proposer comme membre de l'Académie royale de peinture. M. Pierre, alors premier peintre du Roi, s'y opposait fortement, ne voulant pas, disait-il, que l'on reçût des femmes, et pourtant madame Vallayer-Coster, qui peignait parfaitement les fleurs, était déjà reçue; je crois même que madame Vien l'était aussi. Quoi qu'il en soit, M. Pierre, peintre fort

médiocre, car il ne voyait dans la peinture que le maniement de la brosse, avait de l'esprit; de plus, il était riche, ce qui lui donnait les moyens de recevoir avec faste les artistes, qui dans ce temps étaient moins fortunés qu'ils ne le sont aujourd'hui. Son opposition aurait donc pu me devenir fatale, si dans ce temps-là tous les vrais amateurs n'avaient pas été associés à l'Académie de peinture, et s'ils n'avaient formé, en ma faveur, une cabale contre celle de M. Pierre. C'est alors qu'on fit ce couplet:

> A MADAME LE BRUN …
> Au salon ton art vainqueur
> Devrait être en lumière.
> Pour te ravir cet honneur,
> Lise, il faut avoir le coeur
> De Pierre, de Pierre, de Pierre.

Enfin je fus reçue. M. Pierre alors fit courir le bruit que c'était par ordre de la cour qu'on me recevait. Je pense bien en effet que le Roi et la Reine avaient été assez bons pour désirer me voir entrer à l'Académie; mais voilà tout. Je donnai pour tableau de réception la *Paix qui ramène l'Abondance*. Ce tableau est aujourd'hui au ministère de l'Intérieur." Vigée-Lebrun, *Souvenirs*, 1:76–78.

11. The record of the vote on the admission of Mme Guiard taken at the same meeting shows M. Pierre "absent par indisposition." *Nouvelles Archives de l'Art Français* 6 (1890): 184.

12. "Je suplie en conséquence Votre Majesté de vouloir bien me donner ses ordres, et je la suplie aussi de vouloir bien borner à quatre le nombre des femmes qui pourront à l'avenir être admises à l'Académie." Montaiglon, *Procès-verbaux*, 9:157.

13. "L'Académie a de plus délibéré qu'il sera fait, de la part de l'Académie, une lettre de remerciement à M. d'Angiviller d'avoir conservé les droits de l'Académie et la force de ses Statuts, et d'avoir fixé le nombre des Académiciennes à quatre." Ibid., 9: 153.

14. "Plusieurs Damoiselles qui se sont appliquées à la Peinture avoient dessein de se présenter pour estre reçeues Académiciennes." Montaiglon, *Procès-verbaux*, 4:34.

15. "L'Académie ayant considéré que, quoiqu'Elle se fasse un plaisir d'encourager le talent dans les femmes en en admettant quelques-unes dans son Corps, néanmoins ces admissions, étrangères en quelque façon à sa constitution, ne doivent pas être trop multipliées; Elle a arrêté qu'Elle n'en recevroit point au delà du nombre de quatre, si ce n'est cependant au cas où des talens extraordinairement distingués engageroient l'Académie à désirer, d'une voix unanime, de les couronner par une distinction particulière. L'Académie au reste ne prétend pas s'engager à remplir toujours le nombre de quatre, se réservant de ne le faire qu'autant qu'Elle s'y trouvera déterminée par des talens véritablement distingués." Ibid., 8:53.

16. For a broad and provocative discussion of the "fearful disdain of mixture," see Stafford, *Body Criticism*, 211–79.

17. "En la qualité d'Académicienne, sans que sela puise à l'avenir tirer à aucune concéquance." Montaiglon, *Procès-verbaux*, 2:175–76.

18. Ibid., 4:303.

19. Ibid., 4:328.

20. Ibid., 7:41.

21. On the Academy of Sciences, see Schiebinger, *The Mind Has No Sex?* 1–36.

22. "Cejourdhuy, l'Académie estant assemblée extraordinairement, sur ce qui a esté représanté qu'il est du devoir et de l'honneur de l'Académie, en suivant l'intansion du Roy quy est d'espandre sa grasse sur tous ceux quy excellent dans les artz de Peinture et Sculpture, d'en faire part à ceux quy seront jugéz dignes sans avoir égard à la déférance du sexe, Monsieur *Le Brun* ayant présanté un tableau de fleurs faict par Mademoiselle *Girardon*, toute la Compagnie, touché de l'estime dudit ouvrage et cognoissant le mérite de cette damoiselle, a résolu de luy donner la calité d'Académicièe, dont luy sera expédié la Lestre au premier jour." Montaiglon, *Procès-verbaux*, 1:222–23.

23. I am indebted to Nicholas Mirzoeff for this observation on Colbert's practice.

24. Letters seem to have been discontinued for male academicians after the Abraham Bosse scandal of the 1660s, which concerned the contents of his letter of membership. For this information, and many insightful comments on academic practice, I am grateful to Nicholas Mirzoeff.

25. Harriet Bronson Applewhite and Darlene Gay Levy, "Gender, Ceremony, and National Consciousness: Women and Oathtaking in Revolutionary Paris," *Transactions of the Seventh International Congress on the Enlightenment*, 3 vols., published in *Studies in Voltaire and the Eighteenth Century* 265 (Oxford: Siden Press, 1989), 3:1558.

26. Compare, for example, the entries for Nicholas Desportes and Madame Vien, received the same day in 1757. For Desportes: "Les voix prises à l'ordinaire, l'Académie a reçu et reçoit ledit Sr *Desportes* Académicien, pour avoir séance dans ses assemblées et jouir des privilèges, honneurs et prérogatives attribuez à cette qualité, à la charge d'observer les Statuts et Règlements de l'Académie, ce qu'il a promis en prêtant serment entre les mains de M. de *Silvestre*, Ecuyer, Premier Peintre du Roy de Pologne, Directeur et Ancien Recteur." And for Mme Vien: "L'Académie, après avoir pris les voix à l'ordinaire et reconnu sa capacité, l'a reçue et reçoit Académicienne, afin de jouir des privilèges, honneurs et prérogatives attribués à cette qualité, sans néantmoins tirer à conséquence, et Elle a ordonné que les lettres de provision lui seront expédiées, conformément à ce qui a été practiqué en pareille occasion." Montaiglon, *Procès-verbaux*, 7:41.

27. Fraisse, *La Raison des femmes*, 49-62.

28. "Madame Guyard, assise à côté de moi, fit un discours très-bien motivé sur l'admission des femmes artistes à l'Académie, et prouva que le nombre indéterminé devroit être le seul admissible." Jean-Georges Wille, *Mémoires et Journal de J. G. Wille, graveur du Roi*, ed. Georges Duplessis (2 vols.; Paris: Jules Renouard, 1857), 2:268.

29. "Cet article, malgré l'opposition de M. Lebarbier, fut approuvé et passa au scrutin, tout aussi bien que le premier." Ibid.

30. "Parce que nous ne trouvons pas convenable que des *femmes* viennent s'immiscer dans un travail qui leur est étranger, n'étant question que de rédiger des Statuts, qui ne les regardent point du tout puisqu'elles n'y sont pas soumises, n'ayant jamais fait serment d'y obéir." Montaiglon, *Procès-verbaux*, 10:80–81.

31. "Sa Majesté m'a fait l'honneur de me demander s'il n'y avoit pas moyen, sans détruire la loi, de faire admettre Madame *Le Brun* dans cette Compagnie, qu'il est intéressant de soutenir dans toute la rigueur des Statuts, surtout depuis que Votre Majesté a accordé la liberté aux Arts. J'ai eu l'honneur de lui répondre que la Protection dont elle honoroit la Dame *Le Brun* tomboit sur un sujet assez distingué pour qu'une exception en sa faveur devint plutôt une confirmation qu'une infraction de la loi si elle

étoit motivée sur cette respectueuse Protection, et que Votre Majesté voulût bien l'autoriser par un ordre formel." Ibid., 9:157.

32. Ibid., 9:155.

33. "Fondée sur un aussi puissant motif que celui de la protection de la Reine, étoit bien plutôt une confirmation qu'une infraction de la loi." Ibid.

34. "De veiller plus attentivement que jamais à ce qu'aucun de ses Membres ne s'écarte d'une loi aussi honorable pour les Arts et pour ceux qui les cultivent." Ibid., 9: 156.

35. "Dans les Statuts, donnés par Louis XIV à l'Académie de Peinture, il est deffendu à tout Artiste de faire le commerce de tableaux, soit directement, soit indirectement. Ce Règlement a été confirmé par Votre Majesté de la manière la plus authentique." Ibid.

36. In his letter to Pierre, for example, d'Angiviller cites the Statutes that "interdit, de la manière la plus précise, à tous les Membres de l'Académie le commerce de tableaux, soit directement, soit indirectement." He assures the academicians that the king has affirmed a law "honorable" for the arts, one that preserves the "considération que le Roi a bien voulu leur rendre et leur assurer par sa déclaration du mois de Septembre 1776," and, as we have seen, he concludes that letter with a call for greater vigilance in enforcing the law. Ibid., 9:155–56. The minutes of the Academy stress that care has been taken to conserve "en même temps les Statuts de l'Académie dans toute leur force" and that d'Angiviller had brought to the attention of the king "l'article des nouveaux Statuts, qui interdit, de la manière la plus précise, à tout Membre de l'Académie le commerce de tableaux." Ibid., 153.

37. "Vous savez, Monsieur, qu'une de mes premières vues, lorsque Sa Majesté m'eut confié l'administration de ses Bâtimens, fut de procurer à la Peinture et à la Sculpture la liberté dont elles auroient toujours dû jouir, comme tenant un des principaux rangs parmi les Arts libéraux." Ibid., 8:281–82.

38. Thomas Crow, for example, presents this argument when he writes, "The exclusionary energy of the [Academy] was directed at other artists who might challenge its various monopolies, but did not extend to any conformist compulsion toward artists of the most diverse kinds within its ranks. What it wanted to monopolize, to put it simply was talent, and thus to prevent the *Maîtrise* from re-establishing a claim to priority on any artistic level." *Painters and Public Life in Eighteenth-Century Paris* (New Haven: Yale University Press, 1985), 134. For an excellent consideration of art institutions in old-regime France, see Reed Benhamou, *Public and Private Art Education in France*, published as an edition of *Studies on Voltaire and the Eighteenth Century* 308 (1993).

39. "Les arts nobles de peinture et de sculpture sont confondus dans l'ordre commun avec ceux d'appliquer une couche de couleur sur un lambris ou sur un mur et que, sans un acte particulier de l'autorité royale, les Zeuxis et les Phidias, les Raphaël et les Michel-Ange, s'ils revenaient parmi nous, seraient réduits à se faire immatriculer dans une communauté composée pour la plus grande partie, de peintres d'impression ou de brocanteurs et de marchands de tableaux." As quoted in Jacques Silvestre de Sacy, *Le Comte d'Angiviller, dernier Directeur Général des Bâtiments du Roi* (Paris: Plon, 1953), 121. Again, the heterogeneity of this motley mix recalls Stafford's discussion of the disdain for composites.

40. Whereas d'Angiviller is primarily concerned with maintaining the nobility

and liberalness of the visual arts, the students of the Academy are more concerned with maintaining their freedom, by which is meant the right to practice painting and sculpture without belonging to or paying dues to the *Maîtrise*. In 1775 they contest the right of the *Maîtrise* to hinder them from freely practicing painting and sculpture while awaiting official admission to the Académie Royale. However, they also seized on the disdain for mixing with commercial enterprise when they protested "becoming the prey of a community of merchants." Silvestre de Sacy, *Le Comte d'Angiviller*, 121.

41. A.-J.-L. Jourdan, F. A. Isambert, and Decrusy, eds., *Recueil général des anciennes lois françaises depuis l'an 420 jusqu'à la Revolution de 1789* (29 vols.; Paris: 1882–1933) 23:372–75.

42. What Turgot changed, according to Sewell, was not the formal definitions, but the metaphysical assumptions. William H. Sewell, Jr., *Work and Revolution in France: The Language of Labor from the Old Regime to 1848* (Cambridge: Cambridge University Press, 1980), 65.

43. Jacques Rancière, *The Nights of Labor: The Workers' Dream in Nineteenth-Century France*, trans. John Drury, intro. Donald Reid (Philadelphia: Temple University Press, 1989), 5–6.

44. Ibid., 22.

45. Jules Flammermont, *Remonstrances du Parlement de Paris* (3 vols.; Paris: Imprimerie Nationale: 1898) 3:347–48.

46. "Il est de la plus grande importance de maintenir une loi qui contribue à la gloire des Arts, et, ce qui est *bien plus important*, les soutient dans un païs où ils sont si utiles et si nécessaires pour le commerce avec l'étranger." Montaiglon, *Procès-verbaux*, 9:156.

47. Mme de Coicy, *Les Femmes comme il convient de les voir, ou Apperçu de ce que les femmes ont été, de ce qu'elles sont, et de ce qu'elles pourroient être* (2 vols.; Paris and London: Chez Bacot, 1785), 2:61–71.

48. Rancière, *The Nights of Labor*, 6.

49. In the new Statutes given to the Academy after the restructuring of the *Maîtrise*, however, painting and sculpture are still tied to the goal of improving national commerce: "Ces mêmes Arts contribuent encore à l'avantage ainsi qu'à la perfection de la plupart des Arts d'industrie, et à rendre plusieurs branches de commerce plus étendues et plus florissantes." The liberal arts of painting and sculpture thus both contribute to the glory of the nation and help keep industry and commerce flourishing. Montaiglon, *Procès-verbaux*, 8:284.

50. "Il est difficile de parcourir tant d'ouvrages charmants de Mme Le Brun, sans se rappeler avec humeur toutes les tracasseries, toutes les petites persécutions qui lui fermèrent longtemps l'entrée de l'Académie et qui n'ont cédé enfin qu'au pouvoir de l'autorité. Le titre d'une exclusion si injuste n'avait point d'autre motif que l'état de son mari, l'un de nos plus fameux marchands de tableaux, mais l'Académie trouvait les intérêts de son corps si essentiellement compromis par cette circonstance que, pour se garantir à jamais d'une influence si dangereuse, elle avait délibéré de ne plus agréer aucune femme, quelque distingués que fûssent sont talent et ses ouvrages." *Correspondance littéraire*, 13:440.

51. Andrew McClellan, *Inventing the Louvre: Art, Politics, and the Origins of the Modern Museum in Eighteenth-Century Paris* (Cambridge: Cambridge University Press, 1994), 67.

52. In relation to d'Angiviller, I evoke Rousseau in anticipation of my later argument that his thinking about issues of gender coincided with, and may have shaped in a direct way, the attitudes of the Academy's director, as well as those expressed by many of Vigée-Lebrun's critics.

53. On Vallayer-Coster and her relations with d'Angiviller, see Marianne Roland-Michel, *Anne Vallayer-Coster, 1744–1818* (Paris: C.I.L., 1970), 21–31. In particular, d'Angiviller took great pains to have a space in the Louvre rebuilt for the artist. Vallayer-Coster seems to have come from a more elevated background than Vigée-Lebrun. Her father was a goldsmith and head of an atelier called La Croix de Saint-Louis. Her maternal grandfather was director of the Greffes à la Ferme Générale. She married Jean-Pierre Silvestre Coster, an avocat au Parlement and receveur général du tabac. Her marriage contract (reproduced ibid., 264) was signed by Marie-Antoinette (as protector), by Pierre, by the Comte and Comtesse de la Ferté, and by the Marquise de Véry. She enjoyed considerable favor with Marie-Antoinette (in many ways more than Vigée-Lebrun). Unlike Vigée-Lebrun, she had the support of Pierre. Evidence of her modest demeanor is contained in several contemporary accounts cited by Roland-Michel. Dupont de Nemours, for example, wrote in 1779, "Mlle Vallayer réunit les grâces de son sexe à la timidité, qui est souvent une grâce de plus, et a un talent plus grand qu'elle n'ose le croire" (56). Following her reception into the Academy, the engraver Wille noted in his journal, "cette demoiselle, qui prit sa place après les remerciements usités, avec autant de modestie qu'elle est habile, aussi n'eut elle pas une seule voix contre elle au scrutin" (42).

54. Silvestre de Sacy, *Le Comte d'Angiviller*, 101–2.

55. Montaiglon, *Procès-verbaux*, 8:285.

56. "On dit, et je le crois, qu'elle ne se mêle pas de commerce." Ibid., 9:156.

57. "Toute Artiste, Membre de l'Académie, qui fera commerce de tableaux, dessins, matières et meubles destinées à la mecanique des arts, ou se mettra en société avec des marchands brocanteurs, sera exclu de l'Académie." Ibid., 8:299.

58. Even if it could be proven that Vigée-Lebrun did, in fact, mix in the commerce of her husband, that fact would be irrelevant to the argument I am pursuing. Here I am concerned with the specific case d'Angiviller makes *in these documents*, and what that case suggests of attitudes toward and assumptions about women, especially in the larger social structures.

59. "La Dame *Le Brun*, femme d'un Marchand de tableaux, a un très grand talent et seroit depuis longtemps de l'Académie sans le commerce qui fait son mari. On dit, et je le crois, qu'elle ne se mêle pas de commerce, mais en France une femme n'a pas d'autre état que celui de son mari." Montaiglon, *Procès-verbaux*, 9:156.

60. Profession is only one part of *état* in this sense, as Christine Adams has recently shown in her study of the Lamothe family. She also demonstrates that family members who perceived themselves to share the same *état* could have different professions. See "Defining *Etat* in Eighteenth-Century France: The Lamothe Family of Bordeaux." *Journal of Family History* 17 (1992): 25–45.

61. Planiol is here repeating a longstanding definition of the term. See Paul Robert, *Le Grand Robert: Dictionnaire de la langue française*, 2d ed. augmented by Alain Rey (9 vols.; Paris: Le Robert, 1985), 4:174. Marcel Planiol, *Traité élémentaire de droit civil*, 11th ed. (3 vols.; Paris: Librairie générale du droit et du jurisprudence, 1928–31), 1:168.

62. "Hommes plus qu'ingrats, qui flétrissez par le mépris les jouets de vos passions, vos victimes! c'est vous qu'il faut punir des erreurs de notre jeunesse; vous et vos magistrats, si vains du droit de nous juger et qui nous laissent enlever, par leur coupable négligence, tout moyen honnête de subsister. Est-il seul état pour les malheureuses filles?" Beaumarchais, *Le Mariage de Figaro*, in *La Trilogie de Figaro* (Paris: Gallimard, 1966), 266. Suzanne Pucci has given a slightly different reading to Marceline's statement, but one that responds to the broader meaning of the term, which I explicate below. See Suzanne Pucci, "The Currency of Exchange in Beaumarchais' *Mariage de Figaro*," *Eighteenth-Century Studies* 25 (Fall 1991): 77.

63. Turgot's decree refers to guilds as institutions that did not allow the indigent to live from their work and "qui repoussent un sexe à qui sa foiblesse a donné plus de besoins et moins de ressources, et semblent, en les condamnant à une misère inévitable, seconder la séduction et la débauche." Jourdan, Isambert, and Decrusy, *Recueil général des anciennes lois*, 23:375.

64. Montaiglon, *Procès-verbaux*, 9:152–53.

65. Joseph Pothier, *Traité de la puissance du mari sur la personne et les biens de la femme*, in *Oeuvres de Pothier*, ed. M. Dupin (Paris: Chasseriau Libraire, 1823), 6:8. See also, Daryl M. Hafter, "L'Education politique des femmes: Création ou valeur recurrente?" in *La Revolution française et les processes de socialisation de l'homme moderne* (Paris: IRED, 1989), 447–48.

66. Jourdan, Isambert, and Decrusy, *Recueil général des anciennes lois*, 24:77–78.

67. Michael Sonenscher, *Work and Wages* (Cambridge: Cambridge University Press, 1989), 66–67; Daryl M. Hafter, "Artisans, Drudges, and the Problem of Gender in Pre-Industrial France," in *Science and Technology in Medieval Society*, ed. Pamela O. Long, in *Annals of the New York Academy of Sciences* 441 (1985): 71–87. See also, Reed Benhamou, "The Verdigris Industry in Eighteenth-Century Languedoc: Women's Work and Women's Art," *French Historical Studies* 16 (Spring 1990): 560–75.

68. Three distinctions are actually in operation here. First, the distinction between the liberal and mechanical arts, whereby the liberal arts were the more intellectual, requiring both head and hand, but more head. The mechanical arts were *arts* because they required some intelligence and skill, but they relied more completely on physical labor. Below both of these were activities that were not arts at all, for they required *only* hand. Such labor was undertaken by *gens de bras*. The distinction d'Angiviller is directly concerned with is that between the liberal and manual arts.

69. Sewell, *Work and Revolution*, 22.

70. Ibid.

71. *Oeuvres complètes*, 4:698. For the French, see above, Introduction, n. 1.

72. "L'état de la femme est-il moins d'être mère, et n'est-ce pas par des loix générales que la nature et les moeurs doivent pourvoir à cet état?" Ibid., 699.

73. "Terme de jurisprudence: Etat des personnes, l'ensemble des qualités juridiques d'une personne, de ses droits et de ses obligations. Qualité à raison de laquelle une personne exerce un droit ou accompli une obligation. Etat de mineur, de femme mariée. Etat civil, condition d'une personne dérivant des actes qui constatent les rapports de parenté, de mariage, et les autres faits de la vie civile." Emile Littré, *Dictionnaire de la langue française* (7 vols.; Paris: J. J. Pauvert, 1956–58), 3:1097.

74. "C'est la situation d'une femme en puissance de mari. Cet *état* a cela de singulier, que la femme ne peut s'obliger sans le consentement et autorisation de son mari;

elle ne peut pareillement entrer en jugement sans être autorisée de lui, où a son refus par justice, s'il y a lieu de l'accorder." "Etat d'une femme," in Diderot and D'Alembert, *Encyclopédie*, 6:28.

75. "Mais les femmes sont exclues, par leur état, de toute espèce de gloire; et quand par hasard il s'en trouve quelqu'une née avec une âme assez élevée, il ne lui reste que l'étude pour la consoler de toutes les exclusions et de toutes des dépendances auxquelles elle se trouve condamnée par état." Marquise du Châtelet, *Réflexions sur le Bonheur* in *Lettres inédites de Madame le Marquise du Chastelet* (Paris: 1806), 358.

76. Under the Old Regime, women had all the negative obligations of citizenship: in regard to taxes, they did not pay the *taille*, but were subject to "impositions," "corvées publiques" and other real or personal taxes. Although they could not give witness to a will or notarial act, they were subject to the same penalties as any other felon if they committed crimes and, in addition, were subject to penalties men were not in civil matters, such as adultery, and in criminal matters, such as prostitution. See "Femme," in *Répertoire de jurisprudence* (Paris: Chez Visse, 1784), 7:324. The relation of women authors to the law and to their profession was somewhat different than that of women painters, primarily because of the different history and status of writing and its different position vis-à-vis guilds. For a discussion of women writers and their relation to the legal codes, see Carla Hesse, "Reading Signatures: Female Authorship and Revolutionary Law in France, 1750–1850," *Eighteenth-Century Studies* 22 (Summer 1989): 469–87.

77. Pothier, *Traité de la puissance du mari*, 6:1.

78. Rousseau deemed women incapable of developing the morality necessary in civil society because they could not control their unlimited (sexual) passions through reason. For a more specific discussion of Rousseau and women see Chapter 4.

79. Luce Irigaray, *Speculum of the Other Woman*, trans. Gillian Gill (Ithaca, N.Y.: Cornell University Press, 1985), 121. She cites Engels's argument that the first class opposition coincides with the development of an antagonism between man and woman in monogamous marriage, and the first class oppression was that of the female sex by the male (123). Here the concept of *état* as related to the division of society returns via the back door.

80. Carole Pateman, *The Sexual Contract* (Stanford, Calif.: Stanford University Press, 1988), 92–115. In reading Locke's *The Two Treatises of Government*, Pateman stresses that for Locke a man—or rather a father—became a monarch through the consent of his *sons*, not through the simple fact of being a father. Pateman wonders about the mother, and finds elsewhere in Locke's text a first society between man and wife, which had as its basis a "voluntary compact." Pateman wants to know the content of that compact; did women simply give away their rights to their husbands and sons? Locke is vague. He merely assumes a "natural" foundation for the wife's subjugation, elaborating commonly held ideas about man's greater strength of body and mind. Pateman demonstrates how this sexual contract supports not just Locke's social contract, but all major statements of the idea from Hobbes to Freud.

81. David Williams, "The Politics of Feminism in the French Enlightenment," in *The Varied Pattern: Studies in the Eighteenth Century*, ed. David Williams and Peter Hughes (Toronto: A. M. Hakkert, 1971), 334.

82. Ibid., 343–45.

83. The first entry reads that the director wanted the Academy to enforce article

24 of the Statutes of 1777 (Montaiglon, *Procès-verbaux*, 9:40). However, the number was mistranscribed, as it is article *34* of these statutes that forbids commerce, and that was correctly cited in the next entry: "M. Martin, Agréé Peintre d'Histoire, suspecté de faire le commerce de tableaux prohibé par l'article 34 des Statuts de 1777" (9:42).

84. In J.-B. Lebrun's *Almanach historique et raisonné des architectes, peintres, sculpteurs, graveurs et cizelleurs* (Paris, 1776), he is listed under painters of talent who are not yet members of the Academy: "Ménageot, ancien Pensionnaire du Roi, rue Saint-Thomas-du-Louvre, chez m. son père, Marchand de Tableaux," 132. For further discussion of Ménageot, see Nicole Willk Brocard, *François-Guillaume Ménageot* (Paris: Arthena, 1976).

85. Denis Diderot, *Salons*, ed. J. Seznec and J. Adhémar (4 vols.; Oxford: Clarendon Press, 1963), 4:17.

86. "A l'egard de ceux qui, indépendamment de l'exercice de ces arts, ou sans les exercer personnellement, voudront tenir boutique ouverte, faire commerce de tableaux, dessins, sculptures, qui ne seroient pas leur ouvrage, débiter des couleurs, dorures et autres accessoires des Arts de Peinture et de Sculpture; qui s'immisceroient enfin, soit directement, soit indirectement, dans l'entreprise de peinture ou de sculpture de bâtimens ou d'autres ouvrages de ce genre, susceptible d'être appréciés et payés au toisé, ils seront tenus de se faire reconnoître dans la Communauté des Peintres, Sculpteurs, établie par notre Edit du mois d'Aoust de l'année dernière, et de se conformer aux dispositions de cet Edit." Montaiglon, *Procès-verbaux*, 8:285–86.

87. "Interdit, de la manière la plus précise, à tous les Membres de l'Académie le commerce de tableaux, soit directement, soit indirectement." Ibid., 9:155.

88. La Font de Saint-Yenne, *Réflexions sur quelques causes de l'état présent de la peinture en France* [1747] (Geneva: Slatkine Reprints, 1970), 22.

89. McClellan, *Inventing the Louvre*, 50–51.

90. Ibid., 58.

91. M. L'**** P***, *Observations générales sur le Sallon de 1783, et sur l'état des arts en France* (1783), Collection Deloynes, 299:29–30.

92. "Egarés par la charlatanerie des Marchands, & le goût dépravé de quelques prétendus Amateurs, nous dédaignions la grand machine de l'Art; . . . l'on jettoit à peine un regard sur les plus belles compositions de *Poussin*, de *le Sueur*; & l'on ne rougissoit pas d'épuiser en quelque sorte son admiration sur une scène de cabaret & une bambochade flamande." Ibid., 30.

93. Les tableaux d'histoire ordonnés depuis quelques années pour le Roi, nous ramenent au goût du beau, & sauront le fixer parmi nous. Tel fut toujours l'effet des grands encouragemens; c'est par eux que les Arts renaissent & s'élevent à ce degré où ils peuvent illustrer une Nation." Ibid.

94. "Les Vitriers & les Peintres formerent une seule Communauté en France. L'art de ceux-ci, nous le distinguions à peine d'avec le métier des autres." Ibid.

95. Ibid., 31.

96. "Voilà les hommes qui, embellissant chaque Sallon de leurs ouvrages, en ont fait une galerie digne d'attirer la foule." He appeals to the notion of a "public" to justify his opinions. Coup de Patte, *Le Triumvirat des arts*, Collection Deloynes, 305:11.

97. Ibid., 12.

98. "Des traits de flamme et la sensibilité la plus profonde, le plus communicative et la plus entraînante." *Mémoires de Charles-Claude Flahaut Comte de la Billarderie*

d'Angiviller. Notes sur les Mémoires de Marmontel, ed. Louis Bobé (Paris: C. Klincksieck, 1933), 33.

99. "N'y avez-vou• pas senti en lisant cet ouvrage une certaine odeur de vertu suave et enivrante?" Ibid., 47.

100. "La postérité lira vos écrits et ceux de Diderot, et ceux de cet infortuné. Et elle vous jugera, non d'après vos passions d'un jour, non d'après vos intérêts de société, non d'après les préjugés de votre siècle, mais d'après l'éternelle vérité. . . . Le sentiment du vrai respire dans ses écrits et s'y fait sentir si vivant, si animé, qu'il s'empare de vous, vous saisit et vous transporte tellement qu'il vous est impossible de vous soustraire à son empire." Ibid., 48.

101. "La contemplation de ces moeurs patriarchales et agrestes, de ces vertus robustes marchant d'un pas ferme et toujours droit dans la route de la nature, a pu jetter à ses yeux un éclat plus pur que ces vertus discoureuses et raisonneuses qui s'épuisent en paroles et ne se traduisent point en actions." Ibid., 33–34.

102. After 1789, however, many reformist critics associated themselves with the 1648 Academy, the Academy before Colbert. Again I am indebted to Nicholas Mirzoeff for this information.

103. I say "imagined," not to suggest that women had no power and did not act, but to say that there was little danger in 1783 of women actually unbalancing the social order and usurping men's power.

104. The letter is addressed to his wife, and asks her to intercede with her husband to plead Mme Guiard's case. The letters are reprinted in Baron Roger Portalis, *Adelaïde Labille-Guiard, 1749–1803* (Paris: Georges Rapilly, 1902), 98ff. It is, of course, possible that Labille-Guiard is speaking her own fears; my point is that she chooses which argument to make to d'Angiviller based on what will move him—whether she reveals her own attitudes or true feelings is not an issue here.

105. "Je suis désespérée quand je pense à mon père, à l'effet que cela lui produira. On doit s'attendre à être déchiré sur son talent; les savants, les auteurs, sont exposés de même à la satyre; c'est le sort de tous ceux qui s'exposent au jugement public, mais leurs ouvrages, leurs tableaux sont là pour se justifier; s'ils sont bons, ils plaident leur cause. Qui peut plaider celle des moeurs des femmes?" Ibid., 97-98. It is noteworthy that Labille-Guiard includes in her self-portrait of 1785 a portrait bust of her father that resembles a piece of Roman sculpture. The inclusion of this work suggests that, despite her public position as an academic painter, she is still a dutiful daughter.

106. Coup de Patte, *Le Triumvirat des arts,* 7. See also 7–11.

107. "Air: *Mon petit coeur à chaque instant soupire.* 'Quel pere! o Dieux! s'est un monstre féroce; / Quoi' poignarder sa fille de sa main? / Cette action est barbare, est atroce; / Fut-il jamais Pere plus inhumain?' " *Momus au Sallon, Comédie-Critique en vers et en vaudevilles, suivie de notes critiques* (1783), Collection Deloynes, 308:43.

108. "Madame, hélas! épargnez-le, de grace; / Il le faloit pour sauver son honneur. / Ah! regardez comme il fait le grimace! / Cela vous dit qu'il frissonne d'horreur." Ibid.

109. "L'excuse ma paroît fort bonne; / Il est un peu méchant, mais on le lui pardonne." Ibid.

110. "Et en même tems en lui suggere sa reponse: N'est-il pa [*sic*] vrai que c'est une femme étonnante que Madame *Le Brun*? Tel est le nom, Monsieur, de la femme que j'ai en vue, devenue si célebre en aussi peu de tems." Louis Petit de Bachaumont,

Mémoires secrets pour servir à l'histoire de la république des lettres en France depuis MDCCLXII jusqu'à nos jours, ou Journal d'un observateur (36 vols.; London: J. Adamson, 1780–89), 24:4–5.

4. The Im/modesty of Their Sex

1. "Les Anciens avoient en général un très grand respect pour les femmes; mais il marquoient ce respect en s'abstenant de les exposer au jugement du public, et croyoient honorer leur modestie, en se taisant sur leurs autres vertus. Ils avoient pour maxime que le pays où les moeurs étoient les plus pures, étoit celui où l'on parloit le moins des femmes; et que la femme la plus honnête étoit celle dont on parloit le moins." J.-J. Rousseau, *Lettre à Mr. D'Alembert sur les spectacles*, ed. M. Fuchs (Geneva: Droz, 1948), 64.

2. "Ce nombre est suffisant pour honorer le talent, les femmes ne pouvant jamais être utiles au progrès des Arts, la décence de leur sexe les empêchant de pouvoir étudier d'après nature et dans l'Ecole publique établie et fondée par Votre Majesté." Montaiglon, *Procès-verbaux*, 9:157.

3. Linda Nochlin, "Why Have There Been No Great Women Artists?" in *Woman in Sexist Society: Studies in Power and Powerlessness*, ed. Vivian Gornick and Barbara K. Moran (New York: New American Library, 1981), 480–510. Similar claims for rooting woman's lack of cultural production in the systems of education and acculturation are made by Simone de Beauvoir, "Women and Creativity," in *French Feminist Thought: A Reader*, ed. Toril Moi (London: Basil Blackwell, 1987), 17ff.

4. For example, although Riballier's 1779 *De L'Education physique et morale des femmes* cannot be viewed as a "feminist" tract—that is, one that argues for the political, social, and cultural equality of women—it does state the failings of the educational system vis-à-vis women. Claiming to look objectively at how women are educated everywhere on earth, the author concludes that they have not been given the care, attention, or training that men have. He also argues that the exclusion of women from learning relies on "excuses" such as the delicacy of their consitution and the weakness of their temperament. And, most interestingly, he repudiates Rousseau, saying that under the pretext of giving a companion to Emile, Rousseau made a humiliating and degrading portrait "du plus beau, du plus ravissant des ouvrages du créateur." *De L'Education physique et morale des femmes* (Brussels and Paris: Chez les Frères Estienne, 1779), 4–7, 21. In a *Notice abrégé des femmes illustres* appended to his treatise, Riballier mentions women artists, including Vigée-Lebrun and Vallayer-Coster. However, he misattributes to Vallayer-Coster some achievements of Vigée-Lebrun (the images painted for the Académie française), and essentially splits the biography of Vigée-Lebrun between the two women (322, 474). Riballier was a syndic of the faculty of theology in Paris, a doctor of the Sorbonne, and eventually grand maître of the College Mazarin. On Riballier, see Gutwirth, *Twilight of the Goddesses*, 150.

5. For an important discussion of Rousseau's ideas and their connection with the old nobility, see Joan B. Landes's pathbreaking book, *Women in the Public Sphere in the Age of the French Revolution* (Ithaca, N.Y.: Cornell University Press, 1988), 66–89. Gutwirth, *Twilight of the Goddesses*, 122–32, also provides a significant discussion of these issues.

6. Sarah Kofman, *Le Respect des femmes* (Paris: Editions galilée, 1982), 66.

7. In using the attack-defense motif, Rousseau reiterates Montesquieu's concep-

tion of sexuality, revealed in the latter's 1754 *Essai sur le goût:* "La loi des deux sexes a établi parmi les nations policées et sauvages, que les hommes demanderaient, et que les femmes ne feraient qu'accorder: de là il arrive que les grâces sont plus particulièrement attachées aux femmes. Comme elles ont tout à défendre, elles ont tout à cacher" (repr.: Paris: Armand Colin, 1993), 57–58. For a discussion of the different roles of the sexes, as it was conceptualized in legal discourse on seduction, see Nicholas Mirzoeff, "'Seducing Our Eyes': Gender, Jurisprudence, and Visuality in Watteau." *The Eighteenth Century: Theory and Interpretation* 35 (Spring 1994): 135–54.

8. "Que deviendroit l'espece humaine, si l'ordre de l'attaque et de la défense étoit changé? L'assaillant choisiroit au hazard des tems où la victoire seroit impossible; l'assailli seroit laissé en paix, quand il auroit besoin de se rendre, et poursuivi sans relâche, quand il seroit trop foible pour succomber; enfin le pouvoir et la volonté toujours en discorde ne laissant jamais partager les desirs, l'amour ne seroit plus le soutien de la Nature, il en seroit le destructeur et le fléau." Rousseau, *Lettre à Mr. D'Alembert*, 112.

9. Cabanis, *Physical and Moral Aspects*, 1:234.

10. Ibid.

11. Rousseau, *Lettre à Mr. D'Alembert*, 111–13.

12. J.-J. Rousseau, *Oeuvres complètes* (Paris: Gallimard, 1969), 4:694–95.

13. Derrida, *Of Grammatology*, 179–81.

14. "L'Etre suprême a voulu faire en tout honneur à l'espéce humaine; en donnant à l'homme des penchans sans mesure il lui donne en même tems la loi qui les régle, afin qu'il soit libre et se commande à lui-même; en le livrant à des passions immodérées, il joint à ces passions la raison pour les gouverner: en livrant la femme à des desirs illimités, il joint à ces desirs la pudeur pour les contenir." Rousseau, *Emile*, in *Oeuvres complètes*, 4:695.

15. Freud, "On Femininity," 117.

16. Note that some women defended and made a virtue of modesty in interesting ways. For example, Mme de Lambert in her *Réflexions sur les femmes*, first published in 1727, argues that modesty serves woman's true interest in safeguarding her from the tyranny of men. Madame de Lambert, *Réflexions sur les femmes* (Paris, 1828), 109ff.

17. "Un état dont l'unique objet est de se montrer au public, et qui pis est, de se montrer pour de l'argent." Rousseau, *Lettre à Mr. D'Alembert*, 120.

18. "A-t-on besoin même de disputer sur les différences morales des sexes pour sentir combien il est difficile que celle qui se met à prix en représentation ne s'y mette bientôt en personne, et ne se laisse jamais tenter de satisfaire des désirs qu'elle prend tant de soin d'exciter?" Ibid., 120–21.

19. Ibid., 108.

20. Ibid., 106–7.

21. "Après ce que j'ai dit ci-devant, je n'ai pas besoin, je crois, d'expliquer encore comment le désordre des Actrices entraîne celui des Acteurs; sur-tout dans un métier qui les force à vivre entre eux dans la plus grande familiarité." Ibid., 122.

22. Ibid., 110–11.

23. "J'ajoute qu'il n'y a point de bonnes moeurs pour les femmes hors d'une vie retirée et domestique; . . . que les paisibles soins de la famille et du ménage sont leur partage, que la dignité de leur sexe est dans sa modestie, que la honte et la pudeur sont en elles inséparables de l'honnêteté, que rechercher les regards des hommes c'est déjà

s'en laisser corrompre, et que toute femme qui se montre se déshonore." Ibid., 110. Again we can read Rousseau's continuing authority by turning to the influential Cabanis: "Because of her weakness, the woman, wherever the tyranny and the prejudice of men have not forced her to violate her nature, has had to remain inside the house or the hut. . . . She did not mingle in discussions of public affairs, at which not only must there always preside a severe and strong reason, but where also the accent of the character and energy add singularly to the power of reason. In a word, the woman had to leave to the men the exterior cares and the political or civil employments." *Physical and Moral Aspects*, 1 : 236–37.

24. Kofman, *Le Respect*, 72–73.

25. "Qu'un homme se mette à aimer les laitages et le sucre, une femme à en perdre le goût et préférer celui du vin, c'est la catastrophe." Ibid., 73.

26. As quoted in Kofman, *Le Respect*, 73.

27. "Les femmes n'aiment à vivre qu'avec les hommes, elles ne sont à leur aise qu'avec eux. Dans chaque société la maîtresse de la maison est presque toujours seule au milieu d'un cercle d'hommes." As quoted in Kofman, *Le Respect*, 92.

28. Ibid., 92–93.

29. Rousseau, *Lettre à Mr. D'Alembert*, 136.

30. Kofman, *Le Respect*, 93.

31. "Par-tout on considere les femmes à proportion de leur modestie; par-tout on est convaincu qu'en négligeant les manieres de leur sexe elles en négligent les devoirs; par-tout on voit qu'alors, tournant en effronterie la mâle et ferme assurance de l'homme, elles s'avilissent par cette odieuse imitation, et déshonorent à la fois leur sexe et le nôtre." Rousseau, *Lettre à Mr. D'Alembert*, 118.

32. "Suivons les indications de la Nature, consultons le bien de la Société; nous trouverons que les deux sexes doivent se rassembler quelquefois, et vivre ordinairement séparés. Je l'ai dit tantôt par rapport aux femmes, je le dis maintenant par rapport aux hommes. Ils se sentent autant et plus qu'elles de leur trop intime commerce; elles n'y perdent que leurs moeurs, et nous y perdons à la fois nos moeurs et notre constitution: car ce sexe plus foible, hors d'état de prendre notre maniere de vivre trop pénible pour lui, nous force de prendre la sienne trop molle pour nous; et ne voulant plus souffrir de séparation, faute de pouvoir se rendre hommes, les femmes nous rendent femmes" (134–35). For a provocative discussion of Rousseau's attitude toward mixing the sexes, see Kofman, *Le Respect*, 71–75 and 108–17.

33. Mme de Marchais held an important salon where the philosophes, *gens de lettres*, artists, and notables gathered. Although d'Angiviller attended the salon, he allied himself with the status quo, with religion and the monarchy. He has particularly unkind remarks about Voltaire, Diderot, and the atheist, d'Holbach. In the memoirs, d'Angiviller takes Rousseau's side against the philosophes, and chastises Marmontel for abandoning Rousseau and for revealing his secrets. Bobé, *Mémoires*, 29–49.

34. "Cette même caractère de foiblesse et de subordination à autrui se fait voir dans ses relations philosophiques et littéraires, et dans le jugements qu'il porte sur ceux qui ont exercé sur lui leur empire." Ibid., 8.

35. "La De Guyard tient une école de jeunes élèves de son sexe; que tous les artistes logés au Louvre en ont également du leur, et que comme on n'arrive à tous ces logements que par des vastes corridors souvent obscurs, il y aurait beaucoup d'incon-

vénient pour les moeurs et pour la décence du palais de Votre Majesté dans cette confusion de jeunes artistes de différents sexes." Reprinted in A. M. Passez, *Adelaïde Labille-Guiard* (Paris: Arts et Métiers Graphiques, 1971), 301.

36. J. J. Guiffrey, "Ecoles de demoiselles dans les ateliers de David et de Suvée au Louvre," *Nouvelles Archives de l'Art Français* (1874–75), 396–97. This article reproduces only the letters to d'Angiviller of David, Suvée, and the father of one woman student.

37. "Un lieu où doit particulièrement régner la décence, ce qui ne nous permet pas de fermer les yeux sur cet abus." As quoted in Silvestre de Sacy, *Le Comte d'Angiviller*, 176.

38. Guiffrey, "Ecoles de demoiselles," 399.

39. "S'il existe quelqu'abus dans le Louvre et qui soient contraires à la décence, on ne peut qu'applaudir à votre surveillance et aux motifs respectables qui la dirigent; mais votre volonté n'est pas sans doute que des personnes bien nées, très-sages, ayent un sort commun avec celles dont la conduite vous a été présentée comme coupable. Je n'ai aucun intérêt à deffendre des élèves qui ne font chez moi qu'un passage, mais je connois combien l'honneur est cher à un sexe dont il est le principal ornement, et je me fais un devoir scrupuleux de vous dire la vérité." Ibid., 395.

40. Silvestre de Sacy, *Le Comte d'Angiviller*, 177.

41. Jean-Antoine-Nicholas Caritat, Marquis de Condorcet, "Sur l'admission des femmes au droit de cité." In *Paroles d'hommes (1790–93)*, ed. Elisabeth Badinter (Paris: P.O.L., 1989), 58.

42. Rousseau, *Lettre à Mr. D'Alembert*, 111.

43. Ibid.

44. "Comme si tous les austeres devoirs de la femme ne dérivoient pas de cela seul, qu'un enfant doit avoir un père. . . . Ainsi l'a voulu la Nature, c'est un crime d'étouffer sa voix." Ibid., 113.

45. Rousseau, "Discourse on the Origin and Foundations of Inequality," 135–36.

46. "Quand on pourroit nier qu'un sentiment particulier de pudeur fût naturel aux femmes, en seroit-il moins vrai que, dans la Société, leur partage doit être une vie domestique et retirée? . . . Si la timidité, la pudeur, la modestie, qui leur sont propres, sont des inventions sociales, il importe à la Société que les femmes acquierent ces qualités; il importe de les cultiver en elles, et toute femme qui les dédaigne offense les bonnes moeurs." Rousseau, *Lettre à Mr. D'Alembert*, 117.

47. Rousseau, *Emile*, in *Oeuvres complètes*, 4:698.

48. Mme Terbouche, née Anne Dorothée Leicienska, remains a fairly obscure artist, although she has recently been mentioned in several histories of women artists, including Rosizka Parker and Griselda Pollock, *Old Mistresses* (New York: Pantheon Books, 1981), 92–93. For an insightful discussion of the woman painter's modesty in another cultural context, see Wendy Wassyng Roworth, "Anatomy is Destiny: Regarding the Body in the Art of Angelica Kauffman," in *Femininity and Masculinity*, ed. Gill Perry and Michael Rossington (Manchester: Manchester University Press, 1993), 41–62; and also, Wendy Wassyng Roworth, ed., *Angelica Kauffman: A Continental Artist in Georgian England* (London: Reaktion Books, 1992), 11–95.

49. "Celle-ci a eu le courage d'appeler la nature, et de la regarder. Elle s'est dit à elle-même, je veux peindre, et elle se l'est bien dit. Elle a pris des notions justes de la

pudeur, elle s'est placée intrépidement devant le modèle nu; elle n'a pas cru que le vice eût privilège exclusif de déshabiller un homme." Denis Diderot, *Salons*, 3:250.

50. Cette femme s'est mise au dessus de tous préjugés. Elle s'est dit à elle même: Je veux être peintre, je ferai donc pour cela tout ce qu'il faut faire; j'appellerai la nature, sans laquelle on ne sçait rien; et elle a courageusement fait déshabiller le modèle. Elle a regardé l'homme nu. Vous vous doutez bien que les bégueules de l'un et l'autre sexe ne s'en sont pas tues. Elle les a laissés dire, et elle a bien fait." Diderot, *Correspondance*, 8:30.

51. Les envieux ne nous font des fantômes que pour nous retenir dans la médiocrité. S'ils y regardoient de bien près, ils verroient que la décence n'est que le prétexte de leur discours. Combien d'actions malhonnêtes dont ils ne parlent point, parce qu'elles déshonorent; combien d'indifférentes qu'ils appellent malhonnêtes, parce qu'elles conduisent ceux qui s'élèvent au-dessus du préjugé, à l'opulence et à la considération. On permet au vice de regarder la nature, et on le défend au talent. Pourdieu, ne donnez pas là dedans. Mille femmes lascives se feront promener en carrosse, sur le bord de la rivière pour y voir des hommes nuds; et une femme de génie n'aura pas la liberté d'en faire déshabiller un pour son instruction?" Ibid., 8:42.

52. Joan DeJean, "Looking Like a Woman, The Female Gaze in Sappho and Lafayette," *L'Esprit Créateur* 28 (Winter 1988): 35.

53. "Lorsque la tête fut faite, il était question du cou, et le haut de mon vêtement le cachait, ce qui dépitait un peu l'artiste. Pour faire cesser ce dépit je passai derrière un rideau, je me déshabillai et je parus devant elle en modèle d'académie. Je n'aurais pas osé vous le proposer, me dit-elle, mais vous avez bien fait, et je vous en remercie. J'étais nu, mais tout nu. Elle me peignait, et nous causions avec une simplicité et une innocence digne des premiers siècles." Diderot, *Salons*, 3:252.

54. "Comme depuis le péché d'Adam on ne commande pas à toutes les parties de son corps comme à son bras, et qu'il y en a qui veulent quand le fils d'Adam ne veut pas, et qui ne veulent pas quand le fils d'Adam voudrait bien; dans le cas de cet accident, je me serais rappellé le mot de Diogène au jeune lutteur: *Mon fils, ne crains rien, je ne suis pas si méchant que celui-là.*" Ibid., 3:252–53.

55. I'm indebted for this train of thought to conversations with E. Jane Burns about Augustine's attitude toward women and toward his body.

56. Diderot, *Salons*, 3:254.

57. "Alors, au moindre mouvement que faisait leur prunelle de mon côté, je leur disais: *J'en suis aux yeux;* cela les contrariait un peu, comme vous pouvez croire." *Souvenirs*, 1:39. The discussion that follows owes much to comments by E. Jane Burns and Erica Rand.

58. Ibid., 1:39.

59. Ibid.

60. Diderot describes how Mme Terbouche's painting, *Jupiter and Antiope*, was rejected from the Salon, allegedly because it offended morals in showing a nude male figure painted by a woman artist. Diderot, however, believes that it was rejected because it was a badly executed painting. His account of the image and of Mme Terbouche's reaction is quite malicious; not only does he characterize the painting as inept, he also depicts the artist's response to her rejection as that of a raving, indeed we might say hysterical, woman: "Elle en tomba dans le désespoir, elle se trouva mal; la fureur succéda à la défaillance; elle poussa des cris; elle s'arracha les cheveux, elle se roula par

terre; elle tenait un couteau, incertaine si elle s'en frapperait ou son tableau." Diderot, *Salons*, 3:250–52.

61. Candace Clements, "The Academy and the Other: Les Graces and Le Genre Galant," *Eighteenth-Century Studies* 25 (Summer 1992): 469–94.

62. That the *Iliad* was an important source for learned artists can be gleaned from its appearance in artists' portraits, such as Vestier's 1786 portrait of Gabriel-François Doyen (Paris: Musée du Louvre). Also, Coup de Patte specifically chastises Madame Lebrun for her mockery of Homer, *Le Triumvirat des arts*, 27.

63. Lynn Hunt, *Politics, Culture and Class in the French Revolution* (Berkeley: University of California Press, 1984), 113. For a more extended discussion of women and allegory during the revolutionary period, see Gutwirth, *Twilight of the Goddesses*, 252–84.

64. I thank Betty Weinshenker for drawing my attention to this point. DuBos, for example, argues that in making allegories painters liked to show the brilliance of their imaginations. DuBos warns, however, that allegories sometimes are difficult to discern, and do not touch the heart of the viewer. Jean-Baptiste, Abbé DuBos, *Réflexions critiques sur la poësie et sur la peinture* (3 vols.; Paris: Chez Mariette, 1740), 1: 198–99.

65. Clements, "The Academy and the Other," 476–80.

66. Most notable are the brushes stuck into the thumb-hole of the palette, and the shape of the fireplace itself, with its curving front mimicking the female pelvis. On fireplaces and sexual imagery, see John P. Muller and William J. Richardson, eds., *The Purloined Poe: Lacan, Derrida, and Psychoanalytic Reading* (Baltimore: Johns Hopkins University Press, 1988), 48, 130, 189.

67. *Messieurs*, Collection Deloynes, 295:22.

68. *Momus au Sallon*, Collection Deloynes, 292:10.

69. Charles Blanc, "Elisabeth Vigée-Lebrun," in *Histoires des peintres: Ecole Française* (14 vols.; Paris: Librairie Renouard, 1861–76), 2:2. Although this identification was repeated by several scholars after Blanc, it has now been largely discarded, particularly since Hall's daughter, Adelaide-Victorine, was born in 1772, and would have been eight years old when the subject was painted.

70. "Mais quel que soit l'art avec lequel Mme Lebrun s'est appliquée à idéaliser ses modèles, on se sent en présence d'individualités vivantes. Il en résulte pour l'esprit du spectateur un étrange embarras." Ibid.

71. Lucienne Frappier-Mazur, "Marginal Canons: Rewriting the Erotic," *Yale French Studies* 75 (1988): 116.

72. Ibid., 121.

73. Ibid., 120–21.

74. M. Duvivier, "Sujets des morceaux de réception des membres de l'ancienne Académie de Peinture, Sculpture et Gravure 1648–1793," *Nouvelles Archives de l'Art Français* 10 (1852–53). Paris: J. B. Dumolin; repr. Paris: F. de Nobèle, 1967, 386.

75. Bibliothèque Nationale, Cabinet des Estampes, *Ancien Régime* in *Un Siècle d'histoire de France par l'estampe 1770-1871. Collection De Vinck; inventaire analytique par François-Louis Brunel* (Paris: Imprimerie nationale, 1909), no. 1223 Fol. 74.

76. "J'ignore dans quelle classe l'académie a placé Madame le Brun, ou de l'histoire, ou du genre, ou de portraits, mais elle n'est point indigne d'aucun, même de la première. Je regarde son tableau de réception comme très-susceptible de l'y faire ad-

mettre. C'est *la Paix ramenant l'Abondance*, allégorie aussi naturelle qu'ingénieuse: on ne peut mieux choisir pour le circonstances. La premiere figure, noble, décente, modeste comme la paix que la France vient de conclure, se caractérise par l'olivier, son arbuste favori." Bachaumont, *Mémoires secrets*, 24:5–6. (I have preserved the spelling of the original text.)

77. Rosenberg argues that this work is typical of the new neoclassical mode and represents Vigée-Lebrun's attempts to make her work up-to-date. Pierre Rosenberg, "A Drawing by Madame Vigée-Le Brun," *Burlington Magazine* 123 (December 1981): 739–41. Despite what Rosenberg contends, the painting is one of her least neoclassical works. Contemporaries, moreover, saw the work as following Baroque tradition, specifically aligning it with works by Rubens, Pietro da Cortona, and Guido Reni. I am indebted to Kathleen Nicholson for bringing to my attention the mode of this reception piece, and for many hours of conversation in museums and galleries.

78. The work is now thought to have been executed for Richelieu in the 1630s. See Germain Seligman, "'La Prudence amène la Paix et l'Abondance' by Simon Vouet," *Burlington Magazine* 103 (July 1961): 297–99.

79. Hunt, *Family Romance*, 89–123, and Sarah Maza, "The Diamond Necklace Affair Revisited (1785–1786): The Case of the Missing Queen," in *Eroticism and the Body Politic*, ed. Lynn Hunt (Baltimore: Johns Hopkins University Press, 1991), 63–89.

80. Maza, "The Diamond Necklace Affair," 66–69.

81. Hunt, "The Many Bodies of Marie Antoinette," in *Eroticism and the Body Politic*, 117.

82. Maza, "The Diamond Necklace Affair," 82.

83. "De se conformer aux desirs de la Reine et de conserver en même temps les Statuts de l'Académie dans toute leur force." Montaiglon, *Procès-verbaux*, 9:153.

84. Joseph Baillio suggests that Vaudreuil was Vigée-Lebrun's most important private patron in the 1780s. *Elisabeth Louise Vigée-LeBrun*, 52.

85. "Si le trone embelli t'offre un digne modèle, / Que des traits enchanteurs sont bientôt reconnus! / A l'orgueil d'Alexandre il fallait un Apelle: / C'est le Brun qu'il faut à Vénus." M. de Miramond, *Vers à Madame Le Brun, de l'Académie Royale de Peinture, sur les principaux ouvrages, dont elle a décoré le Sallon cette année* (1783), Collection Deloynes, 308:3.

86. Louis Marin, *Portrait of the King*, trans. Martha M. Houle (Minneapolis: University of Minnesota Press, 1988), 210.

87. As quoted in ibid.

88. Etienne Falconet, "Traduction du trente-quatrième livre de Pline," in *Oeuvres complètes* [1808] (3 vols.; Geneva: Slatkine Reprints, 1970), 1:174–75.

89. Chantel Grell and Christian Michel, *L'Ecole des princes, ou, Alexandre disgracie: Essai sur la mythologie monarchique de la France absolutiste* (Paris: Belles Lettres, 1988), 125.

90. "Il est d'un homme d'esprit d'avoir fait baisser les yeux à Campaspe. Gaie, elle auroit blessé la vanité d'Alexandre, qu'elle auroit quitté sans peine. Triste, elle auroit mortifié le peintre." Diderot, *Salons*, 2:216–17.

91. "Mais il y a tant d'innocence et de simplicité dans le caractère de sa tête, que si vous placez un voile au-dessus de sa gorge, et que ce voile tombant jusqu'au bout de ses pieds, tous ses appas nus vous soient dérobés, de manière que vous n'apperceviez plus que la tête, vous prendrez une concubine pour une jeune fille bien élevée, qui

ignore ce que c'est qu'un homme, et qui se résigne à la volonté de son père, qui lui donne l'artiste que voilà pour époux." Ibid., 2:217.

92. "Falconet, mon ami, vous avez oublié l'état de cette femme, vous n'avez pas pensé qu'elle avoit couché avec Alexandre, et qu'elle a connu le plaisir avec lui, et peut-être avec d'autres avant lui." Ibid.

93. Irigaray, *This Sex*, 192–97.

94. "La Déesse paraît. A sa beauté céleste, / Que l'on reconnoit bien la mere de l'Amour! / Mais l'auguste Junon va se parer du Ceste: / Junon peut sur Vénus l'emporter en ce jour. / Trop heureux Maitre du tonnerre! / Si je pouvais. . . . osons lui déclarer la guerre. . . . / Insensé! fuis plutôt de perfides objets. / D'un art imitateur dangereuse imposture! / Pour séduire, en pinceaux l'Amour change ses traits. / Que Junon de Vénus emprunte la ceinture; / Le Brun (j'ai pour garant ton chef-d'œuvre divin) / De charmer elle est bien plus sûre, / En la recevant de ta main." Miramond, *Vers à Madame Le Brun*, 308:6.

95. "Vous renoncez, charmante souveraine, / Au plus beau de vos revenus / Mais que vous serviroit la ceinture de Reine? / Vous avez celle de Vénus." *Iconographie de Marie-Antoinette*, intro. Georges Duplessis (Paris: A. Quantin, 1883), 174.

96. See Marcel Marion, *Dictionnaire des Institutions de la France aux XVIIe et XVIIIe siècles* (Paris, 1923; repr., New York: Burt Franklin, 1963), 75.

97. "C'était Vénus toujours ornée de sa ceinture, ce n'est aujourd'hui que Junon toujours prête à tracasser et à humilier ceux qui l'approchent." *Porte-Feuille d'un Talon Rouge: Contenant des Anecdotes galantes et secretes de la cour de France* (Paris: 178*), 13.

98. "Combien de tes couleurs le savant artifice / Releve encore les appas / De la Divinité propice, / Qui chasse loin de nous le Démon des combats. / Plus de sang, de pleurs, ni d'alarmes: / A ses pieds déposons nos armes: / On n'est heureux que sous sa loi. / Mais je vois l'Abondance: à l'aspect de ses charmes, / Dieu! que le calme est loin de moi!" Miramond, *Vers à Madame Le Brun*, 308:4.

99. Nancy Vickers has commented on the fragmentation of the woman lover's body in "Diana Described: Scattered Women and Scattered Rhyme," *Critical Inquiry* 8 (Winter 1981): 265–79.

100. "Pour des traits mensongers, pour une image vaine / Qui jamais éprouva de semblables fureurs? / Si j'ai pu sur ma tête attirer ta vengeance; / Vénus, j'implore ta clémence: / Eteins de funestes ardeurs." Miramond, *Vers à Madame Le Brun*, 308:5.

101. Ibid., 308:6. For the French, see note 95.

102. Jean-Baptiste Denis, Abbé Guyon, *Histoire des amazones anciennes et modernes* (2 vols.; Paris: Chez Jean Vilette, 1740), 1:87. Guyon does not explain how one came to represent the other.

103. Freud, "On Femininity," 117.

104. Irigaray, *Speculum*, 115.

105. See Chapter 6.

5. The Portrait of the Queen

1. David Russell, *Costume History and Style* (Englewood Cliffs, N.J.: Prentice-Hall, 1983), 302–5; Blanche Payne, *History of Costume* (New York: Harper and Row, 1965), 437–40; and R. Turner Wilcox, *The Mode in Costume* (New York: Charles Scribner's Sons, 1958), 206–14.

2. On avait d'abord distingué parmi les portraits de cette aimable artiste celui de

la *Reine en lévite;* mais le public ayant paru désapprouver ce costume peu digne de Sa Majesté, l'on s'est pressé de lui en substituer un autre avec un habillement plus analogue à la dignité du trône." *Correspondance littéraire*, 13:441–42. The more politically conservative journal, *L'Année Littéraire* (16:262–63), gave a different explanation for the change in portraits: "On a remarqué que celui de la Reine, qui avoit d'abord été exposé au Salon, étoit foible de ton & de couleur; Madame *le Brun* en a substitué un autre qui a plus d'effet; les graces & la ressemblance de cette Princesse auguste sont très-bien conservées."

3. Bachaumont, *Mémoires secrets*, 24:9.

4. "Elle trouva le fier Achille un peu trop familier, de paroître nu devant des Dames, quoique ce fût un usage antique; il tire son épée, sans doute pour faire peur à ceux qui blâmeroient sa nudité; au reste son attitude plaît; & les Dames, qui paroissoient en chemise devant le public, ne pouvoient pas trop critiquer son ajustement; le leur contrastoit avec la noble simplicité qui faisoit la parure de la belle Grecque." *La Morte*, Collection Deloynes, 286:6.

5. *Momus au Sallon*, Collection Deloynes, 292:16, 21, 43, 45.

6. "Un entre autres la représente coiffée d'un chapeau de paille et habillée d'une robe de mousseline blanche dont les manches sont plissées en travers, mais assez ajustées: quand celui-ci fut exposé au salon, les méchants ne manquèrent pas de dire que la reine s'était fait peindre en chemise." Vigée-Lebrun *Souvenirs*, 1:65–66.

7. After the death of her cousin, Princess Charlotte, to whom Marie-Antoinette had given a copy of the work, the queen wrote to the Princess of Hesse-Darmstadt: "La pauvre princesse Charlotte avait un portrait de moi, pareil au vôtre; ce sont les plus ressemblants qui aient été faits; je désirerais bien le revoir, ou au moins savoir entre les mains de qui il a passé." Maxime de la Rocheterie and the Marquise de Beaucourt, eds., *Lettres de Marie-Antoinette* (Paris: Alphonse Picard et fils, 1895), 89.

8. "Ce portrait toutefois n'en eut pas moins un grand succès. Vers la fin de l'exposition on fit une petite pièce au Vaudeville, qui, je crois, avait pour titre: *La réunion des Arts*. Brongniart, l'architecte, et sa femme, que l'auteur avait mis dans sa confidence, firent louer une loge aux premières et vinrent me chercher le jour de la première représentation pour me conduire au spectacle. Comme je ne pouvais nullement me douter de la surprise qu'on me ménageait, vous pouvez juger de mon émotion lorsque la Peinture arriva, et que je vis l'actrice qui la représentait me copier d'une manière surprenante, en peignant le portrait de la Reine. Au même instant, tout ce qui était au parterre et dans les loges se retourna vers moi en applaudissant à tout rompre; je ne crois pas que l'on puisse être jamais aussi touchée, aussi reconnaissante que je le fus ce soir-là," Vigée-Lebrun, *Souvenirs*, 1:66.

9. Marin operates from the premise that in a society power is controlled by those who manipulate ideology, which he defines according to Althusser as "the representation of the imaginary relations that individuals of a given society hold with their real conditions of existence" (vii). Audiences, however, did not always interpret representations as those who constructed them expected. The extent to which such representations actually worked to sustain power is an open question. For a different view of "creating" Louis XIV, see Peter Burke, *The Fabrication of Louis XIV* (New Haven: Yale University Press, 1993).

10. The first two of these: "I am the state," and "This is my body," are familiar. The third, "The Portrait of Caesar is Caesar," comes from Port Royal logicians, and

was posed in conjunction with the question of when one has the right to give to signs the names of things. This utterance is used in the Port Royal *Logic* to found the validity of Christ's utterance, "This is my body." We are able to say the portrait of the king *is* the king because the portrait is a natural sign resembling the king; we are understood here to speak figuratively. Jesus, on the other hand, had the right to say that the bread was his body, and men must understand that literally since there is no visible rapport between the two that would make the bread understandable (to men) as a sign of Jesus's body. Thus, according to the Port Royal *Logic*, everyone is brought naturally to take Jesus's words in the sense of reality. Marin concludes that there is a "remarkable proximity between the two utterances and a no less remarkable distance in their interpretation: the same natural right authorizes the subject viewing the prince's portrait to give to the representation the name of him whom it represents, and to be understood as speaking in figure; and the faithful taking the body of Jesus Christ in communion are understood as making of the bread that body and as understanding the words of Jesus in the sense of reality." Between the Eucharist and a representation of the absolute monarch, Marin concludes, there is both contiguity and insuperable boundary. *Portrait of the King*, 11–12.

11. Ibid., 14.

12. Marin clearly articulates the notions that underpin his book in his introduction, "The Three Formulas." Ibid., 3–15.

13. Representation takes two meanings in the text. As a substitution, "something that was present and is no longer is now represented. In the place of something that is present elsewhere, a given is present here. At the place of representation then, there is a thing or person absent in time and space, or rather an other, and a substitution operates with a double of this other in its place." But re-presentation also introduces an intensity, or frequency, as when the term means to represent or to show one's documents, which amounts to showing oneself officially as someone or something. In this case representation constitutes its subject. Ibid., 5.

14. Ibid., 6.

15. Ibid.

16. Whether or not this actually happens in the imaginations of every or even most individual subject(s), however, is a different matter and one not investigated by Marin, who is interested in developing a theory of representation.

17. See the section of this chapter subtitled "Trianon."

18. Le Doeuff also finds the chiasma an appropriate figure to describe a totalized system of beliefs, although she is concerned with the disciplines of knowledge and their repressive power, rather than with the power of the state, per se.

19. As quoted from Antoine Loysel, *Institutes coutumières* (ed. Michel Reulos; Paris, 1935) in Roland E. Mousnier, *The Institutions of France under the Absolute Monarchy 1598–1789*, trans. Arthur Goldhammer (2 vols.; Chicago: University of Chicago Press, 1979), 2:87.

20. Mousnier, *Institutions*, 1:650.

21. Ibid., 2:88.

22. Marcel Marion, *Dictionnaire des Institutions de la France aux XVII^e et XVIII^e siècles*, 340; Joan Kelly, "Early Feminist Theory and the *Querelle des Femmes 1400–1789*," 85–86. In *Woman, History, and Theory* (Chicago: University of Chicago Press, 1984).

23. Kelly, "Early Feminist Theory," 86.

24. "A la loi de nature laquelle ayant créé la femme imparfaite, faible et débile tant du corps que de l'esprit, l'a soumise sous la puissance de l'homme, qu'elle a pour ce sujet enrichi d'un jugement plus fort, d'un courage plus assuré, et d'une force de corps plus robuste. Aussi nous voyons que la loi divine veut que la femme reconnaisse et rende obéissance à son mari comme à son chef et à son Roy. . . . Et l'on voit dans Isaïe, chap. 3, que Dieu menace ses ennemies de leur donner des femmes pour maîtresses comme une insupportable malédiction." As quoted in Marion, *Dictionnaire*, 340.

25. Jeffrey Merrick, "Fathers and Kings: Patriarchalism and Absolutism in Eighteenth Century French Politics," *Studies on Voltaire and the Eighteenth Century* 308 (1993): 281–303. Merrick articulates the intertwining of the king's and the father's (or husband's) power.

26. On changing the king's image to that of benevolent father, see ibid., and also, Jeffrey Merrick, "Politics on Pedestals: Royal Monuments in Eighteenth-Century France," *French History* 5 (1991): 234–64.

27. Marin, *Portrait of the King*, 27–28.

28. Ibid., 26.

29. "Pour porter les enfants . . . c'est pour cela que vous êtes appelée; c'est par là que votre bonheur sera constaté." Letter from Marie-Thérèse to Marie Antoinette in *Correspondance secrète entre Marie-Thérèse et le Comte de Mercy-Argenteau*, Intro. and notes Alfred d'Arneth and M. A. Geffroy (3 vols.; Paris: Didot, 1874), 1:104.

30. Saecula! Qui Tanti / quae Te tam laeta tulerunt / Talem genuere Parentes!

31. Body here is figurative, as it is in the phrase "academic body." Body refers to an organization or community (and here a couple) of persons acting as one. As "head," the husband was the chief of the organization, ruler of the couple. Thus, he is head and body, whereas the wife is only body.

32. Sarah Hanley, *The Lit de Justice of the Kings of France: Constitutional Ideology in Legend, Ritual, and Discourse* (Princeton: Princeton University Press, 1983), 91–95; also Mousnier, *Institutions*, 2:87.

33. Hanley, *Lit de Justice*, 95. Hanley is quoting the avocat, Jacques Cappel, from a speech given in 1537.

34. Ibid., 261. Here Hanley is quoting from a text that she considers at some length: Nicolas Bergier, *Le Bouquet royal, ou Le Parterre des riches inventions qui ont servy à l'entrée du roy Louis le Juste en sa ville de Reims* (Reims, 1637).

35. For example, Marie de Medici appears dressed in the fleur-de-lys robe of France in Rubens's panel, *The Regent Militant: Victory at Julich* (1630–35; Paris: Musée du Louvre).

36. Merrick, "Fathers and Kings," 298. Merrick argues that at this time the family metaphor (king as benevolent father) actually was invoked in royal propaganda and oppositional pamphlets more frequently than the marriage metaphor, although the latter was certainly still current.

37. Hanley, *Lit de Justice*, 97–98; Mousnier, *Institutions*, 2:89–90.

38. At the Salon of 1783, for example, Ménageot showed an allegory of the birth of the dauphin in which the dauphin is held in the arms of France. Descriptions of the work emphasize the connection between the two and note that news of the British defeat at Yorktown arrived on the day of the dauphin's birth. It is also interesting that

Peace and Abundance are among the allegorical figures witnessing the birth. *Correspondance littéraire*, 13 : 381.

39. Jacques Revel, "Marie-Antoinette in her Fictions: The Staging of Hatred," in *Fictions of the French Revolution*, ed. Bernadette Fort (Evanston, Ill.: Northwestern University Press, 1991), 114; and Hunt, "The Many Bodies," 111–12.

40. *Chronicle of the French Revolution* (London: Chronicle Publications, 1989), 304. The queen was still allowed her rights as a mother, and she could maintain custody of her underage son.

41. Hunt, *Family Romance*, 12.

42. The associations between making portraits, viewing portraits, and falling in love are many. For example, the origin of painting was figured as Dibutadis tracing the portrait of her lover, and the conceit of falling in love with a portrait has roots back to the myth of Narcissus.

43. Even after the portrait by Ducreux was presented to Louis, Marie-Thérèse's agent in Paris, Count Mercy, let it be understood that Marie-Antoinette's beauty was actually quite superior to that represented by the portrait. At Vienna, dissatisfaction with Ducreux's portrait may have prompted the commissioning of yet another likeness of Marie-Antoinette in the same costume and holding the same pose. J. Flammermont, "Les portraits de Marie-Antoinette," *Gazette des Beaux-Arts* 18 (1897): 5–21.

44. Marguerite Jallut, *Marie-Antoinette et ses peintres* (Paris: Noyer, 1955), 10; Flammermont, "Les portraits de Marie-Antoinette," 16.

45. Although sitters (and critics) often complained about the resemblance of a portrait, I know of no other history of portrait making that is comparable to the one told in these letters. I retell this history to suggest why Elisabeth Vigée-Lebrun may have been selected by Marie-Antoinette as her favorite portrait painter.

46. "J'attends le tableau de Liotard avec grand empressement, mais dans votre parure, point en négligé, ni dans l'habillement d'homme, vous aimant à voir dans la place qui vous convient. Je vous embrasse." Letter dated December 1770; *Correspondance secrète*, 1 : 105.

47. *Correspondance secrète*, 1 : 157. Marie-Thérèse paid for this portrait. She apparently liked the work so well that she gave Krantzinger a bonus in addition to his price. *Marie-Antoinette: Archiduchesse, Dauphine et Reine* (Paris: Editions des musées nationaux, 1955), 29.

48. On Marie-Thérèse's warnings about riding "en homme," see *Correspondence secrète*, 1 : 104: "si vous montez en homme, dont je ne doute, je trouve même dangereux et mauvais pour porter les enfants."

49. "J'ai reçu votre portrait en pastel, bien ressemblant; il fait mes délices et celles de toute la famille, il est dans mon cabinet où je travaille, et la masse dans ma chambre à coucher, où je travaille le soir; ainsi je vous ai toujours avec moi, devant mes yeux, dans mon coeur vous y êtes profondement toujours." Letter dated 17 August 1771 from Marie-Thérèse to Marie-Antoinette; ibid., 1 : 196.

50. "C'est bien à moi de me désoler de n'avoir pu encore trouver un peintre qui attrape ma ressemblance; si j'en trouvais un, je lui donnerais tout le temps qu'il voudrait, et quand même il pourrait en faire qu'une mauvaise copie, j'aurais un grand plaisir de la consacrer à ma chère maman." Letter from Marie-Antoinette to Marie-Thérèse, 18 October 1774; ibid., 2 : 248.

51. "Je me suis mise à la discrétion du peintre, pour autant qu'il voudra, et dans

l'attitude qu'il voudra. Je donnerais tout au monde pour qu'il pût réussir et satisfaire ma chère maman." Letter from Marie-Antoinette to Marie-Thérèse, 16 June 1777; ibid., 3:85.

52. "Pardonnez-moi mon importunité pour votre portrait en grand, Mercy reçoit aujourd'hui les mesures pour cela; le premier sera pour mon cabinet, pour y être avec celui du roi; mais ce grand sera pour une salle où toute la famille est en grand; et cette charmante reine ne devrait pas s'y trouver? Sa mère seule devrait en être privée de cette chère fille? Je voudrais avoir votre figure et habillement de cour, si le visage même ne sera pas si ressemblant. Pour ne vous trop incommoder, il me suffit que j'aie la figure et le maintien, que je ne connais pas et dont tout le monde est si content. Ayant perdu ma chère fille bien petite et enfant, ce désir de la connaître comme elle s'est formée doit excuser mon importunité, venant d'un fond de tendresse maternelle bien vive." Letter of Marie-Thérèse to Marie-Antoinette, 20 June 1777; ibid., 3:87.

53. "Votre grand portrait fait mes délices! Ligne a trouvé de la ressemblance; mais il me suffit qu'il représente votre figure, de laquelle je suis bien contente." Letter from Marie-Thérèse to Marie-Antoinette, 1 April 1779; ibid., 3:303.

54. "Je vais lui écrire sur ce sujet, trouvant trop inférieures au rang d'une grande princesse ces parures extraordinaires." Letter from Marie-Thérèse to the Count de Mercy, 18 March 1775; ibid., 2:310.

55. "Un jour qu'elle était à Trianon, coiffée en cornette de paysanne, pour une répétition de *Rose et Colas* à laquelle assistait M*me* Le Brun, elle lui demanda de la peindre en ce costume. Il est dommage que l'artiste n'ait pas parlé de cet épisode et qu'on ait égaré le croquis fait ce jour-là, selon l'ami qui nous le raconte. Au reste la Reine n'a pas eu le temps de satisfaire son caprice, car cette mode extrême a été fort courte. On aimerait à croire que, devenue plus sage et comprenant mieux les exigences de son rang, elle se soit privée de l'amusante satisfaction que d'autres s'accordaient autour d'elle. Le portrait "en gaulle" dont la simplicité affectée avait fait murmurer le public du Salon, pouvait la mettre ne garde contre une fantaisie piquante chez une beauté de cour, puérile et déplacée chez la Reine." Pierre de Nolhac, *Marie-Antoinette à Versailles* (Paris: Flammarion, 1932), 102.

56. Revel, "Marie-Antoinette in her Fictions," 120.

57. Ibid., 123.

58. Hunt, *Family Romance*, 103–4.

59. In a tour of the queen's rooms at Versailles in 1992, the guide told us how badly Marie-Antoinette had been brought up at Schönbrunn; in particular, she had not been schooled in the proper manners. By all reliable accounts, however, life at Schönbrunn was organized much differently than that at Versailles, and commentators have often suggested that the Hapsburgs in Vienna were the first bourgeois royal family.

60. "Qui les a exclues du Trône des François leur a fait perdre dans notre esprit une partie de l'estime que plusieurs d'entre'elles mériteroient à juste titre, et le fruit des avantages qu'elles pourroient avoir reçus de la nature." Guyon, *Histoire des Amazones*, 1:52–53. It may be that women were treated no better in countries where women could ascend to the throne, but it is perhaps worth noting that French women were given civil rights, including the right to vote, much later than women in England and Germany.

61. Hunt, *Family Romance*, 89–90.

62. Gutwirth, *Twilight of the Goddesses*, 301.

63. "Oh! vous, femmes de tous les pays, de toutes les classes de la société, écoutez-moi avec l'émotion que j'éprouve; la destinée de Marie-Antoinette contient tout ce qui peut toucher votre coeur; si vous êtes heureuses, elle l'a été." Madame de Staël, *Réflexions sur les procès de la reine par une femme*, Intro. Monique Cottret (Montpellier: Les presses du Languedoc, 1994), v.

64. "Républicains, constitutionnels, aristocrates, si vous avez connu le malheur, si vous avez eu le besoin de la pitié, si l'avenir offre à votre pensée une crainte quelconque, réunissez-vous tous pour la sauver!" Ibid., vi.

65. "Je reviens à vous, femmes immolées toutes dans une mère si tendre, immolées toutes par l'attentat qui serait commis sur la faiblesse, par l'anéantissement de la pitié, c'en est fait de votre empire si la férocité règne, c'en est fait de votre destinée si vos pleurs coulent en vain." Ibid., xxx.

66. Ibid., xvi; Gutwirth, *Twilight of the Goddesses*, 301.

67. On the trial of Marie-Antoinette see Hunt, *Family Romance*, 92–95; and Elizabeth Colwill, "Just Another *Citoyenne*? Marie-Antoinette on Trial 1790–1793," *History Workshop* 28 (Autumn 1989): 63–87.

68. Marin, *Portrait of the King*, 48–50.

69. "Une robe de percale blanche, un fichu de gaze, un chapeau de paille étaient la seule parure des princesses." Rose Campan, *Mémoires de Madame Campan, première femme de chambre de Marie-Antoinette*, ed. Jean Chalon, with notes by Carlos de Angulo (Paris: *Mercure de France*, 1988), 149–50.

70. Hunt, *Family Romance*, 101. The queen was charged with having incestuous relations with her son and with damaging one of his testicles.

71. Marin, *Portrait of the King*, 194.

72. As quoted by Marin, ibid., 205.

73. Susan Taylor-Leduc, "Louis XVI's Public Gardens: The Replantation of Versailles in the Eighteenth Century," *Journal of Garden History* (Summer 1994), 82–86.

74. Ibid. Robert's painting *View of the Gardens at Versailles at the Time of the Clearing of the Trees, Winter, 1774–75, Entrance to the Tapis-Vert*, executed in 1777, shows the garden awaiting reforestation. Among the characters in the painting are the queen, bending down to attend to children, and the king in discussion with his advisors. For another analysis of this work, see Paula Radisich, "The King Prunes his Garden: Hubert Robert's Pictures of the King's Garden in 1775," *Eighteenth-Century Studies* 21 (Summer 1988): 454–71.

75. Taylor-Leduc, "Louis XVI's Public Gardens," 87.

76. I owe this observation to Nicholas Mirzoeff.

77. "Dans les premiers temps où elle fut en possession du petit Trianon, on répandit dans quelques sociétés qu'elle avait changé le nom de la maison de plaisance que le roi venait de lui donner, et lui avait substitué celui de *petit Vienne*, ou de *petit Schoenbrunn*. Un homme de cour, assez simple pour croire légèrement à ce bruit, et désirant entrer avec sa société dans le petit Trianon, écrivit à M. Campan, pour en demander la permission à la reine. Il avait, dans son billet, appelé Trianon le *petit Vienne*." Campan, *Mémoires*, 83–84.

78. *Correspondance secrète inédites sur Louis XVI, Marie-Antoinette et la Cour et la ville de 1777–1792* (2 vols.; Paris: Henri Plon, 1866), 2:228.

79. "La France sous les traits de l'Autriche réduite à se couvrir d'une panne."

Quoted in Henri Bouchot, "Marie-Antoinette et ses peintres," *Les Lettres et les Arts* 1 (1 January 1887): 46.

80. Discussion of this ceremony is found in all biographies of Marie-Antoinette, e.g., Stefan Zweig, *Marie-Antoinette. Portrait of an Average Woman* (New York: Garden City Publishing, 1933), 13ff.

81. This order and captioning, while certainly not the case for all engravings, can be seen in a large number of them.

82. François Furet and Denis Richet, *The French Revolution*, trans. Stephen Hardman (New York: Macmillan, 1970), 38.

83. Maza, "The Diamond Necklace Affair," 78.

84. This work was in general not highly regarded at the Salon. *L'Année Littéraire*, for example, reported: "Dans celui de Madame la Marquise de la Guiche, on trouve quelques crudités dans la tête & la juppe rouge; je ne saurois d'ailleurs approuver cette métamorphose en *Laitière*, l'idée en est un peu triviale. Ce n'étoit pas ainsi que Rigault, Largillière, Nattier, imaginoient des travestissemens; les leurs étoient plus ingénieux, plus nobles, ou plus galans" (16:263).

85. Terry Castle, "Marie-Antoinette Obsession," *Representations* 38 (Spring 1992): 31.

86. Nina Rattner Gelbart, *Feminine and Opposition Journalism in Old Regime France: Le Journal des Dames* (Berkeley, Calif.: University of California Press, 1987), 179.

87. Ibid.

88. The letter appears in *Correspondance secrète*, 3:250. On the painting, see Roland-Michel, *Vallayer-Coster*, 269.

89. The actress refused to recant when ordered to do so, and she never appeared on stage again. *Chronicle of French Revolution* (London: Chronicle Publications, 1989), 265.

90. Georges Duplessis, introduction, *Iconographie de Marie-Antoinette*, unpaginated. Where he saw bone structure in this sketch is a mystery to me.

91. "David eut la dernière séance de la Reine; il la vit quelques secondes devant lui, plus majestueuse et plus souveraine, que jamais M^{me} Lebrun ou les autres ne l'avaient connue. Plus de rouge sur les joues, plus de poudre dans les cheveux. Un bonnet de linon a remplacé la toque de velours, une petite robe blanche la revêt misérablement; c'est encore une "gaulle," la dernière cette fois." Bouchot, "Marie-Antoinette," 58–59.

92. For a discussion of political attacks on wives and mistresses of rulers, see Maza, "The Diamond Necklace Affair," 63–70. For a comparison of Marie-Antoinette to the scapegoat, see Hunt, *Family Romance*, 114.

93. Hunt, *Family Romance*, 95.

94. Gutwirth, *Twilight of the Goddesses*, 301.

95. Hunt, *Family Romance*, 123.

6. *The Portrait of the Artist*

1. Chère Le Brun, la gloire a ses orages; / L'envie est là qui guette le talent; / Tout ce qui plaît, tout mérite excellent / Doit de ce monstre essuyer les outrages. / Qui mieux que toi les mérita jamais? / Un pinceau mâle anime tes portraits. / Non, tu n'es plus

femme que l'on renomme: / L'envie est juste et ses cris obstinés / Et ses serpents contre toi déchaînés / Mieux que nos voix te déclarent grand homme. Vigée-Lebrun, *Souvenirs*, 1:89. Originally published as *Vers à Madame Lebrun sur les critiques imprimées lors de l'exposition des tableaux du Louvre en 1785, par M. Lebrun, secrétaire des commandements de feu S.A.S. Mgr le prince de Conti*. Collection Deloynes, 1346:313.

2. Vigée-Lebrun, *Souvenirs*, 1:89.

3. See especially Julia Epstein, "Either/Or–Neither/Both: Sexual Ambiguity and the Ideology of Gender," *Genders* 7 (Spring 1990): 99–142. Other recent considerations of the hermaphrodites include Ann Roslind Jones and Peter Stallybrass, "Fetishizing Gender: Constructing the Hermaphrodite in Renaissance Europe," and Randolph Trumbach, "London's Sapphists: From Three Sexes to Four Genders in the Making of Modern Culture," both in *Body Guards*, ed. Julia Epstein and Kristina Straub (London: Routledge, 1991). For a general discussion of monsters and monstrosity, see Stafford, *Body Criticism*, 254–66.

4. There are extended discussions of hermaphrodites in Abbé de La Chau and Abbé Le Blond, *Description des principales pierres gravées du Cabinet de J. A. Monseigneur le Duc d'Orléans* (2 vols.; Paris: Pissot, 1780), 1:105; "Hermaphrodite," in Diderot and D'Alembert, *Encyclopédie*, 8:165ff.; and M. Gautier d'Agoty *Observations sur l'histoire naturelle sur la physique et sur la peinture* (Paris: Chez Delaguette, 1752), part 2, 68ff.

5. "Voix grave, la physionomie effrontée, la demarche d'un homme, la barbe épaisse, beaucoup de poil sur tout le corps, la poitrine séche et décharnée sans apparence de gorge, & n'éprouvoit aucun écoulement périodique. Enfin c'étoit une fille âgée de 16 ans & très-laide." La Chau and Le Blond, *Description*, 1:107.

6. Jean-Pierre Guicciardi, "Hermaphrodite et le Prolétaire," *Dix-Huitième Siècle* 12 (1980): 49–78.

7. As quoted by Guicciardi, "Hermaphrodite," 67. See also J. Duval, *Traité des hermaphrodits* [1612] (Paris: Isidore, Liseux, 1880), 69: "Celles qui la portent ainsi grosse, longue et bien fournie sont appellez *tribades* par Calius Aurelius 1.4, chap. 9; par Plaute, *subigatrices;* par Arnobus *frictrices*, et par le François, *ribaudes*."

8. The tribade is discussed extensively in Marie-Jo Bonnet, *Un Choix sans équivoque* (Paris: Denoël, 1981).

9. Samuel-Auguste-David Tissot, *L'Ononisme: Dissertation sur les maladies produites par le masturbation*, 10th edition, considérablement augmentée (Toulouse: Laporte, 1775), 51–52.

10. "On ne met plus en question au siècle où nous sommes si dans l'espèce humaine il existe des êtres qui réunissent véritablement les deux sexes. Sans doute il y a eu, et il y a encore aujourd'hui, surtout dans les pays chauds, des femmes en qui certaines parties sont excessivement développées et prolongées; ce qui a pu faire croire à des observateurs peu attentifs qu'elles étoient tout-à-la fois femelles et mâles. Mais ce ne sont là que des apparences trompeuses." La Chau and Le Blond, *Description*, 1:105.

11. Again from the abbés: "In truth there have been women who have strangely abused this defect of their conformation [e.g., the enlarged clitoris] and this abuse is very old. Lucian, in one of his Dialogues introduces two courtesans and one says to the other, 'I have everything necessary to satisfy your desires,' to which the other responds, 'are you a hermaphrodite?'" Later they call these practices of "the most depraved taste and the most immoderate libertinage." *Description*, 1:106.

12. See Duval, *Traité des hermaphrodites*, 67, and also M. de L✱✱✱ [Lignac], *De l'Homme et de la femme considerés physiquement dans l'état du mariage* (Lille: J. B. Henry, 1772), 198. Lignac goes so far as to argue that clitorectomies are "healthy" for girls "if they cannot stifle too strong an attachment to the clitoris."

13. From Rousseau's theories we can see how easily the femme-homme could glide into, or be taken for her sister, the tribade, since passivity and modesty are derived from the female sex and applied to woman's sexuality and social position. With her sexuality focused on the clitoris, the tribade disrupts the complementarity of the active penis and the passive vagina in sexual performance. Playing the active partner, the tribade eschews the female sexual position and, by extension, the passive social role. The femme-homme takes the active cultural role reserved only for those who have the power and the will in the sex act. If social roles derive from—are causally related to—sexuality, then aberrant social behavior implies aberrant sexuality. Reading from cultural role to sexual role, one could suspect that the femme-homme is also a tribade. Jacques Gautier d'Agoty, however, earlier argued that through noting the hermaphrodite's desire one could determine its proper biological sex. For example, he noted that the hermaphrodite Drouart acted like a man, but because Drouart desired men, Gautier d'Agoty determined that she must be sexed as a woman, even if her behavior and appearance were masculine. The argument, however, was proposed to support his point that all hermaphrodites were really women: "Tous les Hermaphrodites en général sont dans le fond des filles mal configurées. Leurs gestes et leur attitude masculine ne prouveroient rien: leurs inclinations dominantes doivent plutôt décider le sexe qui les constitue." Gautier d'Agoty, *Observations*, part 2, 73.

14. "Discours de Chaumette à la Commune de Paris," 181–82.

15. From Sade's *Discours aux mânes de Marat et Le Pelletier* as quoted by Chantal Thomas, "Heroism in the Feminine: The Examples of Charlotte Corday and Madame Roland." *The French Revolution, 1789–1989* (Lubbock: Texas Tech University Press, 1989), 75.

16. Au physique je suis du genre féminin, / Mais au moral je suis du masculin. / Mon existence hermaphrodite / Exerce maint esprit malin. / Mais le satire et son venin / Ne sauraient ternir mon mérite. / Je possède tous les talents, / Sans excepter celui de plaire; / Voyez les fastes de Cythère / Et la liste de mes amants, / Et je pardonne aux mécontents / Qui seraient de l'avis contraire. / Je sais assez passablement / L'orthographe et l'arithmétique, / Je déchiffre un peu la musique, / Et la harpe est mon instrument. / A tous les jeux je suis savante: / Au trictrac, au trente-et-quarante, / Au jeu d'échecs, au biribi, / Au vingt-et-un, au reversi, / Et par les leçons que je donne / Aux enfants sur la quinola, / J'espère bien qu'un jour viendra / Qu'ils pourront le mettre à la bonne. / C'est le plaisir et le devoir / Qui font l'emploi de ma journée; / Le matin, ma tête est sensée, / Elle devient faible le soir. / Je suis monsieur dans le lycée, / Et madame dans le boudoir. "L'Enigme, ou Le Portrait d'une Femme Célèbre" (January 1782). *Correspondance littéraire* 13:64. Footnotes add that the celebrated woman is Mme de Genlis; that a play on words reminds the reader of the accusation against Mme de Genlis of having M. de La Harpe for a lover; and that Mme de Genlis is the governess to the children of the house of Orléans.

17. *Moelleuse* comes from the noun *moelle*, meaning the marrow of a bone. To paint *moelleusement* literally meant to paint softly or with mellowness, but *moelleuse* had

the positive connotations of pithy, full of marrow—in other words of having substance. *Molle*, on the other hand, also meant soft, but had the connotations of slack, flabby, indolent, effeminate.

18. As a general principle, *convenance* held that the formal language—including the touches and paint handling—used to depict a figure must be appropriate to the figure depicted. The artist chose the paint handling appropriate to the sex of the sitter, but paint handling itself was at the same time thought by many to be naturally connected to the person of the artist. These competing notions represent the distinction between style and manner as it developed in eighteenth-century art theory. Style was a mode of working selected according to the subject matter; choosing the appropriate style might be a matter of *convenance*. Manner represented the personal quirks of the artist; the moves that identified a particular work as being "in the manner of" this or that painter. Neither style nor manner were conceived as fundamentally "natural," or innate; they were always—at least in part—learned skills and practiced techniques. Sheriff, *Fragonard: Art and Eroticism* (Chicago: University of Chicago Press, 1990), 48–49.

19. This literature, moreover, only repeated the pattern set in the earliest discussion of their work, published in 1774, when the two young women showed at the exhibition of the Académie de Saint-Luc. Mademoiselle Labille was cited for a "touche très hardie et d'une couleur vraie"; her works had "verité et d'agrément." Mademoiselle Vigée, on the other hand, composed with taste and with fire, but was in general a little mannered in her portraits of women. Her color tonalities were more brilliant and seductive than true. Passez, *Adelaïde Labille-Guiard*, 13.

20. "Observations sur les Ouvrages de Peinture et Sculpture, exposés au Salon du Louvre, le 25 Août 1783," *L'Année Littéraire* 16 (Paris: Chez Mérigot): 260. In 1783 this periodical was edited by Louis Stanislas Fréron.

21. *L'Impartialité au Sallon, dédiée à messieurs les critiques présens et à venir* (1783), Collection Deloynes 303:28.

22. *Correspondance littéraire*, 13:442.

23. *Messieurs*, Collection Deloynes, 295:24.

24. "On peut dire en voyant la touche mâle & ferme de ses Portraits, leurs méplats savans, & leurs plans de lumiere de demi-teintes & d'ombre bien établis, & fortement prononcés, que Madame Guyard s'est fait homme." *L'Impartialité au Sallon, dédiée à messieurs les critiques présens et à venir* (Paris, 1783), Collection Deloynes, 303: 29–30.

25. *Apelle au Sallon* (1783), Collection Deloynes, 288:23.

26. Lichtenstein, "Making Up Representation," 77–86. Throughout the rhetorical tradition excessive ornament was conceptualized through metaphors of femininity, and we have seen how in the mid-eighteenth century Rousseau associated artifice with women and their self-display.

27. "Exposition des Peintures, Sculptures, Dessins & Gravures de MM. de l'Académie Royale en 1783," *Mercure de France*, 20 September 1783, 131.

28. "La Nature est moins brillante, & c'est la Nature que l'on doit chercher à rendre." This commentator also notes that the *éclat* is made to please the multitude, but Madame Lebrun's talents are such that she can aspire to more. "Suite de la Lettre sur le Salon," *Journal de Paris* 23 September 1783, 266:1098.

29. "On trouve en général que le coloris des tableaux de Mme Le Brun a trop

d'éclat; la nature est moins brillante et l'art qui cherche à la surpasser manque son effet." *Correspondance littéraire*, 13:440.

30. "La Peinture est ici la Dame d'atour de la beauté; elle prend soin de la parer avec tout l'art de la coquetterie la plus séduisante; mais l'Art est de le cacher." *Apelle au Sallon*, Collection Deloynes, 288:22–23.

31. *Réponse à toutes les critiques sur les tableaux du Sallon de 1783 par un frère de la Charité* (1783), Collection Deloynes, 307:54.

32. *Le Véridique au Sallon* (Paris: Chez Cailleau, 1783), Collection Deloynes 298:19.

33. For an important discussion of this article see, Vivian Cameron, "Two Eighteenth-Century French Art Critics," *Woman's Art Journal* 5 (Spring–Summer 1984): 8–11.

34. *Avis important d'une femme sur le Sallon de 1785, par madame E.A.R.T.L.A.D.C.S. Dédié aux femmes* (1785), Collection Deloynes, 344:26–27.

35. Ibid., 344:28–29.

36. "C'est un homme que cette femme-là, entends-je dire sans cesse à mon oreille. Quelle fermeté dans son faire, quelle décision dans son ton, & quelles connoissances des effets, de la perspective des corps, du jeu des grouppes & enfin de toutes les parties de son art. C'est un homme, il y a quelque chose là-dessous; c'est un homme. Comme si mon sexe étoit éternellement condamné à la médiocrité." Ibid., 344:28.

37. Sheriff, *Fragonard*, 47.

38. Thomas Crow has accepted the traditional identification of Coup de Patte as Louis de Carmontelle (Louis Carrogis), but Richard Wrigley has questioned this identification. For a discussion of this issue, see Crow's *Painters and Public Life*, 261, n. 48. Crow has associated Coup de Patte, who was among those critics advising Vigée-Lebrun to give up history painting, with the political dissidents of the 1780s. Although his politics might explain his opposition to Vigée-Lebrun, who was closely associated with Marie-Antoinette, it is important to note that the critic excoriates Vigée-Lebrun's history paintings in 1783 and 1785, but he praises her portraits (although quite equivocally) and commends the artist in 1787 for limiting herself to the lesser genres: "Quand je refuserois [mes éloges] à Madame LeBrun, elle en seroit dédommagée par ceux de tout Paris; mais je les lui donne avec d'autant plus de plaisir, qu'elle me paroît avoir renoncé à peindre l'Histoire. Je me sais gré de ma franchise, si mes conseils ont peu engagé à consacrer ses pinceaux à un genre où je ne vois que MM. Roslin, Monnier et Vestier, qui la surpassent. Elle en acquerra une réputation moins douteuse." *Encore un Coup de Patte pour le dernier, ou Dialogue sur le Salon de 1787* (1787), Collection Deloynes 378:30.

39. The exact quotation reads, "Est-elle en état de traiter l'histoire?" For rhetorical effect, I have simplified the question in my translation. However, the French text is interesting in that it again raises the question of état. *Le Triumvirat des arts*, Collection Deloynes, 305:27. For a discussion of the woman history painter in England, see Roworth, "Anatomy is Destiny."

40. "Non. Les bras, la tête, le coeur des femmes sont privés des qualités essentielles pour suivre les hommes dans la haute région des beaux arts. Si la nature en produisoit une capable de ce grand effort, ce seroit une monstruosité d'autant plus choquante, qu'il se trouveroit une opposition nécessaire entre son existence physique & son existence morale. Une femme qui auroit toutes les passions d'un homme, est

réellement un homme impossible. Aussi le vaste champ de l'Histoire, qui n'est rempli que d'objets virgoureusement passionnés, est fermé pour quiconque n'y sauroit porter tous les caractères de vigueur." *Le Triumvirat des arts*, Collection Deloynes, 305:27–28.

41. For a discussion of Gautier d'Agoty, see Guicciardi, "Hermaphrodite," 71–74. For an excellent discussion of the hermaphrodite in the *Encyclopédie*, see James McGuire, "La représentation du corps hermaphrodite dans les planches de l'*Encyclopédie*," in *Recherches sur Diderot et sur l'Encyclopédie* 10 (1991): 109–29.

42. Butler, *Bodies that Matter*, 2.

43. Ibid., 15.

44. Ibid., 93–119.

45. Coup de Patte, *Le Triumvirat des arts*, Collection Deloynes, 305:27.

46. *Changez-moi cette tête, ou Lustucru au Sallon: Dialogue entre le Duc de Marlborough, un Marquis François et Lustucru* (Paris: Chez Belin, 1783), Collection Deloynes, 287:24.

47. "Il seroit injuste d'exiger de l'estimable Artiste dont nous parlons, ces formes grandes & sublimes, qu'on ne peut acquérir que par une profonde étude des chef d'oevures de l'antiquité. Les têtes, dans les Tableaux de Madame *le Brun*, sont très-jolies, assurément, mais ce sont de jolies têtes françoises." Fréron, *L'Année Littéraire*, 16:261.

48. My thinking about the imaginative identification necessary to imitation was stimulated by comments made to me by Whitney Davis.

49. "L'Artiste, dit-il, auroit dû réunir le coloris de l'une à l'élégance de l'autre, pour n'en former qu'une seule: autrefois j'ai rassemblé toutes les Beautés de la Grèce, & je n'ai peint que ma Vénus sortant des eaux." *Apelle au Sallon*, 23. The comment conflates the myth of Apelles and Campaspe with that of Zeuxis choosing his models.

50. "Quelques Critiques, pour diminuer la gloire de l'Artiste, disent que Madame Le Brun, plus à portée qu'une autre de consulter les excellens Modeles, n'a fait ici que les copier. Ils prétendent retrouver dans son tableau le *Guide*, le *Cortone, Cignani, Santere* &c; mais tout cela prouve qu'elle n'en a copié aucun. Si elle a cherché à les imiter, rien n'est plus permis, & c'est même un précepte de l'Art." *Loterie pittoresque pour le Salon de 1783* (1783), Collection Deloynes, 291:23.

51. Because many writers of Salon pamphlets remain anonymous, it is sometimes difficult to know if comments were provoked by the writers' attitudes toward women, or their attitudes toward this particularly controversial woman.

52. This maleness of history painting would later be expressed in Le Sueur's undated gouache, *France Asking the Genius of Painting to Transmit to Future Generations the Glory of the French Victories* (Collection André Claude Bidault de L'isle). In this image the genius of painting is represented by an idealized and muscled male nude seated before the canvas. With the brush held in his right hand touching the canvas, he turns toward the modest female figure of France, who is both muse and victory. As muse, she holds a tablet on which are inscribed the names of the French victories meant to inspire painting, and as victory she holds the laurel wreath and palms that are the emblems she gives to the heroes.

53. For a provocative discussion of this genre of history painting, see Clements, "The Academy and the Other," 469–94. One could say a "feminization" of history

painting had gone on in the first half of the eighteenth century, when the female body and the child's body were featured in mythological subjects of the type popularized by Boucher. Moreover, their categorization as history paintings, as Clements has pointed out, stems from Félibien who included *la fable* in his definition of the genre.

54. Roger de Piles, *Abregé de la vie des peintres* (Hildesheim: George Olms, 1969), 396.

55. Parker and Pollock, *Old Mistresses*, 96. Griselda Pollock later repeated this argument in *Vision and Difference: Femininity, Feminism, and the Histories of Art* (London: Routledge, 1988), 46–48.

56. Joan Rivière, "Womanliness as Masquerade," in V. Burgin, J. Donald, and C. Kaplan, eds., *Formations of Fantasy* (London: Methuen, 1986). For further discussion of the debate over female sexuality, see Stephen Heath, "Joan Rivière and the Masquerade," in Burgin, Donald, and Kaplan, eds., 44–48; Irigaray, *This Sex*, 34–67; Montrelay, *L'ombre et le Nom*, 57–58; Juliet Mitchell and Jacqueline Rose, eds., *Feminine Sexuality: Jacques Lacan and the Ecole Freudienne* (New York: W. W. Norton, 1985), 1–26, 86–98, 99–122.

57. In Rivière's criteria, we find a mix of feminine gender roles (they are "capable housewives"; they "maintain social life and assist culture"; they have "no lack of feminine interests, e.g., in their personal appearance") and heterosexual identity ("sexual relations with [the] husband included . . . full and frequent sexual enjoyment"). Rivière, "Womanliness as Masquerade," 34–35.

58. Ibid., 36–37.

59. Ibid., 38.

60. Parker and Pollock, *Old Mistresses*, 86.

61. Fréron, *L'Année Littéraire*, 16:262.

62. *Loterie pittoresque*, Collection Deloynes, 291:23.

63. "Je ne parlerai pas du Portrait de Madame *Guiard*, peint par elle-même, sans faire une remarque qui me paroît singulière. Ce portrait me paroît inférieur à tous ceux qu'elle a exposés au Salon, & celui de Madame *le Brun*, au contraire, est supérieur à ses autres Ouvrages. Ces deux Dames se sont peintes elles-mêmes une palette à la main; mais Madame *Guiard* est très ressemblante, & Madame *le Brun* l'est si peu, qu'on a de la peine à la reconnoître." Fréron, *L'Année Littéraire*, 16:266.

64. "Remarquez-y mille et mille défauts encore, rien ne sauroit détruire le charme de ce délicieux ouvrage. . . . J'ai vu même, à côté de cet ouvrage, des beautés d'un ordre bien supérieur, mais je n'en point vu qui respirent davantage ce je ne sais quoi qui plaît. . . . On sent qu'il n'y a qu'une femme et une jolie femme qui puisse avoir conçu cette charmante idée, qui puisse l'avoir rendue avec une grâce si brillante et si naïve." *Correspondance littéraire*, 13:441.

65. Sheriff, *Fragonard*, 127–28.

66. "En voyant ce portrait, je crois voir la personne, / C'est Lisette elle-même; elle sort du tableau; / Mais, si je l'ose dire, une chose m'étonne, / C'est que Lisette est laide, & son portrait est beau." *Marlborough au Sallon du Louvre*, Collection Deloynes 301:27. Lisette is a nickname for Elisabeth, and several other more flattering verses refer to Vigée-Lebrun as Lisette.

67. Butler, *Bodies that Matter*, 13.

68. Butler, *Gender Trouble*, 140–41.

69. Ibid., 135–36.

70. I am indebted to Bernadette Fort for bringing this configuration to my attention.

71. Comments by Ann Bermingham suggested this line of reasoning.

72. Aileen Ribeiro, *The Dress Worn at Masquerades in England 1730 to 1790 and its Relation to Fancy Dress in Portraits* (New York: Garland Press, 1984), 144–58.

73. *Messieurs*, Collection Deloynes, 295:23.

74. Ronald Paulson, *Emblem and Expression, Meaning in English Art of the Eighteenth Century* (Cambridge, Mass.: Harvard University Press, 1975), 82.

75. I thank Paula Radisich for suggesting to me the importance of her presentation as Rubens's wife, and refer the reader to her excellent essay on Vigée-Lebrun's self-portrait of 1787, "Qui peut définir les femmes? Vigée-Lebrun's Portraits of an Artist," *Eighteenth-Century Studies* 25 (Summer 1992), 441–68. Although all self-portraits collapse the opposition between subject and object, Vigée-Lebrun's work does so in a particularly emphatic way by taking, not a self-portrait by Rubens, but a portrait of Rubens's wife as its model.

76. Son grand effet réside dans les deux différentes lumières que donnent le simple jour et la lueur du soleil, ainsi les clairs sont au soleil; et ce qu'il me faut appeler les ombres, faute d'un autre mot, est le jour." Vigée-Lebrun, *Souvenirs*, 1:75.

77. Fréron, *L'Année Littéraire*, 16:262.

78. Jacques Derrida, *Memoirs of the Blind: The Self-Portrait and Other Ruins*, trans. Pascale-Anne Brault and Michael Naas (Chicago: University of Chicago Press, 1993), 70–73.

79. I am indebted to James Boyles for his analysis of Reynolds's self-portraits.

80. Vigée-Lebrun, *Souvenirs*, 1:267.

81. Ibid., 1:217–18.

82. "Je ne crois pas qu'aucune femme ait encore porté à un degré aussi éminent ce ton de couleur séduisant & vrai, qui ne seroit pas désavoué de l'immortel *Rubens*. La *Paix ramenant l'Abondance* est un chef-d'œuvre." Fréron, *L'Année Littéraire*, 16:259–60.

83. *Les Peintres volants, ou Dialogue entre un François, et un Anglois, sur les Tableaux exposés au Sallon du Louvre en 1783* (1783), Collection Deloynes, 297:12.

84. Bachaumont, *Mémoires secrets*, 24:6.

85. For a discussion of the relation between painting and acting vis-à-vis Diderot, see Sheriff, *Fragonard*, 146.

86. Butler, *Gender Trouble*, 137.

87. Ibid., 136–37. Here Butler is relying on Esther Newton's *Mother Camp: Female Impersonators in America* (Chicago: University of Chicago Press, 1972).

88. Butler, *Gender Trouble*, 138.

89. Yet, in one sense the self-portrait does tell the "truth" about Vigée-Lebrun, for in "real life" she did act in ways that were inconsistent with any notion of a coherent social or sexual identity. She performed as a mother, an ambitious professional artist, a beautiful society woman, a dutiful daughter, an author, a self-employed artisan, a salonniere, a history painter, an academician, a friend of royalty, a tireless manual laborer, a breadwinner for her husband and daughter, and so forth.

90. Butler, *Bodies that Matter*, 118. Butler is here specifically addressing the inter-

twining of issues of race, gender, sexual identification, class, geopolitical displacement, etc.—identifications that are not merely plural, but invariably imbricated in one another.

91. Ibid., 96.

92. Ibid., 99.

93. Ibid., 102–5.

94. Ibid., 103.

95. Michèle Le Doeuff, among others, has also questioned this division, seeing the positions designated masculine and feminine in the symbolic as phantasms of male theorists.

96. Butler, *Bodies that Matter*, 105.

97. Ibid., 108.

98. Butler takes up the logic of mutual exclusion in hetero- and homosexual identities in ibid., 111–115, and she writes, "It may be that if a lesbian opposes heterosexuality absolutely, she may find herself more in its power than a straight or bisexual woman who knows or lives its constitutive instability." I am suggesting that through Butler we can read Vigée-Lebrun's self-image as acknowledging a "constitutive instability" in its seeming embrace of both female erotic friendship and heterosexual desire.

7. Elisabeth, or Italy

1. "C'est par suite de son amour pour son art qu'elle est partie pour l'Italie au mois d'octobre 1789; elle allait s'instruire et se perfectionner." Mlle Sainte-Beuve, "A propos de l'émigration de Mme Vigée-Lebrun," *Bulletin de la Société de l'Histoire de l'Art Français* (1934), 182. The documents reprinted here are, Archives nationales, AA. 40, dossier 1300. In a second letter, Lebrun wrote, "Je vous représentais qu'elle n'était partie pour l'Italie que dans le dessein de se perfectionner dans son art, et d'y travailler comme elle l'a prouvé en envoyant des tableaux exposés à l'avant-dernier Sallon" (184). Lebrun invoked Sièyes earlier, when he reminds the lawmakers that if through her talent his wife was called to associate with those one improperly calls "les Grands," she was, nevertheless, "née dans la classe utile et honnorable du Peuple," and that "elle en conserva toujours les Principes" (182). In one of the most interesting passages from the second letter, Lebrun compares his wife to Marat, for both were calomnied: "L'Ami du Peuple, avant de tomber sous le poignard du fédéralisme, n'avait-il pas été calomnié?" (184). In a pamphlet defending his wife, however, Lebrun presented a slightly different reason for her leaving France. I am indebted to Madelyn Gutwirth for suggesting to me the importance for women of a trip to Italy.

2. As quoted by J. B. Lebrun in his letter to the Comité de Législation: "Sont exceptés ceux qui justifieront qu'ils se sont livrés à l'étude de sciences, arts et métiers, et ceux qui ont été notoirement connus pour s'être consacrés exclusivement à ces études, et ne s'être absentés que pour acquérir de nouvelles connaissances dans leur état." Sainte-Beuve, "A propos de l'émigration," 185.

3. Alexandre Tuetey, "L'émigration de Madame Vigée-Lebrun," *Bulletin de la Société de l'Histoire de l'Art Français* (1911), 172.

4. In her *Souvenirs* (1:164), she records her triumphant reception by the students in Rome, who exchanged for her brushes the palette of the recently deceased Drouais:

"J'ai reçu la visite des pensionnaires de l'Académie de peinture, au nombre desquels était Girodet. Ils m'ont apporté la palette du jeune Drouais, et m'ont demandé en échange quelques brosses dont je m'étais servie pour peindre."

5. In a pamphlet defending his wife, Lebrun wrote of her voyage, "c'était un conséquence toute simple des calomnies qui la poursuivent." J. B. Lebrun, *Précis historique de la vie de la citoyenne Lebrun, peintre* (Paris: Chez le citoyen Lebrun, 1793), 16. He added, however, that for several years she had wanted to go to Italy, and that the arts could only prosper in peace. Artists only worked well when free of fear and distraction, a point especially true for women because of their delicacy: "Si ce que je dis est vrai pour les hommes qui se sont voués à leur culte, à plus forte raison, puis-je le dire, en parlant d'une femme dont la complexion est délicate, et dont les organes sont affaibles par un long travail, et une constante application." Ibid.

6. "J'avais regretté à Naples, et je regrettais surtout à Rome de ne pas employer mon temps à faire quelques tableaux dont les sujets m'inspiraient. On m'avait nommée membre de toutes les académies de l'Italie, ce qui m'encourageait à mériter des distinctions aussi flatteuses, et je n'allais rien laisser dans ce beau pays qui pût ajouter beaucoup à ma réputation. Ces idées me revenaient souvent en tête; j'ai plus d'une esquisse dans mon portefeuille, qui pourraient en fournir la preuve; mais, tantôt le besoin de gagner de l'argent, puisqu'il ne me restait pas un sou de tout ce que j'avais gagné en France; tantôt la faiblesse de mon caractère, me faisaient prendre des engagements, et je me séchais à la portraiture." Vigée-Lebrun, *Souvenirs*, 1:231.

7. The artist is not suggesting here that she was greedy and could not turn down money, but that she could not say no to a request. At no point do the *Souvenirs* so much as hint at a desire to accumulate wealth as a motive for making art. In fact, Vigée-Lebrun constantly disclaims her interest in, and knowledge of, financial dealings. For anecdotes calculated to demonstrate her total lack of financial acumen, see, for example, ibid., 1:92.

8. "Il en résulte qu'après avoir dévoué ma jeunesse au travail avec une constance, une assiduité assez rares dans une femme, aimant mon art autant que ma vie, je puis à peine compter quatre ouvrages (portraits compris) dont je sois réellement contente." Ibid., 1:231.

9. See Simone de Beauvoir, *The Second Sex*, 133. Beauvoir adds, "To tell the truth, one is not born a genius: one becomes a genius."

10. "Un matin, j'étais à faire ma toilette quand on m'annonça que sept à huit élèves peintres venaient me faire une visite. On les fit entrer dans la chambre où se trouvait placée ma Sibylle, et quelques minutes après j'allai les y recevoir. Après m'avoir parlé de tout le désir qu'ils avaient eu de me connaître, ils me dirent qu'ils seraient heureux de voir quelques-uns des mes ouvrages. —Voici un tableau que je viens de finir, répondis-je en montrant la Sibylle. Tous témoignèrent d'abord une surprise bien plus flatteuse pour moi que n'auraient pu l'être les plus gracieuses paroles; plusieurs s'écrièrent qu'ils avaient cru que ce tableau avait été fait par un des maîtres de leur école, et l'un d'eux se jeta à mes pieds, les larmes aux yeux. Je fus d'autant plus touchée, d'autant plus ravie de cette épreuve, que ma Sibylle a toujours été un de mes ouvrages de prédilection. Si mes lecteurs, en lisant ce récit, m'accusent de vanité, je les supplie de réfléchir qu'un artiste travaille toute sa vie pour avoir deux ou trois moments pareils à celui dont je parle." Vigée-Lebrun, *Souvenirs*, 1:240–41.

11. "Qu'on voie son Hamilton-Sibylle, et qu'on tombe à ses genoux!" As quoted

in Pierre de Nolhac, *Madame Vigée-Lebrun, Peintre de la Reine Marie-Antoinette, 1755– 1842* (Paris: Goupil, 1908), 31.

12. "Mon tableau pour Florence a le plus grand succès. J'aurai l'air de fatuité si je vous explique les détails de sa pleine réussite. Jamais de ma vie je n'ai été encouragée à ce point. J'en jouis d'autant plus que les Romains n'accordent presque rien à notre école (C'est bientôt dit). Mais enfin, ils ont pour moi ce qu'ils n'ont jamais eu, le plus grand enthousiasme. Tous les artistes sont venus, revenus, des princesses de toutes les nations, les hommes de même. Car enfin c'est au point que depuis dix jours, ma mati- née se compte par soixante, quatre-vingts personnes de tout rang. On m'appelle Mme VanDyck, Mme Rubens." Bibliothèque d'Art et d'Archéologie, Paris (Papiers Tripier Le Franc, Carton 52, Dossier II).

13. "Aussitôt après mon arrivée à Rome, je fis mon portrait pour la galerie de Florence. Je me peignis la palette à la main, devant une toile sur laquelle je trace la figure de la Reine avec du crayon blanc. Puis, je peignis miss Pitt, la fille de lord Ca- melfort. Elle avait seize ans, et elle était fort jolie." Vigée-Lebrun, *Souvenirs*, 1:171.

14. Eugène Müntz, "Lettres de Mme Le Brun relatives à son portrait de la Gal- erie des Offices (1791)," *Nouvelles Archives de l'Art Français* (1874–75), 449.

15. Ibid., 450.

16. "Onde pare uscito dal pennello di un uomo di sommo merito, più che da quella di una femmina." Ibid., 452.

17. Letter from Ménageot to d'Angiviller, 3 March 1790: "M*me* *Le Brun* vient de finir son portrait pour la galerie du grand-duc à Florence; c'est une des plus belles choses qu'elle ait faites; j'ai trouvé qu'elle avoit encore beaucoup acquis depuis mon départ de Paris. Ce tableau étonne toutes les personnes qui l'on vue jusqu'à présent; on n'avoit pas à Rome l'idée d'un talent de ce genre." Anatole de Montaiglon and Jules Guiffrey, eds., *Correspondance des directeurs de L'Académie de France à Rome avec les Sur- intendants des Bâtiments* (21 vols.; Paris: Jean Schemit, 1906), 15:401.

18. "Le tableau que Mme *Le Brun* vient de finir a le succès le plus complait; ce n'est qu'une voix dans tout Rome qui est dans l'admiration de son talent et qui met ce portrait au rang de plus belles choses; cela justifie la réputation qui l'avoit devancé et dont on pouvoit peut-être douter, parce qu'on suppose volontiers de l'exagération dans les éloges qu'on fait des talents d'une femme aimable; mais cecy ne laisse point d'équi- voque, car les Romains ne sont pas louangeurs et surtout pour les étrangers." Ibid., 15: 403.

19. "L'Académie de Saint-Luc lui a fait une députation et lui a envoyé des lettres de réception sur le brillant succès de ce tableau, hommage bien flateur pour cet artiste, et également honnorable pour sa patrie et pour son sexe." Ibid., 15:413.

20. Jean Gigoux, *Causeries sur les artistes de mon temps* (Paris: Calmann Levy, 1885), 102.

21. For an excellent discussion of shadows and Italian art theory, see Mary Pardo, "The Subject of Savoldo's *Magdalene*," *Art Bulletin* 71 (March 1989): 65–91.

22. Although not common, shadows are more typically found in portraits (as op- posed to self-portraits) during the eighteenth century. For example, in his 1757 *Portrait of Madame Favart* (Oskar Reinhart Collection, Winterthur, Switzerland), J. E. Liotard renders both the sitter and her profile shadow, which is cast on the wall behind.

23. For the story of Dibutadis, see *Elder Pliny's Chapters on the History of Art*, trans. K. Jex Blake (Chicago: Argonaut Publishers, 1968), 336. Pliny includes the story, not

as an example of the origin of painting, but as an example of the origin of clay sculpture, since Dibutadis's father, Butades, takes her drawing and forms from it a clay model, which he dries and bakes. See also Gary Apgar, *Visualizing Voltaire* (New Haven: Yale University Press, forthcoming); Ann Bermingham, "The Origins of Painting and the Ends of Art: Wright of Derby's Corinthian Maid," in *Painting and the Politics of Culture*, ed. John Barrell (Oxford: Oxford University Press, 1992), 135–65; Derrida, *Memoirs of the Blind*, 49–51; George Levitine, "Addenda to Robert Rosenblum's 'The Origin of Painting: A Problem in the Iconography of Romantic Classicism' " *Art Bulletin* 40 (December 1958): 329–31; Nicholas Mirzoeff, "Body Talk: Deafness, Sign, and Visual Language in the Ancien Régime," *Eighteenth-Century Studies* 25 (Summer 1992): 561–85; Robert Rosenblum, "The Origin of Painting: A Problem in the Iconography of Romantic Classicism," *Art Bulletin* 39 (December 1957): 279–90; and Richard Shiff, "On Criticism Handling History," *Art Criticism* 3 (1968): 60–77.

24. Examples include Joseph-Benoit Suvée, *Butades or the Origin of Drawing* (1791; Bruges, Groeningmuseum); Jean-Baptiste Regnault, *Dibutadis Tracing the Portrait of Her Shepherd, or the Origin of Painting*, (Versailles: Musée du château); Alexander Runciman, *The Origin of Painting* (1771; Scotland: Pencuick House) and Joseph Wright of Derby, *The Corinthian Maid* (1783–84; Washington: National Gallery of Art). Perhaps most significant for my purposes is the example by Regnault that was an overdoor for the Salon des Nobles de la Reine at Versailles, and hence in Marie-Antoinette's apartments.

25. Just as the portrait has been connected to falling in love, it is also connected to moments of remembering the beloved. Madame de Lafayette's *Princess de Clèves* contains one of the most famous literary examples of portrait gazing. Visual images include *Le Portrait Cheri*, engraved after a painting by Schall, and *La Consolation de l'Absence*, engraved by Nicholas Delaunay after a painting by Lavreince. Jean Raoux's evocative, *Young Girl Reading a Letter* (Paris: Musée du Louvre) shows a portrait miniature open on the table beside a woman who reads her letter by candlelight.

26. Bermingham, "Origins of Painting," 153.

27. For a somewhat different discussion of this image, see Apgar, *Visualizing Voltaire*.

28. Derrida, *Memoirs of the Blind*, 49.

29. See my discussion of Condillac in Chapter 1.

30. The relationship between drawing and memory, especially in conjunction with Baudelaire, is discussed in Derrida, *Memoirs of the Blind*, 45–49.

31. Bermingham discusses precisely this issue in her pathbreaking essay.

32. See Chapter 3.

33. This line of reasoning was suggested to me by Mary Garrard's well-known analysis of Artemesia Gentileschi's self-portrait as an allegory of painting. "Artemesia Gentileschi's *Self-Portrait as the Allegory of Painting*," *Art Bulletin* 62 (March 1980): 97–112.

34. For a discussion and reproduction of this image see, Joseph Baillio, "Quelques peintures réattribuées à Vigée Le Brun," *Gazette des Beaux-Arts* 119 (January 1982): 20.

35. Shiff, "On Criticism," 66–67.

36. Derrida, *Memoirs of the Blind*, 62.

37. *Souvenirs*, 1:248.

38. "Ma Sibylle, que l'on venait en foule voir chez moi, ne contribua pas peu, j'imagine, à décider beaucoup de personnes à me demander de les peindre; car j'ai beaucoup travaillé à Vienne" (1:278).

39. Ibid., 1:295–96.

40. Vigée-Lebrun's *Sibyl* or a replica, was sent from St. Petersburg to Paris and shown at the Salon of 1798. In 1819, the Duc de Berri bought the work, having seen it in her London studio. Ibid., 2:221.

41. P. 21. For translations of passages from the novel, I am relying on Avriel H. Goldberger's excellent English version of Germaine de Staël, *Corinne, or Italy* (New Brunswick, N.J.: Rutgers University Press, 1987). Hereafter, page numbers to that edition will be provided in the text. The French text reads: "Elle étoit vêtue comme la sibylle du Dominiquin, un schall des Indes tourné autour de sa tête, et ses cheveux, du plus beau noir, entremêlés avec ce schall." Germaine de Staël, *Corinne, ou L'Italie*, ed. Claudine Herrmann (2 vols.; Paris: Editions des femmes, 1979), 1:45. This edition will be cited in notes, wherever a French citation is supplied.

42. "Mme LeBrun a fait un portrait de moi qu'on trouve très remarquable. Elle l'a porté à Paris. Il est pris comme une sibylle ou comme Corinne si vous l'aimez mieux." *Lettres inédites de Mme de Staël à Henri Meister*, ed. Paul Ustéri and Eugène Ritter (Paris: Hachette, 1903), 195–96.

43. Marie-Claire Vallois, "Old Idols, New Subject: Germaine de Staël and Romanticism," trans. John Gavin, in *Germaine de Staël: Crossing the Borders*, ed. Madelyn Gutwirth, Avriel Goldberger, and Karyna Szmurlo (New Brunswick, N.J.: Rutgers University Press, 1991), 83.

44. "Enfin les quatre chevaux blancs qui traînoient le char de Corinne se firent place au milieu de la foule. Corinne étoit assise sur ce char construit à l'antique, et des jeunes filles, vêtues de blanc, marchaient à côté d'elle. Partout où elle passoit, l'on jetoit en abondance des parfums dans les airs; chacun se mettoit aux fenêtres pour la voir . . . tout le monde crioit: *Vive Corinne! vive le génie, vive la beauté!*" (1:45).

45. "La musique se fit entendre avec un nouvel éclat au moment de l'arrivée de Corinne, le canon retentit, et la sibylle triomphante entra dans le palais préparé pour la recevoir" (1:46–47).

46. "Il n'y avoit certainement rien de plus contraire aux habitudes et aux opinions d'un Anglais, que cette grande publicité donnée à la destinée d'une femme; mais l'enthousiasme qu'inspirent aux Italiens tous les talens de l'imagination, gagne, au moins momentanément, les étrangers, et l'on oublie les préjugés même de son pays" (1:43).

47. J. Tripier le Franc, *Notice sur la vie et les ouvrages de M^{me} Lebrun* (Paris, 1828), 190.

48. See Claudine Herrmann's preface to the *Souvenirs*, 1:9.

8. Germaine, or Corinne

1. Vigée-Lebrun painted her self-portrait for the Grand Duke of Tuscany in 1790 in Rome. Lady Hamilton's notoriety dates particularly from the 1780s and '90s, when as companion, and then wife, to Lord Hamilton, English ambassador to Naples, she performed her famous "attitudes" for the international society of that city. Vigée-Lebrun's portrait of Lady Hamilton as a sibyl made in Naples dates from 1792, and it was well known by April of 1807, when Madame de Staël published *Corinne*. In August of 1807, only four months after the publication and great success of *Corinne*, Elisabeth

Vigée-Lebrun traveled to Madame de Staël's château at Coppet to make her portrait. The artist's *Souvenirs* were published in 1835, and so that text could incorporate all of the earlier works.

2. Madelyn Gutwirth, *Madame de Staël, Novelist: The Emergence of the Artist as Woman* (Urbana: University of Illinois Press, 1978), 173. Gutwirth in a note suggests an analogy between the improvisations of Corinne and those of Lady Hamilton.

3. "On la voyait alors marchant dans son salon, tenant en main une petite branche de verdure; quand elle parlait, elle agitait ce rameau, et sa parole avait une chaleur qui n'appartenait qu'à elle seule; impossible de l'interrompre: dans ces instants elle me faisait l'effet d'une improvisatrice." Vigée-Lebrun, *Souvenirs*, 2:184.

4. Geneviève Gennari, *Le Premier Voyage de Madame de Staël en Italie et la genèse de Corinne* (Paris: Boivin, 1947), 146–48.

5. Adèle d'Osmond, Comtesse de Boigne, *Récits d'une Tante: Mémoires de la Comtesse de Boigne* (Paris: Emile-Paul Frères, 1921), 105.

6. Gutwirth, *Madame de Staël*, 287.

7. The Comtesse de Boigne reported that she fell under Madame de Staël's charm while observing her at the theater, and admitted that "examining the play of her physiognomy I surprised myself in finding her nearly beautiful." *Récits d'une Tante*, 223.

8. "Madame de Staël n'était pas jolie, mais l'animation de son visage pouvait lui tenir lieu de beauté." Vigée-Lebrun, *Souvenirs*, 2:181.

9. See Chapter 1.

10. In her memoirs, the Comtesse de Boigne reconstructs her role in one of Lady Hamilton's performances: "Un jour elle m'avait placée à genoux devant une urne, les mains jointes, dans l'attitude de la prière. Penchée sur moi, elle semblait abîmée dans sa douleur; toutes deux nous étions échevelées. Tout à coup, se redressant et s'éloignant un peu, elle me saisit par les cheveux d'un mouvement si brusque que je me retournai avec surprise et même un peu d'effroi, ce qui me fit entrer dans l'esprit de mon rôle, car elle brandissait un poignard. Les applaudissements passionnés des spectateurs artistes se firent entendre avec les exclamations de Bravo la Médea! Puis, m'attirant à elle, me serrant sur son sein en ayant l'air de me disputer à la colère du ciel, elle arracha aux mêmes voix le cri de Viva la Niobe!" *Récits d'une Tante*, 107.

11. Ibid., 107.

12. "Je me souviens que, lorsque je fis mon premier portrait d'elle en sibylle, elle habitait à Caserte une maison que le chevalier Hamilton avait louée; je m'y rendais tous les jours, désirant avancer mon tableau. La duchesse de Fleury et la princesse Joseph de Monaco assistèrent à la troisième séance, qui fut la dernière. J'avais coiffé madame Harte, car elle n'était pas encore mariée, avec un châle tourné autour de sa tête en forme de turban, dont un bout tombait en faisait draperie. Cette coiffure l'embellissait au point que ces dames la trouvèrent ravissante. Le chevalier nous ayant toutes invitées à dîner, madame Harte passa dans ses appartements pour faire sa toilette, et, lorsqu'elle vint nous retrouver au salon, cette toilette, qui était des plus communes, l'avait tellement changée à son désavantage, que ces deux dames eurent presque toutes les peines du monde à la reconnaître." Vigée-Lebrun, *Souvenirs*, 1:202–3.

13. Baillio has suggested insightfully that Vigée-Lebrun considered the work more as a history painting than a portrait. Joseph Baillio, *Elisabeth Louise Vigée-LeBrun*, 101.

14. This work is illustrated and discussed in ibid., 118–19. The generalized fea-

tures are here replaced by individual traits, particularly noticeable in the long, thin face and nose. The image matches the sitter's "portrait" in the *Souvenirs* (1:312), where she is described as appearing "essentially Greek in character with something Jewish, especially in the profile." Indeed, the textual portrayal could again be a reading of the painting in which Vigée-Lebrun gives us a three-quarter view of the face, and at the same time stresses the sharp line of the profile.

15. All the books represented in her portrait are identifiable: Barthélemy's *Voyage of the Young Anacharsis in Greece* and Locke's 1693 treatise on education rest alongside a score of the comic opera *Nina* and that of J. P. Martiny's *Camille ou la souterraine.* These texts mark the particularity of this woman/reader who held a fashionable salon in St. Petersburg. The figure is naturalized to the extent that she is placed in surroundings specific to her, and in this case the naturalizing works to woman's advantage. In Vigée-Lebrun's portrait, Dolgorouky is not the generic sibyl, but a contemporary intellectual woman. Baillio, *Elisabeth Louise Vigée-LeBrun*, 118–19.

16. Naomi Schor has recently commented on the disembodiment (and disempowerment) inherent in allegorizing representations. See *"Triste Amérique: Atala* and the Postrevolutionary Construction of Woman," in *Rebel Daughters*, ed. Sara E. Melzer and Leslie W. Rabine (New York: Oxford University Press, 1992), 144, 151–52. This disempowerment, however, is not necessarily the case for the allegorical portrait. Helen Borowitz, for example, has drawn our attention to the précieuses' revival of the *portrait deguisé* in "The Unconfessed *Précieuse:* Madame de Staël's Debt to Mademoiselle de Scudéry," *Nineteenth-Century French Studies* (1982): 47–48. Kathleen Nicholson has in progress a major study entitled, " 'Beguiling Deception': Women, Allegory and the French Eighteenth-Century Allegorical Portrait." Focused in the first half of the century, this study will illuminate both the genre and its practitioners, making sense of a popular eighteenth-century portrait type that today is little studied and still less appreciated.

17. Vigée-Lebrun, *Souvenirs*, 2:181.

18. Vigée-Lebrun had the canvas enlarged, as is now visible. She reports the enlarging to Madame de Staël in a letter reproduced in Yvonne Bezard, *Madame de Staël d'après ses portraits* (Paris: Editions Victor Attinger, 1938), 17: "J'attends aujourd'hui ou demain le tableau que j'ai envoyé pour regrandir en bas et des deux côtés, ce qui est une opération qui a demandé un soi extrême et du temps."

19. What the eighteenth-century writers and artists called the Temple of the Sibyl at Tivoli (the round temple), we now know was misnamed by them. The temple that the ancients dedicated to the Sibyl is a rectangular structure visible behind the more famous temple.

20. "J'ai eu bien soin de votre Corine; elle est arrivée à bon port et je vous assure que le tableau est et sera un de mes favoris. Il ne m'aura procuré que du bonheur sans peine, mais aussi je vous promets que j'y mettres tous mes soins pour le bien terminer car il faut qu'il soit le plus possible digne de son original: votre intendant, Madame, m'a fait part de ce que vos amis désirent dans le fond du tableau, le Temple de Tivoli et les cascatelles au lieu du golfe de Naple que je voullois faire dans le lointain. Je vais y réfléchir. Comme j'ai fait l'un et l'autre d'après nature, si cela peut s'arranger avec la composition et les lignes que donne l'attitude, je ferai de prefference ce que vous désirez, n'en doutez pas." Bezard, *Madame de Staël*, 17.

21. Ibid., 17.

22. In 1793, for example, she rendered the Countess Bucquoi (Minneapolis: Minneapolis Institute of Arts) seated in an autumnal landscape suggestive of scenery along the Danube. Configuring the Countess into an L-shape, Vigée-Lebrun repeated that shape in the landscape, so that the vertical tree on the left side of the canvas intersects with the horizontal outcropping on which the sitter rests her elbow. Of special interest here, is Vigée-Lebrun's 1791 portrait of Countess Potocka (Fort Worth: Kimball Museum), which shows the sitter seated by the grotto at Tivoli. This figure is fully integrated into the compositional design, as the lean of her body parallels the diagonal movement of the water falling from high above.

23. Goldberger, trans., *Corinne*, 239. "La terre d'ailleurs y est couverte de tant de fleurs, que c'est le pays où l'on peut le mieux se passer de ces forêts." Hermann, ed., *Corinne*, 2:70. On quotations from *Corinne*, see chapter 7, n. 41.

24. "Cette belle Corinne, dont les traits animés et le regard plein de vie étoient destinés à peindre le bonheur; cette fille du soleil, atteinte par des peines secrètes, ressembloit à ces fleurs encore fraîches et brilliantes, mais qu'un point noir, causé par un piqûre mortelle, menace d'une fin prochaine" (2:77–78).

25. "Cependant Corinne souhaitoit qu'Oswald l'entendît encore une fois, comme au jour du Capitole, avec tout le talent qu'elle avoit reçu du ciel; si ce talent devoit être perdu pour jamais, elle vouloit que ses derniers rayons, avant de s'éteindre, brillassent pour celui qu'elle aimoit. Ce désir lui fit trouver, dans l'agitation même de son âme, l'inspiration dont elle avoit besoin" (2:71).

26. "'La nature, la poésie et l'histoire rivalisent ici de grandeur, ici l'on peut embrasser d'un coup d'oeil tous les temps et tous les prodiges" (2:72).

27. Marie-Claire Vallois, *Fictions féminines: Mme de Staël et les voix de la Sibylle* (Saratoga, Calif.: ANMA, 1987), 151. Indeed, it is here that Corinne sings: "The Neapolitan countryside is the image of human passions: sulfurous and fertile, its pleasures seem born of these flaming volcanoes that give the air so much charm and cause the rumbling of thunder beneath our feet" (Goldberger, trans., *Corinne*, 242).

28. "Errant comme des ombres sur les plages dévastées du fleuve éternal" (2:75).

29. "Amour, suprême puissance du coeur, mystérieux enthousiasme qui renferme en lui-même la poésie, l'héroïsme et la religion! qu'arrive-t-il quand la destinée nous sépare de celui qui avoit le secret de notre âme, et nous avoit donné la vie du coeur, la vie céleste? qu'arrive-t-il quand l'absence ou la mort isolent une femme sur la terre? Elle languit, elle tombe" (2:76).

30. At Miseno, however, the improvisation focuses, at least in part, on the relations between husbands and wives. At Tivoli, that between fathers and sons was more prominent, reminding readers of the paternal ghost that forever stands between Oswald, the dutiful son, and Corinne, the woman-genius unsuited to the domestic confinement proper to an English wife.

31. "C'est nécessairement subordonner la peinture à la poésie, que de la consacrer à des sujets traités par les grands poètes; car il reste de leurs paroles une impression qui efface tout, et presque toujours les situations qu'ils ont choisies tirent leur plus grande force du développement des passions et de leur éloquence, tandis que la plupart des effets pittoresques naissent d'une beauté calme, d'une expression simple, d'une attitude noble, d'un moment de repos enfin, digne d'être indéfiniment prolongé, sans que le regard s'en lasse jamais" (1:220).

32. David Wakefield, ed., *Stendhal and the Arts* (London: Phaidon, 1975), 97.

33. Ibid., 97.

34. In addition to the interpretations of Gutwirth and Vallois, see Schor's final discussion of *Corinne* as a disempowering allegory in *"Triste Amérique"*; Ellen Peel's provocative essay, "Corinne's Shift to Patriarchal Mediation: Rebirth or Regression?" in Gutwirth, Goldberger, and Szmurlo, *Germaine de Staël*, 101–12; and Nancy Miller's "Politics, Feminism, and Patriarchy: Rereading *Corinne*," 193–97 in the same volume.

35. Gutwirth, *Madame de Staël*, 281. Gutwirth discusses the novel's popularity and how women used the novel. Battersby calls it "one of the most influential novels of French Romanticism—and the reference point for generations of women trying to wrestle with the shifting categories of 'female' and 'genius.' " Christine Battersby, *Gender and Genius: Towards a Feminist Aesthetics* (Bloomington: Indiana University Press, 1989), 99.

36. Her writings include *Sapho à Phaon* (1790); *Achille et Déidamie* (1799); *Mort de Lucrèce* (1800); *Athénée des Dames* (1808); *Clémentine, ou l'Evélina française* (1809); *Cours de littérature ancienne et moderne à l'usage des jeunes demoiselles* (1821).

37. The entire poem reads: "Je la vois, je l'entends; tes pinceaux créateurs / Donnent l'âme et la vie et l'esprit aux couleurs; / Voilà ses yeux brillants d'ardentes étincelles, / Ces sons mélodieux, ces cordes immortelles, / Qui des ses chants divins accompagnent les vers, / Et la toile animée en parfume les airs. / Je ne sais qui des deux remporte la victoire: / L'une guide la main, l'autre fixe la gloire, / Et la même couronne enlace en ce tableau / Le front inspirateur et l'immortel pinceau. / Staël offrait à Le Brun un talent digne d'elle; / Le Brun méritait seul un si parfait modèle; / L'univers étonné de cet ensemble heureux / Sans choix tombe en silence au pied de toutes deux." *Souvenirs*, 2:183–84.

38. Derrida, *Memoirs of the Blind*, 34.

39. In Ingres's image female figures stand for the *Iliad*, the *Odyessy*, and Fame.

40. Vigée-Lebrun, for example, called on it for her portrait of the composer Paisiello (1791; Versailles: Musée du château).

41. For example, Gérard's portrait of Gros at age twenty (1791; Toulouse: Musée des Augustins), or Girodet's undated *Self-Portrait* (Versailles: Musée du château), or, more dramatic still, Géricault's presumed portrait of Delacroix (Rouen: Musée des Beaux-Arts). George Levitine has discussed the relation between Girodet's portraits and those of Vigée-Lebrun in *Girodet-Troison: An Iconographical Study* (New York: Garland Press, 1978), 318.

42. Derrida, *Memoirs of the Blind*, 34–35.

43. Vallois, *Fictions féminines*, 129.

44. Barbara Stafford, "Toward Romantic Landscape Perception: Illustrated Travels and the Rise of 'Singularity' as an Aesthetic Category," *Studies in Eighteenth-Century Culture* 10 (1981): 17.

45. For a discussion of gender and genius, particularly in the English tradition, see Christine Battersby, *Gender and Genius*.

46. W. J. T. Mitchell, *Iconology: Image, Text, Ideology* (Chicago: University of Chicago Press, 1986), 129–31. Moreover, this natural aesthetic of domination, Burke extends from the family, "the authority of a father . . . hinders us from having that entire love for him that we have for our mothers." From fathers, the sublime is associated with the power of the state and with God.

47. Naomi Schor, *Reading in Detail: Aesthetics and the Feminine* (New York: Routledge Press, 1989), 11–22.

48. Battersby, *Gender and Genius*, 99.

49. "Une grosse figure rouge, sans fraîcheur, coiffée de cheveux qu'elle appelait pittoresquement arrangés, c'est-à-dire mal peignés; point de fichu, une tunique de mousseline blanche fort décolletée, les bras et les épaules nus, ni châle, ni écharpe, ni voile d'aucun espèce." Comtesse de Boigne, *Récits d'une Tante*, 223.

50. As quoted in Bezard, *Madame de Staël*, 17.

51. "Pourquoi ne viendriez-vous pas, avec Mme Meister, à Coppet. Je voudrais fort que Mme Le Brun vînt à Coppet. Je ne sais si j'oserais me faire peindre en Corinne par elle, mais Mme Récamier serait un charmant modèle. Dans tous les cas, la société de Mme Le Brun est aussi aimable que son talent et nous serions charmés de la voir." *Lettres inédites*, 193.

52. François Gérard's image of Récamier made in 1802 (Paris: Musée Carnavalet) is a good example.

53. "J'ai enfin reçu votre magnifique tableau, Madame, et, sans penser à mon portrait, j'ai admiré votre ouvrage. Il y a là tout votre talent, et je voudrais bien que le mien pût être encouragé par votre exemple; mais j'ai peur qu'il ne soit plus que dans les yeux que vous m'avez donnés." Vigée-Lebrun, *Souvenirs*, 2:182.

54. "Madame votre mère, Madame, a fait de moi Corinne dans un portrait vraiment plus poétique que mon ouvrage." Ibid., 2:183.

55. "Je savais bien que vous trouveriez ce portrait de Mme LeBrun mauvais et disgracieux." Bezard, *Madame de Staël*, 18.

Epilogue

1. Le Doeuff, *Hipparchia's Choice*, 128.

2. Ibid., 129.

3. Here I am borrowing a phrase from the title of Lynn Hunt's essay in *Eroticism and the Body Politic*. It is useful to remember that the reticent Vallayer-Coster, who was probably closer to the queen and enjoyed more privileges than Vigée-Lebrun, was not a target for slanderers, and that the male painters who worked for Marie-Antoinette do not seem to have been subject to malicious rumors.

Selected Bibliography

Primary Sources

MANUSCRIPTS

Papiers Tripier Le Franc. Paris: Bibliothèque d'Art et d'Archéologie.

PRINTED WORKS

Angiviller, Comte d'. *Mémoires de Charles Claude Flahaut Comte de la Billarderie d'Angiviller. Notes sur les Mémoires de Marmontel*, ed. Louis Bobé. Paris: C. Klincksieck, 1933.

Beauchene, Pierre Edme Chauvot de. *De l'Influence des affections de l'âme dans les maladies nerveuses des femmes*. Montpellier: Chez Méquignon, 1781.

Beaumarchais, Pierre-Augustin Caron. *Le Mariage de Figaro*. In *La Trilogie de Figaro*. Paris: Gallimard, 1966.

Bienville, D. T. de. *La Nymphomanie, ou Traité de la fureur utérine*. Amsterdam: Chez Marc-Michel Rey, 1778.

Boigne, Comtesse de [Charlotte Louise Eléonore Adèlaïde d'Osmond]. *Récits d'une Tante: Mémoires de la Comtesse de Boigne*. Paris: Emile-Paul Frères, 1921.

Boudier de Villemert, Pierre-Joseph. *Le Nouvel Ami des femmes, ou La Philosophie du sexe*. Paris: Chez Monory, 1779.

Bressy, Joseph. *Recherches sur les vapeurs*. Paris: Chez Planche, 1789.

Cabanis, Pierre-Jean-Georges. *On the Relations between the Physical and Moral Aspects of Man*, trans. Margaret Saidi; ed. George Mora; intro. Sergio Moravia and George Mora. 2 vols. Baltimore, Md.: Johns Hopkins University Press, 1981.

Campan, Rose. *Mémoires de Madame Campan, première femme de chambre de Marie-Antoinette*, ed. Jean Chalon; notes by Carlos de Angulo. Paris: *Mercure de France*, 1988.

Cerfrol, M. de. *La Gamologie, ou De l'Education des filles destinées au mariage*. Paris: Chez la veuve Duchesne, 1772.

Châtelet, Marquise du. *Réflexions sur le Bonheur*. In *Lettres inédites de Madame le Marquise du Chastelet*. Paris, 1806.

Chazet, Alissan de. *Mémoires, souvenirs, oeuvres & portraits*. Paris: Chez Postel, 1837.

Coicy, Madame de. *Les Femmes comme il convient de les voir ou apperçu de ce que les femmes ont été, de ce qu'elles sont, et de ce qu'elles pourroient être.* 2 vols. Paris and London: Chez Bacot, 1785.

Condillac, Etienne Bonnot, Abbé de. *Essay on the Origin of Human Knowledge.* In *Philosophical Writings of Etienne Bonnot, Abbé de Condillac,* trans. Franklin Philip. 2 vols. Hillsdale, N.J.: Lawrence Erlbaum Associates, 1987.

Condorcet, Jean-Antoine-Nicholas de Caritat, marquis de. "Sur l'admission des femmes au droit de cité." Pp. 53–62 in *Paroles d'hommes (1790–93),* ed., Elisabeth Badinter. Paris: P.O.L., 1989.

Correspondance littéraire, philosophique et critique par Grimm, Diderot, Raynal, Meister, etc., ed. Maurice Tourneux. 16 vols. Paris: Garnier Frères, 1877–82.

Correspondance secrète entre Marie-Thérèse et le Comte de Mercy-Argenteau. Introduction and notes by M. Le Chevalier Alfred d'Arneth and M. A. Geffroy. 4 vols. Paris: Didot, 1874.

Correspondance secrète inédites sur Louis XVI, Marie-Antoinette et la Cour et la ville de 1777–1792. 2 vols. Paris: Henri Plon, 1866.

Diderot, Denis. *Correspondance,* ed. Georges Roth. 16 vols. Paris: Minuit, 1955–1970.

———. *Salons,* ed. J. Seznec and J. Adhémar. 4 vols. Oxford: Clarendon Press, 1963.

Diderot, Denis, and Jean Le Rond d'Alembert, *Encyclopédie, ou Dictionnaire raisonné des sciences, des arts et des métiers, par une société de gens de lettres.* Facsimile of 1751–80 edition. 17 vols. Stuttgart: Friedrich Frommann Verlag, 1967.

Discours de Chaumette à la Commune de Paris. Pp. 179–83 in *Paroles d'hommes (1790–1793),* ed. Elisabeth Badinter. Paris: P.O.L., 1989.

"Documents inédites concernant le peintre Louis Vigée." *Bulletin de la Société de l'Histoire de l'Art Français* (1915/17), 108–10.

DuBos, Jean-Baptiste, Abbé. *Réflexions critiques sur la poësie et sur la peinture.* 3 vols. Paris: Chez Mariette, 1740.

DuPaty, Charles-Marguerite-Jean-Baptiste-Mercier. *Lettres sur l'Italie en 1785.* 2 vols. Paris, 1788.

Duval, Jacques. *Traité des Hermaphrodits* (1612). Paris: Isidore, Liseux, 1880.

Epinay, Louise-Florence-Pétronille Tardieu d'Esclavelles, Marquise de Lalive d'. *Les conversations d'Emilie.* Paris: Chez Belin, 1782.

———. *Mes moments heureux.* Geneva, 1759.

Fabre, Pierre. *Essai sur les facultés de l'âme.* Paris and Amsterdam, 1785.

Falconet, Etienne. "Traduction du trente-quatrième livre de Pline." *Oeuvres complètes.* 3 vols. Paris: Denfu, 1808; repr. Geneva: Slatkine Reprints, 1970.

La Femme Foible. Où l'On Représente aux femmes les dangers auxquels elles s'exposent, par un commerce fréquent et assidu avec les hommes: à quoi on a joint quelques avis touchant leur conduite. Nancy, 1733.

Flammeront, Jules. *Remonstrances du Parlement de Paris.* 3 vols. Paris: Imprimerie Nationale, 1898.

Fréron, Elie Catherine. *L'Année Littéraire,* 16 vols. Paris: Chez Mériot, 1751–89.

Gautier d'Agoty, Jacques. *Observations sur l'histoire naturelle sur la physique et sur la peinture.* Paris: Chez Delaguette, 1752.

Genlis, Stéphanie Félicité, Comtesse de. *De l'Influence des femmes sur la littérature française comme protectrices des lettres et comme auteurs.* 2 vols. Paris: Lecointe et Durcy, 1826.

Gigoux, Jean. *Causeries sur les artistes de mon temps.* Paris: Calmann Levy, 1885.

Graillard de Graville, Barthélémy-Claude. *L'Ami des filles.* Paris: Dufour, 1761.

Guiffrey, J. J. "Ecoles de Demoiselles dans les Ateliers de David et de Suvée au Louvre." *Nouvelles Archives de l'Art Français* (1874–75), 396–97.

Guyon, Jean Baptiste Denis. *Histoire des Amazones anciennes et modernes.* 2 vols. Paris: Chez Jean Vilette, 1740.

Jouard, Gabriel. *Nouvel essai sur la femme considérée comparativement à l'homme.* Paris, 1804.

Jourdan, A.-J.-L., F. A. Isambert, and Decrusy, eds. *Recueil général des anciennes lois françaises depuis l'an 420 jusqu'à la Revolution de 1789.* 29 vols. Paris, 1882–1933.

L∗∗∗ M. de [Louis-François Luc Lignac]. *De l'Homme et de la femme considerés physiquement dans l'état du mariage.* Lille: J. B. Henry, 1772.

La Chau, Abbé de, and Abbé Le Blond. *Description des principales pierres gravées du Cabinet de J.A. Monseigneur le Duc d'Orléans.* 2 vols. Paris: Pissot, 1780.

La Font de Saint-Yenne. *Réflexions sur quelques causes de l'état présent de la peinture en France* [1747]. Geneva: Slatkine Reprints, 1970.

Lebreton, Joachim. *Notice nécrologique sur Mme Vincent née Labille.* Paris, l'an XI [1803].

Lebrun, J.-B. *Almanach historique et raisonné des architectes, peintres, scullpteurs, graveurs et cizelleurs.* Paris, 1777.

———. *Prècis historique de la vie de la citoyenne Lebrun, peintre.* Paris: Chez le citoyen Lebrun, 1793.

Lebrun, Ponce Denis Ecouchard [called Lebrun-Pindare]. "Vers à Madame Lebrun sur les critiques imprimées lors de l'exposition des tableaux du Louvre en 1785." Collection Deloynes #1346.

Lemoyne, Pierre. *La Gallerie des femmes fortes.* Paris: Charles Angot, 1760.

Lessing, Gotthold Ephraim. *Laocöon: An Essay on the Limits of Painting and Poetry*, trans. Ellen Frothingham. New York: Noonday Press, 1957.

"Lettre de Madame Lebrun à M. de Calonne." Paris, 1789.

Mémoires secrets pour servir à l'histoire de la république des lettres en France depuis MDCCLXII jusqu'à nos jours, ou Journal d'un observateur. 36 vols. London: J. Adamson, 1780–89.

Montaiglon, Anatole de, and Jules Guiffrey, eds., *Correspondance des directeurs de L'Académie de France à Rome avec les Surintendants des Bâtiments.* 21 vols. Paris: Jean Schemit, 1906.

Montesquieu, Charles de Secondat, baron de. *Essai sur le goût.* Paris: Armand Colin, 1993.

Opinions de femmes de la veille au lendemain de la révolution française, with a preface by Geneviève Fraisse. Paris: Côté-femmes, 1989.

P∗∗∗, Madame de. *Conseils à une amie.* Paris, 1749.

Pahin de la Blancherie, Claude-Mammès. *Nouvelles de la République des Lettres et des Arts.* 1779–87.

Piles, Roger de. *Abrégé de la vie des peintres, avec des réflexions sur leurs ouvrages, et un traité du peintre parfait.* Hildesheim: George Olms, 1969.

———. *Cours de peinture par principes*, intro. Thomas Puttfarken. Nîmes: Editions Jacqueline Chambon, 1990.

Pinel, Philippe. *Nosographie philosophique, ou La Méthode de l'analyse appliquée à la médecine.* 3 vols. Paris: Chez J. A. Brosson, 1813.

Pomme, Pierre. *Traité des affections vaporeuses des deux sexes.* Paris: Chez Desaint et Saillant, 1760.

Porte-Feuille d'un Talon Rouge: Contenant des anecdotes galantes et secrètes de la cour de France. Paris, 1783.

Pothier, Joseph. *Traité de la puissance du mari sur la personne et les biens de la femme.* In *Oeuvres de Pothier,* ed. M. Dupin. Paris: Chasseriau Librairie, 1823.

Procès-verbaux de l'Académie Royale de Peinture et de Sculpture, ed. Anatole de Montaiglon, 11 vols. Paris: Charavay Frères, 1889.

Prost de Royer, Antoine-François. *De l'Administration des femmes.* Geneva, 1782.

Qu'est-ce qu'une femme? with a preface by Elisabeth Badinter. Paris: P.O.L., 1989.

Répertoire de jurisprudence. Paris: Chez Visse, 1784.

"Réponse de M. de Calonne à la dernière lettre de Madame Lebrun." Paris, 1789.

Riballier, [?]. *De L'Education physique et morale des femmes.* Brussels and Paris: Chez les Frères Estienne, 1779.

Rocheterie, Maxime de la, and the Marquise de Beaucourt, eds. *Lettres de Marie-Antoinette.* Paris: Alphonse Picard et fils, 1895.

Rousseau, Jean-Jacques. "Discourse on the Origin and Foundations of Inequality Among Men." In *The First and Second Discourses,* trans. Roger D. Masters and Judith R. Masters; ed. Roger D. Masters. New York: St. Martin's Press, 1964.

———. *Oeuvres complètes,* ed. Bernard Gagnebin and Marcel Raymond. 4 vols. Paris: Gallimard, 1959–1969.

———. *Lettre à Mr. D'Alembert sur les Spectacles,* ed. M. Fuchs. Geneva: Droz, 1948.

Roussel, Pierre. *Système physique et moral de la femme.* Paris: Chez Vincent, 1775.

Staël, Germaine de. *Corinne, ou L'Italie,* ed. Claudine Herrmann. 2 vols. Paris: Editions des femmes, 1979.

———. *Corinne, or Italy,* trans. Avriel H. Goldberger. New Brunswick, N.J.: Rutgers University Press, 1987.

———. *Lettres de Mme de Staël à Henri Meister,* ed. Paul Ustéri and Eugène Ritter. Paris: Hachette, 1903.

———. *Réflexions sur les procès de la reine par une femme,* intro. Monique Cottret. Montpellier: Les Presses du Languedoc, 1994.

Tissot, Samuel-Auguste-David. *Essai sur les maladies des gens du monde.* In *Collection des ouvrages de Médecine de M. Tissot.* Paris: Didot, 1771.

———. *L'Onanisme: Dissertation sur les maladies produites par le masturbation.* 10th edition, considérablement augmentée. Toulouse: Laporte, 1775.

———. *De la santé des gens de lettres et des valetudinaires.* In *Oeuvres complètes de Tissot.* Paris: Chez Allent, 1809.

Tripier Le Franc, J. "Actes de mariage et de divorce de Madame Vigée Le Brun." *Nouvelles Archives de l'Art Français* (1876), 396–99. Paris: J. B. Dumolin.

Trumbull, John. *The Autobiography of Colonel John Trumbull,* ed. Theodore Sizer. New Haven: Yale University Press, 1953.

Vigée, Louis. *Poésies de L. J. B. E. Vigée.* 5th ed. Paris: Delaunay, 1813.

———. *Manuel de littérature à l'usage des deux sexes.* Paris: Chez François Louis, 1821.

Vigée-Lebrun, Elisabeth. *Souvenirs de Madame Louise-Elisabeth Vigée-Lebrun.* 3 vols. Paris: Librairie de H. Fournier, 1835.

———. *Souvenirs,* ed. Claudine Herrmann. 2 vols. Paris: Des femmes, 1986.

Virard, P. *Essai sur la santé des filles nubiles.* Paris: Chez Monory, 1776.

Voltaire, François-Marie Arouet de. *Correspondance.* Vol. 37 in *Les Oeuvres complètes de Voltaire,* ed. Theodore Besterman et. al. 135 vols. Geneva: Institut et musée Voltaire, 1970.

Wille, Jean-Georges. *Mémoires et Journal de J. G. Wille,* ed. Georges Duplessis. 2 vols. Paris: Jules Renouard, 1857.

SALON PAMPHLETS

Citations in notes to pamphlets held in the Deloynes Collection (Paris, Bibliothèque Nationale, Department des Estampes) include their reference number in that collection. They are not reproduced here.

1783

Apelle au Sallon.

Changez-moi cette tête, ou Lustucru au Sallon: Dialogue entre le duc de Marlborough, un marquis françois et Lustucru.

Coup de Patte [pseud.]. *Le Triumvirat des arts, ou Dialogue entre un peintre, un musicien & un poëte sur les tableaux exposés au Louvre, année 1783, pour servir de continuation au Coup de Patte & à la patte de velours.*

La Critique est aisée, mais l'art est difficile.

Entretiens sur les tableaux exposés au Sallon en 1783.

Explication des peintures, scullptures et gravures de Messieurs de l'Académie Royale.

L'Impartialité au Salon, dédiée à messieurs les critiques présens et à venir.

Loterie pittoresque pour le Salon de 1783.

Marlborough au Sallon du Louvre.

Messieurs, ami de tout le monde.

Miramond, [M. de]. *Vers à Madame Le Brun, de l'Académie Royale de Peinture, sur les principaux ouvrages, dont elle a décoré le Sallon cette année.*

Momus au Sallon, Comédie-Critique en vers et en vaudevilles, suivie de notes critiques.

La Morte de trois milles ans au Salon de 1783.

Observations générales sur le Sallon de 1783, et sur l'état des arts en France, by M. L'★★★★ P★★★★.

Les Peintres volants, ou Dialogue entre un françois, et un anglois, sur les tableaux exposés au Sallon du Louvre en 1783.

Réponse à toutes les critiques sur les tableaux du Sallon de 1783 par un frère de la Charité.

Réponse aux critiques des tableaux du Sallon de 1783.

Le Sallon à l'encan. Rève pittoresque, melé de Vaudevilles.

Le Songe, ou La Conversation a laquelle on ne s'attend pas, scène critique.

Le Véridique au Sallon.

1785

L'Aristarque moderne au Salon.

Avis important d'une femme sur le Sallon de 1785, par madame E.A.R.T.L.A.D.C.S. Dédié aux femmes.

Discours sur l'origine, les progrès et l'état actuel de la peinture en France, contenant des notices sur les principaux artistes de l'Académie.

L'Espion des peintres de l'Académie Royale.
Explication des peintures, scullptures et gravures de Messieurs de l'Académie Royale.
Figaro au Salon de Peinture, pièce épisodi-critique, en prose et en vaudevilles, par l'auteur de Momus au Sallon.
Le Frondeur ou dialogue sur le Sallon, par l'auteur du coup de patte et du Triumvirat.
Impromptu sur le Sallon des tableaux exposés au Louvre en 1785.
Inscriptions pour mettre au bas de différentes tableaux exposés au Sallon du Louvre en 1785.
Jugement d'un musicien sur le Salon de peinture de 1785.
Mélanges de doutes et d'opinions sur les tableaux exposés au Sallon du Louvre en 1785.
Minos au Sallon, ou La Gazette infernale.
Observations critiques sur les tableaux du sallon de l'année 1785.
Observations sur le Sallon de 1785. Extraits du Journal général de France.
Le peintre anglais au Salon de peintures exposées au Louvre en l'année 1785.
Promenades de Critès au Sallon de 1785.
Réflexions impartiales sur le progrès de l'art en France 1785.
Les Tableaux, ou Réflexions tardives d'un bon homme qui arrive de la campagne sur le Sallon de 1785.
Vers à Madame Guyard sur le Sallon de 1785.

1787
L'Ami des artistes au Sallon.
Aventures de Critès au Sallon, seconde journée après-midi.
Le Bouquet du Sallon.
La Bourgeoise au Sallon.
Le Cousin Jacques hors du Sallon, folie sans conséquence à l'occasion des tableaux exposées au Louvre.
Critiques des quinze critiques du Salon ou notice faite pour donner une idée des brochures.
Encore un Coup de Patte pour le dernier, ou Dialogue sur le Salon de 1787.
Explication des peintures, scullptures et gravures de Messieurs de l'Académie Royale.
Les grandes prophéties du grand Nostradamus sur le grand Salon de peinture de l'an de grâce 1787.
Lanlaire au Salon académique de peinture.
Lettre d'un amateur de Paris à un amateur de province sur le Sallon de peinture de l'année 1787.
Merlin au Salon en 1787.
L'Ombre de Rubens au Sallon ou l'Ecole des peintres.
La Plume du coq Micille ou Aventures de Critès au Sallon.
Observations critiques sur les tableaux du Sallon de l'année 1787.
Promenades d'un observateur au Sallon de l'année 1787.
Tarare au Sallon de peinture de 1787.

1789
Les Elèves au Salon, ou l'Amphigouri.
Explication des peintures, scullptures et gravures de Messieurs de l'Académie Royale.
Entretien entre un amateur et un admirateur sur les tableaux exposés au Sallon de Louvre, 1789.
Le Frondeur au Salon du Louvre de l'année 1789, anecdotes intéressantes.

L'Observateur au Sallon de l'année 1789.
Observations critiques sur les tableaux du Salon de l'année 1789.
Pensées d'un prisonnier de la Bastille sur les tableaux exposés au Sallon du Louvre.
Remarques sur les ouvrages exposés au Salon.
Sur l'Exposition des tableaux au Sallon du Louvre.
Vérités agréables, ou Le Salon vu en beau.

1791
Ouvrages de peintures, sculptures et architectures, gravures, dessins exposés au Louvre par ordre de l'Assemblée Nationale au mois de septembre 1791, l'an III de la Liberté.
Explication des peintures, sculptures et gravures de Messieurs de l'Académie Royale dont l'exposition a été ordonnée par Sa Majesté.
Explication et critique impartiale de toutes les peintures, sculptures, gravures, dessins exposés au Louvre.
Le plaisir prolongé. Le Retour du Salon chez soi et celui de l'abeille dans sa ruche.

Secondary Sources and Theoretical Writings

Adams, Christine. "Defining *Etat* in Eighteenth-Century France: The Lamothe Family of Bordeaux." *Journal of Family History* 17 (1992): 25–45.

Apgar, Gary. *Visualizing Voltaire.* New Haven: Yale University Press. Forthcoming.

Applewhite, Harriet Bronson, and Darlene Gay Levy. "Gender, Ceremony, and National Consciousness: Women and Oathtaking in Revolutionary Paris," 1557–60. *Transactions of the Seventh International Congress on the Enlightenment.* 3 vols. *Studies in Voltaire and the Eighteenth Century* 265. Oxford: Siden Press, 1989.

Arnaud-Bouteloup, Jeanne. *Marie-Antoinette et l'art de son temps.* Strasbourg: Imprimerie Alsacienne, 1924.

Badinter, Elisabeth. *Emilie, Emilie ou l'ambition féminine au XVIIIe siècle.* Paris: Flammarion, 1983.

Baillio, Joseph. *Elisabeth-Louise Vigée Le Brun, 1755–1842.* Fort Worth: Kimball Art Museum, 1982.

———. "Marie-Antoinette et ses enfants par Mme Vigée Le Brun." *L'Oeil* 308 (March 1981): 34–41 and 74–75; and 310 (May 1981): 53–60 and 90–91.

———. "Quelques peintures réattribuées à Vigée Le Brun." *Gazette des Beaux-Arts* 119 (January 1982): 13–26.

Battersby, Christine. *Gender and Genius: Towards a Feminist Aesthetics.* Bloomington: Indiana University Press, 1989.

Beaujour, Michel. *Miroirs d'encre: Rhétorique de l'autoportrait.* Paris: Seuil, 1980.

Beauvoir, Simone de. "Women and Creativity." In *French Feminist Thought: A Reader,* ed. Toril Moi. London: Basil Blackwell, 1987.

———. *The Second Sex,* trans. and ed. H. M. Parshley. New York: Vintage Books, 1989.

Benhamou, Reed. *Public and Private Art Education in France. Studies on Voltaire and the Eighteenth-Century* 308. Oxford: Siden Press, 1993.

———. "The Verdigris Industry in Eighteenth-Century Languedoc: Women's Work and Women's Art." *French Historical Studies* 16 (Spring 1990): 560–75.

Bermingham, Ann. "The Origins of Painting and the Ends of Art: Wright of Derby's

Corinthian Maid." Pp. 135–65 in *Painting and the Politics of Culture*, ed. John Barrell. Oxford: Oxford University Press, 1992.

Bezard, Yvonne. *Madame de Staël d'après ses portraits*. Paris: Editions Victor Attinger, 1938.

Bibliothèque Nationale, Cabinet des Estampes. *Ancien Régime. I Un Siècle d'histoire de France par l'estampe 1770–1871. Collection De Vinck; inventaire analytique par François-Louis Brunel.* Paris: Imprimerie nationale, 1909.

Blanc, Charles. *Histoire des peintres de toutes les écoles*. 14 vols. Paris: Librairie Renouard, 1861–76.

Blum, André. *Madame Vigée-Lebrun: Peintre des grandes dames du XVIIIe siècle*. Paris: L'éditions d'Art: 1919.

Blum, Carol. *Rousseau and the Republic of Virtue*. Ithaca, N.Y.: Cornell University Press, 1986.

Bonnet, Marie-Jo. *Un choix sans équivoque*. Paris: Editions Denoël, 1981.

Borowitz, Helen. "The Unconfessed *Précieuse*: Madame de Staël's Debt to Mademoiselle de Scudéry." *Nineteenth-Century French Studies* (1982): 32–59.

Bouchot, Henri. "Marie-Antoinette et ses peintres." *Les Lettres et les Arts* 1 (1887): 21–59.

Brennan, Teresa, ed. *Between Feminism and Psychoanalysis*. London: Routledge, 1989.

Brisson, Marie. "Dire l'inconnue: 'Sur les femmes' de Diderot." *L'Esprit Créateur* 29 (Fall 1989): 10–20.

Brocard, Nicole Willk. *François-Guillaume Ménageot*. Paris: Arthena, 1976.

Bronfen, Elizabeth. *Over Her Dead Body: Death, Femininity and the Aesthetic*. London: Routledge, 1992.

Bryson, Norman. *Tradition and Desire From David to Delacroix*. Cambridge: Cambridge University Press, 1984.

Bucci, Mario. *Anatomia Come Arte*. Florence: Edizione D'Arte Il Fiorino, 1969.

Burke, Peter. *The Fabrication of Louis XIV*. New Haven: Yale University Press, 1993.

Burns, E. Jane. *Body Talk: When Women Speak in Old French Literature*. Philadelphia: University of Pennsylvania Press, 1993.

Butler, Judith. *Gender Trouble*. London: Routledge, 1991.

———. *Bodies that Matter*. London: Routledge, 1993.

Cameron, Vivian. "Two Eighteenth-Century French Art Critics." *Woman's Art Journal* 5 (Spring–Summer 1984): 8–11.

Charavay, Etienne. "Réception de Mmes Vigée-Lebrun et Guiard à l'Académie de peinture." *Nouvelles Archives de l'Art Français* 6 (1890): 181–82. Paris: J. B. Dumolin.

Castle, Terry. "Marie-Antoinette Obsession." *Representations* 38 (Spring 1992): 1–38.

———. *Masquerade and Civilization*. Stanford: Stanford University Press, 1986.

Chadwick, Whitney. *Women, Art, and Society*. London: Thames and Hudson, 1990.

Chronicle of the French Revolution. London: Chronicle Publications, 1989.

Cixous, Hélène. "The Laugh of the Medusa." Pp. 279–97 in *The Signs Reader*, trans. Keith Cohen and Paula Cohen. Chicago: University of Chicago Press, 1983.

Clements, Candace. "The Academy and the Other: Les Grâces and Le Genre Galant." *Eighteenth-Century Studies* 25 (Summer 1992): 469–94.

Clinton, Katherine. "Femme et Philosophe: Enlightenment Origins of Feminism." *Eighteenth-Century Studies* 8 (Spring 1975): 283–99.
Colwill, Elizabeth. "Just Another Citoyenne? Marie-Antoinette on Trial." *History Workship* 28 (Autumn 1989): 63–87.
Crow, Thomas. *Painters and Public Life in Eighteenth-Century Paris.* New Haven: Yale University Press, 1985.
Cuno, James, ed. *French Caricature and the French Revolution, 1789–1799.* Berkeley and Los Angeles: University of California Press, 1988.
Darrow, Margaret. "French Noblewomen and the New Domesticity 1750–1850." *Feminist Studies* 5 (Spring 1979): 41–61.
Dean, Carolyn. *The Self and its Pleasures: Bataille, Lacan, and the History of the Decentered Subject.* Ithaca, N.Y.: Cornell University Press, 1992.
DeJean, Joan. "Looking Like a Woman, The Female Gaze in Sappho and Lafayette." *L'Esprit Créateur* 28 (Winter 1988): 34–45.
———. "Staël's *Corinne*, The Novel's Other Dilemma." *Stanford French Review* 11, no. 1 (1987): 77–87.
Dekker, H. T. Douwes. "Angelica Kauffman imitatrice de Madame Vigée-Lebrun?" *Gazette des Beaux-Arts* 104 (November 1984): 195.
———. "Elisabeth Louise Vigée-Lebrun, 1755–1842: Portraits à l'huile." Typescript, 1984. (Privately circulated; copy in Paris, Bibliothèque Nationale.)
———. "Gli Autoritratti di Elisabeth Vigée-Lebrun (1755–1842). *Antichità viva* 22 (July–August 1983): 31–35.
DeLauretis, Teresa. *Alice Doesn't: Feminism, Semiotics, Cinema.* Bloomington: Indiana University Press, 1984.
———. "Sexual Indifference and Lesbian Representation." *Theatre Journal* 40 (May 1988): 155–78.
———. *Technologies of Gender: Essays on Theory, Film, and Fiction.* Bloomington: Indiana University Press, 1987.
Delcourt, Marie. *Hermaphrodite*, trans. Jennifer Nicholson. London: Studio Books, 1961.
Derrida, Jacques. *The Archeology of the Frivolous: Reading Condillac*, trans. John P. Leavey. Pittsburgh: Duquesne University Press, 1973.
———. *Memoirs of the Blind: The Self-Portrait and Other Ruins*, trans. Pascale-Anne Brault and Michael Naas. Chicago: University of Chicago Press, 1993.
———. *Of Grammatology*, trans. Gayatri Spivak. Baltimore: Johns Hopkins University Press, 1976.
Devance, Louis. "La feminisme pendant la revolution française." *Annales Historiques de la Revolution Française* 229 (July–September 1977): 341–76.
Doane, Mary Ann. "Film and the Masquerade: Theorising the Female Spectator." *Screen* 23 (1982): 74–87.
———. *The Desire to Desire: The Woman's Film of the 1940s.* Bloomington: Indiana University Press, 1987.
Duvivier, M. "Sujets des morceaux de réception des membres de l'ancienne Académie de Peinture, Sculpture et Gravure 1648–1793." *Archives de l'Art Français* 10 (1852–53). Paris: J.B. Dumolin; repr. Paris: F. de Nobèle, 1967.
Epstein, Julia. "Either/Or–Neither/Both: Sexual Ambiguity and the Ideology of Gender." *Genders* 7 (Spring 1990): 99–142.

Epstein, Julia and Kristina Straub, eds. *Body Guards*. London: Routledge, 1991.

Faludi, Susan. *Backlash: The Undeclared War against American Women*. New York: Crown Publishers, 1991.

Fidière, Octave. *Les Femmes artistes à l'Académie Royale de Peinture et de Sculpture*. Paris: Charavay Frères, 1885.

Flammermont, J. "Les portraits de Marie-Antoinette." *Gazette des Beaux-Arts* 18 (1897): 5–21.

Fort, Bernadette. "Voice of the Public: Carnavalization of Salon Art in Pre-Revolutionary France." *Eighteenth-Century Studies* 22 (Summer 1989): 368–94.

———, ed. *Fictions of the French Revolution*. Evanston, Ill.: Northwestern University Press, 1991.

Foucault, Michel. *The Birth of the Clinic*, trans. A. M. Sheridan Smith. New York: Vintage Books, 1973.

Fournier-Sarlovèze, Joseph Raymond. *L. A. Brun. Peintre de Marie-Antoinette, 1758–1815*. Paris: Goupil, 1911.

Fraisse, Geneviève. *La Muse de la raison*. Aix-en-Provence: Alinéa, 1989.

———. *La Raison des femmes*. Paris: Plon, 1992.

Frappier-Mazur, Lucienne. "Marginal Canons: Rewriting the Erotic." *Yale French Studies* 75 (1988): 112–28.

Freud, Sigmund. "Femininity." Pp. 99–119 in *New Introductory Lectures on Psychoanalysis*, trans. and ed. James Strachey. New York: W. W. Norton, 1964.

Fritz, Paul, and Richard Morton, eds. *Woman in the Eighteenth Century and Other Essays*. Toronto: Samuel Stevens Hakkert and Company, 1976.

Fuss, Diana. *Essentially Speaking: Feminism, Nature and Difference*. London: Routledge, 1989.

Gallet, Michel. "La Maison de Madame Vigée-Lebrun Rue du Gros-Chenet." *Gazette des Beaux-Arts* 56 (November 1960): 275–84.

Gallop, Jane. *The Daughter's Seduction: Feminism and Psychoanalysis*. Ithaca, N.Y.: Cornell University Press, 1982.

Garrard, Mary. "Artemesia Gentileschi's *Self Portrait as the Allegory of Painting*." *Art Bulletin* 62 (March 1980): 97–112.

Gelbart, Nina Rattner. *Feminine and Opposition Journalism in Old Regime France: Le Journal des Dames*. Berkeley and Los Angeles: University of California Press, 1987.

Gennari, Geneviève. *Le Premier Voyage de Madame de Staël en Italie et la genèse de Corinne*. Paris: Boivin, 1947.

Gilman, Sander. *Sexuality: An Illustrated History*. New York: Wiley, 1989.

Goldstein, Jan. *Console and Classify*. Cambridge: Cambridge University Press, 1987.

Goodman, Dena. "Filial Rebellion in the Salon: Madame Geoffrin and Her Daughter." *French Historical Studies* 16 (Spring 1989): 27–47.

———. "Public Sphere and Private Life: Toward a Synthesis of Current Historiographical Approaches to the Old Regime." *History and Theory* 31 (1992): 1–20.

———. *The Republic of Letters: A Cultural History of the French Enlightenment*. Ithaca, N.Y.: Cornell University Press, 1994.

Goulemot, Jean-Marie. "Prêtons la main de la nature. II. Fureurs utérines." *Dix-Huitième Siècle* 12 (1980): 97–111.

Grell, Chantel, and Christian Michel. *L'Ecole des princes, ou, Alexandre disgracié: Essai sur la mythologie monarchique de la France absolutiste.* Paris: Belles Lettres, 1988.

Grosz, Elizabeth. *Jacques Lacan: A Feminist Introduction.* London: Routledge, 1990.

———. *Sexual Subversions: Three French Feminists.* Sidney: Allen and Unwin, 1989.

Guicciardi, Jean-Pierre. "Hermaphrodite et le Prolétaire." *Dix-Huitième Siècle* 12 (1980): 49–78.

Guiffrey, J. J. "Les expositions de l'Académie de Saint-Luc et leurs critics." *Bulletin de la Société de l'Histoire de l'Art Français* (1910): 77–124.

———. "Histoire de l'Académie de Saint-Luc." *Archives de l'Art Français* 9 (1915).

Gutwirth, Madelyn. *Madame de Staël, Novelist: The Emergence of the Artist as Woman.* Urbana: University of Illinois Press, 1978.

———. *The Twilight of the Goddesses: Women and Representation in the French Revolutionary Era.* New Brunswick, N.J.: Rutgers University Press, 1992.

Gutwirth, Madelyn, Avriel Goldberger, and Karyna Szmurlo, eds. *Germaine de Staël: Crossing the Borders.* New Brunswick, N.J.: Rutgers University Press, 1991.

Hafter, Daryl M. "Artisans, Drudges, and the Problem of Gender in Pre-Industrial France." In *Science and Technology in Medieval Society,* ed. Pamela O. Long. *Annals of the New York Academy of Sciences* 441 (1985): 71–87.

———. "L'Education politique des femmes: Création ou valeur récurrente?" Pp. 445–52 in *La Revolution française et les processes de socialisation de l'homme moderne. Colloque international de Rouen.* Paris: Messidor, 1989.

———. "Vers une nouvelle historiographie de la femme: Métiers feminins à Rouen au XVIIIe siècle." Pp. 133–38 in *La femme en Normandie.* Lisieux: Archives Départmentales du Calvados: 1986.

Hanley, Sarah. *The Lit de Justice of the Kings of France: Constitutional Ideology in Legend, Ritual, and Discourse.* Princeton: Princeton University Press, 1983.

Harth, Erica. *Cartesian Women: Versions and Subversions of Rational Discourse in the Old Regime.* Ithaca, N.Y.: Cornell University Press, 1992.

Hautecoeur, Louis. *Madame Vigée-Lebrun.* Paris: Henri Laurens, n.d.

Heath, Stephen. "Joan Rivière and the Masquerade." Pp. 45–61 in *Formations of Fantasy,* ed. V. Burgin, J. Donald, and C. Kaplan. London: Methuen, 1986.

Helm, W. H. *Vigée-Lebrun, 1755–1842: Her Life, Works, and Friendships.* Boston: Small, Maynard and Co., 1915.

Hesse, Carla. "Reading Signatures: Female Authorship and Revolutionary Law in France, 1750–1850." *Eighteenth-Century Studies* 22 (Summer 1989): 469–87.

Hobson, Marion. *The Object of Art: The Theory of Illusion in Eighteenth-Century France.* Cambridge: Cambridge University Press, 1982.

Huet, Marie-Hélène. *Monstrous Imagination.* Cambridge, Mass.: Harvard University Press, 1993.

Hunt, Lynn. *The Family Romance of the French Revolution.* Berkeley and Los Angeles: University of California Press, 1992.

———. "The Many Bodies of Marie Antoinette." Pp. 108–30 in *Eroticism and the Body Politic,* ed. Lynn Hunt. Baltimore: Johns Hopkins University Press, 1991.

———. *Politics, Culture and Class in the French Revolution.* Berkeley and Los Angeles: University of California Press, 1984.

———, ed. *Eroticism and the Body Politic.* Baltimore: Johns Hopkins University Press, 1991.

Iconographie de Marie-Antoinette: Catalogue descriptif et raisonné de la collection de portraits de Lord Ronald Gower, intro. Georges Duplessis. Paris: A. Quantin, 1883.

Irigaray, Luce. *The Sex Which Is Not One,* trans. Catherine Porter with Carolyn Burke. Ithaca, N.Y.: Cornell University Press, 1985.

———. *Speculum of the Other Woman,* trans. Gillian Gill. Ithaca, N.Y.: Cornell University Press, 1985.

Jallut, Marguerite. *Marie-Antoinette et ses peintres.* Paris: Noyer, 1955.

Jordanova, Ludmilla. *Sexual Visions: Images of Gender in Science and Medicine between the Eighteenth and Twentieth Centuries.* Madison: University of Wisconsin Press, 1989.

Kamuf, Peggy. *Fictions of Feminine Desire.* Lincoln: University of Nebraska Press, 1982.

Kelly, Joan. "Early Feminist Theory and the *Querelle des Femmes 1400–1789.*" Pp. 65–109 in *Woman, History, and Theory.* Chicago: University of Chicago Press, 1984.

Kofman, Sarah. *L'Enfance de l'art.* Paris: Editions Galilée, 1975.

———. *The Enigma of Woman,* trans. Catherine Porter. Ithaca, N.Y.: Cornell University Press, 1985.

———. *Le Respect des femmes.* Paris: Editions Galilée, 1982.

Kojève, Alexandre. *Introduction to the Reading of Hegel,* trans. James H. Nichols, Jr.; ed. Allan Bloom. New York: Basic Books, 1969.

Lacan, Jacques. *The Four Fundamental Concepts of Psychoanalysis,* trans. Alan Sheridan; ed. Jacques-Alain Miller. New York: W. W. Norton, 1978.

———. *Ecrits,* trans. Allan Sheridan. New York: W. W. Norton, 1977.

Lagrange, Léon. *Joseph Vernet et la peinture au XVIIIe siècle.* Paris: Didier, 1864.

Landes, Joan B. *Women in the Public Sphere in the Age of the French Revolution.* Ithaca, N.Y.: Cornell University Press, 1988.

Lanza, Benedetto et al. *Le Cere Anatomiche della Specola.* Florence: Arnaud Editore, 1979.

Laqueur, Thomas. *Making Sex: Body and Gender from the Greeks to Freud.* Cambridge, Mass.: Harvard University Press, 1990.

Le Doeuff, Michèle. *The Philosophical Imaginary,* trans. Colin Gordon. Stanford, Calif.: Stanford University Press, 1989. Originally published as *L'Imaginaire philosophique* (Paris: Payot, 1980).

———. *Hipparchia's Choice,* trans. Trista Selous. London: Basil Blackwell, 1991.

Leeks, Wendy. "Ingres Other-Wise." *The Oxford Art Journal* 9 (Winter 1986): 29–37.

Lejeune, Philippe. *On Autobiography,* trans. Katherine Leary. Minneapolis: University of Minnesota Press, 1989.

Lerner, Gerda. *The Creation of Feminist Consciousness from the Middle Ages to 1870.* New York: Oxford University Press, 1993.

Levitine, George. "Addenda to Robert Rosenblum's 'The Origin of Painting: A Problem in the Iconography of Romantic Classicism.'" *Art Bulletin* 40 (December 1958): 329–31.

———. *Girodet-Troison: An Iconographical Study.* New York: Garland Press, 1978.

Levy, Darline Gay, Harriet Bronson Applewhite, and Mary Durham Johnson. eds. *Women in Revolutionary Paris, 1789–1795.* Urbana: University of Illinois Press, 1979.

Lichtenstein, Jacqueline. *The Eloquence of Color,* trans. Emily McVarish. Berkeley and Los Angeles: University of California Press, 1993.

————. "Making Up Representation: The Risks of Femininity." *Representations* 20 (Fall 1987): 77–87.

Lionnet, Françoise. *Autobiographical Voices.* Ithaca, N.Y.: Cornell University Press, 1989.

Littré, Emile. *Dictionnaire de la langue française.* 7 vols. Paris: J. J. Pauvert, 1956–58.

Lyon, Georgette. *Joseph Ducreux, premier peintre de Marie-Antoinette.* Paris: Le Nef de Paris, 1958.

Marin, Louis. *Portrait of the King,* trans. Martha M. Houle. Minneapolis: University of Minnesota Press, 1988.

Marion, Marcel. *Dictionnaire des Institutions de la France aux XVIIe et XVIIIe siècles.* Paris, 1923; repr. New York: Burt Franklin, 1963.

Maza, Sarah. "The Diamond Necklace Affair Revisited (1785–1786): The Case of the Missing Queen." Pp. 63–89 in *Eroticism and the Body Politic,* ed. Lynn Hunt. Baltimore: Johns Hopkins University Press, 1991.

————. *Private Lives and Public Affairs: The Causes Célèbres of Prerevolutionary France.* Berkeley and Los Angeles: University of California Press, 1993.

McClellan, Andrew. *Inventing the Louvre: Art, Politics and the Origins of the Modern Museum in Eighteenth-Century Paris.* Cambridge: Cambridge University Press, 1994.

McGuire, James. "La représentation du corps hermaphrodite dans les planches de l'*Encyclopédie*." In *Recherches sur Diderot et sur l'Encyclopédie* 10 (1991): 109–129.

Merrick, Jeffrey. "Fathers and Kings: Patriarchalism and Absolutism in Eighteenth-Century French Politics." *Studies on Voltaire and the Eighteenth Century* 308 (1993): 281–303.

————. "Politics on Pedestals: Royal Monuments in Eighteenth-Century France." *French History* 5 (1991): 234–64.

Miller, Nancy. "Arachnologies: The Woman, the Text, and the Critic." Pp. 270–96 in *The Poetics of Gender,* ed. Nancy Miller. New York: Columbia University Press, 1980.

————. "Performances of the Gaze: Staël's *Corinne, or Italy*." Pp. 162–203 in *Subject to Change: Reading Feminist Writing.* New York: Columbia University Press, 1988.

————. "Politics, Feminism, and Patriarchy: Rereading *Corinne*." Pp. 193–98 in *Germaine de Staël: Crossing the Borders,* ed. Madelyn Gutwirth, Avriel Goldberger, and Karyna Szmurlo. New Brunswick, N.J.: Rutgers University Press, 1991.

Mirzoeff, Nicholas. "Body Talk: Deafness, Sign, and Visual Language in the Ancien Régime." *Eighteenth-Century Studies* 25 (Summer 1992): 561–85.

————. "'Seducing our Eyes' Gender, Jurisprudence, and Visuality in Watteau." *The Eighteenth Century: Theory and Interpretation* 35, no. 2 (1994): 135–54.

Mitchell, Juliet, and Jacqueline Rose, eds. *Feminine Sexuality: Jacques Lacan and the Ecole Freudienne.* New York: W. W. Norton, 1985.

Mitchell, W. J. T. *Iconology: Image, Text, Ideology.* Chicago: University of Chicago Press, 1986.

Modleski, Tania. *Feminism without Women: Culture and Criticism in a "Postfeminist" Age.* London: Routledge, 1991.

Moi, Toril. *Sexual/Textual Politics: Feminist Literary Theory.* London: Methuen, 1985.

————, ed. *French Feminist Thought: A Reader.* Oxford: Basil Blackwell, 1987.

Montrelay, Michèle. *L'Ombre et le Nom: Sur la Fémininité.* Paris: Minuit, 1977.

Mousnier, Roland E. *The Institutions of France under the Absolute Monarchy, 1598–1789*, trans. Arthur Goldhammer. 2 vols. Chicago: University of Chicago Press, 1979.

Muller, John P., and William J. Richardson, eds. *The Purloined Poe: Lacan, Derrida, and Psychoanalytic Reading.* Baltimore: Johns Hopkins University Press, 1988.

Müntz, Eugène. "Lettres de Mme Le Brun relatives à son portrait de la Galerie des Offices (1791)." *Nouvelles Archives de l'Art Français* (1874–75): 449–52.

Nochlin, Linda. "Why Have There Been No Great Women Artists?" In *Woman in Sexist Society: Studies in Power and Powerlessness*, ed. Vivian Gornick and Barbara K. Moran. New York: New American Library, 1981.

Nolhac, Pierre de. *Autour de la reine.* Paris: J. Tallandier, 1929.

———. *Madame Vigée-Lebrun, peintre de la reine Marie-Antoinette, 1755–1842.* Paris: Goupil, 1908.

———. *Marie-Antoinette à Versailles.* Paris: Flammarion, 1932.

Nussbaum, Felicity. *The Autobiographical Subject: Gender and Ideology in Eighteenth-Century England.* Baltimore: Johns Hopkins University Press, 1989.

Orr, Linda. "Outspoken Women and the Rightful Daughter of the Revolution: Madame de Staël's *Considérations sur la Révolution Française.*" Pp. 121–36 in *Rebel Daughters*, ed. Sara E. Melzer and Leslie W. Rabine. New York: Oxford University Press, 1992.

Oulmont, Charles. *Les Femmes peintres du XVIIIe siècle.* Paris: Les éditions Rieder, 1928.

Outram, Dorinda. *The Body and the French Revolution: Sex, Class, and Political Culture.* New Haven: Yale University Press, 1989.

Pardo, Mary. "The Subject of Savoldo's *Magdalene.*" *Art Bulletin* 71 (March 1989): 65–91.

Parker, Rosizka, and Griselda Pollock. *Old Mistresses.* New York: Pantheon Books, 1981.

Passez, A. M. *Adelaïde Labille-Guiard.* Paris: Arts et Métiers Graphiques, 1971.

Pateman, Carole. *The Sexual Contract.* Stanford, Calif.: Stanford University Press, 1988.

Paulson, Ronald. *Emblem and Expression: Meaning in English Art of the Eighteenth Century.* Cambridge, Mass.: Harvard University Press, 1975.

Payne, Blanche. *History of Costume.* New York: Harper and Row, 1965.

Peel, Ellen. "Corinne's Shift to Patriarchal Mediation: Rebirth or Regression?" Pp. 101–12 in *Germaine de Staël: Crossing the Borders*, ed. Madelyn Gutwirth, Avriel Goldberger, and Karyna Szmurlo. New Brunswick, N.J.: Rutgers University Press, 1991.

Perry, Gill and Michael Rossington, eds. *Femininity and Masculinity in Eighteenth-Century Art and Culture.* Manchester: Manchester University Press, 1994.

The Phallus Issue. Differences 4 (Spring 1992).

Piles, Roger de. *Abrégé de la vie des peintres, avec des réflexions sur leurs ouvrages, et un traité du peintre parfait.* Hildesheim: George Olms, 1969.

———. *Cours de peinture par principes*, intro. Thomas Puttfarken. Nîmes: Editions Jacqueline Chambon, 1990.

Pillet, Charles. *Les Artistes célèbres. Madame Vigée-LeBrun.* Paris: Librairie de l'art, 1890.

Planiol, Marcel. *Traité élémentaire de droit civil.* 11th ed., 3 vols. Paris: Librairie générale du droit et du jurisprudence, 1928–31.

Plax, Julie. "Elisabeth Vigée-Lebrun's Greek Dinner Party and the Two Faces of Classicism." Art History Associates Lectures Series, 1992. Manuscript.

Pliny. *Elder Pliny's Chapters on the History of Art*, trans. K. Jex Blake. Chicago: Argonaut Publishers, 1968.

Pollock, Griselda. *Vision and Difference: Femininity, Feminism, and the Histories of Art*. London: Routledge, 1988.

Portalis, Baron Roger. *Adelaïde Labille-Guiard, 1749–1803*. Paris: Georges Rapilly, 1902.

Pucci, Suzanne. "The Currency of Exchange in Beaumarchais' *Mariage de Figaro*." *Eighteenth-Century Studies* 25 (Fall 1991): 57–84.

Radisich, Paula. "The King Prunes his Garden: Hubert Robert's Pictures of the King's Garden in 1775." *Eighteenth-Century Studies* 21 (Summer 1988): 454–71.

———. "Qui peut définer les femmes? Vigée-Lebrun's Portraits of an Artist." *Eighteenth-Century Studies* 25 (Summer 1992): 441–68.

Rancière, Jacques. *The Nights of Labor: The Workers' Dream in Nineteenth-Century France*, trans. John Drury; intro. Donald Reid. Philadelphia: Temple University Press, 1989.

Rand, Erica. "Diderot and Girl Group Erotics." *Eighteenth-Century Studies* 25 (Summer 1992): 495–516.

Ray, William. "Reading Women: Fiction, Culture and Gender in Rousseau." *Eighteenth-Century Studies* (1994): 421–48.

Revel, Jacques. "Marie-Antoinette in her Fictions: The Staging of Hatred." Pp. 111–30 in *Fictions of the French Revolution*, ed. Bernadette Fort. Evanston, Ill.: Northwestern University Press, 1991.

Ribeiro, Aileen. *The Dress Worn at Masquerades in England 1730 to 1790 and its Relation to Fancy Dress in Portraits*. New York: Garland Press, 1984.

Riley, Denise. *Am I that Name? Feminism and the Category of "Woman" in History*. Minneapolis: University of Minnesota Press, 1988.

Rivière, Joan. "Womanliness as Masquerade" [1929]. Reprinted in *Formations of Fantasy*, V. Burgin, J. Donald, and C. Kaplan, eds., 35–44. London: Methuen, 1986.

Robert, Paul. *Le Grand Robert: Dictionnaire de la langue française*. 2d ed., augmented by Alain Rey. 9 vols. Paris: Le Robert, 1985.

Robinson, Philip. *Jean-Jacques Rousseau's Doctrine of the Arts*. Berne: Peter Lang, 1984.

Roland-Michel, Marianne. *Anne Vallayer-Coster, 1744–1818*. Paris: C.I.L., 1970.

Roland-Michel, Marianne, and Catherine Binda. "Un portrait de Madame Du Barry." *Revue de l'art* 96 (1979): 40–45.

Rosenberg, Martin. "Raphael's *Transfiguration* and Napoleon's Cultural Politics." *Eighteenth-Century Studies* 19 (Winter 1985–86): 180–205.

Rosenberg, Pierre. "A Drawing by Madame Vigée-Le Brun." *Burlington Magazine* 123 (December 1981): 739–41.

Rosenblum, Robert. "The Origin of Painting: A Problem in the Iconography of Romantic Classicism." *Art Bulletin* 39 (December 1957): 279–90.

Roworth, Wendy. "Anatomy is Destiny: Regarding the Body in the Art of Angelica Kauffman." Pp. 41–62 in *Femininity and Masculinity in Eighteenth-Century Art and Culture*, ed. Gill Perry and Michael Rossington. Manchester: Manchester University Press, 1994.

———. *Angelica Kauffman: A Continental Artist in Georgian England.* London: Reaktion Books, 1992.

Rubin, James. *Eighteenth-Century Life Drawing.* Princeton: Princeton University Press, 1977.

Russell, David. *Costume History and Style.* Englewood Cliffs, N.J.: Prentice-Hall, 1983.

Sainte-Beuve, Mlle. "A Propos de l'Emigration de Mme Vigée-Lebrun." *Bulletin de la Société de l'Histoire de l'Art Français* (1934): 181–85.

Schaefer, Jean Owens. "The Souvenirs of Elizabeth Vigée-Lebrun: The Self-Imaging of the Artist and the Woman." *International Journal of Women's Studies* 4 (1981): 35–49.

Schama, Simon. "The Domestication of Majesty." *Journal of Interdisciplinary History* 17 (1986): 155–84.

Schwartz, Joel. *The Sexual Politics of Jean-Jacques Rousseau.* Chicago: University of Chicago Press, 1984.

Schiebinger, Londa. *The Mind Has No Sex?* Cambridge, Mass.: Harvard University Press, 1989.

Schor, Naomi. *Reading in Detail: Aesthetics and the Feminine.* New York: Routledge, 1989.

———. "*Triste Amérique: Atala* and the Postrevolutionary Construction of Woman." Pp. 139–56 in *Rebel Daughters*, ed. Sara E. Melzer and Leslie W. Rabine. New York: Oxford University Press, 1992.

Scott, Joan Wallach. "French Feminists and the 'Rights of Man.' Olympe de Gouges's Declarations." *History Workshop* 28 (Autumn 1989): 1–21.

———. "'A Woman Who Has Only Paradoxes to Offer': Olympe de Gouges Claims Rights For Women." Pp. 102–120 in *Rebel Daughters*, ed. Sara E. Melzer and Leslie W. Rabine. New York: Oxford University Press, 1992.

Seligman, Germain. "'La Prudence amène la Paix et l'Abondance' by Simon Vouet." *Burlington Magazine* 103 (July 1961): 297–99.

Sewell, William H., Jr. *Work and Revolution in France: The Language of Labor from the Old Regime to 1848.* Cambridge: Cambridge University Press, 1980.

Sheriff, Mary. *J. H. Fragonard: Art and Eroticism.* Chicago: University of Chicago Press, 1990.

———. "The Im/modesty of Her Sex: Elisabeth Vigée-Lebrun in 1783." In *The Consumption of Culture in the Early Modern Period*, ed. Ann Bermingham and John Brewer. New York: Routledge Press. Forthcoming.

———. "Woman? Hermaphrodite? History Painter? On the Self-Imaging of Elisabeth Vigée-Lebrun." *The Eighteenth Century: Theory and Interpretation* 35 (Spring 1994): 3–28.

Shiff, Richard. "On Criticism Handling History." *Art Criticism* 3 (1968): 60–77.

———. "Representation, Copying, and the Technique of Originality." *New Literary History* 15 (1983–84): 333–63.

Silvestre de Sacy, Jacques. *Le Comte d'Angiviller, dernier Directeur Général des Bâtiments du Roi.* Paris: Plon, 1953.

Smith, Sidonie. *A Poetics of Women's Autobiography.* Bloomington: Indiana University Press, 1987.

Sonenscher, Michael. *Work and Wages.* Cambridge: Cambridge University Press, 1989.

Sontag, Susan. *The Volcano Lover: A Romance.* New York: Farrar Strauss Giroux: 1992.

"Souvenirs de Madame Vigée-Lebrun." *Revue critique d'histoire et de littérature* 7 (February 1870): 109–11.

Spencer, Samia, ed. *French Women in the Age of Enlightenment.* Bloomington: Indiana University Press, 1984.

Stafford, Barbara. *Body Criticism: Imaging the Unseen in Enlightenment Art and Medicine.* Cambridge, Mass.: MIT Press, 1991.

———."Toward Romantic Landscape Perception: Illustrated Travels and the Rise of 'Singularity' as an Aesthetic Category." *Studies in Eighteenth-Century Culture* 10 (1981): 17–75.

———. *Voyage into Substance.* Cambridge, Mass.: MIT Press, 1984.

Stanton, Domna, ed., *The Female Autograph.* Chicago: University of Chicago Press, 1987.

Starobinski, Jean. *Transparency and Obstruction,* trans. Arthur Goldhammer. Chicago: University of Chicago Press, 1988.

Staum, Martin. *Cabanis.* Princeton: Princeton University Press, 1980.

Still, Judith. "Rousseau's *Lévite d'Ephraïm:* The Imposition of Meaning (on Women)." *French Studies* 43 (January 1989): 12–30.

Tarczylo, Theodore. "Prêtons la main de la nature. I. *L'Onanisme* de Tissot." *Dix-Huitième Siècle* 12 (1980): 79–97.

Taylor-Leduc, Susan. "Louis XVI's Public Gardens: The Replantation of Versailles in the Eighteenth Century." *Journal of Garden History* (Summer 1994): 67–91.

Thomas, Chantal. "Heroism in the Feminine: The Examples of Charlotte Corday and Madame Roland." *The French Revolution, 1789–1989.* Lubbock: Texas Tech University Press, 1989.

———. *La Reine scélérate: Marie-Antoinette dans les pamphlets.* Paris: Seuil, 1989.

Tripier Le Franc, J. *Notice sur la vie et les ouvrages de M^{me} Lebrun.* Paris, 1828.

Tuetey, Alexandre. "L'Emigration de Madame Vigée-Lebrun." *Bulletin de la Société de l'Histoire de l'Art Français* (1911): 169–83.

Vallois, Marie-Claire. *Fictions féminines: Mme de Staël et les voix de la Sibylle.* Saratoga, Calif.: ANMA, 1987.

———. "Old Idols, New Subject: Germaine de Staël and Romanticism," trans. John Gavin. Pp. 82–100 in *Germaine de Staël: Crossing the Borders,* ed. Madelyn Gutwirth, Avriel Goldberger, and Karyna Szmurlo. New Brunswick, N.J.: Rutgers University Press, 1991.

Vanpée, Janie. "Jean-Baptiste Greuze: The Drama of Looking." *L'Esprit Créateur* 28 (Winter 1988): 46–68.

Vickers, Nancy. "Diana Described: Scattered Women and Scattered Rhyme." *Critical Inquiry* 8 (Winter 1981): 265–79.

Vuaflart, Albert. *La Tombe de Madame Vigée-Lebrun à Louveciennes.* Paris: Société de l'Histoire de Paris, 1915.

Vuaflart, Albert, and Henri Bourin. *Les Portraits de Marie-Antoinette.* 2 vols. Paris: André Marty, 1909–10.

Wakefield, David, ed. *Stendhal and the Arts.* London: Phaidon, 1975.

Whitford, Margaret, ed. *The Irigaray Reader.* Oxford: Basil Blackwell, 1991.

Wilcox, R. Turner. *The Mode in Costume.* New York: Charles Scribner's Sons, 1958.

Williams, David. "The Fate of French Feminism: Boudier de Villement's *Ami des Femmes.*" *Eighteenth-Century Studies* 14 (1980–81): 37–55.

————. "The Politics of Feminism in the French Enlightenment." Pp. 333–51 in *The Varied Pattern: Studies in the Eighteenth Century*, ed. David Williams and Peter Hughes. Toronto: A. M. Hakkert, Ltd., 1971.

Zweig, Stefan. *Marie-Antoinette: Portrait of an Average Woman*. New York: Garden City Publishing, 1933.

Photographic Credits

Index